IDEE UND AUFBAU

DES STAATLICHEN BAUHAUSES

WEIMAR

VON WALTER GROPIUS

BAUHAUSVERLAG G.M.B.H. MÜNCHEN

'Idea and Development of the State Bauhaus Weimar' by Walter Gropius, anonymously designed cover for an offprint of an essay that simultaneously appeared in the book 'State Bauhaus Weimar' 1919–1923

Edited by Frank Whitford

with additional research by Julia Engelhardt

THE BAUHAUS

Masters & Students
by Themselves

THE OVERLOOK PRESS
WOODSTOCK • NEW YORK

First published in the U.S.A. in 1993 by
The Overlook Press
Lewis Hollow Road
Woodstock, New York 12498

First published in the U.K. in 1992 by
Conran Octopus Limited, 37 Shelton Street, London WC2

Library of Congress Cataloging-in-Publication Data

Whitford, Frank
 The Bauhaus: masters & students by themselves/edited
(and selected) by Frank Whitford with additional research by
Julia Englehardt.
 p. cm.
 Includes bibliographical references and index.
 1. Bauhaus. I. Title.
N332.G33B487 1993
707'.1'143184-dc20

 93-1954
ISBN: 0-87951-507-4 CIP

This book was created by
Amazon Publishing Limited, London

Editor's note

Where known, the place of writing and date of a letter appear in italics
at the head of the letter. Suggested places and dates, where any of this
information is not known for certain, are given in roman type in square
brackets.

Biographical details of the leading figures connected with the Bauhaus
appear at the back of the book (Guide to Principal Personalities, p. 312).

Full details of sources are given in Sources of Documents, p. 316.

Design: Derek Birdsall RDI
Editor: Julia Engelhardt
Picture researcher: Kathy Lockley
Proof reading: Peter Moloney
Index: Barry White

Typeset by August Filmsetting, Haydock, St Helens
Printed in Hong Kong

Contents

Preface

This selection of Bauhaus documents has been drawn from a very large number of published and unpublished sources. Given the range of Hans M. Wingler's magisterial anthology of Bauhaus material which first appeared in 1962, it is inevitable that some of the texts he included should also appear here: to have excluded them would have produced a fragmentary and distorted picture of the school's history and activities. But there are many important documents which Wingler chose not to publish or which were unavailable to him at the time, and I have therefore done my best to keep to a minimum material already familiar to the specialist from Wingler's book (and, indeed, elsewhere), in order to include as many unfamiliar documents as possible. Some of them have not been published before in any language; more are to be found only in such relatively inaccessible places as newspapers, journals and exhibition catalogues; more still, have never been published in English. Where translations do already exist, I have returned to the originals wherever possible in order to make my own, as I hope, more accurate English versions. All the translations are mine unless otherwise indicated in the complete list of sources given at the end of the documentary section.

Although the specialist will find some familiar things here, there is also much that will be unfamiliar and perhaps even surprising. This book is nevertheless primarily intended for readers with an interest in the Bauhaus, modern art, architecture, design and art education, but without a detailed, specialist knowledge of these subjects. It is chiefly for them that the book attempts to bring to life not only an institution and its highly original and influential teaching methods, but also the personalities of the artists, craftsmen and students associated with it, the ideas and theories on which its activities were based, and the dramatic external events that repeatedly influenced its direction and determined its ultimate fate.

Some of the material I have selected may seem trivial. The reader might legitimately ask whether it was necessary to include descriptions of students bathing in the nude, of the kind of clothes they preferred to wear, or of the parties they went to, especially when the space occupied by anecdotes could have been devoted to such far more weighty (and less digestible) matters as the writings of the main Bauhaus theorists. But for those who experienced the school at first hand, it was as much a unique community of unusually gifted, creative and unconventional individuals, as it was a hotbed of radical ideas. Seemingly trivial details of the daily round, the clashes of personality, and the problems of administration and welfare therefore tell us more about what the Bauhaus was really like (and what it was really like to be there) than statements about the psychological effects of colour or the social impact of architecture and design. And in any case, theory has by no means been neglected entirely.

For all its apparently exhaustive treatment of the history and development of the Bauhaus, Hans M. Wingler's anthology treats two periods of the school's life less fully than others. These comprise the years in Dessau when it was directed by Hannes Meyer and the months in Berlin before it was closed. There were clear reasons for this. When Wingler was working, Walter Gropius, the founder and first director of the Bauhaus, was still alive, and Wingler had necessarily to rely heavily on his advice and co-operation. Gropius was anxious to preserve and maintain a partisan image of the school and his contribution to it, and to make Meyer's achievement seem less important than it was. Wingler pays scant attention to the Berlin period, not only because it was so short and relatively unproductive, but also because few documents relating to it were available when he was preparing his book. Today, many more documents from the final months are available, and some of them are included here, as are texts that convey a clear impression of Meyer as director, of the weaknesses he perceived in the curriculum he inherited, and of the impact of his ideas and teaching on at least some of his students.

While preparing this book I have received assistance and advice from many people and institutions, which I gratefully acknowledge here. The staff of the Thüringisches Staatsarchiv in Weimar provided me with assistance on a number of occasions, as did Dr Ulla Jablonowski of the Stadtarchiv in Dessau and the staff of the Bauhaus-Archiv in Berlin. The Getty Center for the History of Art and the Humanities, in Los Angeles, were kind enough to provide me with copies of some of their collection of unpublished Bauhaus material. For information, advice, criticism and sometimes all three, I should like to thank Dr Christian Schädlich, Dr Volker Wahl, Elsa Strietman, Mel Calman and Richard Holledge. I must also record my thanks to Sarah Snape, who commissioned the book and supervised its writing and production with patience and tact, to Kathy Lockley, who carried out the picture research and managed to come up with a, to me unexpected, number of startlingly unfamiliar images, and to Derek Birdsall, whose knowledge and enthusiasm have contributed to a design of which the Bauhaus would surely have approved, had its members still been thinking about book design today. I am even more grateful to Julia Engelhart, who accepted what she believed would be a relatively straightforward editing task, only rapidly to realize that the typescript required a more logical shape and was, in any case, full of glaring omissions. She imposed the shape by organizing the texts in the way they now appear, and filled the gaps by selecting texts from sources that I had missed or was unaware of. I thank her for her work, which was essentially that of co-editor.

There is one final, important acknowledgement to be made. It is to Christine Sommer, in whose Weimar flat I have spent so many happy hours, not all of them devoted to the Bauhaus.

Frank Whitford, January 1992

Chronology

1919

In April the 'State Bauhaus in Weimar' opens with Walter Gropius as director. It consists of an amalgamation of the High School for Fine Art and the School of Arts and Crafts. (Until 1915, when it closed for the duration of the war, the latter was directed by Henry van de Velde, the architect who designed the buildings for both institutions, which the Bauhaus now occupies.) Gropius's first staff appointments are the painters Lyonel Feininger (Master of Form in the Print Workshop), Johannes Itten (Master of Form in the Stained Glass and Cabinet-Making Workshops and responsible for the Preliminary Course), and the sculptor Gerhard Marcks (Master of Form in the Pottery Workshop). Carl Zaubitzer becomes Workshop Master in the Print Workshop, Karl Krull is appointed to the same position in the Stonecarving Workshop, and Helene Börner in the Weaving Workshop.

1920

Appointment of the painters Georg Muche (Master of Form in the Woodcarving and Weaving Workshops), Oskar Schlemmer (Master of Form in the Wall-Painting Workshop), and Paul Klee, who teaches part of the Preliminary Course and becomes Master of Form in the Bookbinding Workshop. Hans Kämpfe appointed Workshop Master for woodcarving, Herr Krause for stonecarving, Max Krehan for pottery and Franz Heidelmann for wall-painting. Beginning of monetary inflation in Germany, which is to reach catastrophic proportions during the next three years.

1921

Appointment of the painter and theatrical designer Lothar Schreyer as Master of Form in the new Stage Workshop and of Josef Hartwig, Josef Zachmann, Alfred Kopke and Carl Schlemmer as Workshop Masters for woodcarving, cabinet-making, metal, and wall-painting respectively. The remaining staff inherited by the Bauhaus from the former High School of Fine Art (including Max Thedy and Walter Klemm) resign to found a new school in part of one of the Bauhaus buildings.

1922

Appointment of the painter Wassily Kandinsky, who teaches on the Preliminary Course and becomes Master of Form in the Wall-Painting Workshop. Gropius replaces Itten as Master of Form for cabinet-making. Otto Dorfner appointed Workshop Master for bookbinding. Schreyer takes over responsibility for the Bookbinding Workshop from Klee, who becomes Master of Form in the Stained Glass Workshop. Oskar Schlemmer becomes Master of Form in the Stonecarving and Woodcarving Workshops. He also teaches life drawing. New Workshop Masters are: Christian Dell (metal), Reinhold Weidensee (cabinet-making) and Heinrich Bebernis (wall-painting). Closure of the Bookbinding Workshop. Theo van Doesburg, founder of the Dutch *De Stijl* group, arrives in Weimar to teach a private art course in opposition to the Bauhaus. Some students leave to join him.

1923

After months of controversy, Itten resigns from the Bauhaus, followed by Schreyer. Schlemmer assumes full responsibility for the Stage Workshop. Appointment of the Hungarian Constructivist painter László Moholy-Nagy, who becomes Master of Form in the Metal Workshop and takes over the Preliminary Course, assisted by Josef Albers, the first student to be appointed to the staff as a 'Young Master'. Albers also becomes Workshop Master for stained glass. In the summer, a large Bauhaus exhibition is staged, together with a week of special activities, including lectures, theatrical performances and concerts. This attracts international attention to the Bauhaus for the first time.

1924

The new right wing, nationalist government of the State of Thuringia reduces its subsidy to the Bauhaus and announces that staff contracts will not be renewed. In December the Council of Masters decides to close the school in March of the following year.

1925

Gropius and his staff (with the exception of Marcks and most of the Workshop Masters) move to Dessau, where the Bauhaus is offered a generous subsidy from municipal funds. The following Workshops do not continue in Dessau: Stonecarving, Woodcarving, Pottery and Stained Glass. The tandem teaching system (a Master of Form and a Workshop Master with joint responsibility for each Workshop), is discontinued. The school in Weimar continues to function with a new director, and for a time also with the name Bauhaus. In Dessau more 'Young Masters' are appointed from among former students. They are: Herbert Bayer, Marcel Breuer, Hinnerk Scheper, Joost Schmidt and Gunta Stölzl. The first 'Bauhaus Books' appear.

1926

Now known as a 'High School for Design' (*Hochschule für Gestaltung*), the Bauhaus moves into new buildings designed by Gropius. Six semi-detached and one detached house for the director and some of the teachers, also designed by Gropius, are completed. The first issue of the *Bauhaus Journal*, a quarterly, appears. The Masters of Form become Professors.

1927

Appointment of the Swiss architect Hannes Meyer to teach in the new architecture department. Hannes Wittwer and Carl Fieger appointed to assist him. Georg Muche resigns.

1928

Gropius resigns as Director and moves to Berlin. Bayer, Breuer and Moholy-Nagy also resign. The architect Mies van der Rohe is offered the directorship but declines. Hannes Meyer becomes Gropius's successor. 'Free Painting' classes are given by Klee and Kandinsky for the first time. Carla Grosch and Otto Büttner appointed to teach sport.

1929

Apppointment of the architects Ludwig Hilbersheimer and Anton Brenner, and of Walter Peterhans, who directs the new photographic department. Schlemmer resigns to take up an appointment in Breslau. The Theatre Workshop does not survive him.

1930

Hannes Meyer is removed as Bauhaus director because of his involvement in left wing political activities. Mies van der Rohe is appointed in his place amid student protests and unrest which cause the temporary closure of the Bauhaus.

1931

Klee resigns and moves to Düsseldorf, where he is appointed Professor of Painting at the Art Academy. Gunta Stölzl also resigns.

1932

Lilly Reich, the interior designer (and Mies's mistress) appointed. In the summer, the local Dessau parliament, now controlled by National Socialists, decides to close the Bauhaus at the end of September. Mies decides to continue the school as a private institution – in a disused telephone factory – in Berlin. This opens in October. The Bauhaus buildings in Dessau are henceforth used as a training school for members of the National Socialist party.

1933

In January Adolf Hitler becomes German Chancellor. At the beginning of the new term on 11 April the Bauhaus is occupied by the police and a contingent of storm-troopers. 32 students are arrested. The school remains occupied and inactive until 20 July when Mies announces the closure of the Bauhaus.

The Prehistory of the Bauhaus

In 1923, some four years after the Bauhaus was founded, its director, Walter Gropius, wrote an essay in which he said that the school was attempting to bring about a reconciliation between 'creative artists and the industrial world'. He acknowledged that the Bauhaus was not the first to do this: earlier individuals and institutions had striven to achieve something similar. They included 'Ruskin and Morris in England, van de Velde in Belgium,... Behrens and others in Germany, and finally the *Deutscher Werkbund*'.

It was too soon to know how successful the Bauhaus would be in its intended reconciliation of the creative arts and industry; but it was already clear that the school was one of the bravest and most original of a series of attempts to solve difficult problems in architecture, the arts and crafts and art education which had emerged during the previous century. The spectacular growth in science, technology and industrialization together with the increase in urban populations had precipitated an unprecedented crisis. What had previously been made exclusively by hand was now widely manufactured by machine; skilled craftsmen were gradually replaced by factory workers who were often little more than machine minders; what they produced was admittedly more economical to make and buy than hand-crafted objects, but the inexorable march of mass-production was widely thought to have resulted in a diminution of aesthetic standards.

Those standards seemed to many to be inextricably bound up with wider questions of beauty and quality and linked to moral problems of sincerity and truth. In England, where the Industrial Revolution began, William Morris thought it dishonest for machine-made goods to pretend to be hand-made, while John Ruskin went further in his belief that the machine itself was a source of evil and social ills. It deprived the craftsman of the joy he took in making something useful from start to finish which satisfied his aesthetic sense and denied the public the opportunity to live in an environment that had been shaped with skill and love.

Of course the machine could not be wished away. Those who tried to do so (and who, like Morris, founded businesses to encourage traditional kinds of craftsmanship) were gradually outnumbered by others who, realizing that industrial advance was irreversible, envisaged a new kind of craftsman trained to understand and exploit the machine's potential in an aesthetically sensitive way.

One of the most influential of those people was the German architect Gottfried Semper, who fled to England as a political refugee in 1849 and who, like Morris and others, was alarmed by the appearance and implications of most of the industrially produced goods he saw in London at the Great Exhibition of 1851. Semper, who coined the German word *Kunstgewerbe* as an equivalent for the English phrase 'arts and crafts', believed that the only satisfactory way of producing a new breed of artist-

Page from a catalogue of hand-made chairs issued by William Morris's company

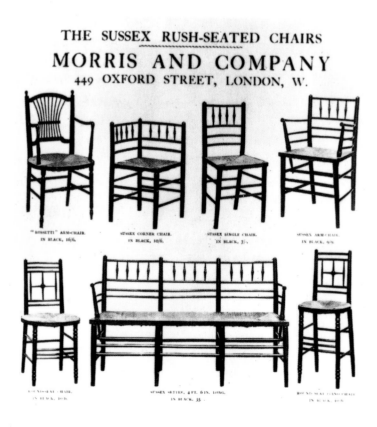

craftsman capable of responding to the special demands of the machine was through a new kind of art education. The traditional craftsman who both conceived and manufactured his products had to be replaced by someone who conceived and described what would be produced by others with the aid of the machine: a designer.

Until the middle of the nineteenth century artists and craftsmen continued to learn their trades as though machines had never existed. Painters and sculptors still acquired their skills in the refined and elitist atmosphere of the academies while craftsmen learned by example within an apprenticeship system which had changed little since the Middle Ages. Painters and sculptors had once been trained in the same way; but with the growth of the academies during the Renaissance the education of artists developed differently from that of artisans. The academies encouraged specialization and the belief that the 'fine arts' were different from and superior to the crafts.

Semper was one of many who believed that the barriers the academic system had erected between the 'fine arts' and the crafts were artificial and damaging and that the academies themselves had become self-indulgent and decadent. His ideas were among those which produced a new kind of art education in nineteenth-century Europe, beginning in England and spreading quite quickly to the Continent and especially the German-speaking countries.

In 1852 a new museum was founded in the South Kensington district of London. Later called The Victoria and Albert Museum, its initial purpose was to collect and exhibit excellent examples of handicraft from all cultures and periods which would serve as models for craftsmen at work then who were manifestly in need of stimulus and inspiration. The museum's educational purpose was made clear by the creation of a school of design attached to it: its students would study and copy objects in the museum's collection before designing their own.

But the new school of design at South Kensington and the many others which quickly sprang up in imitation of it elsewhere in Britain and on the Continent had limited success. The past was made to serve as a model in a present to which it was not entirely appropriate. The new schools were also inevitably regarded as the poor relations of the art academies where painting and sculpture were taught. As time passed, people came to realize that more radical reform of both schools of design and art academies was urgently necessary.

There were practical as well as philosophical reasons why reform was urgent: governments had become aware that the quality of industrially produced goods crucially depended on their design. A well-designed product was not only pleasing to the eye and therefore more likely to find a market; it was also more economical to manufacture. The modern designer therefore had to understand not only why something looked good, but also the

processes required to manufacture it economically in any given material.

At about the same time, new materials and construction methods appeared in the field of architecture and precipitated a crisis similar to that affecting the crafts. The use of iron and glass had resulted in some spectacular buildings, above all, perhaps, in the new railway stations, aptly described as the cathedrals of the nineteenth century. However, most of them were designed not by conventional architects, whose traditional training prevented them from recognizing and exploiting the potential of such materials as cast iron, glass and concrete, but engineers.

It is significant that most of the new 'engineering architecture' provided buildings for such new and entirely modern purposes as railway stations and factories. But there were other peculiarly modern needs, too, not least those of the mass populations who had been attracted to the towns and cities of Europe by the prospect of employment in industry and who were for the most part condemned to live in insanitary slums. Their urgent need for economical, healthy and quickly built housing might also best be met by modern materials and construction methods. It was to be some time, however, before that need was satisfied.

Some people, among them the Belgian architect, designer and painter Henry van de Velde, saw parallels between the work of the engineer-architects and the designers of new products industrially manufactured in new materials. They pointed the way towards new standards of beauty in design because their forms reflected their function. Only when their function was disguised by unnecessary ornament – when they pretended to be hand made – did they become debased.

Henry van de Velde worked in Belgium, France and Berlin before moving to Weimar in 1902, summoned there by a government anxious to improve the quality of its manufactured goods. That government was not national, but regional, and the region in question was Thuringia which lay close to the geographical heart of Germany and was relatively backward industrially and economically. Thuringia's capital was the small, sleepy but culturally distinguished town of Weimar, and it was there that van de Velde set up an 'Arts and Crafts Seminar' to give advice and training to both craftsmen and industrialists. In 1907 that semi-private seminar became a public school of arts and crafts with van de Velde as its first director and in a building which he himself designed.

Van de Velde recognized that designers were not the only people involved in the manufacture of goods. The manufacturers who employed them were as, if not more important, and no design education would be of any account if the manufacturers were unsympathetic to its aims. But van de Velde had little success in persuading the small-scale industrialists of Weimar and the surrounding region to accept his views. The first major companies systematically to employ the services of the new kind of

designer envisaged by van de Velde were situated elsewhere in Germany; they were technologically advanced; and they worked on the large scale.

In 1907 the AEG (the country's biggest electrical concern) appointed Peter Behrens as its chief designer. Behrens, like van de Velde, was formidably versatile: he had been a painter before becoming an architect and designer. He not only designed many of the AEG's products (such as kettles, lighting fitments, electric fans and telephones) but also its advertisements and other printed material, giving them an unmistakable house style. He also created some of the company's industrial buildings. The result was nothing less than spectacular. Given an easily identifiable image by Behrens, the AEG's products became even more successful on the home and foreign markets.

Before his appointment to the AEG Behrens was the director of the art school in Düsseldorf where he had introduced training workshops in which students were trained by actually making things rather than simply designing them on paper. A number of other, similar art schools – above all those in Breslau and Berlin – had been reformed in a similar way at about the same time. Like van de Velde's School of Arts and Crafts in Weimar, their methods proved influential on art and design education throughout Germany after the First World War.

In the year that Behrens became chief designer to the AEG a German organization was founded to encourage industrialists to recognize and encourage the importance of good design. This was the *Deutscher Werkbund* which initially brought together twelve designer-architects and twelve companies in order to arrange for the employment of designers in industry and sustain a publicity campaign directed at the improvement of manufactured goods. Behrens was a member, as were Henry van de Velde and, later, Walter Gropius, who had worked as a junior in Behren's architectural practice in Berlin immediately after qualifying as an architect.

As he acknowledged in 1923, Gropius drew on many sources for his conception of the Bauhaus. It owed something to the general debates about the crafts and industrialization, about the distinctions between artists and artisans, and about the role of ornament and design which were widely and hotly conducted in Britain and on the Continent during the nineteenth century. It owed something more specific to the small number of art schools which were reformed before the First World War and to the ideas of the *Werkbund*. It owed most of all, perhaps, to Henry van de Velde, who had been Gropius's predecessor as director of the School of Arts and Crafts in Weimar.

The School of Arts and Crafts was closed for the duration of the war and van de Velde was, as a Belgian, obliged to leave Germany. But before he departed from Weimar he was asked to suggest a successor if and when the school began work again. The three names he proposed to the authorities were those of August

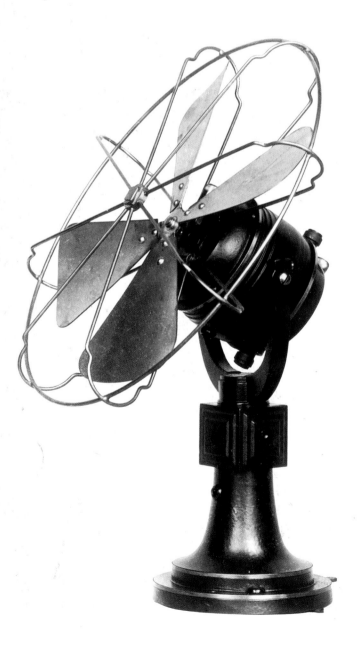

Electric fan designed by Peter Behrens for the AEG company, 1908

Endell, Hermann Obrist and Walter Gropius, men distinguished as architects, designers or educators.

In 1914 Gropius was thirty-two years old and widely regarded as one of the most accomplished architects of his generation. Best known for the shoe-last factory he designed at Alfeld-an-der-Leine in 1910 and for the office building and model factory built for the *Werkbund* exhibition at Cologne four years later, Gropius obviously embraced the most modern ideas enthusiastically.

But by the end of the First World War he was a changed man. He had spent almost all of the war as an officer in the trenches on the Western Front, and the mechanized mass slaughter he experienced there fundamentally changed his attitude to the machine and its influence. As Gropius's membership of such politically revolutionary organizations as the *Arbeitstrat für Kunst* ('Working Soviet for Art') reveals, he now took an attitude to the role of art, architecture and design in society which managed to be both radical and reactionary at the same time.

Germany had changed too of course. The most industrially and technologically advanced country in Europe before 1914, by the time the Bauhaus was founded in 1919 it had become a defeated, bankrupt nation plagued by social unrest, monetary inflation and political instability. These depressing conditions would not last for ever; but while they did, every educational institution would have been wise to take account of them.

Indeed, Gropius was no doubt only prepared to contemplate a further interruption of his career as an architect to become involved, for the first time in his life, in education, because he knew that for some time after the war no-one would be able to make a living by designing buildings. The pressing need to earn money (Gropius had married the widow of the Viennese composer Gustav Mahler during the war and was by now a father) also explains why he was prepared to leave Berlin and work in the small, provincial and narrow-minded city of Weimar, a place which, because of its association with Goethe, Schiller, Bach, Liszt, Nietzsche and many other celebrated figures of German intellectual and cultural history, felt more at home in the past than the present, encouraged unadventurous, even reactionary ideas and was hostile to novelty and innovation in everything.

Given the enormous problems, both external and internal, faced by Gropius from the outset, it was a miracle that the Bauhaus managed to get off the ground and survive at all, let alone become the most famous and influential art school of modern times.

Walter Gropius as a cavalry officer during the First World War

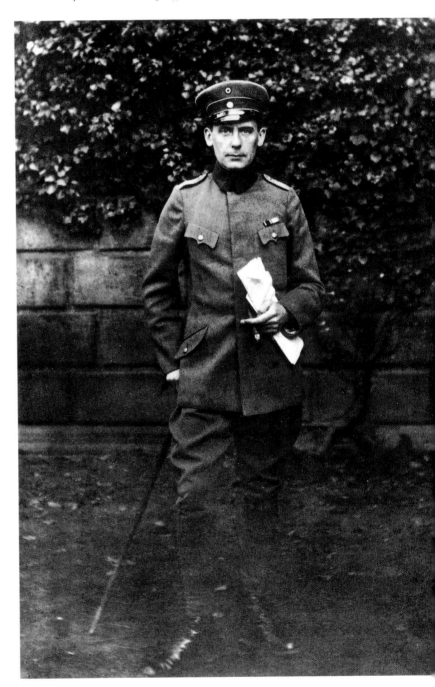

Prehistory

Beauty and Function

William Morris *Arts and Crafts Circular Letter* 1896

... To the medieval craftsman generally, ornament was only incidental. If his ornament was not good ... at least he was making a shoe, a knife, or a cup, or what not, as well as ornament. But you who make nothing but ornament, please remember that a piece of white paper, or an oak panel, is a pretty thing, and don't spoil it. ...

Henry van de Velde 'A Chapter about the Design and Construction of Modern Furniture' in *Pan* 1897

... My ideal would be the reproduction of my creations by the thousand, though definitely under my strict supervision, for I know from experience how quickly a model can lose its detail in production and, through all sorts of dishonest or uncomprehending manipulations, can seem just as ordinary as the object it is supposed to counter: I therefore expect to be thoroughly influential only from the moment at which a large engineering works allows me to make an effect according to the maxim that has given direction to my social beliefs: that a human being is worth all the more in proportion to the number of people to whom his life's work is useful, or whose lives are enhanced by it. ...

 We can succeed in modernizing the appearances of things by carrying out the simple intention of being strictly rational, by following the principle of rejecting without exception all forms and ornamentation which a modern factory could not easily manufacture and reproduce, by plainly stating the essential structure of every piece of furniture and object and by constantly bearing in mind that they must be easy to use. ... It is only because I understand and marvel at how simply, coherently and beautifully a ship, weapon, car or wheelbarrow is built that my work is able to please the few remaining rationalists who realize that what has seemed odd to others has in fact been produced by following unassailable traditional principles, in other words unconditionally and resolutely following the functional logic of an article and being unreservedly honest about the materials employed, which naturally vary with the means of each. ...

Henry van de Velde, lithographed poster, in the Art Nouveau style, for the Tropon food company in Mülheim, 1897

Henry van de Velde 'The Role of the Engineer in Modern Architecture' in *Die Renaissance im modernen Kunstgewerbe* 1901

...There exists a class of persons whom we can no longer refuse to call artists. Their work rests on the one hand on the use of materials which were previously unknown and on the other on an extraordinary boldness which even surpasses the daring of the builders of the cathedrals. The artists I am referring to, who have created a new architecture, are the engineers.... They build houses and mansions for us for the same purposes as those designed by architects and moreover use all kinds of materials to produce totally new objects such as locomotives, bicycles, automobiles, adventurous speedboats and the machines that make up the overwhelming might of our industry....

I have already made frequent mention of locomotives, steamers, machines and bridges, but the first English perambulators, the different bathroom fittings, electric hanging lamps and surgical instruments should also be remembered among the modern inventions which attract by their beauty.

All these articles are beautiful because they are exactly what they should be and their forms become even more beautiful when they are made out of beautiful raw materials which have been properly treated. They remain beautiful until greedy mischief-making manufacturers choose to embellish them in their own way and then, utterly disregarding their original necessity, rob them of their forms. These highly dangerous afterthoughts, which are evil, always know on which sources to draw in order to appeal to the masses who have no experience of the real character of modern beauty and are always mesmerized and immediately taken in by the myriad guises of outward ornamental fantasy.

Adolf Loos [Austrian architect and theorist] in *Ornament und Verbrechen* 1908

...Conditions in the woodcarving and turning trades, the criminally low prices paid to embroiderers and lace-makers are well known. The producers of ornament must work twenty hours to earn the wages a modern worker gets in eight.... If I pay as much for a smooth box as for a decorated one, the difference in labour time belongs to the worker. And if there were no ornament at all – a circumstance that will perhaps come true in a few millennia – a man would have to work only four hours instead of eight, for half the work done at present is still for ornamentation....

The Dawn of Change in Art Education

Gottfried Semper [German architect] in *Wissenschaft, Industrie und Kunst* 1852

...We have artists but no art as such. The academies established by the State educate people to produce art in the grand style, but even if we overlook the broad mass of mediocre talents, the number of highly gifted individuals far exceeds the demand for their services. Only the very few succeed in realizing the ambitious dreams of their youth, and then only at the expense of reality because they are obliged to negate the present and conjure up fantasies of the past [in their work]. The others find themselves at the mercy of the market, and try to make a living wherever they can. Here one of those many contradictions which our age has thrown up becomes clear once again. How shall I describe it in the briefest terms? It would not be clear were I to say that art now applies itself to the crafts as the crafts once applied themselves to art — I certainly do not mean that an unartistic, craft-based attitude has come to dominate. This statement can only be justified inasmuch as the impulse for the refinement of form no longer works upwards from below but downwards from above. But even this interpretation is unsatisfactory since the same occurred in the days of Phidias and Raphael, even more consistently at the time of the ancient Egyptians, and has always occurred whenever architecture reigned hierarchically over the other arts. The anomaly is essentially that this influence from above is now occurring in an age which no longer recognizes the dominance of architecture....

Basically the great art academies are little more than institutions for the sustenance of professors whose clique will take a long time to grasp how isolated it is from the people.... A brotherly relationship between the master, his journeymen and apprentices will mark the end of the academies and industrial schools, at least in their present form....

Hermann Obrist [German artist] in *Eine Künstlerische Kunsterziehung* 1900

...Everyone who wishes to become an artist, whether a draftsman, painter, sculptor, architect, or a creator of functional or decorative objects, all these young people should have to spend a year together undertaking an elementary course of instruction ... and they should be obliged to do nothing but one thing: daily to produce a distillation of part of everything they have seen, even if their initial achievement is of the most modest kind....

After a few months the pupils will form groups entirely by themselves and entirely free from prescription, each according to his inclinations, his curiosity, his technical abilities, his creative drives. And now their achievements have an inner value which derives ... from desire....

Each pupil will once again give birth to each piece of handicraft anew, entirely as it used to be in primeval times; and if it gives him pleasure, it will also be technically creative....

Peter Behrens [German architect and designer] 'Art Schools' in *Kunst und Künstler* 1907

... Today's school of arts and crafts has to meet both the demands of the handicrafts for aesthetic directives and the needs of industry for artistic impulses. The goal, but not always the way, of the two tasks is the same. The Düsseldorf school seeks a mediation by going back to the fundamental intellectual principles of all form-creating work, and allows the principles of form to take root rather in the artistically spontaneous, in the inner laws of perception, than directly in the mechanical aspects of the work. Within the limits of his talent, the pupil will be given the ability to master through his knowledge of the laws of art the manifold and not always fully defined requirements of technique and material....

William Morris *Arts and Crafts Circular Letter* 1896

... in order to have a living school of Art, the public in general must be interested in Art; it must be a part of their lives; something which they can no more do without than water or lighting....

Study in ornament by an anonymous student at the Weimar School of Arts and Crafts under van de Velde's directorship

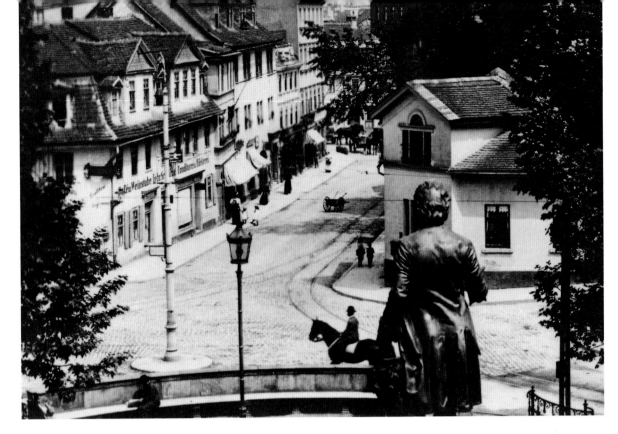

*Weimar, c.1910, view from the Wielandplatz towards the
Frauenthorstrasse and the centre of town. To reach the School of
Arts and Crafts and the Art Academy one walked about 50
metres (150 yards) along the road to the right (the Belvedere-
Allee) and then turned right again into the Kunstschulstrasse*

Weimar: The Art Academy and the School of Arts and Crafts

Description of Weimar in *Encyclopaedia Britannica* XIth edition 1911

WEIMAR, a city of Germany, the capital of the grand-duchy of Saxe-Weimar-Eisenach. It is
situated in a fertile valley on the Ilm, a small tributary of the Saale, 50m. S.W. of Leipzig
and 141m. S.W. of Berlin.... Pop. (1885) 21,565, (1905) 31,121. Weimar owes its importance
not to any industrial development, which the grand-dukes discourage within their *Residenz*,
but to its intimate association with the classical period of German literature, which earned
for it the title of the 'poets' city' and 'the German Athens'. The golden age of Weimar,
covered by the reign of Charles Augustus from 1775 to 1828, has left an indelible impress on
the character of the town.

In spite of the classical associations and of modern improvements, Weimar still retains
much of its medieval character. The walls survive, indeed, only in isolated fragments, but the
narrow winding streets of the older part of town, and the market place surrounded by houses
with high-pitched gables and roofs are very picturesque.... The atmosphere of the whole
town is, indeed, dominated by the memory of Goethe and Schiller.... The most beautiful
monument of Goethe's genius in the town is ... the park, laid out in the informal 'English'
style, without enclosure of any kind....

The history of Weimar, apart from its association with Charles Augustus and his court, is
of little general interest.... The art school, founded ... in 1848, has had a notable series of
eminent painters among its professors, including Preller, Böcklin, Kalckreuth, Max Schmidt,
Pauwels, Heumann, Verlat and Thedy....

Joost Schmidt *How I experienced the Bauhaus* [undated typescript, 1947]

... In 1910 at the age of seventeen I joined the Art Academy in Weimar which at that time was considered to be the freest and most lively art school of all. I – the greenhorn – shyly looked around the studios. In some, people were painting in a way inspired by the Old Masters; in others, honour was being paid to the Impressionists and Pointillism had its enthusiastic disciples. Students coming from Paris said that these styles were *passé* and that the styles of Cézanne and Van Gogh were the latest thing. For the sculptors, the god was Rodin.

The notion of *l'art pour l'art* was enthusiastically defended. The older students passionately discussed the problems of traditional and modern art. I learned more from these older students than from the professors.

The study programme itself was very monotonous. At first drawing with painful precision Greek heroes, gods and demi-gods as plaster casts together with all the holes made in the casts over the years by the bored beginners in the antique class. After that drawing and painting from life: nudes, portraits, people in costume. For months, years. After that, finally, as an advanced student one could do what one wanted. The improvements suggested by my professors brought me scarcely any further; the sharp criticisms of my fellow students helped me more.

Being restricted to the object made me dissatisfied. I should have liked to find out more about the nature of colour and form, about the laws of composition. But to enquire about such things was then forbidden. ...

Henry van de Velde 'The Seminar for Arts and Crafts' in *Geschichte meines Lebens* 1962

... My appointment in Weimar as artistic adviser was regarded far and wide as an important event. ... There was nothing similar in any other country, no other ruler or government had thought to take the ailing crafts under their wing. ...

Henry van de Velde to E. von Bodenhausen

17 [June] 1902

... The lack of technical education for artisans is very serious and the structure is threatened *at its base*. This can be remedied and my institute is what will help. ... I shall look into its method of working in such a way that we shall not end up with a *school* of industrial art but rather a *laboratory* where I, together with *collaborators*, will examine and prepare what is most suited to artisans, and to those industrialists who have faith in our work, in short to those people who will have faith once they have had the material benefits of it! ...

Henry van de Velde to Walter Gropius

8 July 1915

... Help and advice were requested from the Seminar for Arts and Crafts so rarely that after a few years I founded the School of Arts and Crafts in order best to prepare and educate the younger generation of [the State of] Saxe-Weimar in all fields of the arts and crafts.

For as long as an industrialist or craftsman is flourishing, in other words, for as long as he can sell his products, no matter of what kind or quality, he will not go to the artist. And if he does go when business is bad, he goes as though to the devil in order to sell his soul which is determined to do everything to fill his wallet. And if the artist does not then succeed in helping the threatened manufacturer to sell several hundred examples of each new model at the next Leipzig Trade Fair, then the devil or the artist is done for!...

Joost Schmidt *How I Experienced the Bauhaus* [undated typescript, c.1945]

...Opposite the Academy building was the School of Arts and Crafts. The painter and architect Henry van de Velde, one of the leading figures of the Art Nouveau movement, was the director. I heard him give a very intelligent lecture on interior design and I became disillusioned by my 'pure' art training. His students, who devoted themselves to so-called applied art, were not taken seriously by the fine-artists at the Academy. After closer inspection I found this judgement arrogant. A so-called fine-artist can give vent to his feelings in his picture thoughtlessly, whereas someone who wants to design a piece of furniture must discipline his creative urges much more....

Henry van de Velde at his Weimar home, c.1910

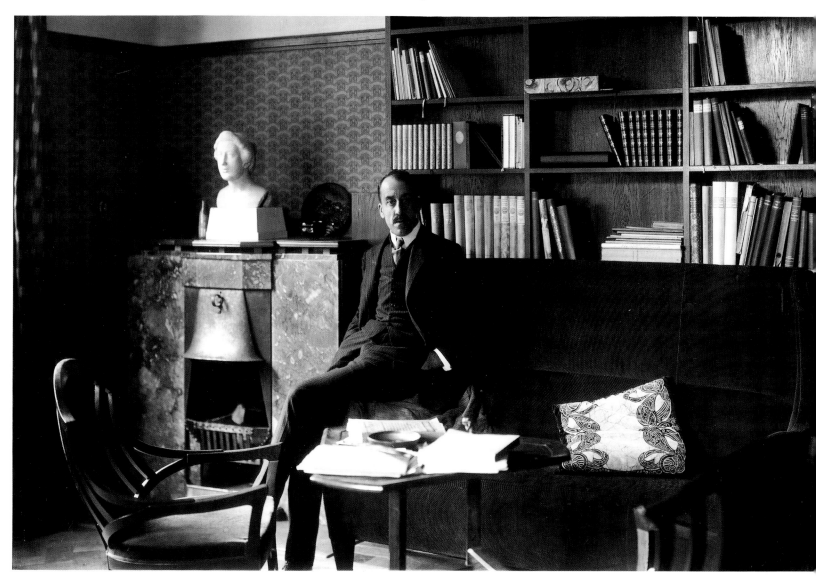

Henry van de Velde 'The Weimar School of Arts and Crafts' in *Geschichte meines Lebens* 1962

...I wanted to base the teaching at the Weimar School of Arts and Crafts on the kind of relationship between master and apprentice that had once existed in the great periods of craftsmanship. The interaction of ideas which had occurred between me and the applied artists in our co-operative work in the 'Seminar for Arts and Crafts' strengthened my conviction that the will to perfection which had to dominate the new school could only arise from a living atmosphere of mutual respect and from a co-operative effort to make objects as well as possible.... In the course of three or four years and as a result of a strict teaching programme, able designers and model-makers would be trained to combat the old-fashioned habits dominating those unfathomable sectors of the market which, in Germany as in all other Central European countries, resulted in products blemished by the stigma of 'cheap and bad' and in the consequent drive to produce one novelty after another....

The training [at the school] was directed by the following principles: 1. Technical drawing, taught with reference to each kind of craft activity. 2. The study of colour, applied to the various branches of the crafts, and 3. The study of ornament which, following the laws of dynamography and abstraction, provided the various branches of the crafts with ornament....

Walter Gropius the Architect

Walter Gropius to Karl Ernst Osthaus [patron of the arts and philanthropist]

Berlin, 31 October 1911

...I have the intention of carrying through by all possible means my ideas for the industrialization of small houses.... The innovation lies in the industrialization of the design: I have a box of building blocks of single building elements out of which I can, with the help of *existing* construction companies, put together houses according to local and individual needs. No one needs to know about this system. In actual cases, I can quietly carry through my principles (they are actually only the final results of already existing building practices) and, once they are successful, then talk about how they came about. The *actual case* is, of course, a question of survival. Under the framework of a real project, I have to have a possibility of coming up with a number of small houses, be it for industry or a garden city....

Walter Gropius to Karl Ernst Osthaus

Vienna, 19 December 1917

...Little by little I'm crumbling inside.... I've got to get away from here for a while and do some work at least, otherwise I'll be ruined as an artist and — be entirely forgotten by the world.... I don't want to be buried alive and must therefore get mightily busy so that the people see that I'm still here....

Walter Gropius to Karl Ernst Osthaus

Berlin, 23 December 1918

... I came here to participate in the revolution. The mood is tense here, and we artists have to strike while the iron's hot. In the Working Soviet for Art [*Arbeitsrat für Kunst*], which I have joined, there's at present a congenially radical atmosphere and productive ideas are being brought up....

Walter Gropius to Karl Ernst Osthaus

Berlin, 23 December 1918

... for the past 14 days I have been storming through Berlin, looking for some job or another, but until now entirely without success, and I am already in despair about how things will turn out. After $4\frac{1}{2}$ years most of the footprints one left behind have been wiped away....

I am working on something entirely different now, which I've been turning over in my head for many years – a *Bauhütte*! With a few like-minded artists.... I ask you to keep quiet about it until I have spoken with you face to face, otherwise the idea, which requires gentle discretion, will be trampled in the economic turmoil before it's able to live....

Walter Gropius to his mother

Berlin, 31 March 1919

... The Working Soviet for Art gives me real joy. I have turned the whole thing upside down since I became chairman and have created a very interesting, lively thing out of it....

All important modern artists, architects, painters, sculptors under one cover ... all come to the meetings and that is incredibly beautiful and animating.... This is the type of life I have always had in mind, but the cleansing effect of the war was necessary for it....

Manifesto of the Working Soviet for Art Berlin, May 1919

... Art and the people must achieve a unity. Art must no longer provide enjoyment for the few but happiness and life for the masses. The aim is the integration of the arts beneath the wings of great architecture....

Walter Gropius 'Architecture in the free democratic state' in *Deutscher Revolutionsalmanach* 1919

... We are stuck deep in the mire of old sins. We cannot be 'liberated' by the political revolution, only by the completion of the spiritual revolution. Capitalism and power politics have made our species creatively dull, and living art is being suffocated by the broad mass of bourgeois philistines. The intellectual bourgeois of the old Reich – lukewarm, without energy, intellectually lazy, arrogant and malformed – has demonstrated his inability to support a German culture....

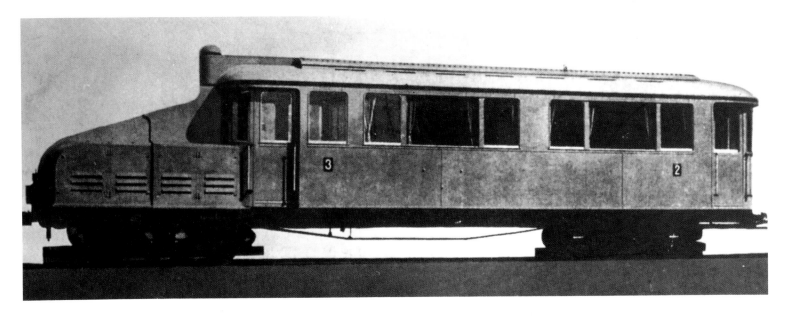

*Gropius the architect and designer: (above) locomotive, 1912.
(below) the Fagus shoe-last factory, Alfeld-an-der-Leine, 1911
(designed with Adolf Meyer), one of the earliest modern
industrial buildings*

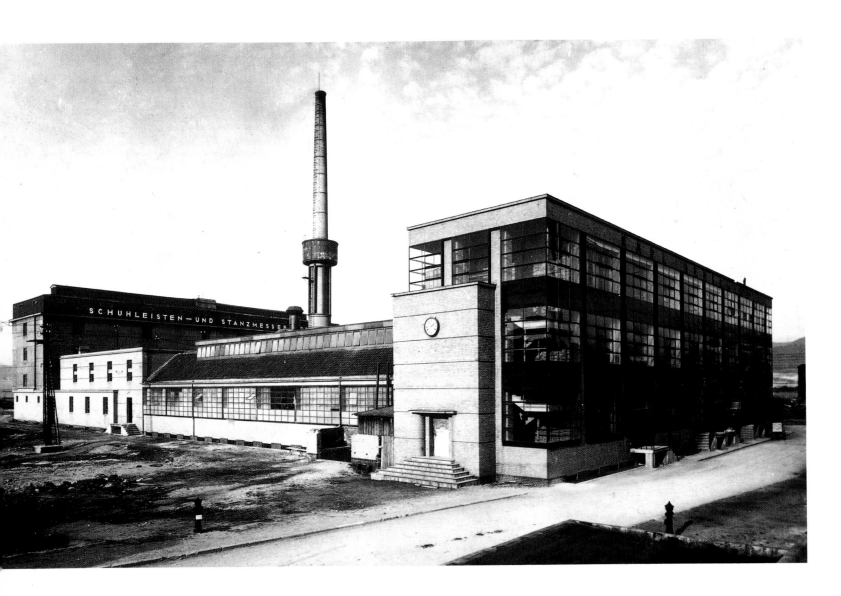

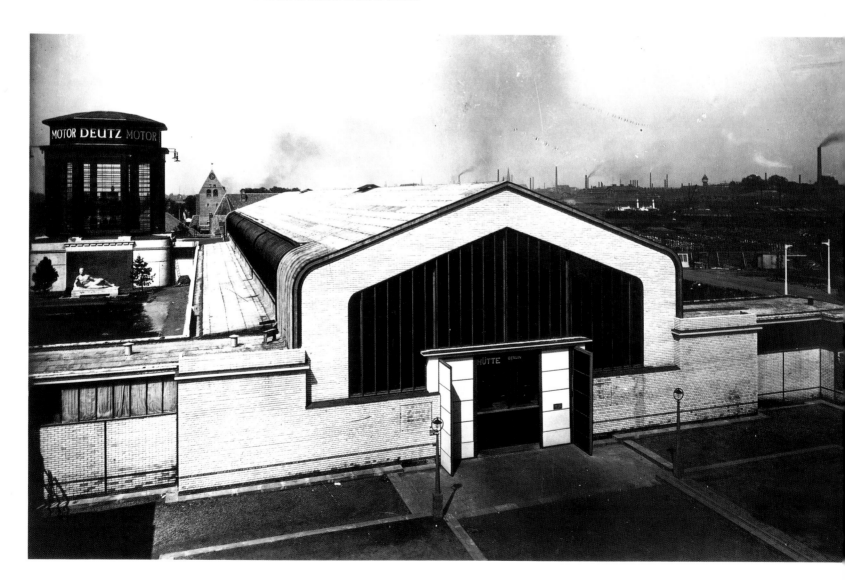

IN DIESEM HAUSE GAB SICH
DAS DEUTSCHE VOLK DURCH
SEINE NATIONALVERSAMMLUNG
DIE WEIMARER VERFASSUNG
VOM 11. AUGUST 1919

*(above) metal plaque, with lettering designed by Gropius, on the façade of the
National Theatre, Weimar: It commemorates the signing of the German Constitution
11 August 1919 by the Constituent Assembly, which met and debated in the theatre
for several months.
(below) machine hall (designed with Adolf Meyer) for the Werkbund Exhibition,
Cologne, 1914. This, together with an office building, was constructed especially for
the exhibition and demolished when it closed*

The Appointment of Gropius to Weimar

Henry van de Velde to Walter Gropius

[Weimar] *11 April 1915*

... I would like briefly to ask you, my dear Herr Gropius, two questions.
1. Would you be interested in taking my place as director of the School of Arts and Crafts in Weimar? (I resigned on 1 April but have been asked to remain until 1 October 1915).
2. Where and in which periodical can I find reproductions of your work?
I have recommended to the Ministry *you*, Obrist and Endell. . . .

Walter Gropius to Fritz Mackensen [director of the Weimar Academy of Arts and Crafts]

[Berlin] *19 October 1915*

... What I envision is an autonomous teaching organism, which of course has to develop from a modest base, but which is artistically *independent* and which perhaps (at first) is administratively *co*-ordinated with the existing academy.... On all essential matters I would be able to work well only according to my *own* ideas.... The *absence of restrictions* must be an explicit condition....

Walter Gropius to Ernst Hardt [theatre director in Weimar]

Berlin, 16 January 1919

...van de Velde proposed ... that I should succeed him in Weimar. I put my ideas in writing and after visits to the Ministry and the Grand Duke there the matter seemed to be more or less settled. Since the Grand Duke was to provide the money, everything is now temporarily hanging in the air, but on the other hand his abdication has removed my major worry that I would not be able to work there effectively....

Walter Gropius to his mother

Berlin, 31 March 1919

... I am now director of both van de Velde's school of arts and crafts and the art academy, and after adding a new department of architecture, I want to create a new, unified institution with the name 'State Bauhaus in Weimar'. I have 10,000 Marks (monthly), a free studio and have even been guaranteed State commissions which were especially important for me. I begin on 1 April ... Weimar is completely full; perhaps I shall rent van de Velde's villa.... In Weimar I was immediately offered the title of Professor. I turned it down, and you will probably not understand why....

Walter Gropius to Ernst Hardt

Weimar, 14 April 1919

... My idea of Weimar is not a small one.... I firmly believe that Weimar, precisely because it is world famous, is the best place to lay the foundation stone of a republic of intellects.... I imagine Weimar building a huge estate around the Belvedere hill with a centre of public buildings, theatres, a concert hall and, as a final aim, a religious building; annually in the summer great popular festivals will be held there....

Walter Gropius in 1920. *The picture is by Weimar's leading photographer at the time, Louis Held*

The First Years: Weimar, 1919–25

The Bauhaus got off to an inauspicious start. It was founded in April 1919 in Weimar, and both the time and the place seemed to condemn it to a brief life from the very beginning. The time was a moment of unparalleled political and economic chaos, and Weimar was a place of jealously guarded traditions and reactionary opinions, all of them hostile to anything which, like the Bauhaus, proposed startling innovation and radical change.

Enemies of the Bauhaus gathered from the start. The school's novel plans for the training of craftsmen, the reinvigoration of industry and the arts and crafts alarmed and annoyed the majority of local tradesmen and artisans. The school's absorption of the existing Art Academy caused resentment among painters and sculptors in the region and beyond. Educationists noticed that its founder and first director, Walter Gropius, had not been involved with education of any kind since qualifying as an architect more than a decade before; taxpayers resented the lavishing of public funds on an enterprise they were unable to understand; and nationalists feared that, with several foreigners among its staff and students, the Bauhaus would foster 'cosmopolitan' rather than 'German' values.

In 1919 Germany was a defeated, despised and bankrupt nation. It was also politically volatile. The old order, the empire, had collapsed at the end of the war. The Kaiser had abdicated and gone into exile in Holland. A republic had been proclaimed, and an abortive Communist revolution had brought murder and mayhem to the streets of Berlin and the other major cities.

By April 1919 there was no new constitution and there had been no elections. While mutilated veterans begged and sold matches on the streets, the black market flourished at the hands of gimlet-eyed fixers and confidence men. The politicians responsible for designing the new constitution were still conferring – not in the German capital, Berlin, which continued to suffer from street-fighting and other kinds of unrest, but in Weimar, regarded by many as the cultural capital and still comparatively quiet. The politicians met in the National Theatre, a few minutes' walk away from the buildings the Bauhaus occupied. In spite of the relative calm a large number of troops had been ordered to Weimar to deal with demonstrations and protect the politicians. Many of them were occupying part of the Bauhaus buildings and would not withdraw until the new constitution was written.

The unwelcome presence of troops and the tense atmosphere were two of the less daunting problems which Walter Gropius faced during the first months of his directorship of the Bauhaus. He had put forward proposals for a new school of arts and crafts in Weimar during the war when the old order still existed and he knew who he was negotiating with. But now, in 1919, it was no longer clear precisely with whom he was expected to deal and, more important, on whom he could rely for funds. Not until the autumn of 1919 after the constitution had been drawn up and elections were held did matters become more certain. Germany

Lithographed invitation, designed by the student Karl-Peter Röhl, to the opening ceremony of the Bauhaus at the National Theatre in Weimar, 21 March 1919

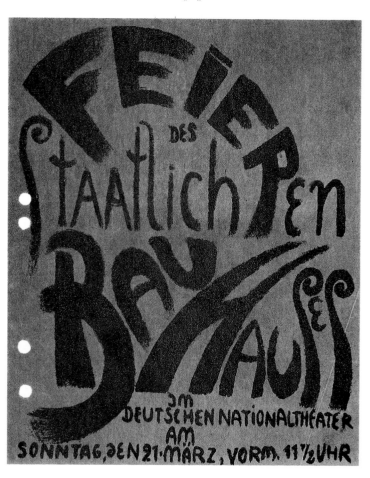

became a federation of states, each with its own parliament, and Weimar became the capital of the state of Thuringia. The Bauhaus, officially known as the State Bauhaus, was from then on the responsibility of the Thuringian Ministry of Education.

Not that these new arrangements improved the economic situation. Money continued to be short, its value at first steadily and then rapidly eroded by the inflation which, by 1922, reached catastrophic proportions. Financial difficulties plagued Gropius during the first months and even years of the life of the Bauhaus. Workshops needed to be established and equipped; staff had to be paid; students required housing, food and, in some cases, even clothing. Much of Gropius's time was therefore spent in urgent negotiations with the authorities, begging wealthy individuals for money, and in the often imaginative acquisition of victuals, tools, coke and coal.

Nor did Gropius's problems end there. At his suggestion, the Bauhaus was created from an amalgamation of two existing institutions whose buildings it took over: the School of Arts and Crafts founded by van de Velde and the older Academy of Fine Art which occupied a building (also designed by van de Velde) on the other side of the same narrow street. The former had been closed for most of the war, its premises occupied by a reserve army hospital. But the latter remained open, and Gropius was obliged to assume responsibility not only for its students but also, and more worryingly, for its teachers, several of whom were rooted in the academic tradition and opposed to his unconventional ideas.

They were 'fine-artists' to a man – painters, sculptors or print-makers – and proud of the Academy's splendid past. Gropius had not only brought an end to an institution famous for having produced some of Germany's most distinguished artists, but he had also announced that his new school would not teach 'fine art' at all. The inevitable results were disputes, increasingly bitter and debilitating, which came to an end only after the Academy was resurrected in a slightly changed form in September 1920.

At least Gropius was at liberty to recruit some teachers himself. But since his plans for the the school were unconventional, where could he find people sympathetic to his ideas and sufficiently versatile to realize them? His aim was a curriculum in which craft skills would be informed by artistic sensibility and judgement. This consequently demanded teachers who were both consummate craftsmen and accomplished artists. Such versatile talents seemed not to exist anywhere in Germany (or anywhere else for that matter) and so Gropius was obliged to employ painters and sculptors with a firm theoretical grasp of fundamental aesthetic principles together with craftsmen with specialist skills. The former were to be known as *Formmeister* (Masters of Form), the latter *Werkstattmeister* (Workshop Masters) and they were to teach in tandem, the fine-artists communicating a sense of what the students might create, the craftsmen a sense of how they might practically achieve it.

This arrangement also caused problems, since the fine-artists were reluctant to involve themselves in craft matters and the craftsmen resented interference from those they considered unqualified to give opinions in their Workshops. The Workshop Masters also noticed that they did not enjoy identical conditions of service, in spite of assurances that they would be treated the same as the Masters of Form. Discrimination continues: those members of the Bauhaus staff who remain best known and most frequently celebrated are the painters and sculptors, while the names of such leading Workshop Masters as Christian Dell, Josef Hartwig and Max Krehan are far less familiar.

The emphasis in the Bauhaus curriculum on handicraft, on the making of things with a specific purpose, together with Gropius's hostility to the fine arts, frustrated many of the students. Not only those who had previously enrolled at the Art Academy but many of the new arrivals, too, had ambitions to be painters and sculptors. They fondly believed that they would receive the appropriate formal instruction at the Bauhaus, and complained (and sometimes left for other institutions) when they realized that they were able to paint and sculpt only informally and in their limited free time.

Given such problems (and at a time when Gropius's marriage was in terminal difficulties), the survival of the Bauhaus for more than a few months represented a major achievement. But it did more than survive: it eventually flourished.

One of the reasons for the school's survival was the enormous optimism which accompanied its foundation. The manifesto and programme Gropius wrote, and the speeches in which he explained and justified his ideas and plans to students, politicians and industrialists are positively Utopian in their breadth of vision. But they are also level-headed, acutely aware of contemporary realities and the obstacles to progress they represented.

Gropius's pronouncements were inspired by a desire for nothing less than a new world order after the catastrophe of the Great War. He hoped that the Bauhaus would eventually become a successful community of creative individuals who, living and working together, would set an example to society at large. By shaping the environment by means of artistically sensitive design, the members of the Bauhaus would also enhance the quality of life enjoyed by everyone in the larger community.

But Gropius's statements also reflect an awareness of economic problems. The Bauhaus would not train students to become painters and sculptors, he said, because no-one was buying art. Every student had to acquire a craft because a skilled craftsman would always be able to earn a living.

There was more to Gropius's advocacy of craftsmanship than economic considerations, however. He believed that the fine arts were in crisis and that the root of the problem lay far deeper than the current catastrophe. He thought that the fine arts had begun to decline as long ago as the Renaissance when their traditional

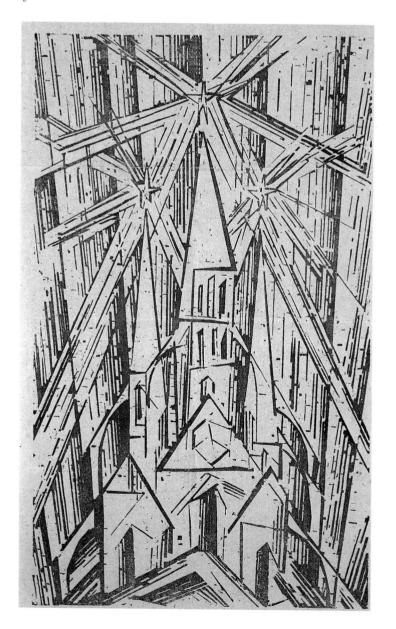

Lyonel Feininger's woodcut illustration (in the Cubo-Expressionist style) for the Manifesto and Programme of the Bauhaus, 1919. Only later was it given the title 'The Cathedral of Socialism'

links with the crafts became loosened as the painters and sculptors, seeking enhanced status, argued that their skills were superior to those of the artisans. Barriers were thus erected between the fine arts and the crafts, between artists and artisans to the detriment of all of them. If the fine arts and the crafts were to flourish once again, those barriers had to be demolished and co-operation between artists and artisans encouraged.

Trained as an architect, Gropius believed that architecture was supreme among the visual arts because a building ideally achieves a synthesis of them all: painting and sculpture as well as all the crafts. He illustrated his Bauhaus manifesto with a woodcut of an imaginary medieval cathedral because he thought that it was above all in the Middle Ages, in the great Gothic cathedrals of Europe, that carvers in wood and stone, makers of stained glass, painters of frescoes, smiths, weavers, gold- and silversmiths had collaborated with masons and architects to create some of the finest buildings in the history of art.

The medieval cathedral and what Gropius fondly believed were the circumstances of its creation became a kind of model for the Bauhaus. He invented the name 'Bauhaus' not only because it specifically referred to *bauen* ('building', 'construction') – but also because of its similarity to the word *Bauhütte*, the medieval guild of builders and stonemasons out of which Freemasonry sprang. The Bauhaus was to be a kind of modern *Bauhütte*, therefore, in which craftsmen would work on common projects together, the greatest of which would be buildings in which the arts and crafts would be combined.

The inspiration provided by the *Bauhütte* explains the unusual form the Bauhaus took from the very beginning. It was unlike all existing schools of art and craft in several important ways. To begin with, teachers and students were not known as such. The teachers were 'Masters' while the students were 'Apprentices' or 'Journeymen', depending on the level of accomplishment they had achieved. Examinations were not conducted by the Bauhaus itself but by local guilds legally empowered to qualify Apprentices as Journeymen and Masters.

Perhaps most important of all was the arrangement of the school into Workshops. Each Apprentice had to join a Workshop where he or she acquired a specific craft, not by learning about it in theory but by working on real projects, just as any apprentice would within the traditional guild system. Here, too, there were practical as well as philosophical considerations. Real projects were potential money earners, and Gropius hoped that the Bauhaus would eventually be able to support itself from the sale of its Workshop products which would also provide apprentices with an income. If successful, the Bauhaus would in the long run be absorbed by its Workshops and no longer be dependent on the State for its finances. From the start, therefore, the Bauhaus had not only a director, but also a business manager responsible for securing commissions and supervising financial affairs.

Given Gropius's insistence on the pre-eminence of architecture and his belief that the arts and crafts would be reunited in major building projects, it seems strange that for several years architecture was not taught at all at the Bauhaus. This was because Gropius believed that an architect, like a painter or sculptor, ought to possess at least one craft skill and preferably more. The Bauhaus Workshops were designed to provide such skills. Only later might students proceed to specialist architectural training which, initially at least, would have to be provided by other institutions. Experience of collaborating on building projects would be gained in other ways. Nevertheless, some students and Masters repeatedly argued for the introduction of a Building Workshop at the school.

Gropius maintained his own private architectural practice at the Weimar Bauhaus. There he worked on commissions – for the most part for houses for wealthy individuals – subcontracting the design and manufacture of the furnishings and fittings to the Bauhaus Workshops. Such commissions were few, however, not least because the prevailing economic conditions militated against new buildings of any kind; but there was one major piece of work in 1920 when Adolf Sommerfeld, one of the greatest friends the Bauhaus ever had, asked Gropius to design a villa for him in Berlin. This large house, built mostly in wood and quite unlike anything Gropius had designed before, provided many of the school's Workshops with valuable experience (to say nothing of funds). The decorative woodcarvings, furniture, wall hangings, floor coverings and stained glass windows were all produced in the Workshops or by Bauhaus apprentices working on the site.

The lack of an architecture department can be explained in terms of Gropius's educational philosophy. So, too, can the most novel feature of the Bauhaus curriculum, the Preliminary Course. No other art academy or school of arts and crafts had anything like it. As its name implies, the Preliminary Course was designed for new students. It lasted for half a year – one semester – and students were expected successfully to complete it before moving on to a Workshop of their choice.

Put simply, the Preliminary Course was concerned with basic manual skills and, more importantly, matters fundamental to all artistic creativity: with colour, form, texture, composition, expression, and so on. Gropius understood that accomplished craftsmanship was not enough for the manufacture of high-quality products. They had also to be informed by an artistic sensibility of a high order. It was this that the Preliminary Course was designed to provide. But first it had to unlock and encourage the creative potential of each of the students.

The Preliminary Course was designed and mostly taught by Johannes Itten, a former elementary-school teacher who had later run his own private art school in Vienna. One of Gropius's earliest appointments, Itten had decided and unusual views about creativity and self expression, all of which were clearly reflected

The first page of the 'Programme of the Bauhaus', 1919. It is interesting to compare the relatively conventional typography of this document with later graphic design at the Bauhaus

in his unconventional (and sometimes bizarre) teaching methods. He was also a leading disciple of a strange religious sect known as Mazdaznan whose beliefs and rituals came to be incorporated in aspects of the Preliminary Course.

If Workshop activities were necessarily practical, what went on in the Preliminary Course was markedly theoretical and metaphysical. Although many of the students were prepared to admit that the course did rid them of many of their prejudices and prepare them for later work in the Workshops, as many were at first puzzled and later dismayed by the physical jerks, strange formal exercises and spiritual discussions Itten required of them.

Itten directed but did not teach the entire Preliminary Course. Other Masters, most notably the painters Wassily Kandinsky and Paul Klee, assisted him by designing and teaching their own self-contained courses in colour, form and composition. Intended to be basic, these were in fact highly theoretical, informed by the teachers' own metaphysical and difficult ideas and many students did not find them easy to understand. Later on, when Itten left the Bauhaus and the Preliminary Course was taken over by László Moholy-Nagy and Josef Albers, it assumed a more practi-

The cover of the Bauhaus book, 'An Experimental House by the Bauhaus', about the Haus am Horn. The book was designed by Moholy-Nagy

cal form and provided a more rational introduction to Workshop activities.

Itten, Kandinsky and Klee were among those whom Gropius appointed to the staff of the Bauhaus. They were all painters, and in view of Gropius's insistence that fine art would not be taught at the school, their appointment, together with that of such other painters and sculptors as Lyonel Feininger, Gerhard Marcks, Lothar Schreyer, George Muche, Oskar Schlemmer and László Moholy-Nagy, was motivated by wider considerations. Most if not all of these artists were known to be uncompromising innovators and articulate theorists. Among the leading members of the avant-garde, they were men of ideas, able to discuss and argue.

The ideas cultivated by some of the painters on the Bauhaus staff were, however, part of the problem during the school's early years. They tended to be metaphysical and stressed the spiritual rather than practical aspects of art and design. As a consequence of their interest in theory (but also of the economic difficulties involved in setting up the Workshops and getting them to start production) there was more talk than action at the Bauhaus, more speculation than production, for some time. Itten's romantic, unworldly notions, extreme enough even without the addition of Mazdaznan, were manifestly taking the Bauhaus and its students along a path which, though pleasantly picturesque, led nowhere.

Some of Itten's colleagues, most notably Georg Muche (who assisted on the Preliminary Course and was initially Master of Form in the Weaving Workshop), were sympathetic to his views, but most others, Oskar Schlemmer (Master in the Stonecarving Workshop and, after 1923, of the Bauhaus theatre) among them, were not. Gradually Gropius became alarmed at the distance the Bauhaus seemed to have travelled from his original conception and, not entirely unjustly, blamed Itten, who in 1923 was persuaded to resign.

But Itten was not the only cause of conflict. Another, about the place of the machine in society and the extent to which the Bauhaus curriculum should reflect an interest in science and technology, was potentially more divisive and caused even more lively disputes at staff meetings than Itten's continuing presence at the school.

By the end of 1920, no more than eighteen months after the foundation of the Bauhaus, Gropius seems to have been in the process of revising his ideas about the crafts and industrial design. His doubts about the way the school was developing were strengthened when in 1921 Theo van Doesburg, the Dutch founder of *De Stijl,* took up residence in Weimar. He loudly criticized the Bauhaus and its staff and taught rival courses of his own which attracted several students disillusioned with Itten and his mysticism.

Although Gropius always denied it, van Doesburg's irritating and well publicized presence in Weimar had much to do with the direction the Bauhaus now took – towards greater rationality of design, functionalism and an acceptance of the benefits of the machine. Workshop products even began to betray the influence of *De Stijl.* For example, Marcel Breuer now abandoned the raw primitivism of his first furniture designs in order to make chairs which, in their construction and appearance, owed much to the *De Stijl* member Gerrit Rietveld.

The year 1923 proved crucial for the Bauhaus. Itten finally departed at Easter (for the headquarters of the Mazdaznan movement outside Zurich in Switzerland) and the Hungarian Constructivist László Moholy-Nagy replaced him as director of the Preliminary Course. Moholy-Nagy was assisted by Josef Albers, the first of several students to be offered teaching positions when they graduated.

Moholy-Nagy, who dressed like an industrial worker and had little time for metaphysics, was personally likeable, but his uncompromisingly rigorous artistic philosophy and, what seemed to some, overzealous worship of the machine were not to all tastes. The painters on the Bauhaus staff, above all Feininger and Klee, were alarmed by Moholy-Nagy's growing influence in the Metal Workshop and especially the Preliminary Course.

While Klee and Kandinsky continued to contribute to the Preliminary Course in virtually unchanged form, Moholy-Nagy and Albers preferred to stress not the subjective and emotional aspects of artistic creativity but the rational and functional use of materials together with a versatile approach to a wide variety of techniques, especially such relatively new and technically based media as photography.

There is no better example of the change in direction at the Bauhaus at this time than that provided by a comparison of the Sommerfeld Villa of 1920 with the Haus am Horn, designed and built for the Bauhaus exhibition of 1923. Both were decorated and equipped by the Bauhaus Workshops, both demonstrated what could be achieved if architects, craftsmen and designers collaborated closely with each other. But the former, built entirely in wood, was picturesque, peculiar and Expressionist, while the latter, constructed in new materials from elements prefabricated on site, was an example of the modern, rational, functional and mechanized.

The Haus am Horn was intended to be one of the focal points of the Bauhaus exhibition, held during August and September 1923. Designed by George Muche under Gropius's supervision (staff and students had rejected Gropius's own design) and built on the Horn, a quiet, tree-lined street on a hill overlooking Weimar's famous park, the single-storey, flat-roofed, cubic house displayed Bauhaus-produced textiles, furniture and kitchen equipment.

The house was also intended to demonstrate how cheap a truly functional house could be, especially if built in large numbers. Ease of use was the prime concern. All surfaces were easy to clean and all rooms had easy access. In the kitchen, for example, all the

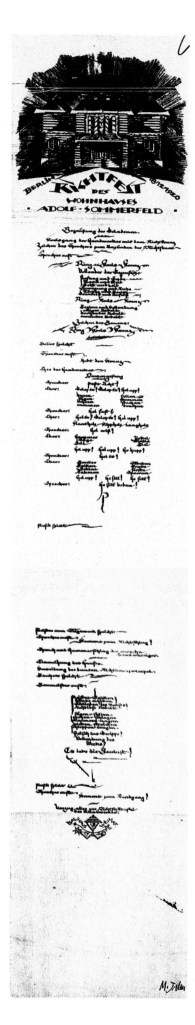

cupboards and drawers could be reached without moving far, and the walls in the children's room were covered with blackboards on which the children could scribble at will. The house, financed by the same Adolf Sommerfeld whose Berlin villa had been designed by Gropius and equipped by the Bauhaus three years before, was meant to be the first of a series which customers could buy virtually off the peg. But it remained unique, partly because the hyperinflation of the German Mark reached its height in 1923 and neither the necessary capital nor potential clients could be found.

Despite the grave economic situation, the Bauhaus exhibition itself and the week of special events, lectures and concerts which accompanied it were a great success, at least in national and international terms. As far as Weimar was concerned it failed to reconcile the school with the city.

For some time the Weimar authorities had been asking Gropius to submit the activities of the Bauhaus to public scrutiny in the form of an exhibition. At first Gropius resisted: there was so little to show, and what little the Bauhaus had achieved so far might cause even greater misunderstandings. However, by 1922 Gropius sensed that he could resist no longer. He must in any case have felt that an exhibition would help him consolidate the developments at the Bauhaus towards functional design and industrial production.

The exhibition consisted essentially of a selection of Workshop products and a display of photographs of modern architecture (in the Bauhaus buildings themselves), of the work of the teachers (in the Weimar museum), and the Haus am Horn. But there were other attractions, too. Schlemmer produced a large mural for the foyer of one of the Bauhaus buildings and other murals were painted by Herbert Bayer on the upper floors.

The four days between 15 and 19 August were designated 'Bauhaus Week'. Lectures were given by Gropius, Kandinsky and the Dutch architect J.J.P. Oud. Schlemmer's *Triadic Ballet* and *Mechanical Ballet* were performed, and there were premières of works by Stravinsky, Busoni and Hindemith. Shows of scientific films which exploited slow-motion effects were also arranged.

Gropius's lecture, which he called 'Art and Technology: A New Unity', marked the public emergence of a man purged of medievalizing craft-romanticism and Utopian dreams. It proved a timely turnabout, for even as Gropius was speaking plans were being made in Berlin to stabilize the currency and secure international loans which, after 1924, transformed the German economy and succeeded in making German industry one of the most powerful in the world once again.

No fewer than fifteen thousand people, many of them from foreign countries, travelled to Weimar for the 1923 exhibition. Press reaction was almost unanimously positive.

But even at the moment of its greatest success the Bauhaus was beset by further problems. In 1923 a new national government

took power in Berlin and a wave of demonstrations by radicals of both left and right throughout the country threatened to bring the government down. Troops were sent to Weimar to keep the peace. Gropius, suspected of left wing sympathies, was visited by the military who searched his flat but found nothing incriminating. In December the national government fell and early in 1924 the nationalists gained the upper hand in the state of Thuringia. The first Nazi to be appointed to any regional government in Germany joined the Thuringian cabinet.

For the nationalists in the regional parliament the Bauhaus had always been too 'cosmopolitan'. It neglected 'German' cultural values; there were too many Jews among its students and teachers; and in appointing the foreigners Kandinsky and Moholy-Nagy to its staff, it demonstrated its Bolshevik sympathies. Local craftsmen, always the most conservative of individuals, were more opposed to the Bauhaus than ever, now that it was preaching close links with industry. And the general public, always angry that their taxes were being spent on such an eccentric institution, were even more susceptible to anti-Bauhaus propaganda.

In September 1924 the Thuringian Minister of Education informed Gropius that only half the necessary public funds were henceforth available to it and gave cautionary notice of dismissal, effective from March 1925, to all Bauhaus staff. At the end of 1924 Ministry officials made a tour of the school and announced that the only teaching contracts that could now be offered would be valid for no more than six months. Three days later Gropius and the Council of Masters publicly announced that the Bauhaus would have to close at the end of March 1925. There were angry protests in the national and international press. Influential figures from the world of industry and the arts expressed their dismay. It seemed as though the life of the Bauhaus was about to end even at the moment it had come of age.

But Gropius and his staff were immediately courted by several, more liberal and forward-looking German cities, Frankfurt and Breslau among them. These were keen to bask in the glory reflected by the now famous Bauhaus and, more important, to benefit from the school's potential influence on local industry. After much discussion and visits to the most promising locations, the director and Council of Masters eventually decided to accept the offer made by the city of Dessau, the capital of the state of Anhalt to the north-east of Weimar and closer to Berlin. The second phase of the Bauhaus was about to begin.

Programme, designed by the student Martin Jahn, of the topping-out ceremony of the Sommerfeld Villa, in the Dahlem suburb of Berlin, 18 December 1920. The villa was designed by Gropius and Adolf Meyer and furnished and decorated by the Bauhaus Workshops

Weimar

Weimar, 1919–25

The Bauhaus Manifesto

Walter Gropius *Manifesto and Programme of the Bauhaus* Weimar, April 1919

The ultimate aim of all creative activity is the building! The decoration of buildings was once the noblest function of the fine arts, and the fine arts were indispensable to great architecture. Today they exist in complete isolation, and can only be rescued from it by the conscious co-operation and collaboration of all craftsmen. Architects, painters and sculptors must once again come to know and comprehend the composite character of a building both as an entity and in terms of its various parts. Then their work will be filled with that true architectonic spirit which, as 'salon art', it has lost.

The old art schools were unable to produce this unity; and how, indeed, should they have done so, since art cannot be taught? Schools must be absorbed by the *workshop* again. The world of the pattern-designer and applied artist, consisting only of drawing, must at last and again become a world in which things are *built*. If the young person who takes joy in creative activity begins his career now, as he formerly did, by learning a craft, then the unproductive 'artist' will no longer be condemned to inadequate artistry, for his skills will be preserved for the crafts in which he can achieve great things.

Architects, painters, sculptors, we must all return to crafts! For there is *no such thing* as 'professional art'. There is no essential difference between the artist and the craftsman. *The artist is an exalted craftsman.* By the grace of Heaven and in rare moments of inspiration which transcend the will, art may unconsciously blossom from the labour of his hand, *but a foundation of handicraft is essential for every artist.* It is there that the primary source of creativity lies.

Let us therefore create a *new guild of craftsmen* without the class distinctions that raise an arrogant barrier between craftsman and artist! Let us together desire, conceive and create the new building of the future, which will combine everything – architecture *and* sculpture *and* painting – in a *single form* which will one day rise towards the heavens from the hands of a million workers as the crystalline symbol of a new and coming faith.

Programme of the State Bauhaus in Weimar

The State Bauhaus in Weimar has arisen out of the merger of the former Grand Ducal Saxon Academy of Fine Art with the former Grand Ducal Saxon School of Applied Arts with the addition of a new department of architecture.

The Aims of the Bauhaus

The Bauhaus strives to unite all creative activity within a single whole, to reunify all the practical artistic disciplines – sculpture, painting, the applied arts and crafts – as the inseparable components of a new architecture. The ultimate, if distant aim of the Bauhaus is the unified, total work of art – the great building – in which there are no distinctions between monumental and decorative art.

The Bauhaus intends to train architects, painters and sculptors of all levels of attainment and ability as conscientious craftsmen or independent creative artists, and to found a working community of outstanding artist-craftsmen and students who know how to create and give spiritual unity to buildings in their entirety – from their basic structure to their consolidation, finishing, decoration and furnishing.

The Principles of the Bauhaus

The creation of art is independent of and superior to all methodology. Art itself cannot be taught, but craft certainly can be. Architects, painters and sculptors are craftsmen in the original and true sense of the word. Therefore all students must receive a thorough training in the crafts in the Workshops and in experimental and practical sites as the indispensable basis of all creative work. Our own Workshops will be gradually extended and apprenticeship agreements will be made with outside workshops.

The school is the servant of the Workshops and will one day be absorbed by them. Thus there are no teachers and students at the Bauhaus, only Masters, Journeymen and Apprentices.

The student Karl-Peter Röhl's winning entry for the competition to design the Bauhaus official seal, 1919

The method of teaching derives from the character of the Workshops:

Organic forms developed from craft skills.

The avoidance of all prescription; a preference for the creative; individual freedom, but a strictly disciplined course of study.

Master's and Journeyman's examinations held according to the statutes of the Trade Guilds by the Bauhaus Council of Masters or independent bodies.

The collaboration of students in the work of the Masters.

Commissions also given to students.

The communal planning of extensive Utopian buildings – structures for the people and for religious worship – conceived for the distant future. The co-operation of all Masters and students – architects, painters and sculptors – on these plans with the aim of gradually achieving a harmony of all the parts and elements associated with building.

Constant contact with the leaders of the crafts and industry in the country.

Involvement in public life, with the people, in the form of exhibitions and other activities.

New attempts in exhibition-making to solve the problem of how to show pictures and sculptures in an architectonically-designed space.

The cultivation of friendly contact between Masters and students outside work. Thus theatre, lectures, poetry, music, costume parties. The development of a light-heartedly ceremonial atmosphere at these gatherings.

The Range of Instruction

Teaching at the Bauhaus embraces all practical and theoretical areas of artistic creation.

A. *Architecture*
B. *Painting*
C. *Sculpture*

including all branches of the crafts.

The students will be trained in the crafts (1) as well as in drawing and painting (2) and in theory (3).

1. *Craft training* – whether in our own, gradually expanding Workshops or in others contracted to teach – includes:

a) sculptor, stonemason, stucco worker, wood-carver, potter, plaster-caster.
b) blacksmith, locksmith, metal-founder and turner.
c) cabinet-maker.
d) decorative painter, glass-painter, mosaic-maker and enameller.
e) wood-engraver, lithographer, printer, chaser.
f) weaver.

The craft training is the foundation of all instruction at the Bauhaus. Every student must acquire a craft.

2. *Training in drawing and painting includes:*
a) free sketching from the imagination and memory.
b) the drawing and painting of heads, nudes and animals.
c) the drawing and painting of landscapes, figures, plants and still-lifes.
d) composition.
e) the execution of murals, panel paintings and decorated shrines.
f) the design of ornament.
g) lettering.
h) construction and projection drawing.
i) the design of exteriors, gardens and interiors.
j) the design of furniture and utensils.

3. *Training in theory includes:*
a) art history – not presented as the history of style but with a view to imparting an active understanding of historical working methods and techniques.
b) the study of materials.
c) anatomy – from the living model.
d) the physical and chemical science of colour.
e) rational painting methods.
f) basic book-keeping, drawing up contracts, sub-contracting.
g) individual lectures of general interest in all areas of art and science.

Division of Teaching
The training consists of three courses of instruction:
I. *Instruction for Apprentices*
II. „ „ *Journeymen*
III. „ „ *Junior Masters.*
Individual instruction is at the discretion of the individual Masters within the framework of the general programme and of the timetable which is revised every term.
 In order to provide the students with a technical and artistic training that is as versatile and comprehensive as possible, the timetable will be designed so that every student of architecture, painting or sculpture will be able to participate in parts of the other courses of instruction.

Admission
Space permitting, any person of unblemished record, regardless of age and sex whose previous training is thought adequate by the Council of Masters of the Bauhaus. The fees are 180 Marks per annum (it is intended that they will gradually be reduced to nothing as the income of the Bauhaus increases). In addition there is a single admission fee of 20 Marks. Foreigners pay double fees. *Enquiries should be directed to the Secretariat of the State Bauhaus in Weimar.*

APRIL 1919
The Administration of the State Bauhaus in Weimar:
Walter Gropius

First Impressions

Johannes Driesch [student] **to Lydia Driesch-Foucar**

[Weimar] *10 October 1919*

...it's fantastically different here, I tell you. The canteen is the most wonderful thing I've seen until now in this respect. For 3.50 [Marks] you can feed yourself for the day, two breakfasts, lunch, coffee at four o'clock and dinner, and portions – you wouldn't be able to eat a quarter of it. And I can work here – potter's wheels, ceramics department, everything is there. Feininger is a wonderful person. Above all, there are real people here, fine chaps.... But the main thing, and that's shown by our student meetings, is the great desire for the single end, the unity of thought among the people and the various forms of expression of art and craft which have seized the majority of students...

Johannes Driesch to Lydia Driesch-Foucar

[Weimar] *16 October 1919*

...The day before yesterday we did something splendid: a little band of violins, lutes, one-string fiddles, ocarinas, mouth organs and saucepan lids went to Gropius's house and played him a serenade, at one in the morning. When Gropius appeared at the window, we called out to him to come down; and then we carried him in a triumphal procession to the canteen where the party was still going on, and then we danced until four. It was wonderful. The whole place is fabulous anyway: one big family, teachers and students. Bauhaus people can do everything, are allowed to do everything and get everything. You can go to see the *Iphigenia* in the National Theatre for 50 pfennigs, etc. And above all the classes! Marcks, the sculptor, who's my teacher, is very good. For the first three days in the week we draw every morning, heads or nudes. Afternoons throughout the week technical things are explained or tried out, everyone casts his things himself, and on the mornings of the final three days everyone can do whatever he wants. Yesterday I started to work on my own.
I'm telling you, I haven't worked like this for ages!...

Oskar Schlemmer to Tut Schlemmer [his wife] on the train between Leipzig and Dresden

13 July 1920

...I saw all sorts of things in Weimar. Gropius, the director of the Bauhaus, invited me to go there and put a studio at my disposal.... It's a beautiful, quiet place, an important, historic area in which the young, high-spirited Bauhaus people lark about. Most of them in costumes like Russian blouses. I ate in the canteen, cheaply. Even the director eats there. [The Bauhaus] is bitterly opposed by the reactionaries. They want to do much but can do nothing because there's no money and they therefore end up playing games.... Many people are leaving....

Against the Odds

Herr Kämmer [Bauhaus Business Manager] **to Walter Gropius**

Weimar, 15 April 1919

...The lack of accommodation for students is now so grave that I want to suggest that the Young Masters are given temporary permission to sleep in their Workshops....

Walter Gropius confidential memorandum to the Student Council, 14 October 1919

...I have succeeded in securing lorries to transport coal directly from the mine. The transportation will be financially viable only if students themselves provide active help. We require two teams of three to travel with the lorries and help load the coal. Students must also unload the coal here since the cost would otherwise be so high that our budget could not meet it.

I request an immediate answer to the question whether the students are willing to agree to my proposal. We shall give everyone travelling to the mine a free lunch for a week. There will be two lorries for three days. Whether the teams change or the same people go every day remains open.

Since it is essential that this matter should not be spoken about around the town I request that the question be discussed confidentially in committee....

Oskar Schlemmer during his Bauhaus period. His letters and diaries provide one of the most vivid accounts of life at the school

Oskar Schlemmer, 'Roman', 1925, oil on canvas *Lyonel Feininger, 'Barfüsserkirche in Erfurt', 1924, oil on canvas*

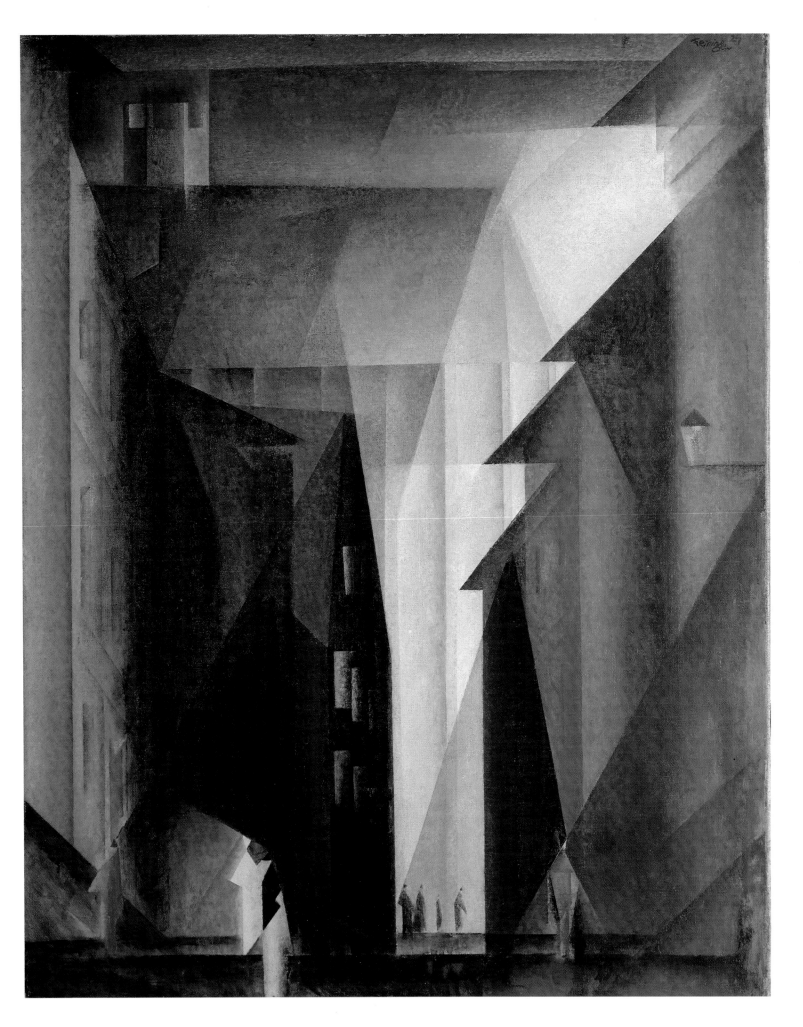

Alma Mahler [Gropius's wife] on Weimar in 1920 in *Mein Leben* 1963

...On 20 March we moved into Walter Gropius's apartment.... The general strike is no longer quite so serious.... The gutters are not being cleared, a dreadful smell hangs over the streets. Water has to be fetched from far away. But the most annoying thing about it is that the workers are preventing the dead from being buried....

Today there was the funeral procession for the workers who had been killed during the demonstration. The procession went past my window. An endless series of banners with the words: 'Long live Rosa Luxemburg! Long live Liebknecht!'...

Walter Gropius to the Thuringian Cultural Ministry

Weimar, 31 March 1920

...We cannot work without materials and tools! If help does not come quickly I am pessimistic about the existence of the Bauhaus. Many (students) must or want to leave it because they cannot work....

Herr Kämmer to Walter Gropius

Weimar, 28 July 1920

...During the month of August use of the canteen will remain very light. If only lunch is prepared much fuel can be saved....

Gropius as Director

Walter Gropius speech to representatives of the crafts and industry in Weimar, Spring 1919

...Gentlemen, we now come to the aim ... when art and craft permeate each other. Today they stand side by side strictly separated from each other almost by a wall. The craftsman – industry as well – needs the vital flow of the artist's creative power which has the power to thaw out the frozen form and shape it anew. The artist on the other hand lacks a grounding in craft which is alone capable of putting him in the secure position of shaping his material confidently. During culturally strong epochs the boundaries between art and craft were so blurred that every craftsman was an artist and every artist a craftsman. The entire people *built*, created: that was their most elevated activity – doing business was secondary.
It was so in Germany during the best Gothic period and it must become so here again. Artists and craftsmen are one and the same; they belong together. Craft or applied art as – architecture....

Lyonel Feininger to Julia Feininger [his wife]

Weimar, early Friday, 30 May 1919

Yesterday there was a tea at the Klemms'. There were fifteen or more people there, all Weimar intellectuals.... And then! Our director with spouse – I'd rather not write about this at the moment – but I'm thinking a lot about the subject of Gropius. In him and her [Alma Mahler] we are facing two, completely free, sincere and exceptionally broad-minded people who admit to no inhibitions of any kind and who are so unusual in this country that they necessarily have a disturbing and uncommon effect.... You know that I'm also a fanatic! Gropius sees the craft in art – I the spirit. But he will never demand of me that I change my art, and I want to support him in every way I can because he is such a loyal and honest man and a great idealist devoid of selfishness. Creative or not, he is personality second to none here – and 'she' is in a class of her own!...

Lyonel Feininger to Julia Feininger

Weimar, 22 June 1919

...To my way of thinking there are few really significant talents at the school, even when judged by the standards of so-called mature art. Thedy's class, which without exception exhibited dry, worthy academic stuff, had the worst of it. A student from such a class can never liberate himself, unless he were given his marching orders by Thedy himself – something which this well-meaning, weak philistine could never bring himself to do.... He was beside himself about the vote, quite dismayed. In the end it was pathetic when he stood up in the meeting and declared it 'unjust' simply to overlook this or that student. Shaking his head, he declared the 'good' work by students from other classes to be 'dreadful' – he couldn't understand it, etc.... I had to fight with myself before denying him my vote, too – but it's precisely for that reason that I'm here, to battle against artistic sterility....

Lyonel Feininger during the early years of the Bauhaus. Feininger was perhaps Gropius's closest friend among the teachers. He taught little and for many years acted as a kind of artist-in-residence, whose presence alone was thought to have a beneficial effect

Walter Gropius speech to the Students of the Bauhaus at an exhibition of student work, July 1919

... The exhibition has made the Council of Masters rack its brains. On the first day we could not decide how to award the prizes and met again after mature consideration. I myself have an oppressive feeling of personal responsibility when I look at your work, and for some days it has made me very agitated. This is because we find ourselves in dreadfully chaotic times and this little exhibition faithfully reflects them. I spent all of Sunday in the exhibition, too, because I wanted to understand and assess the abilities of each and every one of you in order to get an accurate idea of a cross-section of the work of the Bauhaus. Gentlemen: there is talent here, but also the most dreadful confusion. It was not my wish that outsiders should have visited the exhibition since it can only have confused them. I wanted the exhibition to be only for us here internally. I suggest that we have no more public exhibitions in the foreseeable future, and that we begin to work from a new standpoint so as to pull ourselves together and become self-sufficient in these restless times. That, I hope, will be a considerable achievement.

If I now ... express a purely personal opinion, I do so not as a judge who assumes papal infallibility ... but because I sense your need for me finally to take a stand so that everyone can form a clear opinion of me and my plans.... I refuse to inflict mediocre judgements either on you or myself....

Gentlemen: first the externals. Many beautiful frames, splendid presentation, finished pictures – but for whom? I particularly requested you to submit studies and ideas. Not a single painter or sculptor has exhibited compositional sketches which ought to be at the heart of an institution like ours. Who today is in a position to paint a completed, fully executed picture? ...

For all of us, the main thing undoubtedly remains the experience and what the individual makes of it. We find ourselves in a *dreadful catastrophe of world history*, in the midst of a *revolutionary change in our entire lives* and *the entire inner life of man*.

For the artistic person this is perhaps a stroke of luck – as long as he is strong enough to bear the consequences – since what we need is the courage which allows us to experience inwardly. Then, suddenly, a new path for the artist will be opened up.... the greatest intensity, the stirring up of one's entire being by suffering, privation, fear, difficult relationships or love, lead to authentic forms of artistic expression. Many students have just returned from the field of battle. Those who experienced death out there have come back totally changed; they sense that no further progress can be made along the old paths. I notice that some of you are uncertain and are wrestling bitterly with yourselves. One day you will suddenly make a breakthrough and will know which direction you must take. We shall have our surprises; some will decide to begin at the beginning again – even when they have already become advanced students and have made some kind of reputation.

Because I feel all this so clearly, I should for my part not like to do anything drastic. Everything will grow out of itself. You will all honestly ask yourselves whether you must necessarily devote yourselves to art, whether your motivation is so strong, your strength so

great, that you will be able to overcome the terrible difficulties already piling up as a result of the world situation. Only he who can honestly give a positive answer to this question has in my opinion the right to devote himself to art. Our impoverished country has scarcely any funds for cultural matters and cannot support those who simply want to occupy their time and cultivate a minor talent. Gentlemen: I have to insist on this because my conscience demands it. Because I foresee that many of you will, in the foreseeable future, unfortunately be forced by circumstances to change to jobs which earn money, and only those will stick with art who are prepared to go hungry for it. We have to *forget the time before the war* which was *completely different.* The sooner we adapt to the new, changed world, to its new, if rough beauty, the sooner the individual will rediscover his own personal happiness. The suffering of Germany will help us turn within ourselves and grow more profound. As the material possibilities have declined, spiritual possibilities have increased enormously. Before the war we put the cart before the horse and wanted to bring art to the general public backwards, by means of organization. We created artistic ashtrays and beer tankards and wanted to move upwards towards the large building gradually. Everything by means of cool-headed organization. That was a presumption on which we came to grief, and now it will be done the other way about. What will develop are not large, intellectual organizations but small, secret, closed associations, lodges, guilds, cabals which preserve a secret, a core of belief and wish to create artistically until a general, great, productive, intellectual and religious idea emerges from the individual groupings, an idea which must ultimately find expression crystallized in a great, total work of art. And this great total work of art, this cathedral of the future, will illuminate the smallest things of everyday life with floods of light. Therefore the opposite process to that adopted hitherto. We shall not experience it, but we are, of this I am convinced, the precursors and first instruments of just such a new world philosophy.... If appearances are not misleading, then the first signs of a new unity following on from chaos can already be seen. I dream of an attempt to create a small community here out of the scattered isolation of individuals. If we succeed we shall have accomplished a great deal.

In conclusion I return to the crafts. The coming years will demonstrate that craft will be the salvation of us artists. We shall no longer exist *alongside* the crafts but shall be *part* of them since we shall be obliged to earn our livings. For great art this historical, I should say this inevitable development is a necessity. All the great artistic achievements of the past, the miracles of Indian and Gothic art arose out of a total mastery of craft.

You will ask how my plans for the crafts will develop so that we shall not produce a torrent of people who are unable to earn a living from art. I am working ceaselessly on the realization of my plans. In the autumn a commercial Workshop will be introduced, at first for sculptors, and for the painters I hope there will be a taught course in the decorative painting Workshop. Then we shall gradually see who wishes to stay with us, who is a true Apprentice, Journeyman or Junior Master: at the moment these words scarcely have any meaning since the sense of craft is missing. Much depends on whether I can achieve anything in the face of our miserable financial prospects. If I succeed, I shall throw myself with all energy into the task of reorganizing the Bauhaus, and hope to create the basic conditions in which you will feel at your ease....

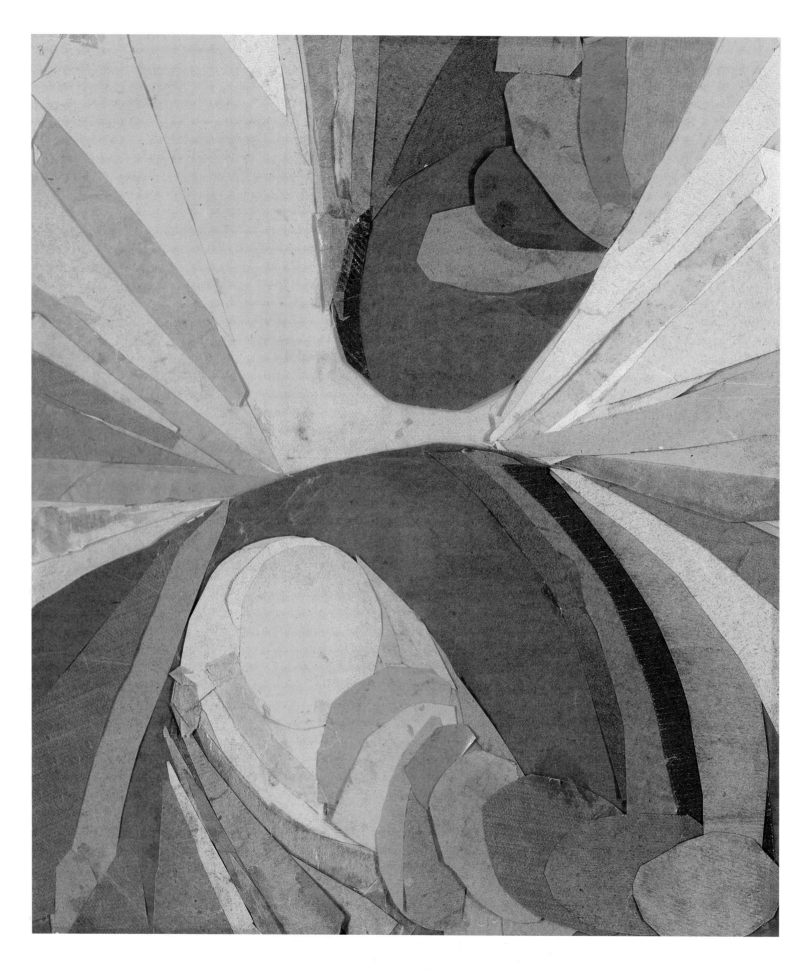

Max Peiffer-Watenphul, colour study executed as part of Itten's
Preliminary Course, c.1920, collage with coloured paper

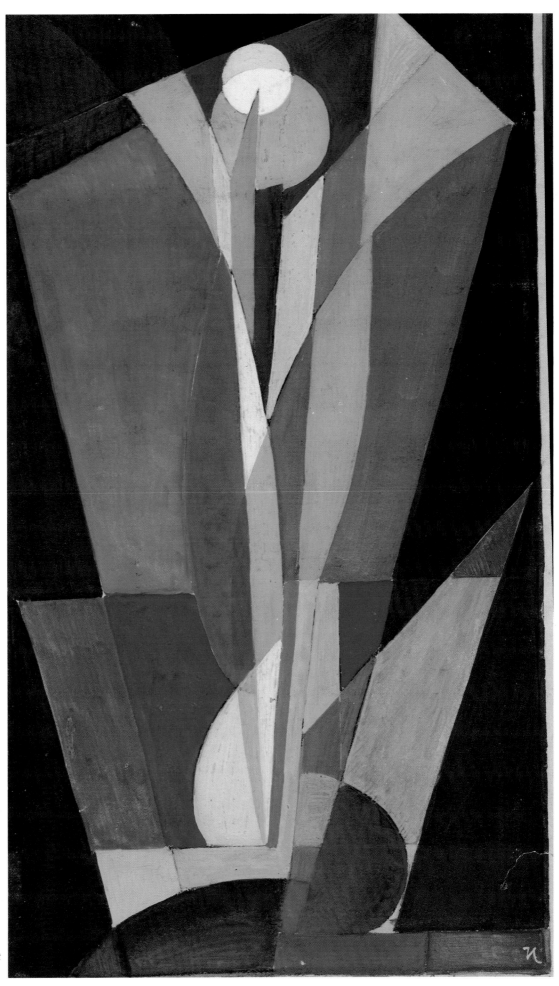

Hans Haffenrichter, 'Abstract
Composition' c.1922

Max Thedy memorandum to Walter Gropius

9 January 1920

... At a very heated meeting of the Chamber of Artists I defended your aims by explaining that it takes time to organize. Since then I have clearly seen where your experiments are leading and the results they have already had. I only regret that you have performed these experiments at a highly reputed, flourishing school like the one here in Weimar which serves the higher, the Fine Arts. I have become increasingly convinced that it is precisely your experiment which is creating an artistic proletariat and that you are therefore producing just what you wished to oppose. Since I am convinced that when the young people finish their studies they are inadequate as craftsmen, let alone painters ... for all these reasons ... I must ... tell you that from now on I shall no longer support your programme since I no longer believe that it will be a success and consider it to have failed....

Wilhelm von Bode [Director General of the Berlin Museums] letter to Oberhofmarschall (retired) Baron von Fritsch

13 January 1920

... Gropius had presented me with a programme that to me appeared a little radical, but was quite acceptable in its essential points. He elucidated it verbally, to the effect that he was primarily concerned, as I am, with the re-establishment of the crafts; that he intended first to enlist only competent craftsmen and to train young people thoroughly in the crafts for some years – fine art would have to come later! And then he started right off with the appointment of Feininger! ...

Oskar Schlemmer to Otto Meyer-Amden [fellow artist and close friend]

Cannstadt, 4 November 1920

... Gropius strongly urges me to come. He writes that the reactionaries' stubborn resistance is slowly crumbling; he will be given complete freedom; the old Art School professors are beginning to find the air too bracing and are withdrawing, leaving him with chairs he should fill if he wants to keep them.... An offer is also being made to Klee, who will probably accept at once....

Gropius seems more interested in getting artists than in getting devoted teachers. Itten is the exception and indeed stands out brilliantly among the quieter men who make up the rest of the staff....

Oskar Schlemmer to Otto Meyer-Amden

Cannstadt, 21 December 1920

... It looks hopeful that, for me, there will be no question of actual teaching, systematic instruction. Only Itten is doing that. Lyonel Feininger is available to talk to the students only on one day of the week. I imagine co-operation with students who can choose their teacher and help them with their work – I think a lot of the kind of applied, three-dimensional activity out of which further, special work for the student would grow naturally of itself....

The Preliminary Course

Helmut von Erffa on Itten's Preliminary Course

...It was not easy to get oneself accepted for his preliminary course, which prepared one for the Workshops. After we had an interview with Gropius, we still had to be passed by a one-man Student Council. I remember my trepidation as I was led into the room, whitewashed and totally bare, except for a huge black wooden cross on one wall. On a simple iron bedstead sat a haggard young man in a monk's habit. His cheeks were hollow, his eyes burned feverishly. He was one of Itten's most trusted pupils. 'Really a saint', my companion whispered. The young man looked me over while my companion stood in respectful silence. Then he said something in an ecstatic singing voice and nodded. He had seen none of my drawings and barely heard me utter a word but I had passed the test and was accepted. 'The Master has complete trust in his intuitive judgement', my companion explained after we had left the room....

Alfred Arndt 'How I got to the Bauhaus in Weimar' 1968

...There were about twenty of us, predominantly men, with very few women. The door opened. Itten came in and said, 'Good Morning.' We stood and in chorus said, 'Good Morning'. Thereupon Itten said, 'That isn't a Good Morning!', went out again, came back in, and said, 'Good morning!' The same from us, only louder this time. But Itten wasn't satisfied. He felt we hadn't woken up yet; we were still cramped. 'Please stand up. You have to be loose, completely loose, or you won't be able to work. Turn your heads. That's it! More! You've still got sleep in your necks!'...

Johannes Itten 'My Preliminary Course' in *Gestaltungs-und Formenlehre* 1963

...Three tasks were set for me in the Basic Course:
1. To free the creative powers and thereby the art talents of the students. Their own experiences and perceptions were to lead to genuine work. The students were to free themselves gradually from dead conventions and to take courage for work of their own.
2. To make the students' choice of career easier. Here the exercises with materials and textures proved a valuable aid. In a short time each student found out which materials appealed most to him; whether wood, metal, glass, stone, clay or yarn best stimulated him to creative activity. Unfortunately, at that time we lacked a workshop for the Basic Course in which all fundamental skills, such as planing, filing, sawing, bending, glueing and soldering, could be practised.
3. To convey to the students the fundamental principles of design for their future careers. The laws of form and colour opened the objective world to the students. In the course of the work the objective and subjective problems of form and colour were integrated in many ways....

Gunta Stölzl diary entry [1919–20]

...His [Itten's] first words were about rhythm. One must first educate one's hand, first make the fingers supple. We do finger exercises just like a pianist does. In these beginnings we already sense through what it is that rhythm occurs; an endless circular movement begun with the fingertips, the movement floods through the wrist, elbow and shoulder to the heart; one must feel this with every mark, every line; no more drawing that is not experienced, no half understood rhythm. Drawing is not the reproduction of what is seen, but making whatever one senses through external stimulus (naturally internal, too) flow through one's entire body; then it re-emerges as something entirely personal, as some kind of artistic creation or, more simply, as pulsating life....

Paul Klee to his wife Lily

Weimar, 16 January 1921

...Yesterday I devoted myself entirely to the Bauhaus and had myself shown over the place for the first time. In the morning Itten was working with the Preliminary Course class. When I got there around ten o'clock the break had just begun. Wearing a wine-red suit, the Master was standing with a group of girls and boys and asking them to show him work. He gave one group a writing exercise based on the text 'Little Mary Sat on a Stone'. They were only allowed to begin writing when they clearly felt the spirit of the song. But these weren't members of the Preliminary Course as such but advanced students.

Then the break was over. We went into the studio next door, a vast room. Along one wall were supports holding experiments in the use of materials. They looked like the bastardized offspring of couplings between the art of savages and children's toys. Along the other three walls were tables at which the apprentices sat on three-legged piano stools. The seats were wooden and red, the feet iron. Everyone had a huge piece of charcoal in his hand and a pad of cheap paper on a drawing board in front of him. The Master walked up and down, wine-red, in trousers that were very wide at the top. The coat was done up, held together with a belt of the same material which had a large buckle at the front. His head is half schoolmaster, half parson. Now and again he glanced to the side with an expression which one might falsely read as mildly contemptuous. The spectacles must also receive a mention.

After he'd walked up and down once or twice he moved towards an easel and a pad of paper. He grasped a stick of charcoal, gathered his body together as though charging himself with energy and then suddenly made two movements, one after the other. We saw a shape formed by two energetic strokes, vertical and parallel, on the topmost sheet of paper. The pupils were then instructed to copy it. The Master criticized the work, had one student demonstrate, controlled the attitude of his body. Then he demanded that it be done while beating time; then he had the same exercise performed with everyone standing. It seems that what's intended is a kind of body massage in order to train the machine to function with feeling.

Similarly new elementary forms like and others were created and copied.

For example and with several explanations about why and about the kind of expression.

Then he said something about the wind, had some of the students stand up and express the feelings inspired by wind and storm. Afterwards he gave the exercise: the representation of the storm. For that he allowed about ten minutes and then inspected the results. With that he criticized. After the criticism work resumed. One sheet of paper after another was torn up and fell to the ground. Several worked with great energy so that several sheets of paper were used up at the same time. After they had all grown rather tired he let the members of the Preliminary Course take the exercise home with them for further practice.

In the evening at five o'clock 'Analysis' was held in a large room built like an amphitheatre. It's more like a kind of lecture room but with chairs rather than benches. At the bottom was a blackboard with a pad of cheap paper which 'Richard' pinned up. Right at the top was a projector. Once again the Master walked up and down by way of preparation and charging his batteries. Then he presented the formal elements which he wished to discuss in the picture by Matisse, *La Danse*, which was later projected. He then had the students draw the compositional scheme of this picture, once even in the dark. Then he had them add to this scheme after the model, sometimes telling them to copy a single figure. Again and again he walked up and down the steps of the room, inspecting, criticizing.

In the first row Frau Itten was also sitting at the Master's feet, further back Herr [Peiffer-] Watenphul [student]. Higher than everybody else, I sat on a chair in the corner and smoked my pipe.

Then after six o'clock this, too, was over....

*Max Peiffer-Watenphul, study in rhythm, produced during Itten's Preliminary Course, c.*1920

Alfred Arndt 'How I got to the Bauhaus in Weimar' 1968

... Itten had ordered everyone to get a large pad of newsprint, charcoal, chalk, and soft pencils. One day he said, 'Today we're going to draw the war.' Everyone was to make a drawing of his experiences in the war or his impressions of the war. We drew. Dieckmann, who had been through the war and had a shot-up hand, sat next to me. He leaned on his shattered arm and sketched, with great concentration I must say, trenches with barbed wire, guns and soldiers. Behind me was Menzel, the youngest member of the *Vorkurs*, who had not been in the war. He was in a turmoil of work; his chalk broke constantly. After less than five minutes he said, 'I'm through', and left. When Itten returned after several hours we had to put all the sheets on the floor and pick the one that best carried out the assignment. The choice fell on Menzel, who had rushed the chalk back and forth with his fist, breaking it several times, making sharp points and zigzags, hammering it down upon the paper. Itten said, 'Here you see very clearly this was done by a man who really experienced the war in all its relentlessness and harsh reality. It's all sharp points and harsh resistance; in contrast look at this sheet' (the one by Dieckmann). 'This artist did not experience the war; this is a Romantic picture in which even the landscape and all the details, so to speak, play at being a soldier'....

Around the middle of the semester we were concerned with studies of texture: rough-smooth, pointed-blunt, soft-hard and so on. The last stage was more or less the high point. Itten urged us to be on the look-out on our walks for materials in refuse dumps, junk piles, dustbins, and scrap heaps. With these materials we were to create something that would clearly represent the essential nature of and contrast between the individual materials....

Johannes Itten 'My Preliminary Course at the Bauhaus' in *Gestaltungs- und Formenlehre* 1963

... The students had to explore these series of textures with their fingertips while their eyes were closed. In a short time their sense of touch improved to an astonishing degree. After that, I had them make combinations of textures from contrasting materials. Fantastic creations resulted whose effect was at that time entirely novel. While carrying out these exercises the students were overcome by a creative fever.... They rediscovered their entire environment: rough pieces of wood and wood shavings, steel wool, lengths of wire and string, polished wood and sheep's wool, feathers, glass and tinfoil, mesh and woven things of all kinds, leather, fur and shiny cans....

(above left) Werner Graeff, study in rhythm, produced during Itten's Preliminary Course, 1920

(below left) Rudolph Lutz, study in three-dimensional form, produced during Itten's Preliminary Course, 1920–21

(below right) Vincent Weber, study in materials, produced during Itten's Preliminary Course, 1920–21

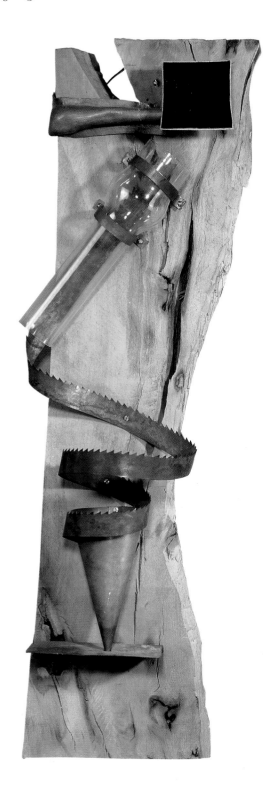

(left) M. Mirkin, *study in contrast using various materials,* 1920 *(reconstruction)*

(below) Friedl Dicker, *study in dark and light tones, produced during Itten's Preliminary Course, c.*1920

. . . Exercises in abstract form compositions served the purpose of improving the thinking and at the same time the development of new presentation media. These exercises in form were not formalistic exercises in style as they are widely understood today.

The three basic forms, the square, triangle, and circle, are characterized by the four different directions of space. The character of the square is horizontal and vertical, the character of the triangle is diagonal, that of the circle is circular.

Initially I attempted to convey these characteristics of form to the students as an experience. I made them stand up and make circles with their arms until at last the entire body had entered into a relaxed swinging motion. . . .

Johannes Itten The Colour Sphere in *Kunst und Farbe* 1961

... Instead of a circle we use the sphere which was already chosen by Philipp Otto Runge as the most useful shape for the presentation of the order of colours. The sphere is an elementary, symmetrical form which is most suitable for the presentation of the characteristic and manifold properties of the world of colour. It permits the presentation of the law of complementarity and the illustration of all basic relationships of colours to each other as well as their relation to black and white. If we think of the colour sphere as a transparent body on which each point is of a certain colour, it is possible to fit in all imaginable colours. Each point on the sphere can be determined by its latitude and longitude. For a clear presentation of the order of colour, six parallel circles and twelve meridians should be sufficient. ...

Johannes Itten Analysis of Old Masters in *Utopia: Dokumente der Wirklichkeit* 1921

... To experience a work of art means to relive it, to give independent life to its essence, the living quality inherent to its form. The work of art is reborn within me.

We say that to experience a work of art means to re-create it. ... Everyone can be shown how to draw a circle but not everyone has the ability to experience a circle. I can release the necessary power within him but I cannot give him that power. Because the act of experiencing depends on the dynamic forces of the mind and spirit, and because we shall never comprehend what the soul, what the spirit is, we have to say that it is a gift of God inborn in His image and the channel through which He breathes His spirit into man's soul.

A representation which has life is always something that has been experienced, and something experienced always has life. Something dead will never acquire life and something living will never be dead. ...

The act of experiencing is a faculty of both the mind and body. If it is initially concerned with appearances of a coarsely material kind, then the physical senses are at work. If it is then concerned with sensitive spiritual appearances, then it is the mind through which the experiencing is produced.

To perceive form means to be moved and to be moved means to form. Even the most gentle feeling is a form which radiates movement. Everything living reveals itself to man by means of movement. Everything moves and nothing is dead. Otherwise it would not exist.

Everything that is distinguished by the quality and quantity of movement, is distinguished by time and space. All forms are different, just as form is different. ...

Without movement there is no perception, without perception there is no form, and without form there is no substance. Substance = Form. Form = Movement in Time and Space, therefore Substance = Movement in Time and Space.

We maintained above that all physical substances provide the means of representation. But all substances are forms. The form is therefore a means of representation. If this is so and the essence of form is rooted in its intellectual and spiritual origin, which can never be comprehended, then the conclusion easily follows:

The means of representation are as unteachable as form is. To teach and to learn means to have comprehended and to comprehend. The assertion that form can be taught can only seem valid to someone of inferior understanding.

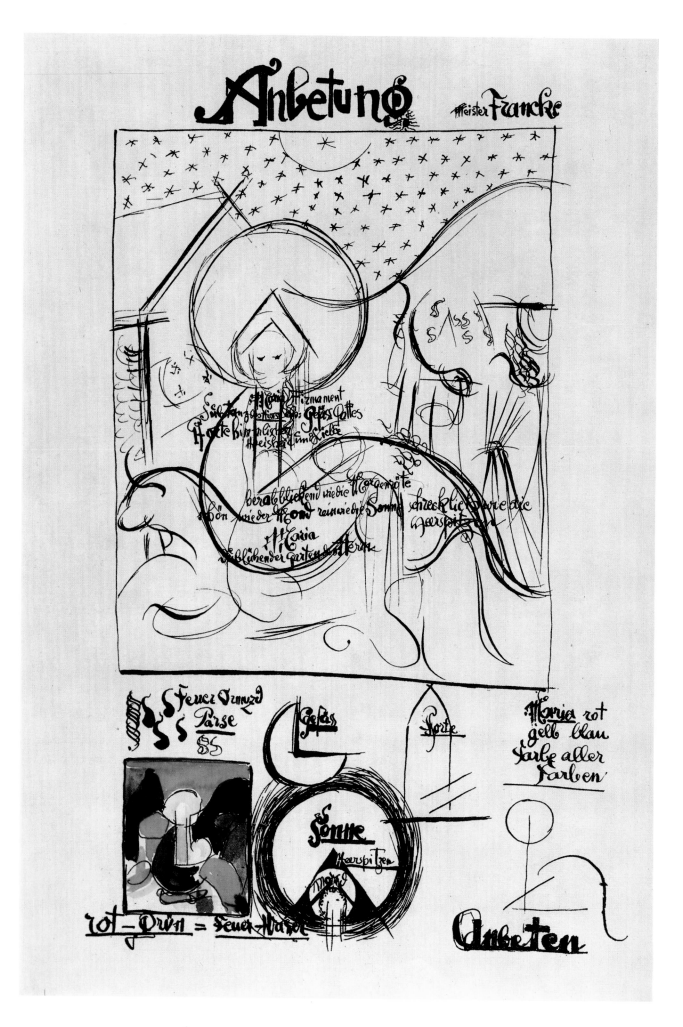

Question: Are teaching and comprehension at all possible? We shall never fathom the essence of a thing. Substance, form, movement: none of these is teachable, comprehensible. All that can be perceived is perception.

Modesty and great humility before Him, The Incomprehensible, helps us bear the weight of this insight.

I can perceive the perception. I can perceive the state of being moved, not the movement itself but the state. Thus all teaching and learning is a perception of the state of movement of the person teaching or learning. . . .

These, then, are the three different degrees of the state of being moved. If I draw the line with my hand I am physically moved. This is the first, physical degree. If I move with my senses along a line, I am in the second, spiritual degree of being moved. If I imagine the line mentally, I am in the third degree of being moved. The physical degree is an external state of being moved, the intellectual degree is an internal state and the spiritual degree is both external and internal together. Seen from above, brightness and clarity correspond to the inward, intellectual state of being moved, while darkness and gloom correspond to the outward, physical state of being moved. Just as the sun and moon illuminate, so does the third degree illuminate the first and rescues it from darkness. . . .

Oskar Schlemmer to Otto Meyer-Amden

Cannstatt, Whitsun, 16 May 1921

. . . In Weimar Itten teaches 'Analysis'. He shows photographs, and the students are supposed to draw various essential elements, usually the movement, the main contour, a curve. Then he shows them a Gothic figure. Next he displays the weeping Mary Magdalene from the Grünewald altar; the students struggle to extract some essential feature from this complicated picture. Itten glances at their efforts and then bursts out: if they had any artistic sensitivity, they would not attempt to draw this, the noblest portrayal of weeping, a symbol of the tears of the world; they would sit silent, themselves dissolved in tears. Thus he speaks, then departs, slamming the door! . . .

Johannes Itten, sketch (1920–21) analysing Meister Francke's
'Adoration' (in the Hamburg Kunsthalle). This sketch, which was
developed to provide an illustration for Itten's 1921 article about
the analysis of Old Master paintings as a teaching aid (see pp.59
& 98), illustrates his attempts to disclose the fundamental
compositional devices underpinning each painting and the
emotional and spiritual qualities they express

Itten the Mystic

Paul Citroën 'Mazdaznan at the Bauhaus' 1964

...There was something demonic about Itten. As a Master he was either ardently admired or just as ardently hated by his opponents, of whom there were many. At all events it was impossible to ignore him. For those of us who belonged to the Mazdaznan group – a unique community within the student body – Itten exuded a special radiance. One could almost call it holiness. We were inclined to approach him only in whispers; our reverence was overwhelming, and we were completely enchanted and happy when he associated with us pleasantly and without restraint....

Health and everything connected with it, such as breathing, movement and nutrition, played an important role in Mazdaznan – it might even be called the cornerstone of the doctrine. ... The Weimar circle was conducted from a more spiritual standpoint, but nevertheless we enjoyed relatively good health on the whole. Still, most of us did not look blooming. This must be ascribed to the fact that in Germany, disintegrating in economic inflation, sufficient and decent food was available only at great cost. The Bauhaus kitchen was conducted according to Mazdaznan principles, so we did get food that was unspoiled, though, because of a lack of money, not as nutritious as we needed. A general undernourishment was the result, stomach and intestinal trouble the rule, and our appearance what one might expect.

We became more and more sectarian. It is incredible what sheer madness we fabricated or took up from our reading, together with the certainly excellent and worthwhile precepts.... Group singing is certainly a beautiful thing, and when rhythmical movements are added it can only be good for one, even if it seems grotesque to an outsider....

Fasts were the high point of our training, and spring and autumn were the seasons designated for this. We attempted and actually attained a thorough-going, internal physical cleansing, provided we kept strictly to the instructions and above all broke the fast in a wise manner, returning to normal daily rations very slowly and by degrees. This return to normality was most difficult of all, for after a period of fasting we were often overwhelmed by a ravenous hunger.

We began our fast by taking a strong laxative, after which, for a week, or two, or even three, depending on what we had decided, we neither ate nor drank, except perhaps some hot fruit juices. We communed with nature frequently, took hot baths, read spiritual works, sang, and communicated only with understanding friends. Since we owned a garden on a hill overlooking Weimar, with several hundred raspberry bushes, fruit trees, and so on, we couldn't spend our fast any better place than there, weeding – one of our favourite pastimes, since we were dedicated to rooting out the weeds of the whole world, the enemies of creativity – and practising other useful tasks. And no one disturbed our pious singing there.

After a hot bath in one of the cubicles at the public bath house I intended to rub myself, according to the precepts, with ashes or charcoal. This, too, was part of the process of purification, this time of the skin. But when I got up from my bath, I lost my senses and fell unconscious beside the bathtub – lucky thing, too – spilling the black powder, while a fine rain sprayed over me from the shower. When I came to I was lying right in the middle of a greying puddle.

There were more such unpleasant side effects for the beginner in fasting. There was, among other things, a little needle machine with which we were to puncture our skins. Then the body would be rubbed with the same oil which had served as a laxative. A few days later all the pinpoints would break out in scabs and pustules – the oil had drawn the wastes and impurities out of the deeper skin layers to the surface. Now we were ready to be bandaged. But we must work hard, sweat, and then, with continued fasting, the ulcerations would dry out. At any rate, so the book said. In actuality the puncturing didn't go according to plan or desire, and for months afterward we would be tormented with itching....

Itten in 1921 wearing the robe he designed for himself. He is holding a large set of dividers. On the wall is a projection of the colour sphere he designed to demonstrate colour relationships. (Photograph by Paula Stockmar)

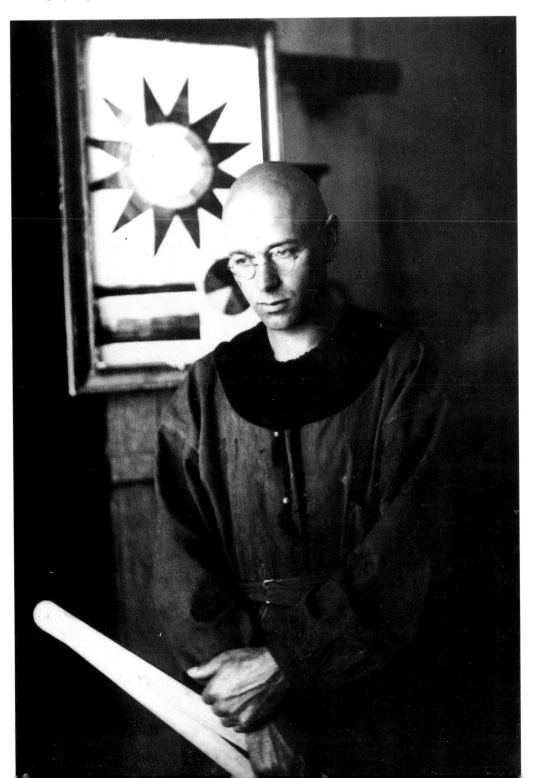

Oskar Schlemmer to Otto Meyer-Amden

Weimar, 7 December 1921

... As I already wrote, Itten introduced the Mazdaznan doctrine. Returned this summer from a convention in Leipzig he was, as he put it, completely convinced that, despite his previous doubts and hesitations, this doctrine and its impressive adherents constituted the one and only truth.

But the consequences: first the kitchen (the student canteen) was converted to Mazdaznan principles. The argument being that only with this sort of cooking could we afford to keep the canteen open these days. The meat eaters must give in, and some claim they need the meat. But that is not all: Itten allegedly carries Mazdaznan principles into the classroom, differentiating between the adherents and the non-adherents on the basis of ideology rather than on the basis of achievement. So apparently a special clique has formed and is splitting the Bauhaus into two camps, the teachers also being drawn in. Itten has managed to have his course made the only required one; he further controls the important Workshops and has a rather considerable, admirable ambition: to put his stamp on the Bauhaus. To be sure, he has been stamping about on it since its inception (three years ago). Gropius, the only other person who, as director, is qualified (The 'Council of Masters' has been in full existence only six months), let Itten have his way, since he himself was too much taken up with organization and administration. Now Gropius has finally taken a stand against Itten's monopoly and asserts that Itten must go back to where he belongs, i.e. to his pedagogic tasks.

So Itten and Gropius are duelling it out, and we are supposed to play referee....

Itten's ideal would be a craftsman who considers contemplation and thought about his work to be more important than the work itself.... Gropius wants a man firmly rooted in life and work, who matures through contact with reality and through practising his craft. Itten likes talent which develops in solitude, Gropius likes character formed by the currents of life (and the necessary talent).

The first ideal results in little that is tangible (the saying goes that at the Bauhaus one sees nothing, and one is always asked to be patient), much talk about work and the necessary conditions. The other ideal results in superficiality, even officious bustle with as few tangible products as the quiet one offers.

These two alternatives strike me as typical of current trends in Germany. On the one hand, the influence of oriental culture, the cult of India, also a return to nature in the *Wandervögel* movement and others like it; also communes, vegetarianism, Tolstoyism, reaction against the war; and on the other hand, the American spirit, progress, the marvels of technology and invention, the urban environment....

What position does the Council of Masters take? Klee remains the most passive; he says next to nothing. Feininger talks about general feelings. Muche acts as Itten's second and assistant, although remaining much more tolerant than Itten. Marcks, Gropius's intimate, seconds him. Schreyer, the theatre reformer, wants to effect a reconciliation. And I – well, I would also like to do so, but I would further want to see the areas of activity clearly assigned according to talent and capability, and this would mean expressing truths which I do not feel equal to....

(left) Student advertisement inviting those wishing to buy Mazdaznan diet and cookery books at discount prices to sign their names. Strict vegetarianism was an important Mazdaznan principle. Mazdaznan, introduced to the Bauhaus by Itten, was a derivation of ancient Persian Zoroastrianism. Before and after the First World War it enjoyed something of a vogue in Europe and on the west coast of the USA. Itten succeeded in converting several Bauhaus students to the faith

(right) George Muche, c.1921. Muche was the teacher closest to Itten in his ideas and attitudes, at least during his early years at the Bauhaus, when he joined the Mazdaznan movement. Primarily a painter, he later become interested in architecture, designing the Haus am Horn and the Steel House in Dessau

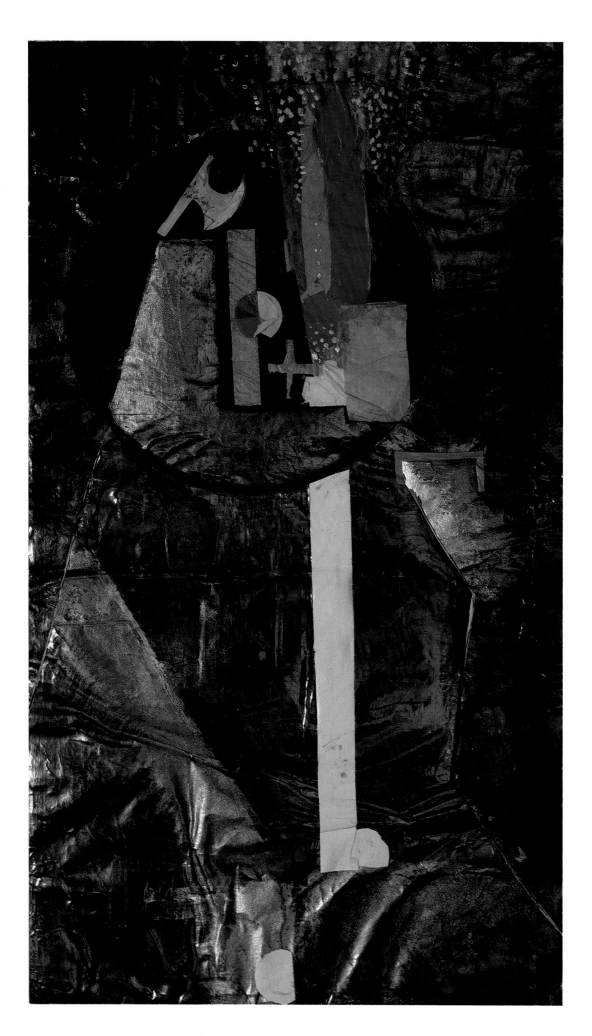

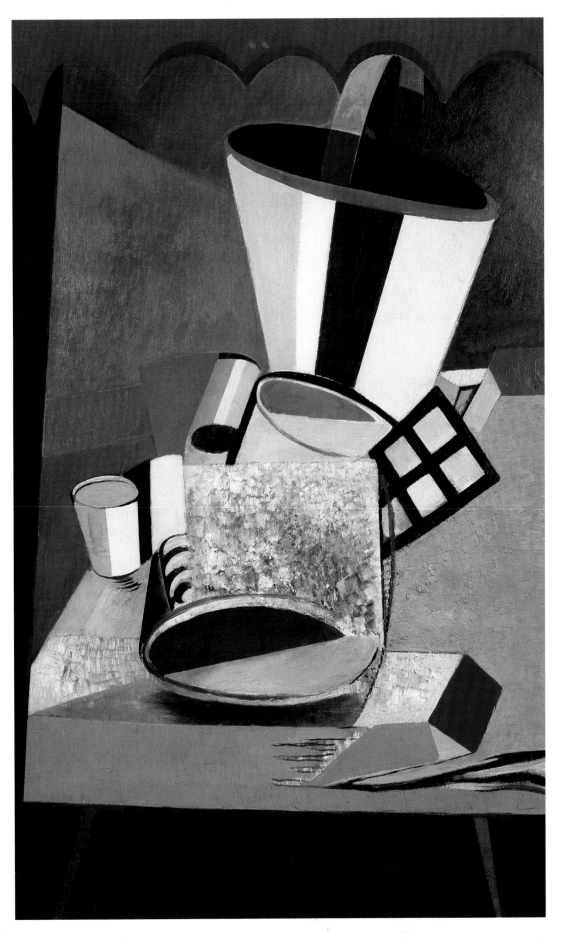

(left) Johannes Itten or Friedl Dicker, colour composition 'paraphrase of the creation hymn from the Rigveda', c.1920, painted collage

Georg Muche, 'Two Buckets', 1923, oil on hardboard. When he joined the Bauhaus Muche was a non-figurative painter. Like Itten's, however, his work became increasingly representational

Lothar Schreyer Memories of *Der Sturm* and the Bauhaus, 1966

...We decided to invent a Bauhaus costume. I can't remember who dreamed it up.
It was tailored by our apprentice Kube who worked with the accuracy ... of a court tailor.
The costume – whoever wore it was at liberty to choose the colour and the material it was
made from – consisted of a kind of Russian blouse and baggy, jodhpur-like trousers which
were very wide around the hips and tight at the ankles, not unlike one of the figures in
Schlemmer's *Triadic Ballet*.

Thus attired, we went walking – those of us brave enough – together with our
Apprentices and Journeymen, through Weimar. One day it was announced – by Itten if I'm
not mistaken – that hair is the sign of sin (actually an idea of the old mystics). We had to
shave our heads bald. Itten and Muche once dared to go to Berlin for a meeting at the
Ministry in their Bauhaus costumes and with their heads shaved. Itten had a suit made of
purple-violet, expensive cloth, Muche one of mouse-grey material. And thus, without
topcoats and with completely bald heads, they arrived at the Anhalt station. Soon they were
standing outside the station, Itten with the noble bearing and magnificent colours of an
archbishop, Muche by his side smiling unperturbed and towering above everything, tall and
slim like a gigantic carp. On foot and with difficulty the two managed to progress to the
Potsdamer Platz. By then the enthusiasm of the Berliners had become so great and Itten
and Muche such a significant obstacle to the traffic that they had to get quickly into a car.
For safety's sake this took them back to the Anhalt station. There in the waiting-room
they waited for the next fast train back home to Weimar. (So legend has it.) ...

*Gertrud Arndt, studies in the relationship between basic forms
and colours, executed during Klee's course, 1923–24. The texts
read (left, clockwise from top) '3 forms in one form; logical/
partly constructive, touching; lying close together; penetrating
each other; fully constructive' (right, below) 'fully constructive,
logical'*

The Elementary Courses: Form and Colour

Paul Klee teaching notes in 'Essays on the study of pictorial form'

A. Lectures in the winter term, 1921–22

14 November 1921

By way of introduction, a brief clarification of concepts. Firstly, what the concept of analysis involves. What we usually mean by analysis in everyday conversation is chemical analysis. E.g: one preparation or another sells extremely well because of its great efficacy. The good business it brings the manufacturer makes other manufacturers curious and they take a sample to the chemist for analysis. He must work methodically so as to break down the preparation into its component parts. To discover its secret.

In another case, a kind of food is damaging to health. Here, too, a chemist must intervene in order to uncover its harmful constituents. In both cases there is a whole consisting of parts which are initially unknown. It is those parts that are sought.

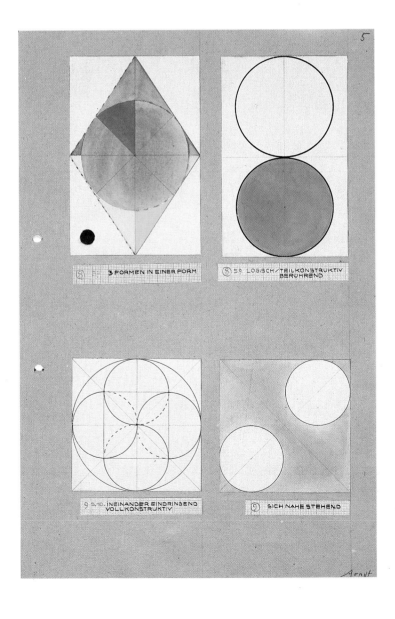

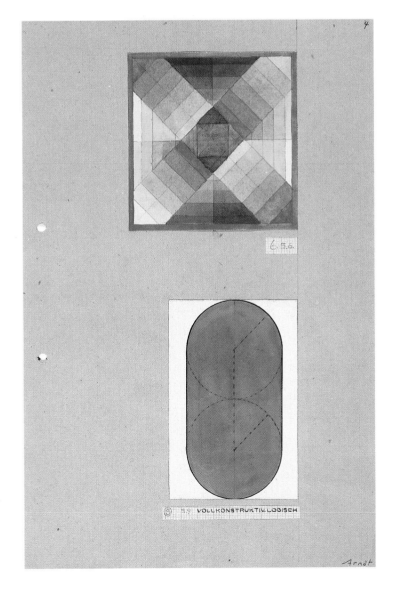

In our kind of business our reasons or motives are naturally different. We do not analyse works of art because we want to imitate them or because we distrust them.

We investigate the paths someone else has followed in making a work of art work so as to begin to walk ourselves.... This way of looking should prevent us from thinking of the work of art as something rigid, immutably fixed. With the aid of such exercises, we shall be able to prevent ourselves from stealing up to a work of art in order quickly to pluck whatever is closest to us and then running off with it.

*

A special kind of analysis consists of investigating a work of art in terms of the stages involved in its making. I use the word 'genesis' to describe this kind of analysis. The first book of Moses which deals with the creation of the world is also called Genesis. There is written what God created on the first day, the second day and so on. The entire world surrounding us is given an historical structure.

*

We are makers of images, working practitioners, and for this reason we naturally prefer to move around on formal territory. Without forgetting that before the birth of form, or, put more simply, before the first mark is made, there is an entire pre-history which consists not just of man's desire, his passion to express himself, not just of the external need to do this, but also of a general human condition, the nature of which we call an attitude to the world. Driven by an inner necessity, this attitude demands expression in this or that direction.

I emphasise this so that it will not be falsely assumed that a work of art consists only of form. On the other hand, however, I must emphasise here even more strongly that the most precise scientific knowledge of nature, of plants, animals, the earth and its history, the stars is of no use to us if we do not have all the tools we need to describe it. That the most intellectual understanding of the interaction of these things in the whole world is of no use to us if we do not possess the forms to represent it. That the most profound feelings, the most beautiful soul, will be of no use to us if we do not have the forms to hand which correspond to them....

*

After these general hypotheses I shall begin where all pictorial form begins: with the point which is set in motion.

Shortly after a pencil or some other sharp point is brought into play, a *line* appears (the freer its initial movement, the clearer the impression of motion).... In prehistoric times when no distinction was made between writing and drawing [line] was the given element. Our children, too, mostly start with it: one day they discover the phenomenon of the point in motion – and we can scarcely imagine with what enthusiasm. At first they move the pencil with the greatest freedom in whichever direction causes pleasure. As they look at the first results, they simultaneously discover that the pathways they have traced are now clearly described. Those children who continue to be delighted by chaos are not natural makers of images, but others will soon progress to the creation of a certain order. They begin to be critical of the pathways they have followed. The chaos of the initial game yields to the beginnings of order.

The free making of lines is subjected to an anticipated final effect. There now begins an activity with very few lines. One remains primitive.

*

*

But one cannot persevere with the primitive for long. One has to discover a means of enriching the impoverished result without destroying or erasing the clarity of the simple sketch.

*

One has to organize. Things that are important and things that are subsidiary.

Active Line . . .

In all these examples the main line occurs freely and independently. It is, so to speak, a walk for its own sake. Without destination.
. . . On the other hand this new line is limited. . . . Here we might speak of a business transaction rather than a walk. The straight lines testify to it. But the free line as well as the limited line are of a purely active type.

Medial Line

In these new cases the limited line describes such planar figures as the triangle and square. Or, as here, the circle and ellipse.
 As line, they have a calming character and have neither a beginning nor an end. Fundamentally (as the action of the hand) it is certainly still line, but when completed, the linear conception has been instantly replaced by the impression of plane. With that, the impression of motion also disappears (no one looking at the moon will be tempted to ride around and around its periphery), replaced by the conception of perfect calm (chiefly in the case of the circle).

Passive Line
In these cases, the lines have an entirely passive character.
 We still see lines; but the point here is not linear action producing linear results arising from the treatment of planes. The line is not made but experienced. . . .

The plane is . . . the quiet element. If it starts to move, however, it approaches the character of line. The further the line AB continues to move, the thinner the described plane becomes relative to its length until we can ultimately speak of the coincidence of A and B, and with that we arrive again at the active line. . . .

*

. . . Exercise: the violin. Models: one 'cello, two violins.
Introductory remarks: the violin as perfected form, as work of art, as self-sufficient personality (not a machine). The conception of, for example, Picasso, Braque and the Parisians of today.
 Suggested analytical beginnings for the uncertain, afterwards free compositional exercises with the forms that have been achieved. Unspoken wish: the freest compositions, more metaphysical than actual violin. Results: primarily more of an analytical kind. . . .

Hans Fischli [student] on Klee's teaching

...Without inner preparedness it was scarcely possible to attend one of Klee's classes. Did he choose his students or simply take in everyone at his door? If he had scales, what kind of weights did he use? Was there an invisible net stretched across the entrance to his room which only let disciples through? Were we his pupils? Did we believe him? Did we change what he taught? Did he have a message to impart and, if so, what was it?...

In his classes Klee taught us neither how to draw nor how to use colour, but what lines and points were...

There was an infinite variety of marks – lacking in character, weak or strong in character, stuck-up fellows and bluffers, lines which one would have preferred to take to hospital because one feared that their end was imminent, and others which had had too much to eat. If a line stood up straight, then it was healthy, if it was at an angle, it was sick; if it was lying down, one thought that that was what it liked the most.

With the line, as with the point, there was a limit to decency. If a point became too cheeky, too conceited, inflated or too well fed, as though it had devoured many other points in its vicinity, one would regretfully have to eject it from the family of proper points. If it became too flat, it no longer deserved its short monosyllabic name; it wished to be more than a point and became a lazy, disyllabic planar form. Lines acted in exactly the same way, depending on what one's basic attitude was to these creatures....

Paul Klee, diagrammatic sketch illustrating the structure of
Bauhaus teaching, 1922, from the Preliminary Course in the
outer circle to building and stage in the centre, via the study of
materials – stone, wood, metal, colour, yarns, glass, and clay –
and practical and theoretical training. The flags at the top
read: 'propaganda' and 'publishing house'

(below) four pages from Klee's teaching notebook for lectures first
given in the winter term, 1921–22. Klee followed his notes very
closely and drew the diagrams on a blackboard using chalks
held in each hand – he was ambidextrous

Diagram labels: Propagierung / Verlag — Vorlehre — Kompositionslehre — Farblehre — Stein — Holz — Graphiklehre — Ton — Bau und Bühne — Metall — Naturstudium — Holzstudium — Glas — Webstoffe — Farbe — Konstruktionslehre — Material- und Werkzeuglehre — Vorlehre — Vorlehre

11

Als Linie kennzeichnet sie sich von beruhigendem
Charakter und anfang oder endlos. Elementar betrachtet
(als Handlung der Hand) ist sie gewiss noch Linie, aber
zu Ende geformt; wird die lineare Vorstellung von
der Flächenvorstellung unverzüglich abgelöst. Damit
verschwindet auch der bewegliche Charakter (niemand
wird beim Anblick der Mondscheibe versucht
sein auf seiner Peripherie Karussel zu fahren)
abgelöst durch den Begriff vollkommenster Ruhe
(beim Kreis hauptsächlich)

Linear passiv

Ganz passiven Charakter hat die Linie in diesem
Falle

fis
15/16

Man sieht wohl Linien, aber es handelt sich nicht
um lineare Thaten, sondern auch um lineare Ergebnisse
aus Flächen-Handlungen.
Die Linie wird nicht getan, sondern erlitten.

12

Umgekehrt zum Verlauf dieser kurzen Dar-
stellung der Linie verläuft die darin zugleich
enthaltene Darstellung der Fläche. Als die
Linie aktiv war teilte sie es in imaginäre
Flächen. Dazwischen drängte sich der Flächen-
charakter hervor, und wurde dann
aktiv als die Linie als passiv bezeichnet
wurde.

Die Fläche ist, rein gezeichnet, das ruhige
Element. Gerät sie aber in Bewegung,

So nähert sie sich dem Liniencharakter
Je weiter die Linie AB sich fort-
bewegt, desto dünner wird dadurch geschriebene
Fläche in Verhältnis zu ihrer Länge,
bis man schliesslich von einem Zusammen-
fallen von A mit B sprechen kann, womit
wir bei der aktiven Linie wieder angelangt sind.
* (dieser Abschnitt ist repetiert auf Seite 143-144)

Paul Klee 'Paths of Nature Study' in *Staatliches Bauhaus Weimar, 1919–1923*

For the artist, dialogue with nature remains the *sine qua non*. The artist is a human being; he is himself Nature, a part of nature within the natural world.

The number and variety of paths the artist may explore in his own work as well as in the study of nature connected with it, change only in terms of his attitude to the extent of his reach within this natural world.

The paths often seem very new without perhaps fundamentally being so.... To be new by comparison with yesterday is a revolutionary characteristic, however, even if the vast world of the past has not yet been shaken by it. The joy in its newness need not be any less because of this. The broad historical view taken with the aid of memory ought only to protect us against the desperate search for novelty at the expense of naturalness.

Yesterday's artistic attitudes and the study of nature connected with them consisted of a downright painfully meticulous investigation of the differentiations in the appearance of things. The 'I' and the 'Thou', the artist and his subject, sought a relationship along the optical-physical path through the layer of air which lies between the 'I' and the 'Thou'....

What the investigation of the appearance of nature managed to achieve should not be underestimated because of this: it needs only to be extended. Today, this single approach does not meet all our requirements any more than it represented the only requirement before now, the day before yesterday. The artist of today is more than a refined camera: he is more complicated, richer and broader....

This is gradually becoming clear in the following way: a sense of the totality of things is informing our understanding of the objects of nature, whether the object is a plant, an animal or a human being, whether it exists within the space of a house, a landscape or the universe. Because of this sense of the totality of things, a more spatial understanding of the object is being achieved.

Our knowledge of what the object contains within itself makes it grow out beyond its superficial appearance – because of the knowledge that the thing is more than its surface reveals. The human being dissects the object and uncovers what lies within in the form of sections. The nature of the object is thus ordered in terms of the number and kind of sections necessary. This is visible penetration, achieved partly and simply with the aid of a sharp knife, partly with more delicate instruments which are able to make the material structure or the material function of the object clearly visible.

In sum, the knowledge gained in this way enables the 'I' to make conclusions about the inner nature of the object from its visible exterior. It does so intuitively, since the 'I' is moved by the investigation of optical-physical appearances to experience feelings which, depending on the variety of directions they take, can penetrate the external appearance and reach within. What was previously anatomical is now more physiological.

Beyond these ways of looking at the inward nature of the object are other paths. These lead to a humanization of the object and create a resonant relationship between the 'I' and the object which transcends the optical fundamentals. Firstly there is the non-optical path of common rootedness in the earth which becomes visible in the 'I' from beneath; and secondly there is the non-optical path of cosmic communality which comes into view from above. These are metaphysical paths in unification.

It must be emphasised that intensive study leads to experience, and that the processes touched on here are consolidated and simplified by it. But perhaps it should be added by way

of explanation that the lower path leads through the realm of the static and produces static forms, while the upper path leads through the realm of the dynamic. On the lower path which gravitates towards the earth, lie the problems of static equilibrium described by the phrase 'to stand in spite of all possibilities of falling'. The yearning for freedom from earthly bonds leads to the higher paths, via swimming and flying to free movement and total motion.

All these paths meet within the eye and, transposed into form, lead from the point at which they meet to a synthesis of outward sight and inward vision. At this meeting-point configurations are also formed which depart from an object's visual appearance completely, but which nevertheless, from the total point of view, do not contradict it.

Through what he has experienced on the various paths and has transformed in his work, the student demonstrates the stage which his dialogue with the natural object has reached. His development in the contemplation and observation of nature... his own way of looking at the world, enable him to arrive at the free creation of abstract forms which, transcending the wilfully schematic, achieve a new naturalness, the naturalness of the work of art.

He then creates a work or participates in the creation of works which are a reflection of God's creation.

Joost Schmidt, colour exercises produced during Klee's class, c.1923

Hans Fischli on Klee's studio

...We were permitted to observe the fish in his (Klee's) large aquarium; he switched the light on or off, he carefully drove some away from where they were so as to see concealed ones better.

His pictures, both finished and unfinished, stood and lay about. They said: look at us surreptitiously; he trusts those he allows to come in here. But he never showed them to us.... Large clay pots filled with many clean brushes stood on the table. Bottles with thinners and agglutinants, varnishes or lacquers. We saw what kinds and makes of paints he used, and he concealed the many kinds of fine paper just as little. We looked into his kitchen – he did not need a cook book; he had his recipes which he changed and rearranged ... according to time and need. Many called and call Paul Klee a magician, but he was not. He never performed conjuring tricks.

He was an inventor who discovered magical things. Conjuring is the virtuoso trickery of an illusionist.

Klee's pictures never lie....

Klee in his studio at the Weimar Bauhaus, 1925. Klee used to work concurrently on several paintings – hence the number of easels

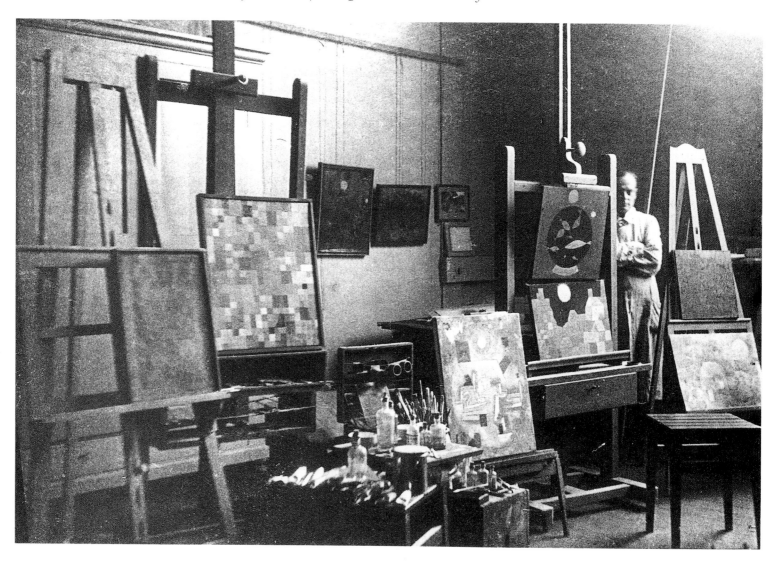

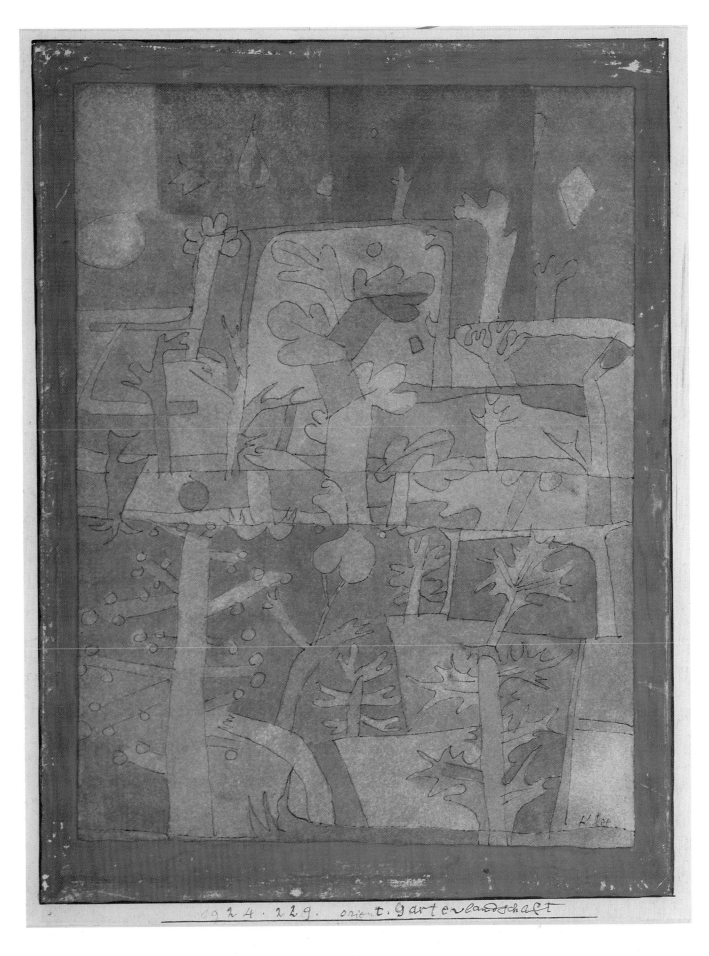

Paul Klee, 'Oriental Garden Landscape', 1924,
watercolour, pen and ink

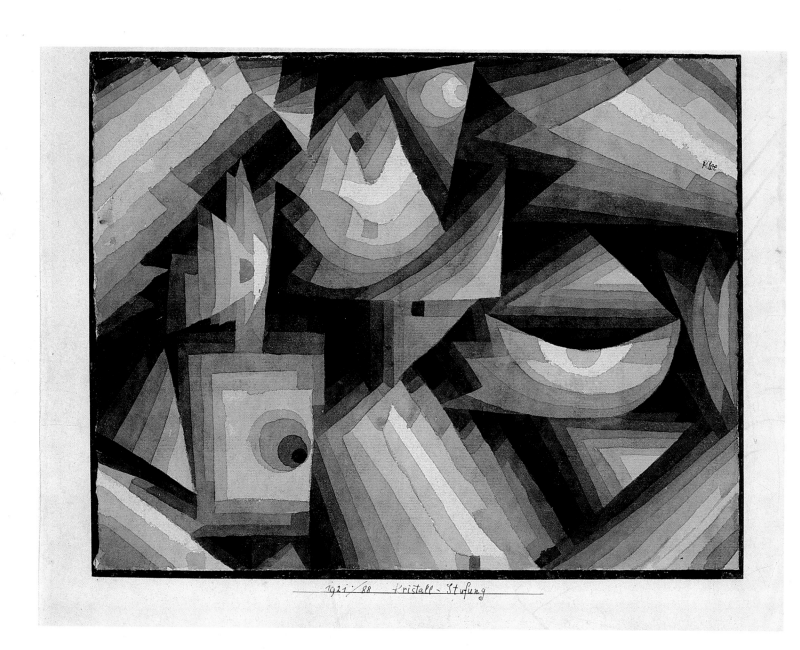

Paul Klee, 'Crystal Gradation', 1921, watercolour

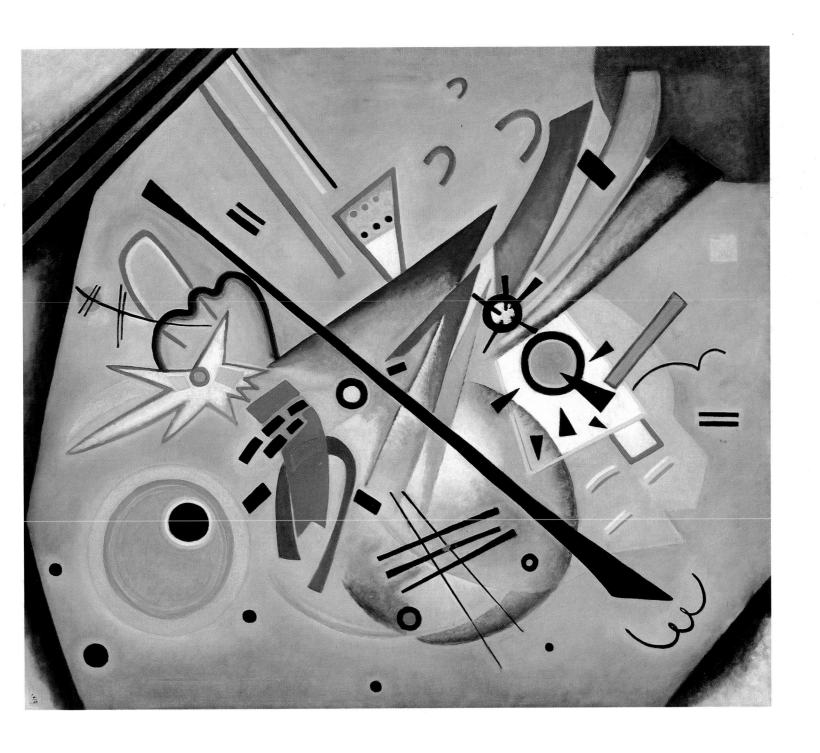

Wassily Kandinksy, 'On Grey', 1923

Oskar Schlemmer to Otto Meyer-Amden

Weimar, 3 January 1926

...Kandinsky once organized a questionnaire. A circle, a square and a triangle were printed on a sheet of paper and one was asked to fill each out in red, blue or yellow. I didn't take part. The result, although I don't know the precise statistics, were: circle – blue, square – red, triangle – yellow. All the learned men agreed about the yellow triangle but not the others. In any case I unconsciously always make the circle red and the square blue. I don't know enough about Kandinsky's explanations, only in rough terms: the circle is the cosmic, absorbing, feminine, soft form; the square the active, masculine. My opposing argument: the red circular plane (or sphere) occurs positively (actively) in nature: the red sun, the red apple (or orange), the surface of red wine in a glass. The square does not occur in nature, it is abstract ('Nature works towards the destruction of the straight line', Delacroix) or even metaphysical, for which the colour is blue. Kandinsky constructs an entire edifice of teaching on this dogma: every curved line is part of a circle and must therefore be blue, every straight line red, every point yellow, varied into infinity. During his lectures only hesitant voices are raised. Why?...

Mondrian: he is actually the God of the Bauhaus and Doesburg is his prophet....

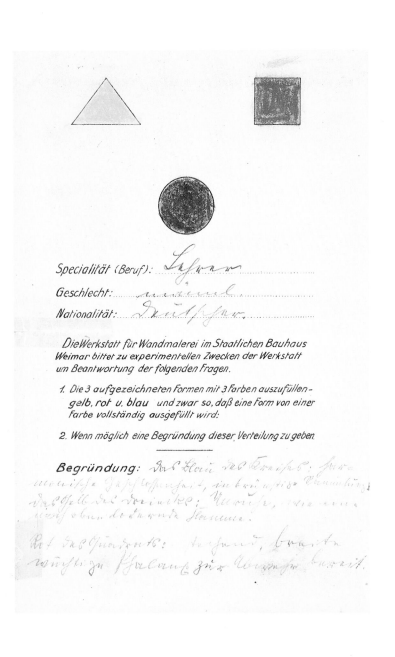

Wassily Kandinsky 'The Basic Elements of Form' in *Staatliches Bauhaus Weimar, 1919–1923*

Our work at the Bauhaus is in general subordinate to the finally dawning unity of different realms that only a short time ago were held to be strictly divided from one another.

The realms that have recently striven to unite are: *art* in general, in the forefront of which are the so-called plastic arts (architecture, painting, sculpture), *science* (mathematics, physics, chemistry, physiology, etc.) and *industry*, regarded from the standpoint of technical resources and economic factors.

Our work at the Bauhaus is of a synthetic nature.
Synthetic methods also, of course, embrace the analytical. The inter-relation of these two methods is inevitable.

<div align="center">*</div>

On this basis our teaching on the basic elements of form must also be constructed.

The question of form in general must be divided into two parts:
1. Form in the narrower sense – surface and volume.
2. Form in the broader sense – colour and its relationship with form in the narrower sense.

In both cases our exercise must proceed logically from the simplest forms to the more complicated. Thus, under the first part of the question of form, surface is reduced to three basic elements – triangle, square, and circle – and volume to the basic solids deriving from them – pyramid, cube, and sphere.

Since neither surface nor volume can exist without colour, i.e., since in reality form in the narrower sense must at once be examined as form in the broader sense, dividing the question of form into two parts is something that can only be done schematically. Furthermore, the organic relationship between the two parts must be established in advance – the relationship of form to colour and vice versa.

The science of art that is only now coming into being can, seen from the perspective of the whole history of art, provide little illumination in this matter, for which reason our present task must be first to level the path just described.

<div align="center">*</div>

Thus, every individual form of study has before it two simple tasks:
1. The analysis of given phenomena, which must as far as possible be regarded in isolation from other phenomena, and
2. The relation of those phenomena which have just been analysed in isolation to one another – synthetic method.

The first should be as narrow and as limited as possible, the second as broad and as unfettered.

Kandinsky and a questionnaire (completed by Alfred Arndt)
which sought to demonstrate the affinities between the primary
colours and the primary forms. Kandinsky distributed the forms
throughout the Bauhaus and to private addresses in Weimar,
believing that the results would scientifically validate his theories

Lothar Schreyer 'Memories of *Der Sturm* and the Bauhaus' 1966

...One of our apprentices came into my studio ... 'Ja, Herr Schreyer,... I must tell you what has happened. As you know, I have certain difficulties with non-figurative painting. When Kandinsky was appointed and he exhibited his paintings at the Bauhaus I was so outraged that I came to you and asked for advice. Was this still painting? You went so far as to call it absolute painting. Where will it lead? First you abstract from the object. Then you leave out the object altogether. Only spots of colour remain. Then you abstract the spots of colour to geometric shapes. All that remains is to leave these out, too. And absolute painting necessarily ends in nothingness. You told me then to talk to Kandinsky myself. For a few weeks I was like a cat on hot bricks. But today, just now, I talked to Kandinsky.'

'And what happened?', I asked.

'I had prepared myself thoroughly', the confession began. 'First I painted a picture, with tempera because it had to dry very quickly, on cardboard, 44×44 cm., and therefore based on the famous figure 4 – which you and Kandinsky say miraculous things about as the mystic cypher of the earth. 4 multiplied by 11 – the figure 11 as the symbol of the new beginning. And then the square format as the symbolic form of the earth. Herr Schreyer, the symbols with which we have to play around at the Bauhaus are a load of nonsense!... I painted the piece of cardboard white, completely white. I then took it to Kandinsky and said politely: 'Master Kandinsky, I have finally succeeded in painting in the absolute style a picture of absolute nothingness.... Kandinsky took my picture entirely seriously. He set it up in front of us and said: 'The proportions of the picture are in order. They are aiming for earthliness. The earthly colour is red. Why did you choose white?' I replied: 'Because the white plane represents nothingness.' 'Nothingness is a great deal', Kandinsky said. 'God created the world out of nothingness. So let us make use of some of the creative power God has given us and create a little world out of the nothingness.' He took brush and paint, applied a red, a yellow and a blue spot to the white surface and put a transparent bright green shadow beside them. Suddenly there was a picture there, a proper picture, a magnificent picture....

Wassily Kandinsky 'Colour Course and Seminar' in *Staatliches Bauhaus Weimar, 1919–1923*

Colour, like all other phenomena, must be examined from different viewpoints, in different ways, and by the appropriate methods. From a purely scientific point of view, these ways may be divided into three areas: that of physics and chemistry, that of physiology, and that of psychology. (Of particular importance is the special question of sociological relations; this, however, goes beyond the scope of the question of colour as such, and hence necessitates a special study.)

If these areas are applied particularly to man, and viewed from the standpoint of man, then the first area deals with the nature of colour, the second with external means of perception, and the third with the results produced by its internal effect.

It is clear, therefore, that these three areas are equally important and indispensable for the artist. He must proceed synthetically and employ the available methods most appropriate to his aims.

But apart from this, the artist can examine colour theoretically in two ways, such that his own point of view and his own characteristics must supplement and enrich the three above-mentioned areas.

These two ways are:

1. The examination of colour – the nature of colour, its characteristics, power and effects – without reference to any practical application, i.e. as 'purposeless' science.

2. The examination of colour in the way dictated by practical necessity – more limited purpose – and the carefully planned study of colour, which presents its own considerable problems.

Of these methods we may ask three main questions, which are organically linked to three further main questions, and which, taken together, embrace all the individual questions involved in our two ways of proceeding:

1. The examination of *colour* as such – of its nature and characteristics:

(a) *colours* in isolation

absolute and relative value

(b) *colours* in juxtaposition

Here, one should begin with the most abstract possible colours (colour as one imagines it), and proceed via those that occur in nature – starting with the colours of the spectrum – to colour in the form of pigments.

2. The purposive juxtaposition of colours in a unified structure – the construction of colour – and

3. The *subordination* of colour – i.e., of an individual element – and of its purposive juxtaposition – i.e., of construction – to the artistic content of the work: composition of colour.

These three questions thus correspond to three more, arising out of the question of form in the narrower sense – in reality colour without form cannot exist:

1. Organic juxtaposition of colour in isolation with its corresponding primary form – pictorial elements . . .

2. Purposive structuring of colour and form – construction of the complete form, and

3. Subordinated juxtaposition of the two elements in the sense of the composition of the work.

Since at the Bauhaus colour is associated with the aims of different workshops, solutions to individual, particular problems must be deduced from the solution to the main problems. Here, the following conditions must be observed:

1. The demands of two- and three-dimensional forms.

2. Characteristics of the given material.

3. Practical purpose of the given object and the actual commission.

Here, a logical

dy of the organic makeup of

lity of fixing it with bonding materials – according to the actual substance – the technique naturally associated with it, the way of putting on colour – according to the given purpose and material – and the juxtaposition of colour pigment with other coloured materials, such as stucco, wood, glass, metal, etc.

The Workshops

Oskar Schlemmer to Otto Meyer-Amden

Cannstatt, 7 August 1920

... It's incredible that the Workshop equipment, in excellent condition before the war, was sold during it so that now scarcely a planing bench remains – and that in an institution with a 'craft base'. Scarcely any thought, not even the most Utopian, can be given to building....

Joost Schmidt *How I experienced the Bauhaus* [undated typescript]

... The following Workshops were planned: carpentry and joinery, metal, weaving, pottery, mural painting, stained glass, sculpture, printing and, crowning them all, the architecture department.

 Following the old craftsman's motto:

Apprentice, that is any man,

Journeyman, who something can

Master, a creative man,

 the members of the Bauhaus became Apprentices, Journeymen or Masters.

 The training in the Workshops was intended to be given by two Masters. An artist known as a Master of Form was responsible for the artistic instruction while a Craft Master gave technical training. Both had to work towards the reuniting of the designer and the maker, towards the unity which had been customary during the old craft era and which had caused it to blossom....

Oskar Schlemmer to Otto Meyer-Amden

Weimar, 21 December 1920

... The Bauhaus runs the risk of becoming little more than a modern academy of the arts (the nature of the appointments suggests this), because the essential distinguishing feature – the crafts, the Workshops – is treated as peripheral.... And the students apparently have little enthusiasm for practical craftsmanship: the chief ambition is to become a modern painter. On the positive side, Gropius plans to give himself and the Bauhaus time; nothing is to be exhibited publicly for the first five years....

Oskar Schlemmer memorandum 1921

Council of Masters on 9 December 1921

The conflict was caused by the *commissions* which produced a collision of views about School and Workshop. If the number of commissions multiplies, the result may be that one Workshop has to operate away from the Bauhaus for longer periods of time (for example, the Wall-Painting Workshop.) The Workshop will then be empty, the students will have to go without valuable instruction, and the other Workshops will be denied the chance of co-operating (with the absent Workshop).

One possible solution might be to divide (the Bauhaus) into a *School and Experimental Workshop* on the one hand, and a *Production or Building Workshop* on the other. In the School and Experimental Workshop *handi*craft would provide the basis of education and training with a touch of Romanticism (tinkering about). The Production or Building Workshop would work rationally, possibly up to the level of the large mechanized factory. The one Workshop would *conceive* that which the other would *make* with all the means technology provides. . . .

The Weaving Workshop, Weimar, 1921

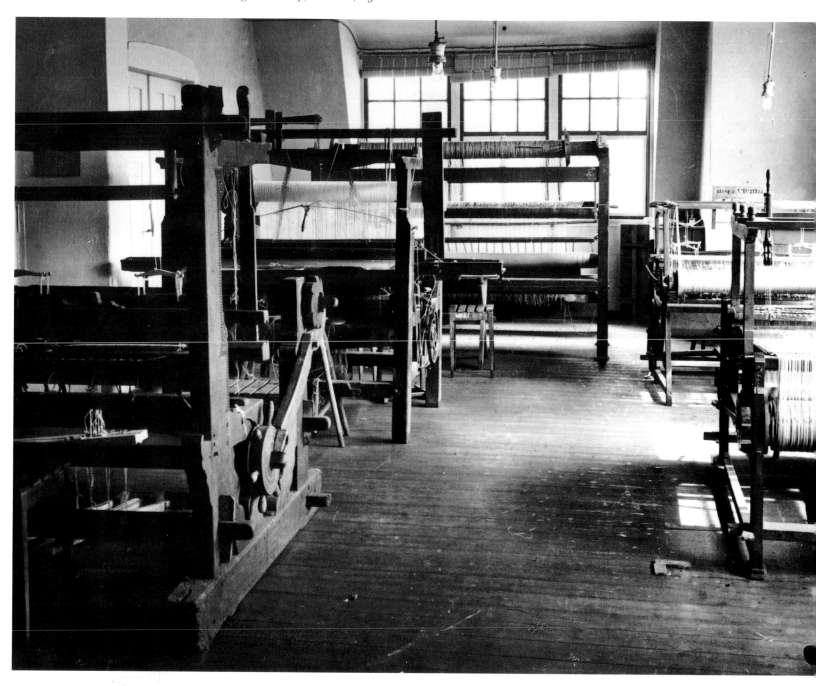

Anni Albers 'The Weaving Workshop' in *Bauhaus 1919–1928*

... They began amateurishly and playfully, but gradually something grew out of their play which looked like a new and independent trend. Technique was acquired as it was needed and as a foundation for future attempts. Unburdened by any practical considerations, this play with materials produced amazing results, textiles striking in their novelty, their fullness of colour and texture, and possessing an often quite barbaric beauty....

Gunta Stölzl *The Development of the Bauhaus Weaving Workshop* 1931

... Weaving is an old craft which has evolved principles upon which even the mechanical loom must still build today. A high degree of handicraft, dexterity, skill and understanding must be acquired, and these are not, as in the case of tapestry, to be nourished by imaginative power or artistic feeling. The coming to grips with the flat loom had, as its natural result, the limitation of materials, the restriction of colour, the tying of the form to the weaving process.

The use of a material on the other hand, limits and determines the choice of the elements. Conclusions about function are always dependent on the conception of life and of the living. In 1922–23 we had an idea of living fundamentally different from that of today. Our ideas could then still be poems fraught with ideas, flowery decoration, personal experience! They also quickly met with approval outside the walls of the Bauhaus with the public at large. They were the most easily understood and, thanks to their subject matter, the most ingratiating of those wildly revolutionary Bauhaus creations....

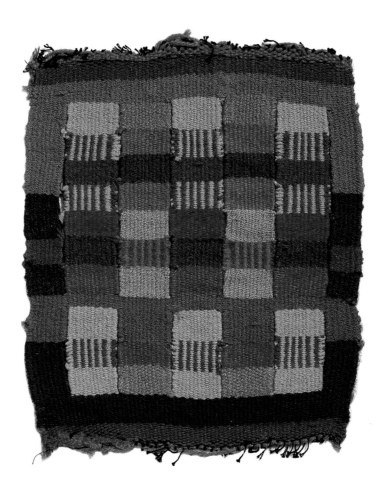

Dr Otto [Berlin lawyer] **to Walter Gropius**

Berlin, 1 December 1923

... I am thinking about buying a carpet for my wife's bedrom from the Bauhaus Weaving Workshop – if the price is not beyond my means. It will be for the space between the bed and the window in front of the large mirror. If a particularly beautiful example ... about 1 m. wide and 1.5 m. long should be available, will you inform me and tell me the price? ...

Walter Gropius to Dr Otto

Weimar, 11 December 1923

... A very fine carpet 1 by 1.3 m. has just been finished. It would certainly suit your wife's room. We could part with it for 150 Gold Marks. ...

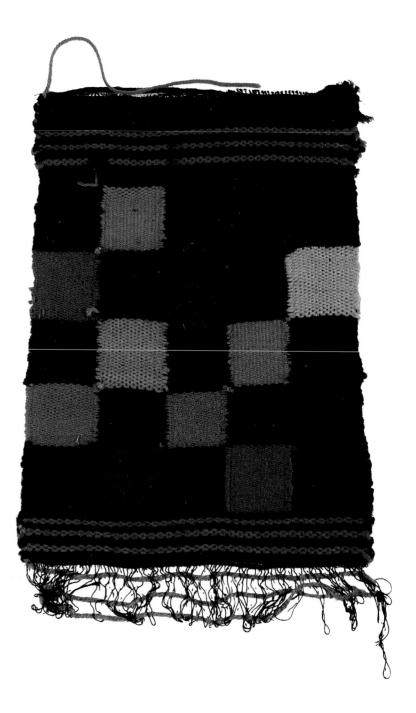

Immeke Mitscherlitsch-Schwollmann,
two weaving samples for wall hangings, c.1925

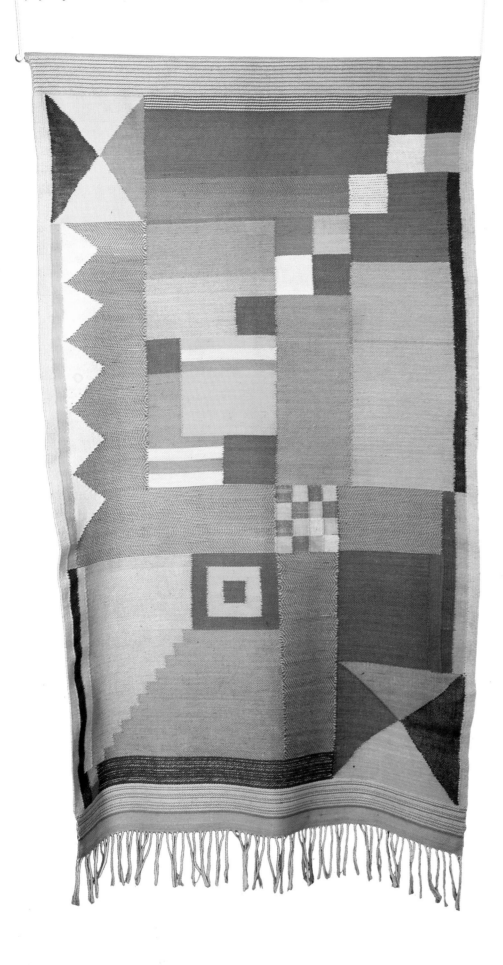

Otte Koch, carpet, 1922–23

Ida Kerkovius, appliqué fabric, 1921

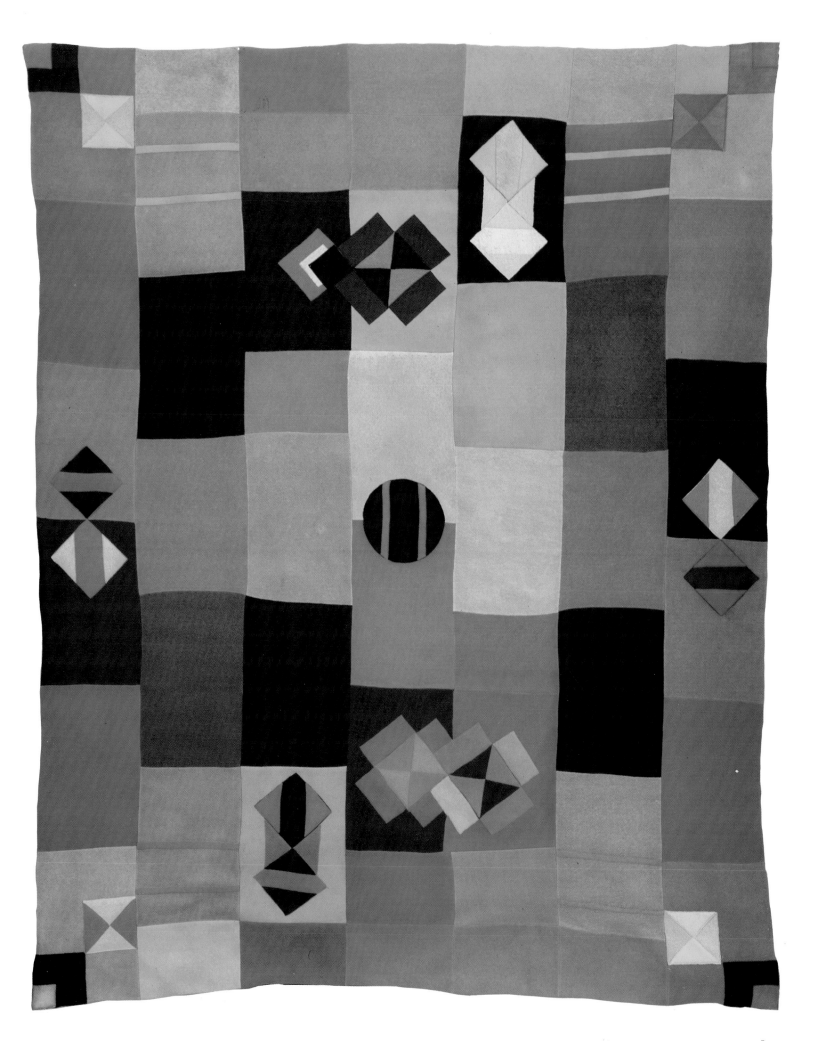

Oskar Schlemmer to Otto Meyer-Amden

Weimar, 14 June 1921

... The Utopian imaginings of the moderns lack great tasks. There is space for them in the illusionistic world of the theatre. We must be content with surrogates, must make in wood and cardboard that which is denied us in stone and iron. Perhaps Gropius felt the same. He has summoned Lothar Schreyer to Weimar, a poet and artist of the stage who founded a 'theatre of struggle' [*Kampfbühne*] in Hamburg, so that we shall now be getting here an injection of the theatrical. I much welcome it....

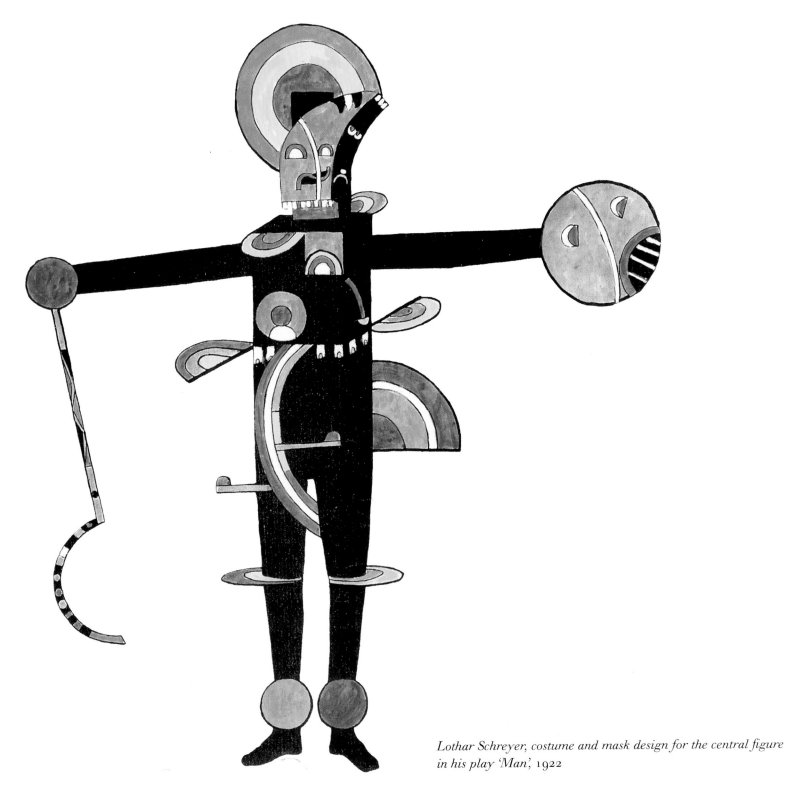

Lothar Schreyer, costume and mask design for the central figure in his play 'Man', 1922

Ludwig Hirschfeld-Mack on his reflected light compositions in *Berliner Börsenkurier*, 24 August 1924

... Yellow, red, green, blue in glowing intensity, move about on the dark background of a transparent linen screen – up, down, sideways – in varying tempi. They appear now as angular forms – triangles, squares, polygons – and again in curved forms – circles, arcs and wave-like patterns. They join, and overlappings and color-blendings result.

At the Bauhaus in Weimar we worked for two years on the development of these reflected light compositions, which had begun as a chance discovery during a simple shadow-play entertainment....

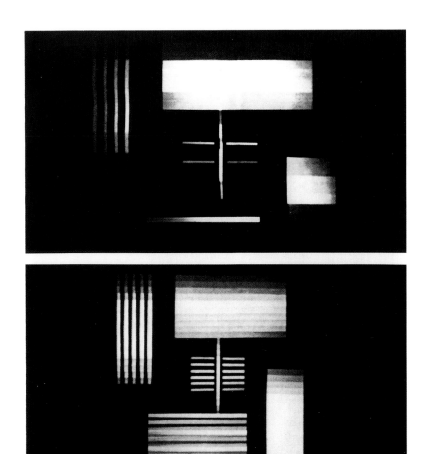

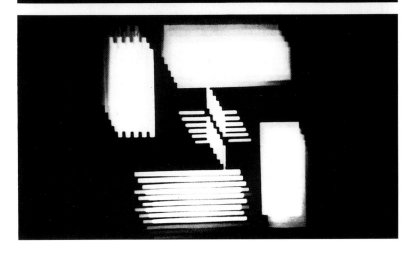

Ludwig Hirschfeld-Mack, three stages of a reflected-light composition, c.1923. Moving abstract shapes were projected onto a screen to the accompaniment of (usually piano) music

Hans Haffenrichter [student] 'Lothar Schreyer and the Bauhaus Stage', 1970

… We developed a 'Song to Mary', danced in front of a large tapestry painted by Schreyer, a 'Dance of the Wind Spirits', with rhythms played on an African calabash xylophone, and a 'Trooper's Dance' in full costume, which we designed ourselves. At the same time in many conversations Schreyer explained the connection between what we were doing and his stage plays – their meaning and significance; thus we came closer to the man himself. Finally Schreyer composed and developed his 'Moon Play' for us. The '*Spielgang*', as he named his specific scores, made his intentions clear in every detail. The long daily training stood us in particularly good stead for the *Klangsprechen* [speaking on a particular pitch] of the poetry.

Lothar Schreyer, two pages from the diagrammatic 'score' of his play 'Crucifixion', 1920. The text to be spoken (upper line) is accompanied by indications of pitch and timbre and physical movements in the lower lines

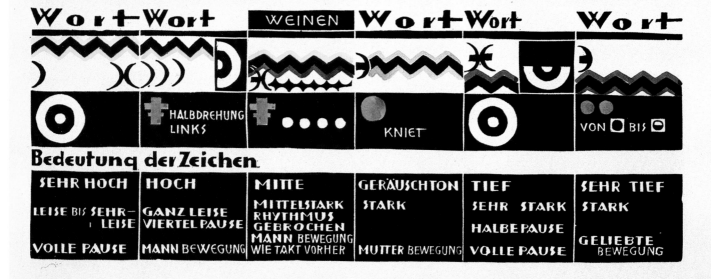

The player had first to find his own *Grundton* [base note], and from this find his own *inneren Klang* [internal sound]. The words of the poem were strictly rehearsed in the rhythm and bar of the '*Spielgang*' and in the pitch and intensity of the *Klangsprechen* until the 'spiritual dimension' became actuality. The movements of the players derived from the tone of the words. Thus every individual movement and our paths across the stage were accurately rehearsed in costume and with dance props. The dance shield was very hard to master in the beginning, especially when it had to be moved in closer time with the speech. Gertrud Grunow often helped us here with her harmonizing exercises. . . .

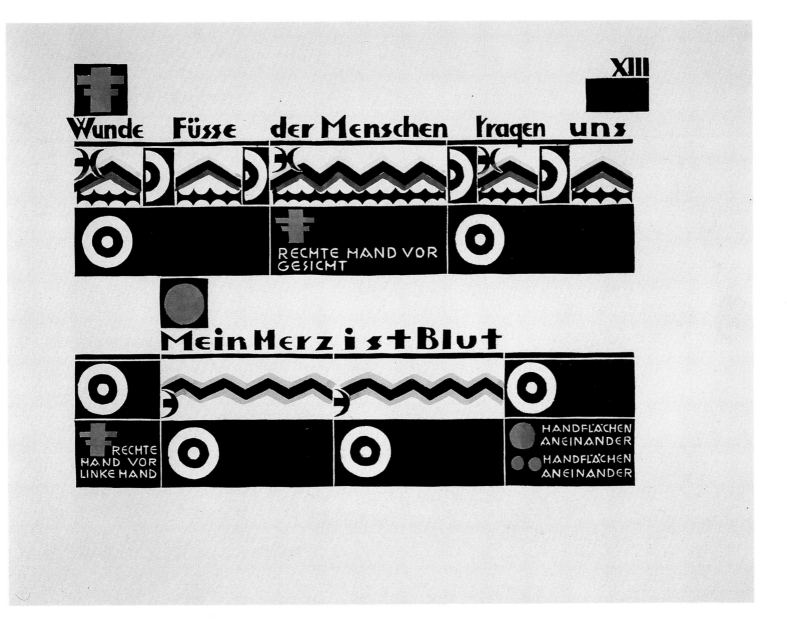

Lou Scheper [student] on the Wall-Painting Workshop

…In the early days games went hand in hand with the objective nature of the task in this Workshop as everywhere else in the school. It was like this when the canteen was being painted. Its walls and ceiling, whose furthest corners could only be reached by colour-soaked sponges thrown into the air, served as a playground for the creation of lively ornamentation of the smallest size and in the brightest colours. Working together, we painted and sprayed with both delight and a bad conscience, for we knew that what we were doing was entirely non-functional. It was not appropriate for a room in which one was intended to eat and relax. And this happened while knowledge about the psychological effect of colour had already begun to be discussed and was already being methodically investigated at the Bauhaus! Itten, the law-giver, demanded a joyless contemplative grey-green as the background for an oriental saying which was intended to educate us while eating….

*(right) Joost Schmidt, colour exercises produced during Klee's class, c.*1920, *watercolour (gouache)*

(left) Fritz Schleifer, design for a competition in the USSR, possibly a club for workers in Moscow or Leningrad, 1925, *ink and watercolour. The insignia of the German Communist youth movement is at the bottom right. The design was made during the year after Schleifer left the Bauhaus Wall-Painting Workshop*

Herbert Bayer on the Wall-Painting Workshop under Kandinsky as Master of Form 1978 [lower case throughout as in the original]

... 1. experimenting in many techniques on the walls of the workshop under the guidance of the master of technique (*werkmeister*). experimental designs for painting houses and walls, super graphics, outdoor advertising, etc., some of them executed on the walls of the workshop.
2. theoretical teaching consisting mostly in discussions with the form master on color organizations, color systems, psychology of color as propounded in kandinsky's book 'about the spiritual in art'. (being personally very interested in color theories, i studied the systems of goethe, philipp otto runge and ostwald. unexpectedly, i had to tell about my knowledge in this area during the verbal examination before the board of the guild in order to receive my journeyman's document.) later in dessau, i had the pleasure to invite wilhelm ostwald to give a lecture and to introduce the color system.
3. practical work, painting exteriors and interiors, among them sommerfeld house, berlin, designed by gropius. this was a way of earning an income for a minimal existence. ...

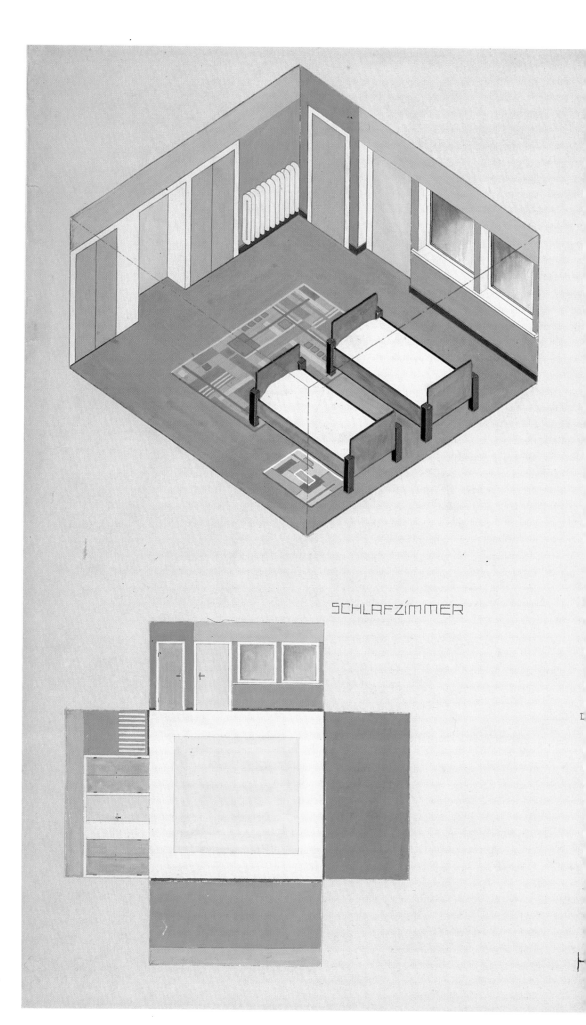

SCHLAFZIMMER

*Alfred Arndt, study for the
colour scheme of the upper floor of
the Auerbach house, Jena, 1924*

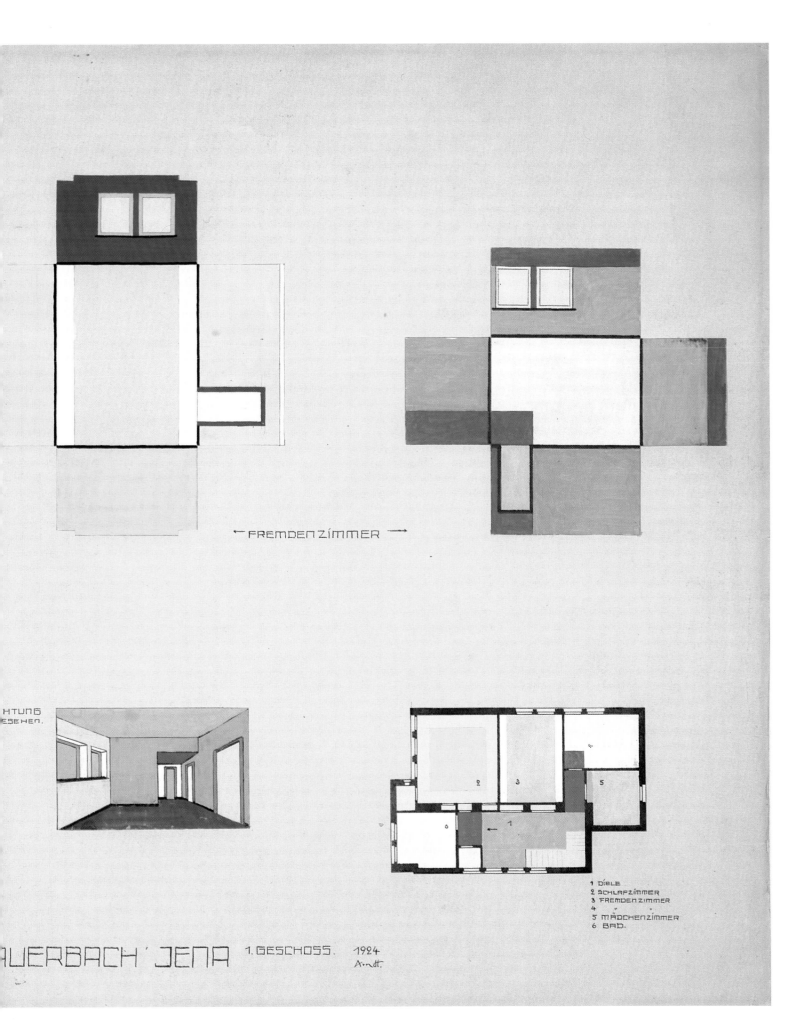

← FREMDEN ZIMMER →

HTUNG
ESEHEN.

1 DIELE
2 SCHLAFZIMMER
3 FREMDENZIMMER
4
5 MÄDCHENZIMMER
6 BAD.

AUERBACH JENA 1. GESCHOSS. 1924
Arndt.

Johannes Itten & Friedl Dicker, from the article 'The Analysis of Old Masters' in 'Utopia, Dokumente der Wirklichkeit', Weimar 1921, letterpress. The text, designed in what for Itten was a characteristically eccentric fashion, reads: 'Everything living reveals itself to mankind by means of movement. Everything living reveals itself in forms. Thus every form is visible in movement and every movement visible in form. The forms are the containers of movement and movement the essence of form'

Statutes of the State Bauhaus, Weimar, appendix 3, July 1922

... The Printing Workshop ... does not train apprentices ... as do the other Workshops, but gives all members of the Bauhaus who request it training in all technical areas of printmaking.... The print shop is essentially a productive Workshop which carries out commissions for artist's prints of every kind as well as entire editions. A large number of leading artists have all had their prints made in our Workshop....

Lyonel Feininger to Julia Feininger

Weimar, 17 November 1921

... The front cover of the portfolio is turning out very beautifully. Hirschfeld is printing my woodcut, as he did the small samples, with the roller right on the paper. You will have to see this dark surface, with a few bright spots growing out of the mysterious structure, to get an idea of the strong effect it makes.

I haven't seen Gropi for days. I hope he is not angry with me for refusing to participate in the competition for the Bauhaus seal. I am not made to invent symbols, and besides there should be something that is not done by me....

(left) Parchment binding (probably by Anni Wotiz) using a device based on the letter 'M' for 'The Revelations of Sister Mechthild of Magdeburg, or the Flowing Light of the Godhead', c.1923.
(below) Cover of the Bauhaus regulations showing the new official seal designed by Schlemmer, which was adopted by the school after a competition among the Masters in 1922. The first 'Expressionist' seal was designed by a student (see p.39)

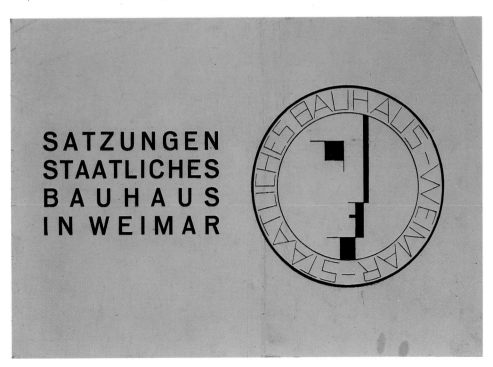

SATZUNGEN
STAATLICHES
BAUHAUS
IN WEIMAR

Advertisement announcing the fifth portfolio of Bauhaus prints 1921

For the first time we are offering the collector the opportunity, otherwise made impossible by economic conditions, to acquire an international collection of graphic work of fundamental importance in which Germany, France, Holland, Italy and Russia are represented by their most significant artists. The success of the enterprise is due to the selfless co-operation of the artists of all countries and of the widows of deceased artists. The contents of the portfolios will be welcomed by those who recognize the quality of leadership in the following names and who wish to serve it:

Archipenko / Bauer / Baumeister / Beckmann / Benes / Boccioni (Estate)
Braque / Burchartz / Campendonk / Carra / Chagall / Chirico / Coubine / Delaunay
Derain / Dexel / Max Ernst / Le Fauconnier / Feininger / Filla / Fiori / Oskar Fischer
De la Fresnaye / Gleizes / Goncharova / Gris / George Grosz / van Heemskerk
Heckel / Hoetger / Itten / Jawlensky / Jeanneret / Kandinsky / Kirchner / Klee
Kokoschka / Kubin / Larionov / Laurencin
Lehmbruck (Estate) / Leger / Lhote / Lipschitz / Macke (Estate) / Marc (Estate)
Marcks / Marcoussis / Matisse / Meidner / Mense / Metzinger / Molzahn
Morgner (Estate) / Muche / Mueller (Otto)
Munch / Ozenfant / Pechstein / Picabia / Picasso / Prampolini / Rohlfs / Scharff
Schlemmer / Schmidt-Rottluff / Schreyer / Schwitters / Severini / Soffici / Survage
Stuckenberg / Topp / Tour-Donas / Wauer.

Wassily Kandinsky *Small Worlds*

The 'Small Worlds' sound forth from 12 pages.
4 of these pages were created with the aid of stone,
4 – with that of wood,
4 – with that of copper.

$$4 \times 3 = 12$$

Three groups, three techniques.

Each technique was chosen for its appropriate character. The character of each technique played an external role in helping to create 4 different 'Small Worlds'.

In 6 cases the 'Small Worlds' contented themselves with black lines or black patches. The remaining 6 needed the sound of other colours as well.

$$6 + 6 = 12$$

In all 12 cases, each of the 'Small Worlds' adopted, in line or patch, its own necessary language.

12

WEIMAR 1922

Ludwig Hirschfeld-Mack, 'Reaching for the Stars', 1922, lithograph

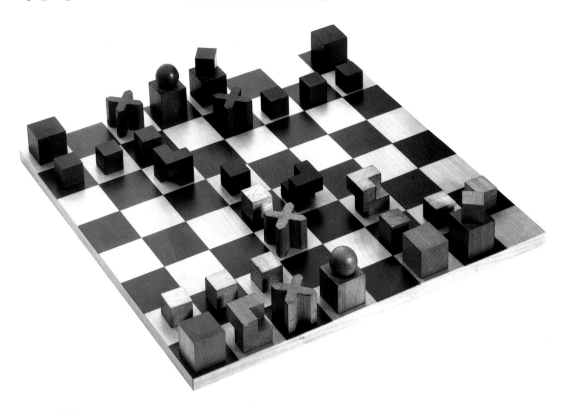

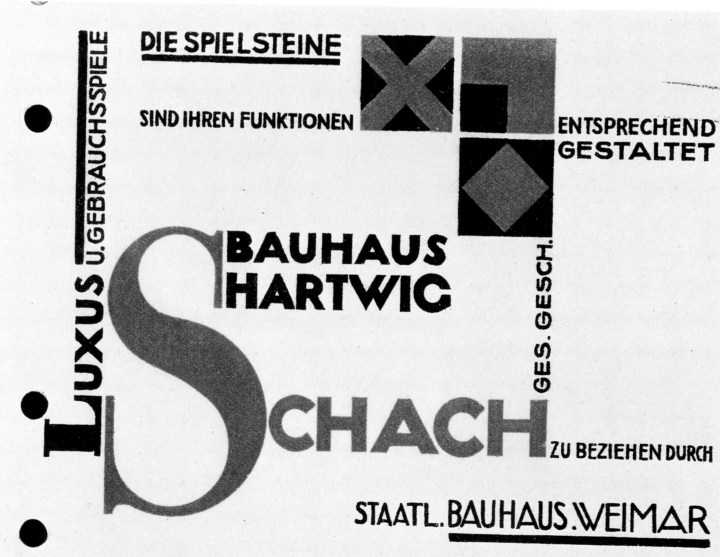

Walter Gropius to Julius (Naum) Slutzky [gold- and silversmith]

Weimar, 19 October 1921

You will join the Bauhaus as a 'Young Master' with the same privileges as the Journeymen. We are giving you Room 16 in the Workshop Building together with the joint use of the forge in the basement which will soon be installed. We will be responsible for the cost of the gas and for the installation of your own tools.

As guaranteed income you will initially receive 500 Marks monthly. For any time spent on carrying out work on commission you will in addition receive a Journeyman's wage, calculated according to the tariff in force at the time in question. The objects you produce at times when there are no commissions will belong to the Bauhaus. The materials will be provided by the Bauhaus or, if you use your own, the purchase price will be reimbursed.

We hope that a mutually beneficial relationship will gradually be established, but you must observe the regulations of the State Bauhaus absolutely and avoid influencing the Metal Workshop in any way lest any disagreements arise with the new Master who is yet to be appointed.

Walter Gropius memorandum to Naum Slutzky

13 March 1923

... By chance it's again come to my attention that you've accepted a sizeable commission for 12 brooches without informing the Bauhaus and involving the administration in the commission. I greatly regret that, in spite of all our efforts, you appear not to understand in the slightest that arrangements ... have to be made in the interests of both sides....

Memorandum of a discussion between the Workshop Masters 15 July 1923

Master Krehan says that in his [Pottery] Workshop every activity is made very difficult by the lack of interest on the part of the Master of Form [Gerhard Marcks]. In addition, the Master of Form repeatedly tells the members of the Workshop what to do without the previous agreement of the Workshop Master.... Several Workshop Masters confirm the scant understanding of craft on the part of the Masters of Form.... The Workshop Masters receive their salaries at the end of each month, the Masters of Form are paid for an entire quarter ... in view of the extraordinarily severe currency devaluation they are significantly worse off than the Masters of Form, in spite of the identical salaries....

(above left) Josef Hartwig, chess set, 1924. (below left) Joost Schmidt, advertisement for the Bauhaus chess set (lithograph of hand-lettering), explaining that the shape of each piece corresponds to the way it moves. Together with a variety of wooden toys, the chess set, manufactured and marketed by the Bauhaus, was one of its most successful products during the Weimar period

Lothar Schreyer on the Ceramics Workshop in Memories of *Der Sturm* and the Bauhaus, 1966

...For us in Weimar the work of the pottery was almost invisible, for the pottery, with Gerhard Marcks as Master of Form and Max Krehan as Workshop Master was situated in Dornburg between Jena and Apolda.... Under the eyes of such a Master ceramic plates, pots and jars became like living beings with which we had, so to speak, a personal relationship....

Lydia Driesch-Foucar memories of the beginnings of the Bauhaus Pottery at Dornburg

...The six wheels (or were there seven? – I can't remember exactly) stood in a row by the long side of the Workshop in front of the windows. At the top by the wall sat Master Krehan so that he could see all five of us from his wheel, in a row in front of him. He thought it important that one stage of the working process after another should be thoroughly learned, and that every movement of the hand should become second nature before we progressed to the next. How often did we believe we had turned a whole board full of 'beautiful' little pots which Krehan then pitilessly tipped into the clay pit while murmuring 'waste of time!'
He did not allow pots with bases that were too thick or had uneven edges or other technical mistakes to go into the kiln. He preferred to turn a board full of good forms himself which he would allow us to engrave or paint with our own designs and then fire so that we didn't lose patience. It was a very good lesson ...

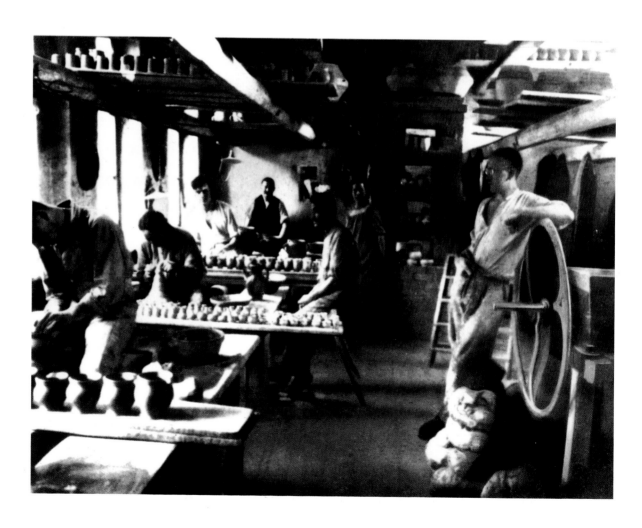

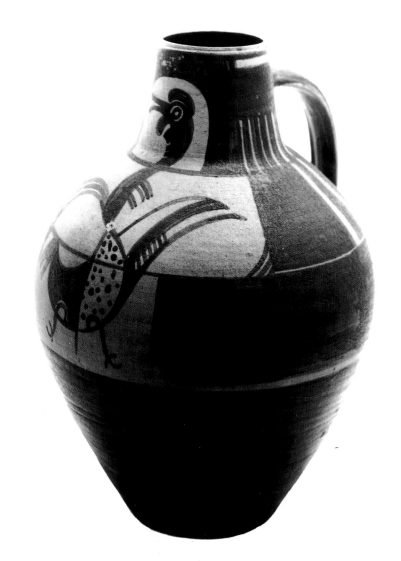

(left) *The Bauhaus pottery at Dornburg, 1924. Max Krehan, the Workshop Master (and owner of the pottery which the Bauhaus rented in the village of Dornburg, thirty kilometres from Weimar on a bank overlooking the River Saale) sitting, centre, with students, among whom are Hübner, Thoma, Grote, Wildenhain, and Friedländer (at the rear by the kiln)*

(right) *Max Krehan and Gerhard Marcks, decorated jug, 1924. Marcks, Master of Form in the Bauhaus pottery, often decorated ceramics thrown by Krehan, the Workshop Master. Their collaboration was closer than that between the Masters in any other Workshop.*

(below) *Theodor Bogler, storage containers, 1923, porcelain, Otto Lindig, 1923, cocoa service. Both were industrially manufactured by the Älteste Volkstedter Porzellanfabrik. Bogler's containers were originally made for the kitchen of the Haus am Horn (see illustration on p.154)*

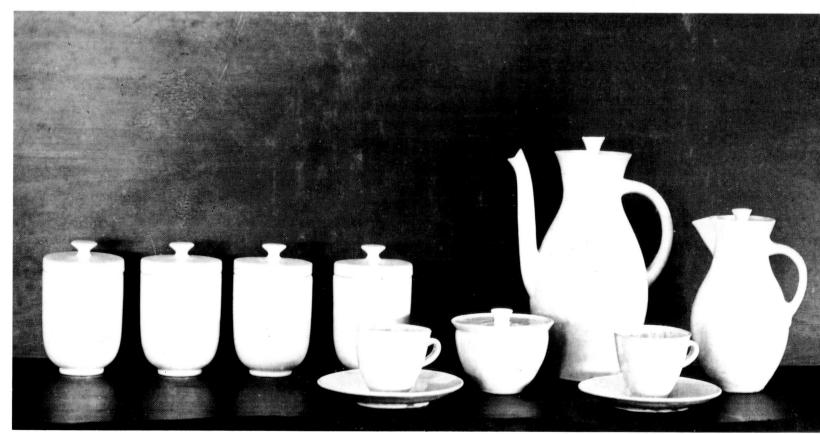

The Sommerfeld House

Walter Gropius to Joost Schmidt

28 April 1922

Many thanks for your letter. I'm pleased that you've reached an agreement with Sommerfeld since things had come to such a pass that I no longer really believed that he was well disposed towards us. Don't make any firm financial arrangement with him. That must be done by me or the Bauhaus as hitherto, otherwise the accounting gets muddled. You can certainly ask for money for yourself and Lili Gräf for as long as you're working there and inform me or the Bauhaus of the size of these sums. I do not believe that you will complete the carving in four weeks. Whether you want Gräf to assist you I leave entirely up to you – perhaps she can be useful.

Your working space remains yours and won't be shared by another even though we shall be extraordinarily short of space, even more than hitherto. I think that I shall shortly be in Berlin and would like to discuss various matters with you then....

Woodcarving Workshop in 1920. On the bench at the rear is a piece of decoration probably carved by Joost Schmidt for the Sommerfeld Villa. The chest by Lili Gräf in the foreground at right also found a home there. The totem-like sculpture in the corner is by Karl-Peter Röhl

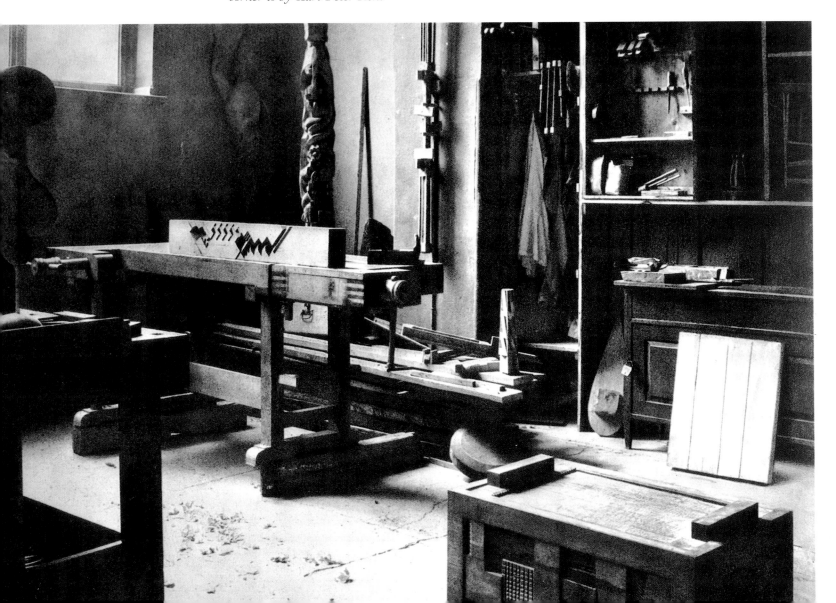

Helene Nonne-Schmidt [co-student and wife of Joost Schmidt] on the interior decoration of the Sommerfeld Villa

... The character of the Sommerfeld Villa was determined by the material provided by the contractor and his desire for as many carvings as possible in every conceivable place inside and outside the building. The teak came from a wrecked warship which Sommerfeld had purchased and whose officers' mess was completely clad in this wood. After it had been renovated, this wood (which is exceptionally difficult to work with) had to be treated in terms of its given structure. Technically, nothing else is possible. Sommerfeld had his own workshops erect the plank scaffolding above the socle of granite blocks. They prepared the teak, as did the Bauhaus Workshops which is where some of the carvings were made before being applied to the building in Berlin. The surface and structures of the carvings were crucially influenced by the material and its innate qualities. In this way the 'jagged style' emerged ...

Detail of Joost Schmidt's carved decorations in teak, 1921–22, for the banister above the rear door in the entrance hall of the Sommerfeld Villa in the Dahlem suburb of Berlin. It is a symbolic representation of Adolf Sommerfeld's saw mill. Overleaf: Walter Gropius and Adolf Meyer, Sommerfeld Villa, Berlin, 1920–21.

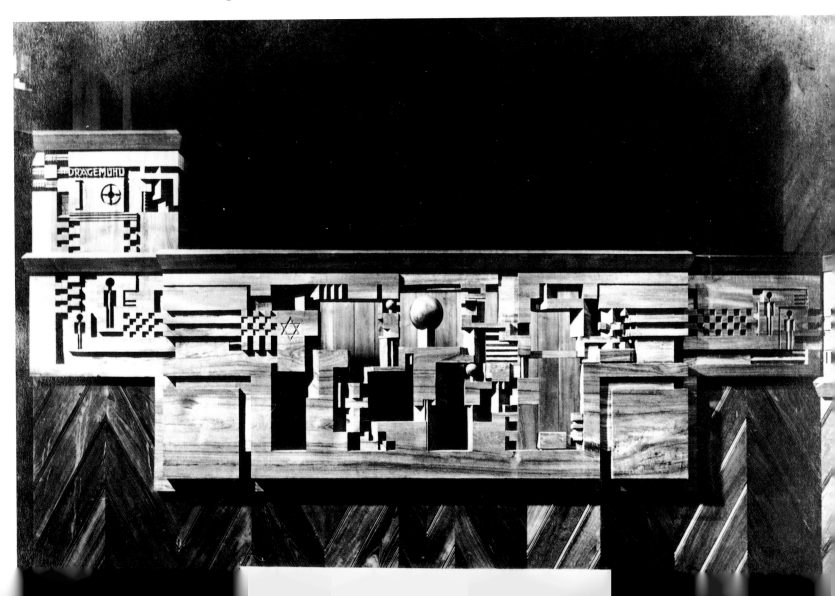

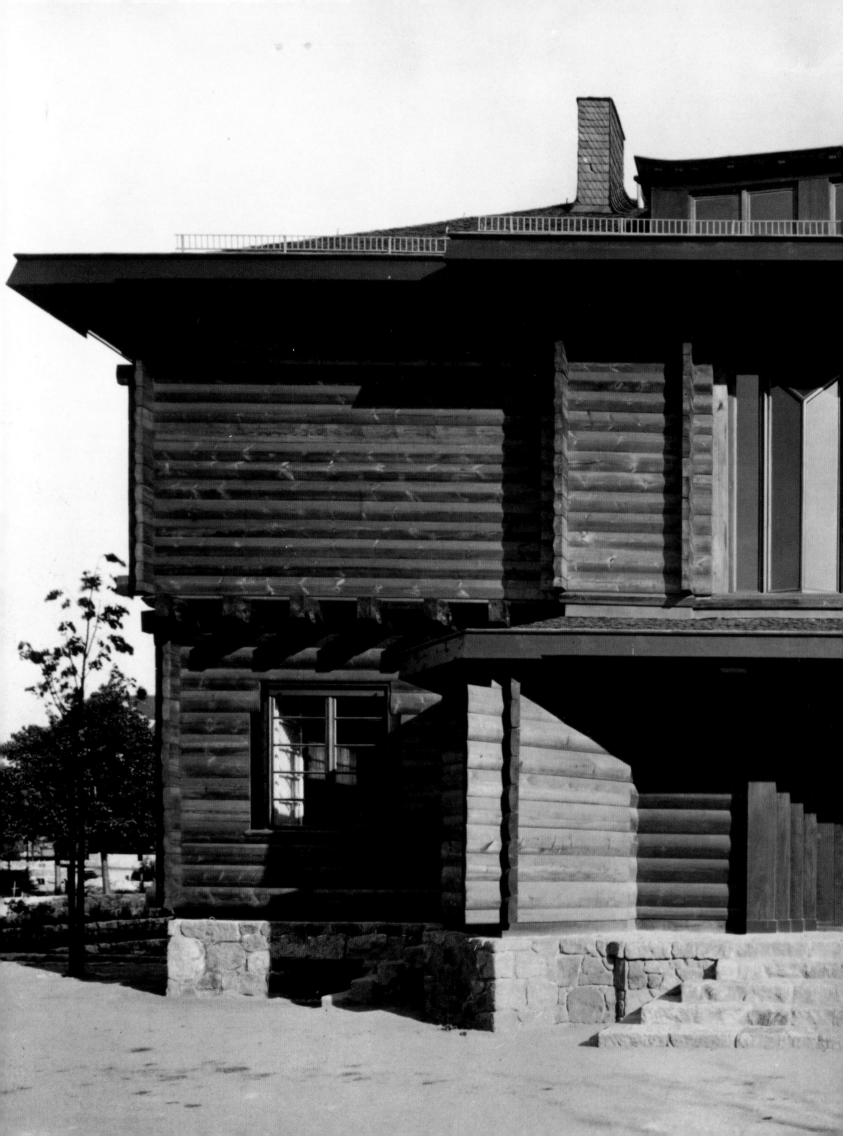

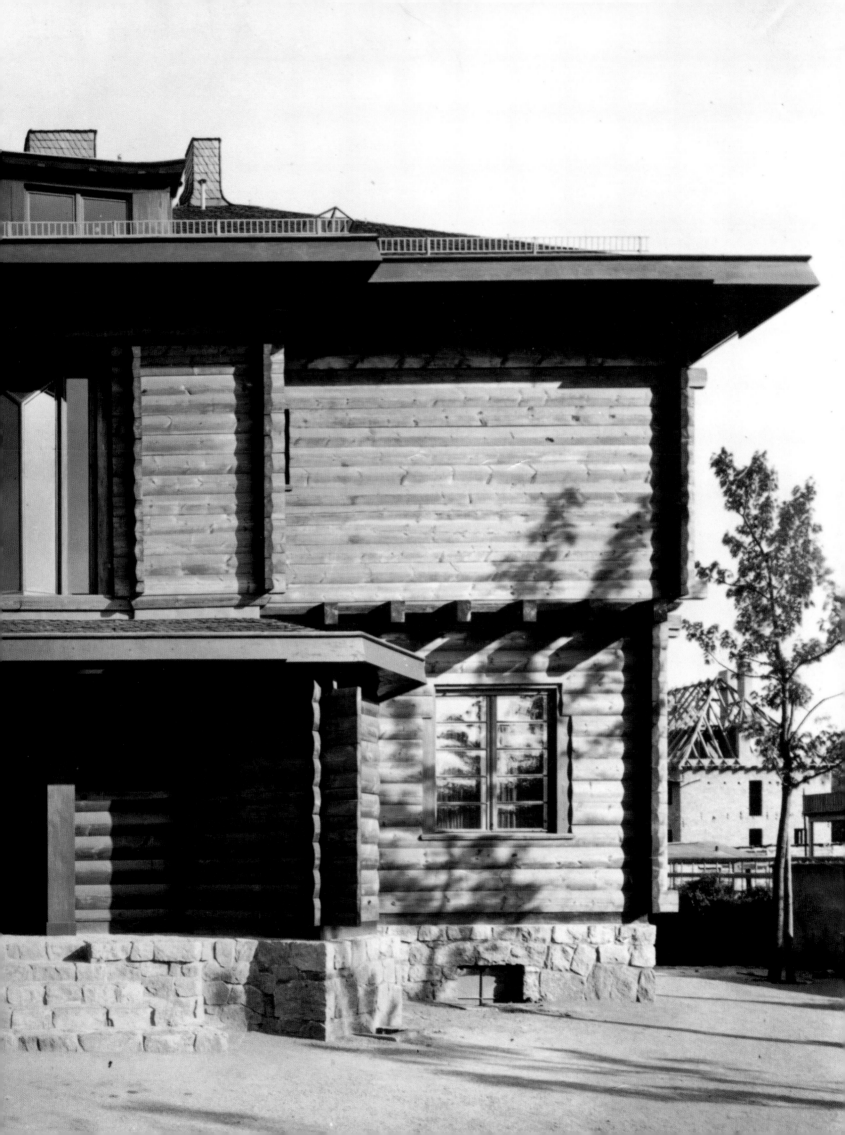

Walter Gropius to Adolf Sommerfeld

14 October 1922

... You are dealing with the Schmidt matter in an unqualified manner, but in such things I know you to be an incorrigible petty shopkeeper who never learns anything. Why must I write you rude letters before you recognize your obligations? Aren't you aware of the extraordinary things Schmidt has achieved in your entrance hall?

He was so outraged by the way you talked to him about financial matters that he wanted to chuck it in completely. You have the gift of poisoning the mood of the artists working for you. That's very unbusinesslike because mood is very important for artists so that they can create more happily. But in this respect it seems to be thrown away on you. So let's rather come to particulars.

We agree: Schmidt receives the normal Journeyman's wage, details of which are enclosed and which for the most part has already been paid. The profit of 20,000 [Marks] for the Bauhaus was received together with your letter to me of 28 September. Possible further hours worked by the Journeyman will be charged by the Bauhaus, the bills presented to you by Schmidt as its Journeyman. Only after pressure from you have I agreed to accept the kind of accounting which I don't like and is disadvantageous to the Bauhaus rather than the kind of normal bill such as the one enclosed.

You guaranteed Schmidt a net fee of 50,000 Marks. But he rightly agreed to this only on condition that the value of the Mark remain as it was on the day of the agreement, i.e. 28 September 1922. This is because the work will, as you know, take up quite a number of weeks yet and until it is finished the Mark may lose so much that the 50,000 will be worth only a fraction of their original value.

I ask you to pay Herr Schmidt, who has been working for you for a year already, 30,000 Marks immediately and the rest once the work is completed – taking into consideration the possible devaluation of the Mark.

Please acknowledge receipt of this letter. So, now I've got that off my chest still in the hope that the petty Napoleon will be a little more generous.

Adolf Sommerfeld to the State Bauhaus

Weimar, 18 October 1922

re: woodcarving

The account of 14 October sent to me is incorrect. Herr Schmidt has received more money. You will therefore oblige by correcting the bill.

When am I going to see Herr Schmidt? Is he perhaps waiting until the Dollar is worth 10,000 [Marks]? If so, I'll refuse to build, preferring to sell matches in artistic boxes which I shall certainly commission the Bauhaus to make with what little remains of my fortune.

Dörte Helm, appliqué curtain for the Sommerfeld Villa, 1920–21

Alfred Arndt *Life at the Bauhaus and its Festivals* [lower case throughout as in the original]

...one day we got up enough courage to arrange a large carnival celebration in which the nicest surprise was the episode, "sommerfeld" berlin with "oskar schlemmer." schlemmer recommended to the good-hearted sommerfeld that he appear in a napoleon mask which he was going to make for him. schlemmer made the same mask for himself. what happened? sommerfeld [patron of the bauhaus] was well disposed towards the bauhaus, and when he came to a group of bauhäuslers who were thirsty, he gave the waiter an order and said: "i shall pay for it all!" and schlemmer, also in a napoleon mask, went to other bauhaus groups, gave the waiter his order and said: "i shall pay for it all!" and when it came to paying the bill, there was only one napoleon – by the name of sommerfeld! and when he discovered that good old oskar schlemmer had played a trick on him, he said: "well, the artists here are not so stupid, i like that!" and smilingly he paid it all!

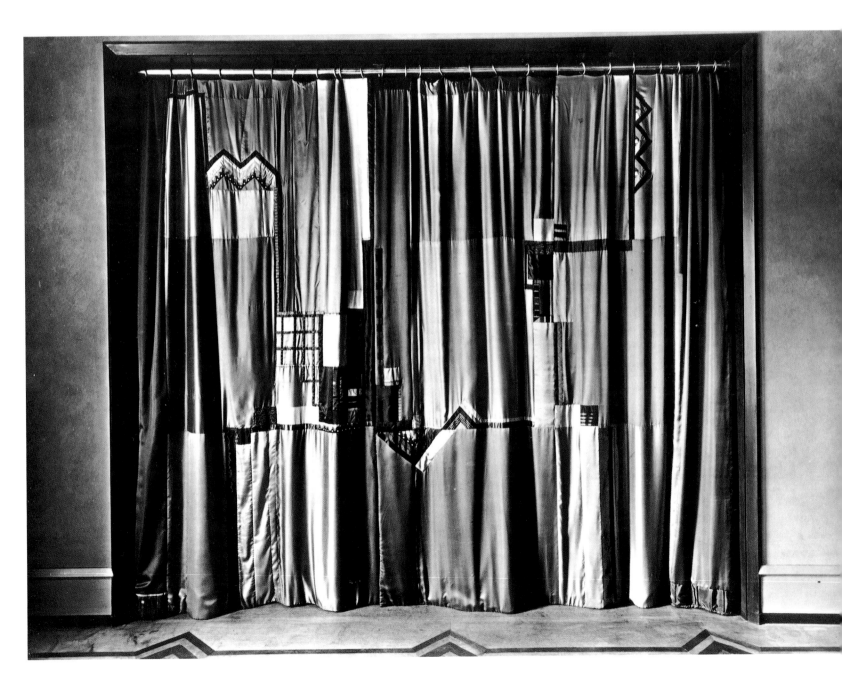

E. Schrammen, cover of the first issue in May 1919
of the student journal 'Der Austausch' (The Exchange).
Woodcut in the Expressionist style

The Students

Herbert Bayer in *Herbert Bayer: Painter, Designer, Architect,* 1967
[lower case throughout as in the original]

…during a weekly gathering with friends for exchanges of thought, we came across kandinsky's book, "about the spiritual in art". coincidentally, i saw the first proclamation of a new art school in weimar, called bauhaus, and was told an interesting rumor about it by margold: "during entrance examinations, the applicant is locked up in a dark room. thunder and lightning are let loose to get him into a state of agitation. his being admitted depends upon how well he expresses this experience by drawing or painting".

 this report, although untrue, and kandinsky's book (i falsely assumed that kandinsky was already at the bauhaus; he actually came in 1922) fired my enthusiasm and made me leave darmstadt for weimar at once.…

Lydia Driesch-Foucar memories of the beginnings of the Bauhaus Pottery at Dornburg

... (In Munich) I heard about the ... slogan of the Weimar Bauhaus: 'Art and craft, a new unity'. At last what I and many others had been looking for for a long time. In the spring of 1920 I moved to the Bauhaus in Weimar.

As far as the advertised Pottery Workshop was concerned, what awaited me was at first a disappointment: there wasn't one. I found only a group of enthusiastic young people who, working mostly with abstract forms, drew, painted and made studies of materials out of scrap metal, wood or other things while at the same time arguing energetically, organizing parties or even scrubbing lithographic stones clean in the cellar. It was intended that everything was to be created anew from the ground up, and the other Workshops were also just beginning. For me it was the community which I had been looking and wishing for for a long time....

Alfred Arndt *Life at the Bauhaus and its Festivals* [lower case throughout as in the original]

in 1919, in the midst of political strife and unimaginable economic plight, young people, mostly men, came to the weimar bauhaus. the majority still wore soldiers' uniforms which the girls made look "civilian" by dyeing them and removing the collars.

many came from the "*wandervögel*" movement, wore long hair which to everyone's amusement, they had cut off later at a bauhaus dance.

usually a pot was put over the person's head and the hair cut off around it. some had their hair shaven off completely. the baldness stimulated ideas, such as painting one's shaven head with black squares for a party....

Lothar Schreyer, hand-painted timetable for the winter term, 1921–22

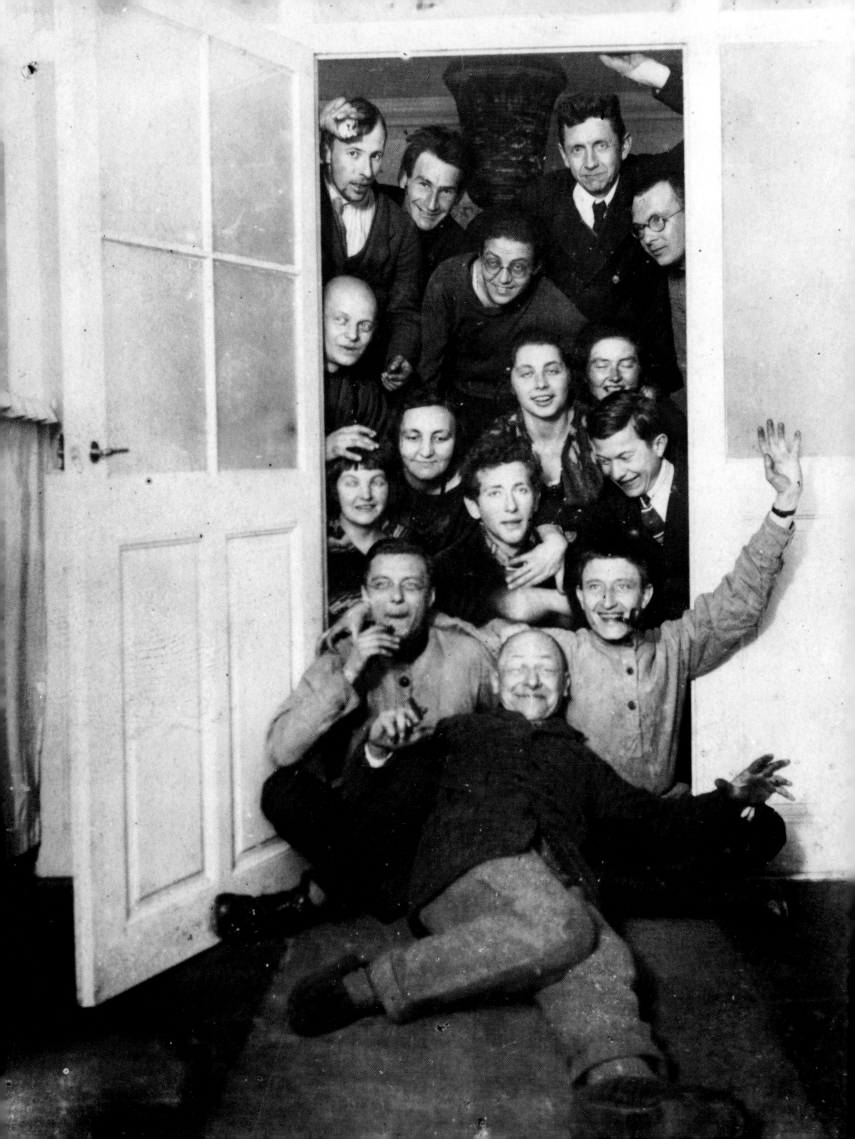

Dr Emil Herfurth [leading opponent of the Bauhaus] *Weimar and the State Bauhaus*
Weimar, February 1920 [pamphlet]

... We demand that the personal conduct of the members of the art institute conform to our
great tradition and Weimar's style of life.
... The town has been most accommodating even in regard to the large crowd of new artists,
especially in view of the enormous difficulties in living conditions created by the
considerably increased numbers of students at this time. The guests show little gratitude.
They consciously think of themselves as outsiders, deliberately display their contempt for the
old Weimar, and by their conspicuous conduct provoke the opposition of the most patient
citizen....

Lydia Driesch-Foucar memories of the beginnings of the Bauhaus Pottery at Dornburg

... One of my happiest memories of that time was bathing in the River Saale. On hot
Saturdays and Sundays, but also in the warm evenings after work we would go down to the
Saale to swim together. Down in Dornburg we had to cross over the railway line and from
there reached the meadows beside the Saale which extended across the whole of the broad
valley. The Saale flowed through the middle of it with many loops and meanders. One of
them had formed what was virtually an island covered with tall trees – probably alders and
willows – and the ground was covered with sand and high grass. The Saale was blocked at
this point so that you could swim. The bank was surrounded by trees and tall bushes so that
no-one could see it from the street that was higher up but quite far away.... An ideal place
for bathing! In addition to Marcks with his family and the apprentices, guests from Weimar
were often there, too. As though in paradise, the strong, handsome young men and women
disported themselves in the water, the sun and the green surroundings. They were truly
dionysian scenes and pictures which repeatedly dominate the memories of my entire,
earlier life.

Staatsrat Rudolph [civil servant] **to the Bauhaus Direction**

Weimar, 4 September 1920

We have received, via the Interior Ministry, the following complaint from the Director of
the Second Administrative Area:
Bauhaus students living in Dornburg are bathing in the River Saale – males and females
together – without any bathing costumes whatsoever and in places accessible to everyone.
People walking past have taken objection and this infringement of decency has caused public
annoyance and represents a danger to morals, especially for young people. The direction of
the School might be advised to attempt to have the male and female students take heed of
the duty to observe general standards of decency.

We kindly request a response to the above complaint.

Group of students and teachers, c.1921–23, anonymous
photograph. Oskar Schlemmer is second down from the top on the
left and Tut Schlemmer is below him. Josef Albers is at the
bottom on the right while Gunta Stölzl is in the centre to Oskar
Schlemmer's left

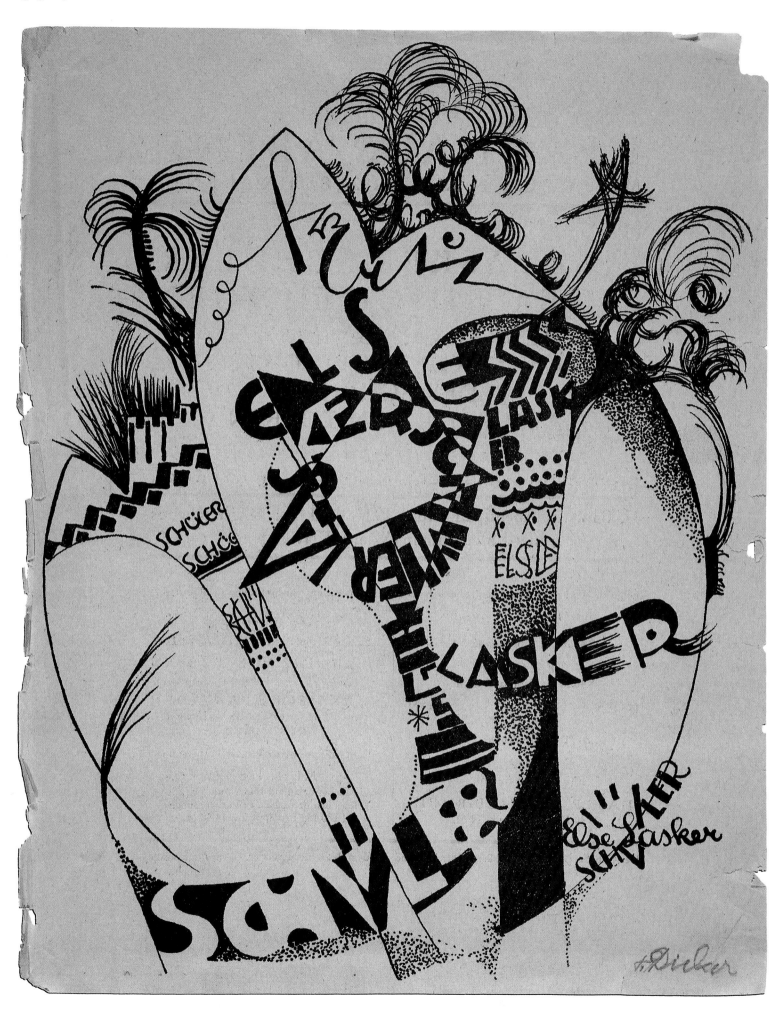

Joost Schmidt *How I Experienced the Bauhaus* [undated typescript]

... In October 1919 I returned to Weimar right in the middle of the labour pains of the Bauhaus.... Gropius was engaging modern artists to join the old Academy teachers on the staff. The students were a disparate band. Some of the former students of both the Academy and the School of Arts and Crafts had found their way back, and a group arrived from the artistic city of Munich, attracted by the Bauhaus manifesto. From Vienna, Itten brought twenty-five of his pupils with him.

Like me, many of them had had terrible experiences in the war. We were inspired by the desire to work for a new, better and more peaceful world. Some of the students wanted to escape from the intellectual and spiritual confusion of the post-war period; they hoped they would find the path to a more purposeful existence at the Bauhaus. Others came from the youth movement and believed that their ideals would be realized by the Bauhaus.

At many student meetings the Bauhaus was passionately discussed and the arguments for and against the Bauhaus, for and against modern art became heated. Most of my former fellow students at the Art Academy were against the Bauhaus and against modern art. They were supported by some of the former professors at the Academy. They felt protected by the screams of protest from the philistines of Weimar. Gropius was bitterly attacked and as manfully defended....

Walter Gropius to Lily Hildebrandt [his mistress]

Weimar, December 1920

... The Bauhaus cracks at the seams, the individuals tear themselves and me to pieces out of love, out of stupidity, out of hate. I have to act as a Solomon above the quarrelling factions. Hardly was the affair with Itten resolved – I let him know that his constant threats to resign did not impress me and were too easy, whereupon he decided to stay – when a new scandal broke loose! Itten students against the Teutons which became very violent. It's like this: the brainy Jewish group, Singer-Adler, has become too presumptuous and has unfortunately also influenced Itten considerably. With this lever they are trying to get the whole Bauhaus into their hands. Against that the Aryans revolted, of course. I have to reconcile now.

Both groups tear at me to take their side, but I restrain my feelings, knowing full well that I am called upon to watch over the stability of the whole.... I may succeed in cutting down the fighting groups including Itten.... People like Singer and Adler do not belong in the Bauhaus and will have to be eased out in time if we are to have some peace. Both feel that this has been a fiasco for them and they were very embarrassed. The battle started during a talk by Else Lasker-Schüler [Expressionist poet] whom I did not meet....

Friedl Dicker, poster for a reading given by the Expressionist poet Else Lasker-Schüler, 1920

Oskar Schlemmer to Otto Meyer-Amden

Cannstadt, 3 February 1921

... the Bauhaus programme has attracted a fearless band of young people (we have a crazy sampling of modern youth). All this means that the Bauhaus is 'building' something quite different from what was planned – human beings. Gropius seemed very aware of this; to his mind the academies made a grave mistake by neglecting the formation of the human being. He wants an artist to have character, and this should come first, not later. Yet at times he appears alarmed at the outcome: no work gets done, but there is a great, great deal of talk ... the young men express their inner confusion by throwing aside conventions and inhibitions and sliding into the Great Indolence....

Marie-Luise von Banceis in *Berliner Tageblatt* 18 October 1922

...A strange lot, these so-called Bauhaus people of the Weimar school. They are so well known to the locals that no-one bothers to look at these curious creatures any more. They still make strangers curious, however, and would make the crowds gather if a gang of them were to go along the busy streets of a large town. In multi-coloured little skirts, bright as a goldfinch, the boys with flying locks, the girls with their hair often cut short, wearing fantastic, loosely hanging costumes which are stylized, timeless, capriciously bizarre, more or less happily selected, invented, made up. Clasps in their hair, ribbons, bare feet, sandals, low-necked, short-sleeved, bare-headed. Through the thin linen suits of several of these disciples of art peeks something like bashful poverty....

Alfred Arndt *Life at the Bauhaus and its Festivals* [lower case throughout as in original]

...to alleviate the poverty of the bauhäuslers, someone had the idea of opening a "dada-stall" on the traditional weimar christmas market. everyone began to make things. decorations, toys, cloth animals, dolls, paper games, wooden games. especially pretty were the animals of briarwood, slightly whittled and gaily painted. the pottery of dornburg contributed a lot of ceramics, also dolls' kitchenware. this was our first humorous appearance before the public. we were very successful, especially with the children, to whom we gave our berets in the end, having nothing left for sale. in spite of all obstacles, there were friends in weimar, artists, art lovers, etc., who looked forward with great anticipation to the further development of the bauhaus.... of course, a blessing for many of the students was the bauhaus canteen with its inexpensive good food, which became even better and cheaper after gropius began the *"bauhaus siedlung."* at first a garden area was used for growing vegetables and potatoes. a real gardener was employed and the students were the "helpers," for which they received "food stamps." for two marks a night the bauhäuslers acted as "extras," preferably in *"die räuber"* by schiller.

Helene Nonne-Schmidt interview with Basil Gilbert, 1966

....The students were so poor that money had to be earned somehow. Schmidtchen earned himself a few extra marks by helping Otto Dorfner [a bookbinder and printer contracted to the Bauhaus] ... to decorate such personal and celebration documents as congratulation cards, jubilee certificates and the like. The lettering was quite fancy and had to be applied with gold leaf on parchment. To acquire the necessary skill for this task, Schmidt borrowed some of those beautifully decorated medieval books that were in the Weimar State Library and diligently copied the hand-written script during his spare hours at home....

Walter Gropius to Herr Bergs [businessman and prospective Bauhaus patron]

Weimar, 29 January 1923

... Usually without any prospect of earning money and in many cases without any kind of support from home, many students are forced to deny themselves the most necessary things and to feed themselves so inadequately that it is absolutely clear that this kind of existence will quickly lead for those affected to complete physical collapse. Last winter there were already cases of undernourishment. Even now we do not know what is to happen and the worst is yet to come: there will be no coal deliveries for the next few months when we have to reckon with a bad cold spell. Since neither coal nor proper food will be providing the body with external or internal warmth, all creative activity must cease. The prospect of what is confronting us depresses the spirits – which, already in our present predicament, see no reason for joy. Nevertheless one must still wonder at the resilience and energy of young people. They know how to adjust to the given circumstances and not to reveal their undeniable suffering to the outside world....

Xanti Schawinsky [student] in *Junge Menschen* 1924

Actually I am dough. What kneads me is time. When I came to the Bauhaus six months ago I was a façade decorated with little motifs. Today I am a red cube (red, as I then discovered, is 'boiling in itself'). Everything became clear, the cube is damned simple. And it boils anyway.

I believe that everyone who comes to the Bauhaus undergoes such a transformation. But the internal temperature depends on the boiling point of the individual. And that's the entire crazy point. ...

The demand for clarity grows increasingly powerful in us. A house is a machine for living in, and a forest is a forest....

What our masters serve up is not compatible with our flesh and blood. But we've become different people nevertheless... There's not nearly as much talk as the interested reader might imagine from this fat magazine....

We rather play-act when we've got free time. There's not a dry eye anywhere. Until late at night – until the hangman Hebekrach appears, makes a scene with his pulsating voice and chases us down into Hades. – Or we dance! What, you've never died at a Bauhaus dance? You're still an ordinary earth worm, you've still never tried to solve Shakespeare's riddle about 'to be or not to be'.

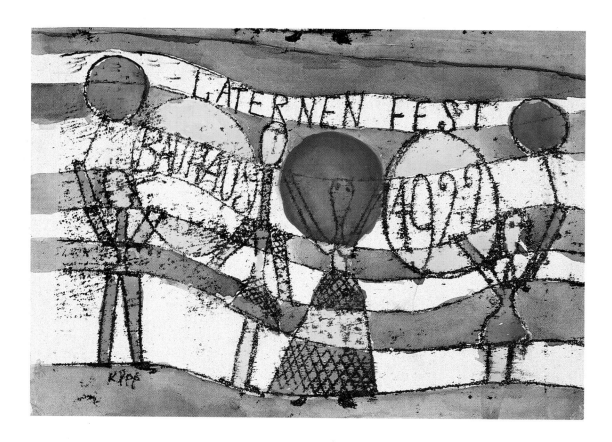

Bauhaus Parties

Lothar Schreyer Memories of *Der Sturm* and the Bauhaus, 1966

... We had wonderful parties both large and small at the Bauhaus. Whenever a particularly fine piece of work was completed it was celebrated by the Workshop concerned. When [the student] Ida Kerkovius finished her first large rug we had a party in my small flat under the roof of the old house on the edge of the park which used to belong to Frau von Stein [Goethe's close friend]. The carpet was extremely handsome and, four square m. large, almost filled the entire room. We surrounded it with burning candles and squatted around it on the floor chatting happily and quietly while the fountain bubbled away outside the window. When [the student] Kurt Schwerdtfeger invented his 'reflecting light display' in the Stage Workshop – a magical, abstract interplay of coloured shadows – and presented it for the first time in the hall of the Bauhaus, this, too, was a party. We also spent happy hours whenever Paul Klee, whom everyone loved, announced a musical evening in the hall and played Mozart for us on his violin. The students at Dornburg together with Gerhard Marcks presented a Christmas play to the inhabitants of Dornburg which [the student] Theodor Bogler – today a Benedictine monk in the Abbey of Maria Laach – had compiled entirely from old traditional sources. With this play the Pottery Workshop won the hearts of the population for the widely despised Bauhaus. Felix, Paul Klee's son – he was about ten or twelve years old at the time – entertained us all with his delightful Punch and Judy show which, irreverent but kind, gave away all the Bauhaus secrets. The big celebrations – the Lantern Festival and the Kite Festival – are unforgettable. The Workshops toiled for weeks

simply preparing for these festivals. No effort was spared in turning the most fantastic shapes into functional lanterns. When the really warm summer nights arrived and the glow-worms glowed in the bushes in the old Goethe Park we walked in a long crocodile through the park, up around the hill and through the town, a host of lanterns in the darkness, sometimes singing, sometimes keeping silent, but completely filled with the beauty of our lights in the beautiful night. One sunny autumn day on a small hill above Weimar we let the kites fly up, true works of art, fragile and large, birds, fishes, abstract shapes, trembling on their long strings, almost disappearing in the blue of the sky....

Farkas Molnár [student] Life at the Bauhaus

...Most energy was developed at the fancy dress parties... A snail arrives, is lifted into the air, squirts perfume and emits beams of light.... Kandinsky loved to appear as a [radio] aerial. Itten came as an amorphous monster, Feininger as two right-angled triangles. Moholy-Nagy as a segment penetrated by a cross, Gropius as Le Corbusier, Muche as an unwashed apostle and Klee as the song of the blue tree....

(left) Paul Klee, invitation to the Bauhaus Lantern Festival, 1922, *hand-coloured lithograph*

(right) Lothar Schreyer, watercolour design for an invitation to the Bauhaus Lantern Festival, 1922. *Together with the Kite Festival, the Lantern Festival combined a sense of occasion with practical Workshop exercises in which the imagination was given free rein. The Festivals were also intended to acquaint the people of Weimar with the activities of the school in an impressive and entertaining way*

'Sex at the Bauhaus' in *Weimarer Zeitung* 1924

...There is no need to list the occasions on which Bauhaus people of both sexes have rolled around naked somewhere in the open air.... There is no need to associate oneself with the complaints arising from cases in which such unusually unrestrained fraternization between young people of both sexes has ultimately led, in the case of the females, to motherhood. But I must condemn all this as the result of an entirely irresponsible attitude and especially as a consequence of the damaging educational methods of the Bauhaus if, as has actually happened, such pregnancies are publicly celebrated with all sorts of noise, and if, for example, a cradle is constructed in the Bauhaus Workshops for the resulting infant and then carried in triumph to the flat of the girl concerned....

Marie-Luise von Banceis [journalist] 'Bauhaus Kite Festival in Weimar' in *Berliner Tageblatt* 18 October 1922

...And now they all stand in the sky bathed in their own glory – the kites which seemed so large down here on the ground but are now like tiny dots up there, some scarcely visible to the eye. Very beautiful ones display their splendour: polygonal, gleaming monsters, fishes with long glittering tails turning and twitching, curious cubistic basic shapes, crystals, snakes, balloons, suns, stars, airships, shells, lamps, tiny and gigantic, kites of every imaginable kind, gloriously miraculous birds straight out of the dreams and fairy tales of artists, the griffin, the winged horse of the poet, the enchanted flying coat. And something more and not often seen – cheerful, whimsical little kite-men, their hair made of gold paper, plump bodies, noses and ears, arms and legs made of paper clippings....

Kole Kokk [journalist] on a Bauhaus party, in the Berlin newspaper *8 Uhr Abendblatt* 18 February 1924

...We arrive in a medium-sized and extravagantly ugly dance hall along a narrow corridor. The decorative painting on the walls was obviously done in the 1880s and shows young, harp-playing maidens on a green heavenly meadow. Do the male and female students of Kandinsky, Feininger or Klee really want to dance in this place? Is it permitted for a Constructivist even to enter this room without attacking the lady harpists with the fanaticism of the iconoclasts? These are stupid reservations which after half an hour's enthusiastic participation have fled.... Everything is done by the Bauhaus people themselves. Firstly, there's the band. I have no worries about the five boys who play in it. If they can't make a living from painting any more, they can begin to tour the very same day. They are the best jazz band I have ever heard jamming, musical to the tips of their fingers. Never has the Banana Shimmy been better played, no one will ever do 'Java Girls' with more energy.... One dance follows the next almost without a pause. But if they do eventually take a break, a pretty girl swings her bare legs over the edge of the stage and plays the squeeze box with captivating virtuosity....

(right) Invitation, designed and hand-lettered by Joost Schmidt, to a student party at the Ilmschlösschen pub in Oberweimar celebrating (several months late) the fifth anniversary of the Bauhaus, 1924. Among the attractions were a Reflected-Light Play, presumably by Hirschfeld-Mack, dancing, and a tombola

(below) The Bauhaus Student Band, 1924. From left to right: Hans Hoffmann, Heinrich Koch, Rudolf Paris, Andor Weininger. The word on the card means 'excitement'. Photograph by Louis Held

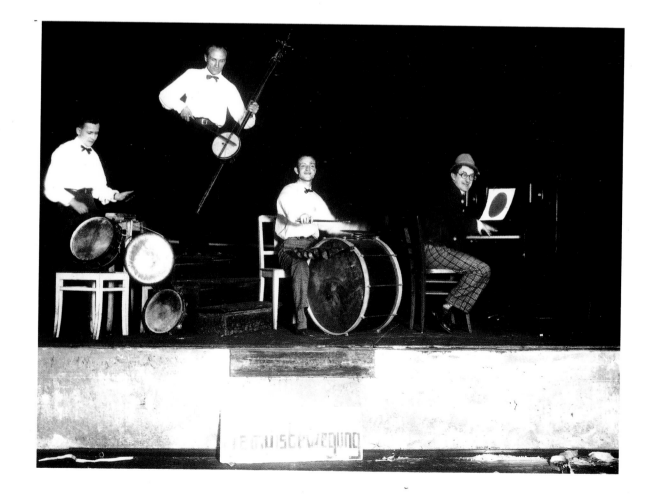

(above) Lyonel Feininger, 'Oberweimar', 1921, oil on canvas

(opposite) the party at the Ilmschlösschen on 29 November 1924.
The words on the cards read: 'Resignation', 'Tension',
'Catastrophe', 'Passion', 'Arrival', 'Interval', 'Excitement' and
'Climax'. The participants cannot, alas, be identified

Felix Klee 'My Memories of the Weimar Bauhaus', 1970

...Every weekend there was a small party at the Bauhaus. And once a month a large fancy-dress party was organized with some funny theme or other.... For financial reasons all these parties were held in the little hostelries of neighbouring Oberweimar. I remember the 'Ilmschlösschen' and the 'Golden Swan' there. Hirschfeld [–Mack] played on his 'squeeze box'. Andor on the piano and Schmidtchen (Joost Schmidt) played the only piece he could on his violin. And our Bauhaus dance to the music was improvised – in other words there were quite specific rules for it. It consisted of enthusiastic stamping for which much space was required....

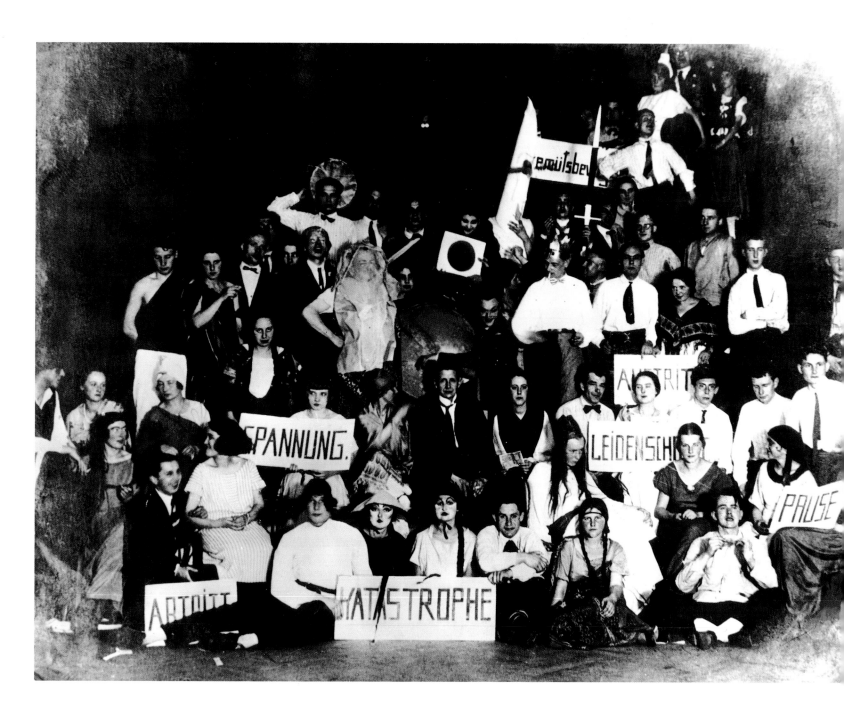

Van Doesburg in Weimar

Theo van Doesburg to Anthony Kok [poet, contributor to *De Stijl*]

7 January 1921

...At Weimar I have turned everything radically upside down. This is supposed to be the most famous Academy with the most modern teachers! Every evening I have talked to the students and spread the *vermin* of the new spirit. Within a short time *De Stijl* will reappear in a more radical way. I have tremendous energy and know now that our views will achieve victory over anyone and anything....

Theo van Doesburg in 1924, photograph by Lucia Moholy

(right) Theo van Doesburg, colour plans for interior design, 1919

Oskar Schlemmer to Otto Meyer-Amden

Weimar, end of March 1922

...One of the most vocal opponents is van Doesburg, the Dutchman who advocates architecture so radically that for him painting does not exist, except insofar as it mirrors architecture. He defends his notions most eloquently, drawing the Bauhaus students under his spell — especially those interested chiefly in architecture, who deplore the Bauhaus's deficiency in this area. The Bauhaus lends itself readily to his rejection of it and its Masters.... He rejects craftsmanship (the focus of the Bauhaus) in favour of the most modern tool: the machine. Exclusive and consistent use of only the horizontal and the vertical in art and architecture will, he thinks, make it possible to create a style which eliminates the individual in favour of collectivism....

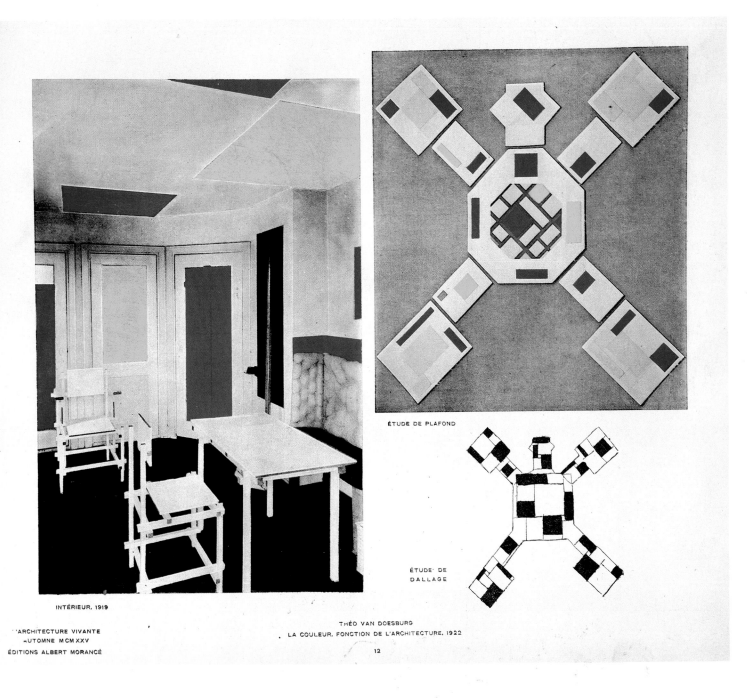

ÉTUDE DE PLAFOND

ÉTUDE DE DALLAGE

INTÉRIEUR, 1919

'ARCHITECTURE VIVANTE
AUTOMNE MCMXXV
ÉDITIONS ALBERT MORANCĖ

THÉO VAN DOESBURG
LA COULEUR, FONCTION DE L'ARCHITECTURE, 1922

12

127

(left) Theo van Doesburg, Composition IV, 1917,
three stained-glass windows.
Designed for Jan Wils's town house for Mr de Lange

Karl-Peter Röhl, 'Styl 1923 Weimar – Abstract composition',
1923, oil on canvas. This and Röhl's painting on p.137
demonstrate the dramatic impact made on the student by van
Doesburg's activities in Weimar. Röhl's style quickly changed
from Expressionist to Constructivist, and he left the Bauhaus

Werner Graeff [student] 'van Doesburg in Weimar'

...Van Doesburg ... could not understand why Gropius who, as early as 1911 (in Alfeld) and 1914 (in Cologne) had given bold proof of his Constructivist spirit and variety, could as director of the Bauhaus in the beginning have produced or even merely countenanced a backsliding into Expressionism and romantic rapture. In contrast to the medieval-handicraft ideal of the original Bauhaus programme, van Doesburg promoted the machine and the mass production of well-designed goods. By 1922 he was already anticipating part of the later Bauhaus programme. He gave many lectures on typography and instituted a design course of his own. Nevertheless, this was the beginning of the Weimar *De Stijl* group....

Werner Graeff remarks by a member of the Bauhaus

...Van Doesburg's instruction in form was basically quite different from Itten's famous Bauhaus Preliminary Course. Like Itten, van Doesburg was a good teacher. If Itten sought to discover and encourage the inborn gifts of the individual ('impressive', 'expressive' or 'constructive' in nature), van Doesburg was exclusively interested in the constructive. If Itten discovered that everyone preferred his own individual colour scale, van Doesburg and Mondrian taught a universally valid, objective range – yellow/red/blue + white/grey/black. Properly used, the most powerful expression could be achieved with the aid of these modest means. Van Doesburg was a bitter opponent of romantic tendencies. He preferred to wear a dressed hat and fashionably-cut suits – Itten on the other hand was a follower of a mystical, fantastic sect. He designed a kind of priest's costume and would walk about in it through Weimar without any embarrassment, just as van Doesburg went out walking with his monocle, white tie and black shirt (both to the amazement of the inhabitants of Weimar). They were the greatest opposites imaginable, personal enemies perhaps, but they were nevertheless alike in their remorseless single-mindedness, their unusual propagandistic but also pedagogic gifts....

Vilmos Huszár [painter and member of *De Stijl*] 'Bauhaus' in *De Stijl* September 1922

...Where is there any attempt to unify several disciplines, at the unified combination of space, form and colour? Pictures, nothing but pictures ... graphics and individual pieces of sculpture. What Feininger exhibits was done better in France ten years ago (Cubism of 1912).... Klee ... scribbles sickly dreams.... Itten's emptily pompous daubing aims only for superficial effect. Schlemmer's works are experiments familiar to us from the work of other sculptors.... In the Weimar cemetery stands an Expressionist monument by director Gropius: the result of a cheap literary idea, it cannot compete even with Schlemmer's sculptures.... In order to reach the goals aimed for by the Bauhaus in its manifestoes other masters are required, masters who know what the creation of a unified work of art entails and can demonstrate their ability to create such a work....

In a country which is torn politically and economically, can one justify the spending of large sums of money on an institute such as the Bauhaus is today?

My answer is: No – No – No!...

Lyonel Feininger to Julia Feininger

Weimar, 7 September 1922

...Kandinsky thinks that van Doesburg will soon be going to Berlin – in the autumn: he's moving because Weimar is much too narrow for his activities. Be honest: how many are there at the Bauhaus who really know what they want or are strong enough to work with enough patience to make something of themselves? For most of them, van Doesburg – unsentimental if also entirely devoid of genius – provides something of a crutch in the midst of all the restless and contentious individual opinions, something certain and clear they can hold on to. . . . Why and how is there voluntary submission to the van Doesburg tyranny while all the measures taken, or even just the wishes expressed at the Bauhaus are totally opposed? I believe that nothing can be done to counter it. Either the Bauhaus philosophy is strong enough to overcome the internal and external opposition, or everything will collapse. This is because today there truly are too few people able to support the cause unequivocally and with a clear head. We move from suspicion to suspicion, danger to danger. . . . And this is because the Bauhaus imposes obligations – van Doesburg does not: one can come and go, one is entirely free to submit and, as everybody tells himself, just as free to go one's own way. Naturally it's gross sabotage of everything the Bauhaus aims to do. But almost everyone must experience something like it before they achieve a balance. If van Doesburg were a Master at the Bauhaus he would not harm everything but would be useful because he represents the opposite pole to the rampant Romanticism which is haunting us. But he would probably not be able to restrict himself to any limits but would soon, like Itten in his time, want to take over the whole thing. . . .

Postcard of the studio wing of the Bauhaus from Theo van Doesburg to Antony Kok, 12 September 1921. The text in the margins reads: 'Before the collapse [the Bauhaus] is in the process of being bombarded by the cannons of De Stijl'

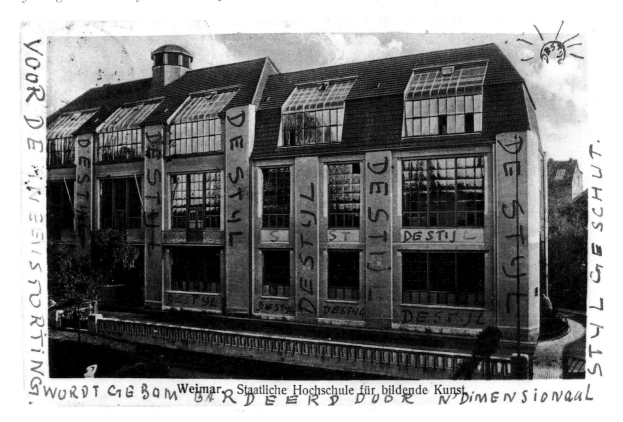

Weimar. Staatliche Hochschule für bildende Kunst.

The Question of Architecture

Oskar Schemmer to Otto Meyer-Amden

Weimar, 23 June 1921

...There are no architecture classes at the Bauhaus, no student wants to become an architect, or rather can't become one for that reason. But the Bauhaus supports the notion of the primacy of architecture. That's naturally because of Gropius who's the only architect at the Bauhaus but has no time at all to teach....

Walter Gropius, monument to the 'March Dead', Weimar cemetery, 1921. Commissioned by local trades unions, the 'concrete lightning bolt' commemorates workers who were shot dead by the military while striking against the right wing Kapp putsch in 1920. Destroyed by the Nazis, the monument was restored after the Second World War

Oskar Schlemmer memorandum 21 December 1921

... I have always felt the lack of an architecture department occupying a strongly dominant position at the Bauhaus, the significance of which has until now only been suggested in the Programme. It ought to give the Bauhaus its character. In the Statutes, too, it is given too little significance in comparison to the Workshops, whose constitution is not sufficiently distinguished from that of the workshops in the old schools of arts and crafts. From the point of view of the power of the Bauhaus idea I regret this since the School of Building and the Academy, which we wanted to incorporate, are winning the right to an independent existence. I have a very high opinion of the architecture department because I believe that the new architecture grows out of painting. This stood and still stands at the focal point of modern art. It has conquered sculpture and is on the point of overpowering architecture. The architect who makes use of the applied arts and artists to 'adorn' his building has the wrong idea. They must interpenetrate it.

The director and only architect at the Bauhaus ought here to have his most appropriate and honourable field of activity....

Oskar Schlemmer to Otto Meyer-Amden

Weimar, end of March 1922

... What keeps me awake at night is the Bauhaus. Just picture it, almost without a fixed pole, assailed from all sides. In point of fact, and outsiders confirm this: the name *Bauhaus* arouses certain expectations, and justified ones. You might expect architecture and building to be the main thing, and instead you find a modern school.... The Construction and Architecture Class or Workshop, which should be the core of the Bauhaus, does not exist officially, but only Gropius's private office. His commissions for factories and houses, carried out with more or less finesse, thus provide the centre round which everything else is supposed to revolve. It is an architectural bureau, its aims directly opposed to the schooling function of the Workshops. The better products of the Workshops are turned to a practical use, with varying success, by the architecture office. This defect in the Bauhaus causes me, and has always caused me, my greatest sorrow....

Oskar Schlemmer memorandum to the Council of Masters 30 October 1922

When the Bauhaus was founded it was with a view to creating the Cathedral or Church of Socialism, and the Workshops were created along the lines of the guilds which built the medieval cathedrals. For the time being the idea of the cathedral has retreated into the background and with it certain kinds of thought of an artistic kind. Today it is the case that we should at best think of the dwelling house, perhaps *only* of the house, or at any rate of the house of the *most simple* kind. In view of the economic crisis it is perhaps our task to be pioneers of a new kind of simplicity, that means to find a simple form that is both decent and appropriate for everything that is vital for life. The question is whether our work should be determined by thoughts of such a social and ethical nature, or by the facts of existence of the Workshops which, simply because they are there, must be put to work.

Changing Direction

Walter Gropius statement about the differences of opinion at the Bauhaus 3 February 1922

Those differences of opinion about crucial problems at the Bauhaus which have recently been exercising the Masters have given me cause, as founder of the Bauhaus, to review, primarily for myself, the theoretical and practical principles on which the school is based.... We are all clear that the old idea of *l'art pour l'art* is out of date and that all those things which concern us today do not exist in isolation but are anchored in our developing philosophy. The foundations on which our work is built can therefore never be broad enough, and today they are too narrow rather than too broad. This is demonstrated by the parallel attempts being made in Russia which bring together music, literature and science which are regarded as activities emanating from the same source....

Master Itten recently asked us to decide either to make individual, single pieces of work in complete contrast to the economically-orientated world outside or to seek contact with industry. I believe that it is in this formulation of the question that the big 'factor X' lies, the factor which needs to be resolved. To come right out with it: I look for unity in the *fusion* of these forms of life, not in their *separation*. How is it that we can approve as much of the form of a well-built automobile, aeroplane or modern machine as we can of the form of a beautiful work of art made by a creative individual?... For some time industry has been attempting to attract creative talents to improve the forms of their products (the *Deutscher Werkbund* and better). Meanwhile young artists have begun to concern themselves with the phenomena of industry and the machine. They start with the design of what I would like to call the 'useless' machine – both creative approaches are therefore already converging!...

The Bauhaus has begun to break with the previous conventional kind of academic training which taught students how to become little Raphaels and pattern-designers. It has begun to return to the people those creative talents who had fled from a life of creative labour to their own and the people's detriment. The Bauhaus has quite consciously aimed to replace the principle of the division of labour by returning to collaborative work in which the creative process is perceived to be an indivisible whole. To do this it has been necessary to rebuild from the ground up, in order to have any prospect of giving back to the present generation a proper sense of the way craftsmanship and design are interwoven.

True craftsmanship must first be revived if young people are to understand the entire, developing process of the activity of design. But this does not mean that the machine and industry must be rejected. The only basic contradiction is between the division of labour on the one hand and collaborative effort on the other – a synthetic conception rather than an analytic one. The machine does not rely on one or other of these conceptions any more than the craftsman's tools do. If the creatively gifted person had a factory with all its machines at his disposal, he would be able to create new forms, different from those produced by hand and whose new possibilities cannot be anticipated before the time for them has come.

If it were to lose contact with work and the manner of working of the outside world the Bauhaus could become a haven for eccentrics. The school has a responsibility to train people who clearly perceive the essential nature of the world in which they live and who have the ability to create out of their combined knowledge and imagination typical forms which symbolize that world. Everything therefore depends on the combination of individual

creative activity and the wider practical work of the world! If we reject the outside world entirely then our only escape would be to the Romantic island. I see a danger for our youth in the signs of a wild Romanticism which has grown out of an understandable reaction against the dominant mental attitude – numbers and power – and the fiasco of nation states. Some of those at the Bauhaus pay tribute to a misunderstood Rousseauesque 'Return to Nature'.... It would be consistent if the person who rejects this world in its entirety honestly retreated to an island.... But if he remains in this world, then the forms of his creations will reflect its rhythms all the more clearly as he comes to grips with it....

There is still an enormous gulf between the activity of our Workshops and the present state of industry and the crafts in the outside world. How that gulf will eventually be bridged is the unknown X factor which clearly none of us is able to resolve. Contact with industry and the practical work of the world can only be achieved gradually. I can imagine that the work of our Workshops will gradually lead to the increasing manufacture of prototypes.... Students who have completed their studies at the Bauhaus will, with the skills they have acquired here, be in a position to exert a decisive influence on existing industrial and craft products – if they would only decide to ... work from within. The huge shift from analytic to synthetic kinds of working is occuring in all areas – even industry will adapt to it. There will be a demand for people who have been given the kind of thoroughgoing, comprehensive training we attempt to provide at the Bauhaus, and these people will *release* the real machine from its constraints! The Fine Artist who is tentatively searching for the useless machine is already using the compass of the future to orientate himself. He is not an opponent of the machine...; he wants to conquer its demons....

Gerhard Marcks reply to Gropius's memorandum 16 February 1922

One cannot derive an entire philosophy from the dispute about the machine aesthetic. The existence of the machine cannot be *denied* but it should not be overestimated. Give it its due and no more. Today one obviously travels by rail and uses a typewriter but one would scarcely type a love letter or one to Father Christmas.

If one therefore does not reject the machine aesthetic but acknowledges it, one can go to work without prejudice.

The mechanized form has long since been invented – by engineers who were perhaps also artists: whether one is an artist or not is not a question of one's profession.

... Whoever wants to help the engineers, metal-workers, potters, joiners etc. should become one himself, i.e. he should immerse himself in the object and not in theory.

Otherwise the following will happen:

A painter wanted to have a flower bed made in his garden after one of his own colour compositions, and he not only had the colours in his head he also knew which flowers had these colours. He therefore summoned the gardener: 'Here is my idea – plant it!' But the gardener shook his head: 'Sir, you've put a cactus here beside a bog lily and one requires dry conditions, the other water. Here are fritillaries which bloom in April, here are sunflowers which bloom in October, and between them is cress which doesn't bloom at all in the shade – I can't make the bed like this.' – 'Then you're no gardener!'

Resumé: ... each apprentice has to become what none of us is: Master of Form and Workshop Master in one person.

Kurt Schmidt, 'Form and Colour', c.1924, painted wood relief

Karl-Peter Röhl, 'Composition', 1926, gouache on cardboard

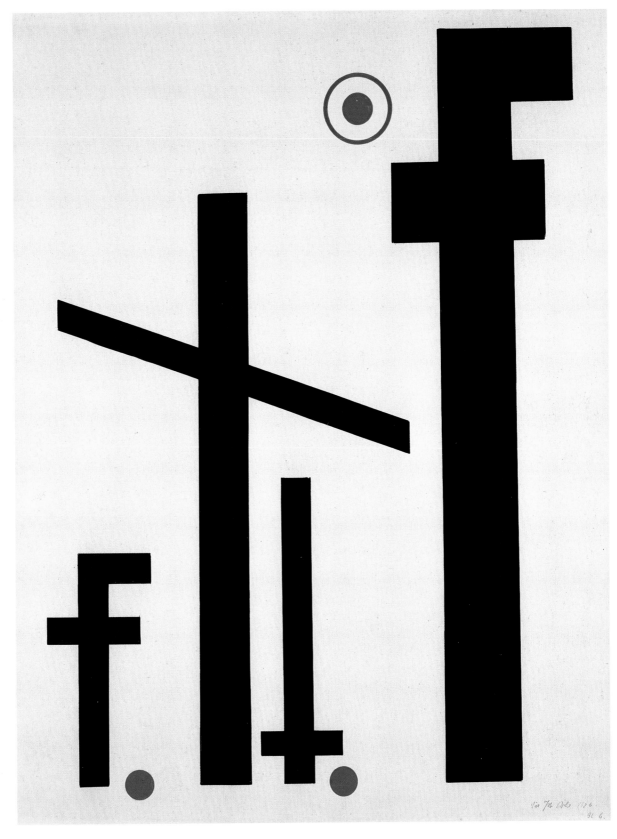

Oskar Schlemmer diary entry November 1922

What do I want? I want to create a style of painting which, free from all aesthetics and fashion, is determined by necessity. This necessity must be different from that demanded by functional objects and machines.

This style is therefore by necessity of an ethical kind. The representation of a style of life 'in order to enhance consciousness of the self.'

I want to achieve this in works which, altogether self-sufficient, naturally contribute to and shape their appropriate environment – especially architecture.

I do not believe in craft. We shall not re-create the crafts of the Middle Ages any more than we shall the art of the medieval period. They have been overtaken by entirely modern developments. Hand-made craft objects in the age of technology and the machine would be products for the rich, and they would lack the broad basis and the popular roots they previously had. Today industry makes the equivalents of traditional craft products, or it will come to make them in a form determined by its whole development: standardized, solid objects of use whose design is true to the materials in which they are made.

The same is true of architecture. The boldness and the innovations derive from technical achievements. A wonderful example: the country house by Frank Lloyd Wright. These developments take their inevitable course from the spirit of objectivity free from all great artistic ambitions.

I do not believe that craft, as practised by us at the Bauhaus, can reach beyond the aesthetic to fulfil deeper social tasks. It is not achieved by 'contacts with industry'. What would be required is a total absorption by industry. That cannot be our task. We would have to turn our backs on the Bauhaus.

Ilya Ehrenburg [Russian writer] 'Letters from Café Deutschland in 1922'

...You musn't think that I've moved so far to the 'right' that I'm now saddened by the successes of 'left-wing' art. No, I'm simply still in love with the kind of art that's been declared dead; and I have a right to my portion of sadness.

In one of the Workshops [of the Bauhaus] I saw a student. With much thought he was laying one trouser button upon another. I asked him what was he doing and he replied 'a construction'. I also saw how 'constructivistic' lamps were made. There are more simple and more 'constructive' lamps in the shops and they are made without the assistance of artists. Not a single constructivist would be prepared to sit on a 'constructivist' chair for longer than five minutes. Nevertheless utilitarianism is the motto.

The painter Braque said that one must control the feelings with the ruler. That's very good. Goethe knew this, too. But those on the left have used the ruler to punish the feelings.

Beauty is a living thing. It's all around us. It's here in this city. It brings the past and present intimately together. Here there's a viaduct – on the road to Jena. Then there's Erfurt Cathedral. Nature itself cries out, so to speak, for art....

And science? The constructivists visit with pride the small old room in which Goethe studied the principles of colour. But it wasn't with them that Faust was written! Something has disappeared from art. With trepidation I write the word that was forbidden for so long: inspiration has disappeared....

Walter Gropius memorandum to the Masters of Form 13 March 1923

It seems to me that the reason for the circumstances in the Workshops and the failure of the students to respond to the indescribably great efforts made on their behalf lies partly in the way the Preliminary Course is run. I have the impression that the aim of the Preliminary Course – to train the individual to work creatively – is, although affirmed by us all, nevertheless inadequate in practice and has produced in many students the opposite of what we should be aiming for. The artistic presumption which we wanted to suppress is more rampant than ever. The free, speculative work of the first half year and the large doses of intellectual fare the students are given are obviously overloading their minds and are leading them – for the most part still too young and not yet independent – into arrogant attitudes and a misunderstanding of whom and what they are. The corrective that would be provided by getting them to work with their hands is almost entirely absent since Workshop training in the nature of materials is left up to each individual and experience has shown that only very few of them work briefly in this Workshop.

The advantage gained from having each newly arrived student immediately confronted by Itten's strong personality so that he came to know himself, was lost because people who were still unable to rely on themselves were left to work far too much on their own. I have the impression that they ought to be more firmly and specifically directed during the early part of the course so that they are occupied all the time they are on the premises and systematically acquire during this first period the fundamentals of a later ability in both craft and drawing. The effect of the system adopted until now has shown that the individual, after completing the Preliminary Course and overburdened with a ferment of ideas and thus with a lack of self discipline, enters a Workshop where a quite different kind of hard, manual work is expected of him for which he is not equipped. The result is that he is perplexed and unable to work with his hands in a simple, continuous and ordered way. Every blow of the hammer is turned into a philosophy, entire airy castles of words are constructed and the work itself never progresses beyond its early stages.

Since we now have several years experience in this field it seems wise to think everything through again in order to remove the weaknesses. . . . In the attached draft of a timetable measures are taken to occupy the Preliminary Course students for the entire day under supervision. It is clear that no *single* Master can be burdened with such work, which must be shared. I believe that it will be advantageous particularly for the newly arrived student if he is immediately faced by severe challenges which he will have to meet in order to be accepted [by a Workshop].

In my plan I propose that we employ all the Preliminary course students productively in the Workshops right from the beginning. I think it entirely possible that from the start the Preliminary Course student should be thus engaged for three mornings a week, that he should assist in the Workshops or produce objects after prototypes made in other Workshops. . . . There is already work in almost all the Workshops to which the Preliminary Course students can contribute. (Stage, Weaving, Metal, etc.) On two further mornings the free study of materials would be continued. On the 6th morning the courses in form and colour would be held. The five mornings of manual work would be best supervised by one of the older students. I suggest Albers for this. He has the training in teaching and the energy needed to organize the work. The new rooms in the Reithaus on the River Ilm are admirably suited for Preliminary Course Workshops and are at present being extended

specifically for this purpose. For the afternoons I propose two sessions of drafting (elements of projection, representative geometry) and two of drawing after nature, rather in the way that Kandinsky has just introduced. One further afternoon for mathematics and physics, for which a teacher has yet to be found, and the 6th afternoon for the analysis of pictures as Itten has taught until now, or for other lectures. The harmonization classes given by Fräulein Grunow will continue on an individual basis. For this the students will be released from Workshop activities.

I request a detailed response to these proposals.

Werner Graef in *Inside the Bauhaus*

... The change in orientation of the Bauhaus was a change in the founder, a recovery by him of his senses. Gropius lost certain illusions. Whereas he wished fundamentally to reform handwork and raise it to a more dignified, higher level, he had to stand by and see his Bauhaus attacked and vilified, not alone by the average citizen, but even in craft circles themselves. Whereas he envisaged the collaboration of all the craft disciplines and arts in building, and though his Sommerfeld House (1921) indeed fulfilled this programme, it remained as a whole completely unconvincing since it fell far behind his famous prewar buildings, the Fagus Works in Alfeld (1911) and the buildings of the Cologne Werkbund Exposition of 1914. In 1922 Gropius found his old, straight road again....

Klee, postcard advertising the 1923 exhibition

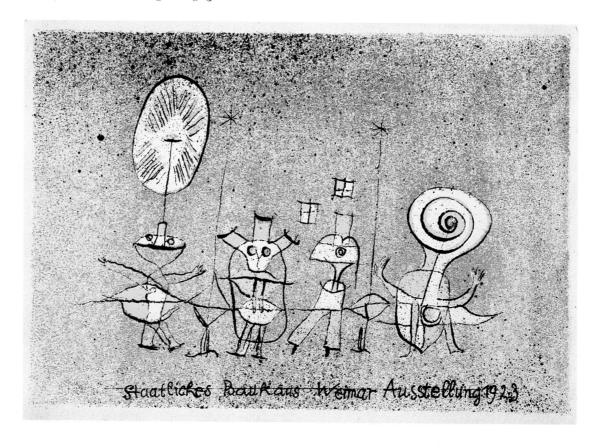

The Bauhaus Week

Walter Gropius memorandum to the Workshops 25 March 1922

...The argument *for* a public exhibition, to which a wider public ought to be invited, is based partly on the financial need of our Journeymen and Apprentices who will only be able to earn properly if we offer our products for sale. In addition, only an exhibition of this kind will make it possible to discover the sort of people who will support the Bauhaus financially and will thus enable further developments to be made.

The argument *against* such an exhibition is the continuing lack of co-operation between the Workshops, the lack of larger works which can make the idea of the Bauhaus clear to the public, and the small number of completed, usable products in some of the Workshops....

Gerhard Marcks memorandum to the Council of Masters

Dornburg, 22 September 1922

...The Bauhaus Week has begun! Posters on all railway buffet cars! The President is coming to the opening. The hotels are packed with foreigners. 1,000 flats had to be evacuated to make way for the art writers. In every square the Bauhaus Internationale is played. The only thing to smoke is Bauhaus brand. Huge hard currency speculation is shaking the money markets.

And the reason for this? There are a few cupboards full of little bits of cloth and pots in the museum, and all Europe is excited. Poor Europe!

That, with due deference, is my view of the 1923 Bauhaus Week.

Lyonel Feininger to Julia Feininger

5 October 1922

...Two meetings again today and tomorrow. We are forced into a compromise, to come out now with the big exhibition we had been planning. We are all reluctant to agree to such art politics.... The fact is that we have to show to outsiders how we perform (and what we are able to produce) in order to win over the industrialists. It is a question of do or die for the Bauhaus. We have to steer toward profitable tasks and mass production. That goes decidedly against our grain, and we are aware of forestalling the process of evolution. But we won't consider it a sacrifice if it saves the cause.... Gropi appears in a new light. He has a clear perception of these realities; only he is on the side of the purely mechanical approach. Thank God that Kandinsky, Itten and Muche preserve the pedagogic balance very well....

Oskar Schlemmer Manifesto of the 1923 Bauhaus Exhibition, February 1923
(withdrawn immediately after publication, because of the reference to Socialism)

The State Bauhaus, founded after the catastrophe of the war, in the chaos of revolution and at a time when art was explosive and laden with pathos, will first become the rallying-point for those who, believing in the future and storming the gates of Heaven, wish to build the Cathedral of Socialism. The triumphs of industry before the war and the orgy of destruction for which it was responsible during it awakened that impassioned Romanticism which was the heartfelt protest against materialism and the mechanization of art and life.
The misery of the times was also spiritiual anguish. A cult of the unconscious and uninterpretable, a tendency to mysticism and sectarianism sprang out of the search for those most elevated things which, in a world full of doubt and weariness, are in danger of being derprived of their meaning. The storming of the realm of Classical aesthetics heightened the limitless of feeling which found sustenance or justification in the discovery of the East and in the art of negroes, peasants, children and the insane. The origins of artistic creation were sought as boldly as its limits were extended. An expressive fervour, like that of altarpieces, appeared. But again and again it was in paintings that the decisive values took refuge. Outstanding achievements of individual hyperbole, as unfettered as they are unliberated, they must all, apart from the unity of the picture itself, remain in debt to the proclaimed synthesis. Honest craft wallowed in an exotic delight in materials while architecture built Utopia on paper.

The reversal of values, changes in viewpoint, name and concept produce the counter-image, the next belief. Dada, court jester in this kingdom, plays ball with paradoxes and makes the atmosphere free and easy. Americanism transposed to Europe, the new world wedged into the old, death to the past, to moonlight and the soul – thus the present arrives with a conquering gesture. Reason and science, 'the ultimate power of man', are the regents, and the engineer the imperturbable executor of unlimited possibilities. Mathematics, construction and mechanism are the elements, might and money the dictators of the modern phenomena of iron, concrete, glass and electricity. The dynamism of the motionless, the dematerialization of matter, the organization of the inorganic, produce miracles of abstraction. Based on the laws of nature, they are the achievements of the intellect in the conquest of nature, based on the might of capital, they are the work of man against man. The speed and high tension of mercantile forces make expediency and utility the measure of all effectiveness, and calculation takes hold of the transcendental world: art becomes a logarithm. Art, long since deprived of its name, lives a life after death in the monument of the cube and the coloured square. Religion is a precise thought-process and God is dead. Man, confident and perfect, in exactitude surpassed by every doll, puts his trust in the results of the test tubes until even the formula for 'spirit' has been found.... Goethe: 'If the hope is fulfilled that men, with all their strengths, with all their hearts and minds, with understanding and love, are united and man takes notice of man, then what no man can yet conceive will come to pass – Allah will need to create no more, we shall create his world.' This is the synthesis, the condensation, the enhancement and concentration of everything positive into a powerful mean. The idea of the mean, far from imperfection and weakness, understood rather as scale and balance, will become the guiding idea of German art. Germany, land of the centre, and Weimar at its heart is not for the first time the place of spiritual decision. The important thing is to recognize what we need if we are not to lose

ourselves aimlessly. In the reconciliation of polar opposites; as in love with the most distant past as with the most distant future; turned away from reaction as from anarchism; from selfish aims, single-me marching towards the typical, from the problematic towards the valid and secure – so we shall become the bearers of responsibility and the conscience of the world. An idealism of activity embraces, penetrates and unites art and science and technology and influences research, teaching and production, it will build the artistic house of mankind which is but a symbol of the cosmic system. Today we can do no more than ponder the plan of the whole, prepare the ground and get the building bricks ready. But *We are! We have the will! And we are creating!*

Lyonel Feininger to Julia Feininger

28 July 1923

...'Art and Technology, a New Unity' is the slogan on our Bauhaus poster at the railroad station. Oh dear, will there really be no more in art than the technology necessary to become profitable from now on? Since times are bad, art has to give in, and authority is granted it by associating with usable things – a hateful conception. But I may say, God bless us, we are not at that point yet....

Opening of the Bauhaus Week, 1923. Among the crowd listening to a speech in the entrance hall of the Workshop Wing are (centre, with spectacles) the government art adviser, Dr Edwin Redslob (2) and, (to his right), Kandinsky (1)

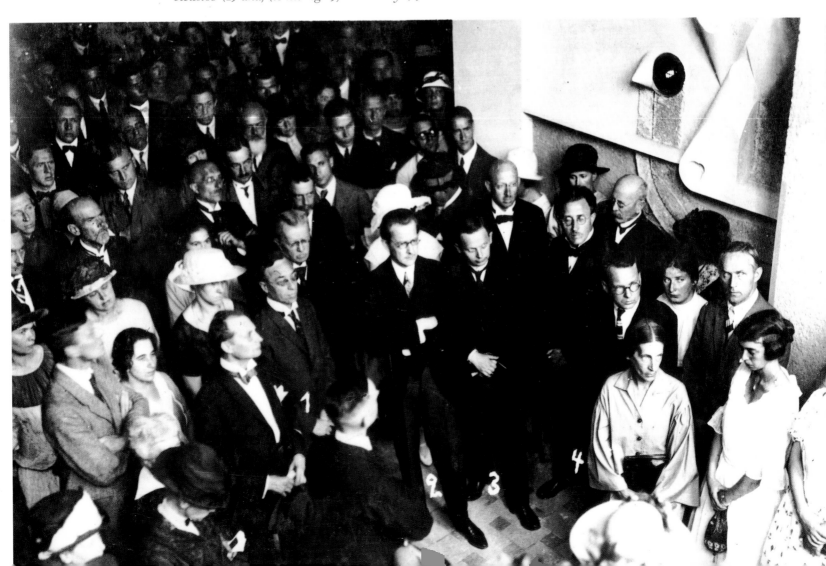

Fly-sheet with map advertising the 1923 exhibition. The text
includes information about the 'theoretical work', Workshop
products, prototypes for industrial mass-production exhibited
(and for sale) in the main Bauhaus buildings, the Haus am Horn
(house and contents for sale), and paintings and sculpture by the
Masters and students in the Weimar museum. Daily guided tours
are announced. The diagrammatic map, accompanied by an abridged
train timetable, shows Weimar's position relative to major cities

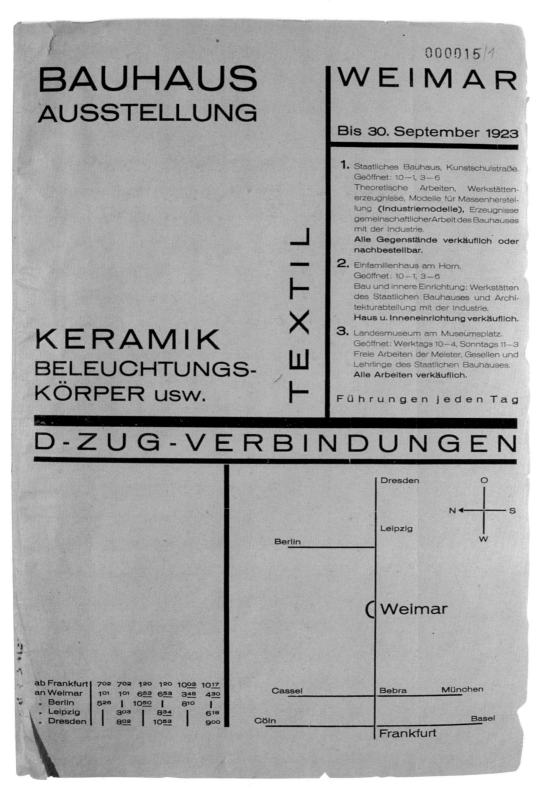

Sigfried Giedion 'The Bauhaus Week in Weimar, August 1923'

... I no longer know how I heard about it, but I had to go there. So I took the night train from Munich to Weimar. I had a glimpse of a world that was being reborn. An indelible impression of that demonstration remains with everyone who took part in it for the rest of his life – at least it's been so with me.

For the first time one had a total view of the universe of the art of today. In the Weimar theatre Hermann Scherchen conducted one of the first performances of Stravinsky's *Soldier's Tale.* In the Jena theatre, which Gropius had just renovated and transformed, we saw Schlemmer's *Triadic Ballet.* In addition an attempt was made to realize an entirely abstract conception: a red and a blue square glided past each other in front of a black background.... This was a ballet by Kandinsky....

(left) Feininger, postcard for 1923 *exhibition.*
(right) Kandinsky, postcard for 1923 *exhibition*

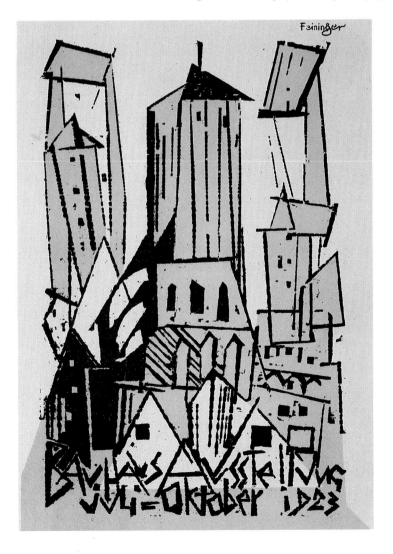
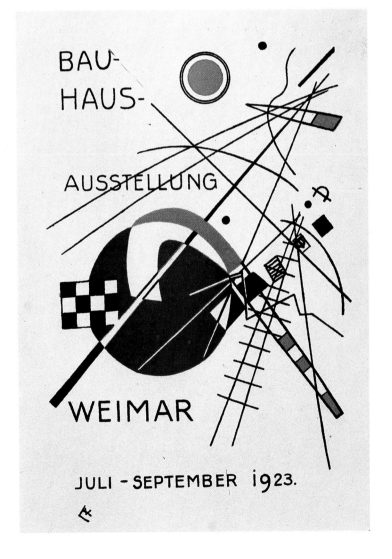

Herbert Bayer, cover for 'State Bauhaus Weimar, 1919–1923'

Oskar Schlemmer diary entry November 1922

The decoration of the Bauhaus vestibule for the planned exhibition will provide an excellent example of the Bauhaus theory of architecture. The new structure will have to be simple, allowing little latitude for the painter as a muralist and even less for the sculptor.
And that also explains why the Wall-Painting and Sculpture Workshops at the Bauhaus are problematical; their scope remains limited, for the Temple of the Future, the Cathedral of Democracy, the Edifice of Socialism will be some time in coming.

For the present we have our simple building and must take the representative where we find it. The vestibule cries out for creative shaping. It could become the trademark of the Bauhaus; within the space created by van de Velde we shall combine wall painting with sculpture, displaying them in a context which normally seldom presents itself. But we must show them in this context if we ever hope to receive jobs of this worth, and even better ones.

(left) Herbert Bayer, postcard for 1923 exhibition.
(right) Moholy-Nagy, postcard for 1923 exhibition

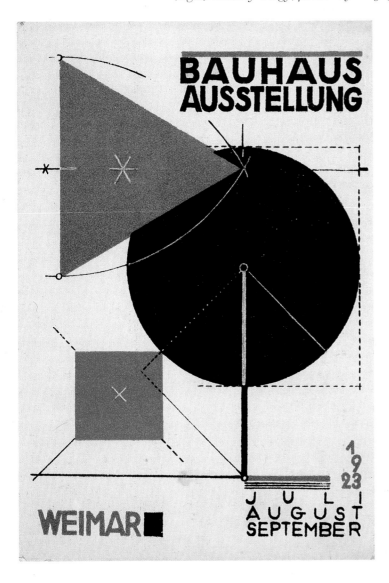

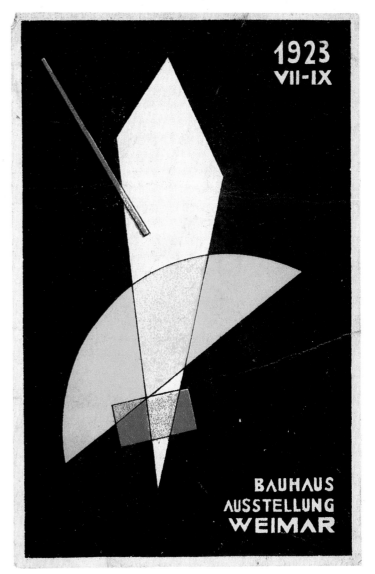

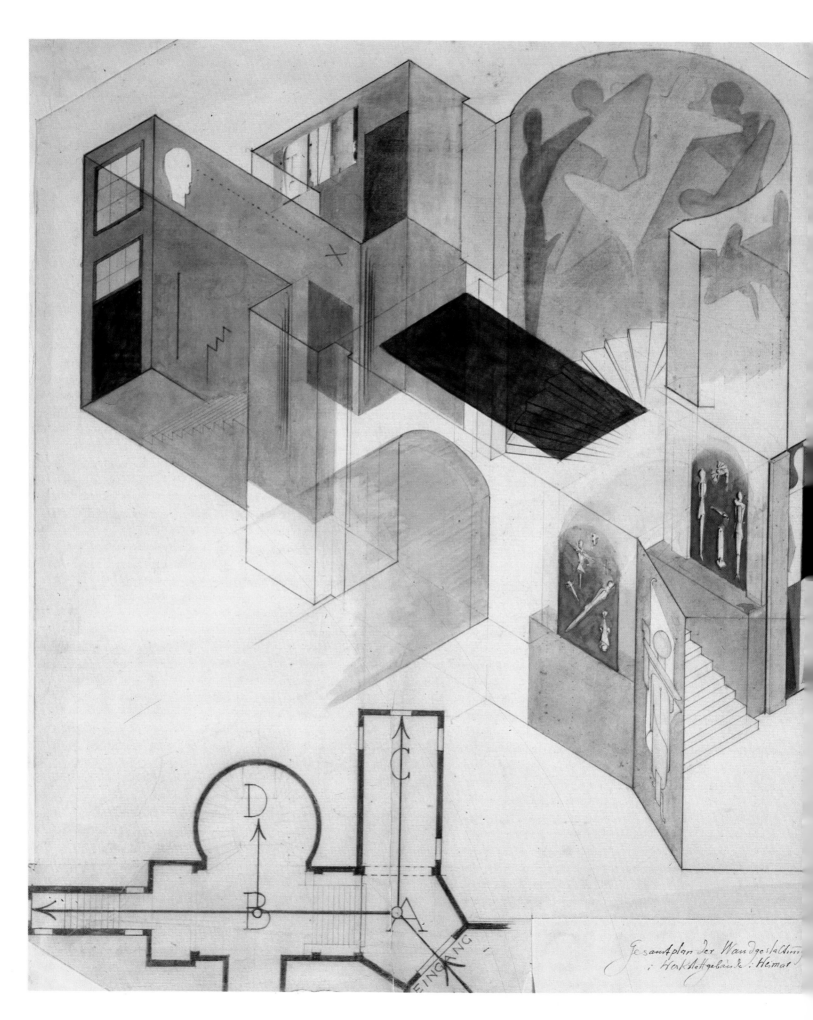

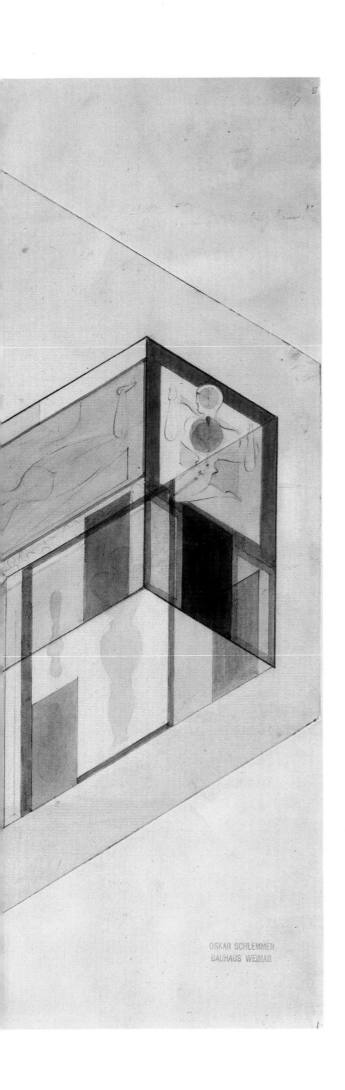

OSKAR SCHLEMMER
BAUHAUS WEIMAR

Schlemmer, design for decoration of Bauhaus vestibule in the Workshop Wing. It includes a mural by Schlemmer and relief sculptures by Schlemmer and Joost Schmidt. The intention was to give the original interiors, designed by van de Velde, an appearance more in keeping with the spirit of the Bauhaus. The decorations remained for several years after the Bauhaus left Weimar, but in 1930 the Nazi director of the school which had followed the Bauhaus into the building had the murals and sculptures destroyed. They have since been partly restored

Ludwig Mies van der Rohe on Gropius's office, redesigned for the 1923 Exhibition

... We were rather disappointed and we said, 'That is so strange, it is all so decorative, like the *Wiener Werkstätten* (Vienna Workshops)'. We were thinking especially of Gropius's writing desk [Mies may have meant his magazine rack]. He had a meander band on both ends, not inlaid but built of solid wood – not a decoration, the whole thing was a piece of decoration. Then he had a lighting contraption with a few wires, etc. – light tubes. In any case we decided that if one doesn't watch out, the thing will go in the wrong direction....

(below) Three reconstructions of Herbert Bayer's murals on the landings of the two upper floors and on the ground floor of the Workshop Wing.
(far right) The director's office with furniture and decorations designed and made by the Workshops, including a magazine rack by Gropius and a lighting fixture by Moholy-Nagy

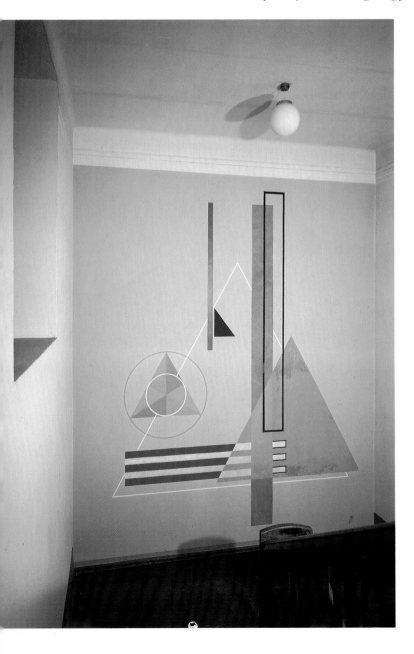
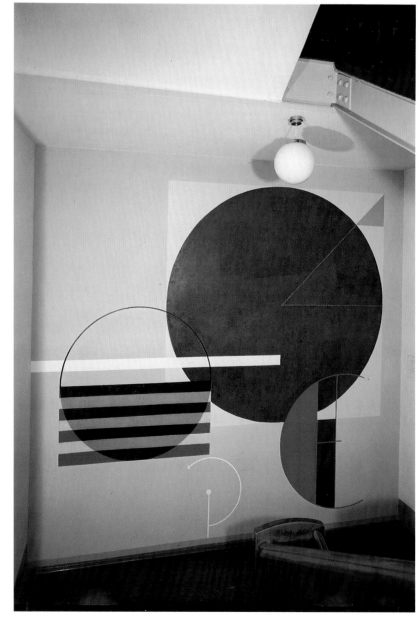

Walter Passarge [critic] 'The Bauhaus Exhibition in Weimar' in *Das Kunstblatt* 1923

... The spirit of architecture hovers over the exhibition. Its actual heart is the exhibition of international architecture, while the exhibition of fine art in the *Landesmuseum* is only marginal. ...

Special emphasis is placed on the design and decoration of interiors. Here the most significant achievement is the decoration of the entrance hall and stairwell of the Workshop building by Oskar Schlemmer. ... The abstract relief by Joost Schmidt in the entrance hall is an attempt to achieve sculptural values through complex stereometric forms. Finally the beautiful, alas, uncompleted office by W. Gropius must be mentioned. The attempts to arrive at a new form of lighting element are remarkable.

Among the products of the Workshops there are some very beautiful woven fabrics, examples of ceramics and metal work. ... The Cabinetmaking Workshop has also made some good pieces. Only small, brightly coloured examples of stained glass are displayed. ...
The Wall-Painting Workshop is showing interesting experiments with new techniques. ...

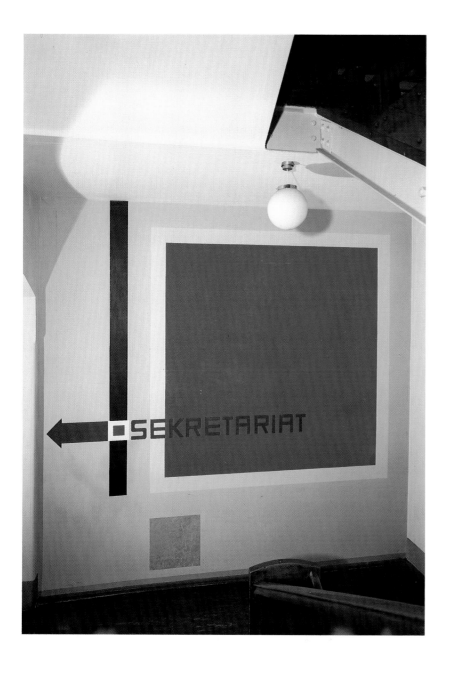

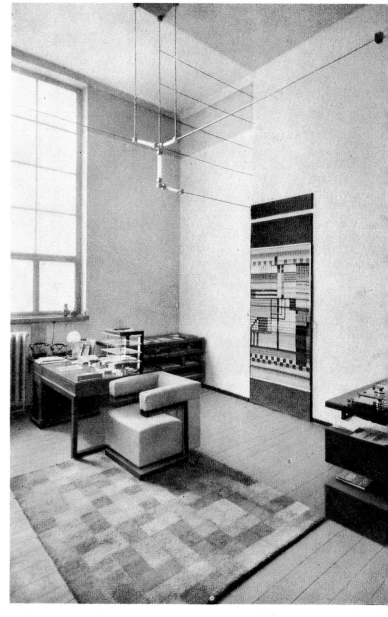

Augusta de Wit [critic] review of the Bauhaus exhibition, in *Nieuwe Rotterdamsche Courant* 27 August 1923

...[There was] a concert, at which Busoni, appearing for the first time after a long illness, was present at the performance of six of his pieces [six piano compositions]. Egon Petri from Berlin executed them for the first time; and on the same occasion occurred the first performance of Hindemith's *Marienlieder*, sung by Beatrice Lauer-Kottler from Frankfurt....

The close of it [the Bauhaus Week] was the lantern parade, Sunday evening, starting at the Bauhaus and skirting the edge of the park, Goethe's beautiful creation, until it reached the Armbrust [hall] in the Schützengasse in the heart of the old town. The lanterns, fantastic in form and colour, had recently been used by the Bauhaus youth to pay homage to Johannes Schlaf – the poet could be seen marching happily in the midst of his admirers.

Finally, at the end, a coloured screen play was performed [the reflected-light plays of Ludwig Hirschfeld-Mack]. Colours which moved in accord with a fuguelike, flowing music and which kept changing....

Ludwig Hirschfeld-Mack, postcard for the 1923 exhibition

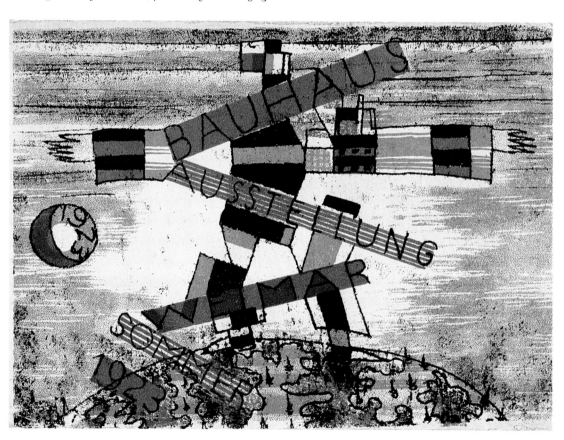

The Haus am Horn

The Masters and Students of the Weimar Bauhaus to Henry Ford, William Randolph Hearst and others 25 January 1923, translated by Lyonel Feininger [errors in the original]

...The '*Staatliches Bauhaus*' now has reached the decisive stage, where it devolves upon its organization to demonstrate publically the progress made during the 3 years of its activities towards bringing about the fusion of the artist with the technician and artizan.

Besides the individual products of the Workshops of the 'Bauhaus' (Carpentering, Furniture, Stone- and Wood-sculpturing, Gold- Silver- and Coppersmithy, Decorative Painting, Stained Glass, Art Printing, Products of the Weaving-looms, Potteries, and an Exhibition of Painting and Designs) it is planned to build and furnish completely *a new type of Dwelling-House*, the outcome of the united efforts of *Artist, Technician*, and *Merchant*, in which the First has striven after the best *Form*, the Second after the most adequate *Constructive Methods*, and the Merchant, after Economy and fitness.

The influence of this Exhibition will be widespreading; especially the new House Type, to be built on the situation reserved by the State for the Bauhaus Colony in a very beautiful elevated locality in Weimar, adjoining the Park, will open up quite new possibilities for cojoint effort of the architect, artist and technician....

Germany, in its present dire condition, cannot bring forth the means for the development of Projects, the importance and rentibility of which can only be realized in the Future.

We shall need in *standard* currency, the comparatively very modest sum of $3000 (Three Thousand Dollars) or from 12.000–13.000 *Gold Marks* (which sum today varies between 30,000–60,000 Marks in paper currency), for the building and furnishing of this model house.

We make our appeal to yourself, who have the priviledge of living in the Land whose population is to-day in the act of taking the reins of the Leadership of the White Race into its grasp; your name has the proud distinction of standing high on the list of America's chief representatives....

Paul Westheim on the Bauhaus exhibition in the Berlin magazine *Das Kunstblatt* 1923

...Three days in Weimar and one can never look at a square again for the rest of one's life. Malevich invented the square way back in 1913. How lucky he didn't have his invention patented. The ultimate of Bauhaus ideals: the individual square. Talent is a square, genius an absolute square. The *De Stijl* people have put on a protest exhibition in Jena – they claim to possess the only true squares.... By the way, in the kitchen [of the Haus am Horn] I missed a Cubist idol – the Maggi stock cube....

Dr Edwin Redslob [government art adviser] on the experimental house

... There is evidence that a type of design is developing which organically unites several small rooms around a large one, thus bringing about a complete change in form as well as in manner of living. Of all the plans I have seen, none appears to me so apt to clarify and solve the problem as the one submitted by the Bauhaus. The plight in which we find ourselves as a nation necessitates our being the first of all nations to solve the new problem of building. These plans clearly go far towards blazing a new trail....

Interiors of the Haus am Horn. (left) The lady's bedroom. (right) The kitchen. All furniture and fittings were designed and made in the Workshops

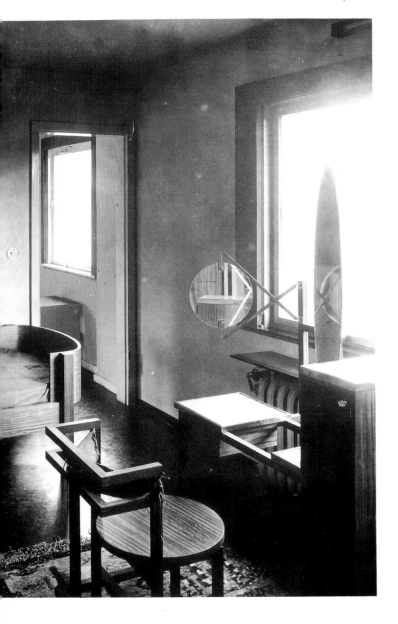 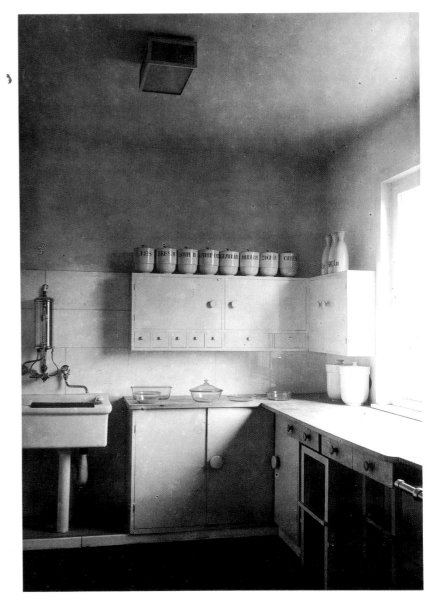

Josef Albers 'Haus am Horn' in *Neue Frauenkleidung und Frauenkultur* 1924

... For last year's Bauhaus exhibition an experimental model house for a single family was built and completely furnished for the first time as a joint [Bauhaus] project.

A large central living room is surrounded by a number of very small rooms in such a way that their functional relationship, their practical design and the distribution of furniture within them take up the least possible space and do not make them seem claustrophobic. Moreover, one woman can easily keep them in order and keep them clean. There are no corridors. The single staircase leads to the cellar. From the entrance in a recessed porch one goes through the vestibule with its cloak facilities directly into the living room. To the left is the kitchen, to the right the guest bedroom. Off the kitchen is the dining room, and off that the children's room which leads to the lady's bedroom. Off this is the bathroom which leads to the master bedroom. An extension of the living room offers a view of the outside. In addition to that, the living room has raised windows along two sides. There is nothing here which makes work and interferes with an impression of clarity: there are no sectional sofas or bedside tables, no sideboards or buffets, no cabinets, chandeliers, ball feet, mouldings, profile boards, cornices, ornaments, patterns, curtains, blinds or knick-knacks. All the doors are competely smooth, the furniture is as far as possible also smooth, the cupboards are mostly built-in, each of the windows consists of a single pane of glass and can be covered by built-in shutters, the window ledges and the shelves above the radiators are of glass and the walls of the bath are of white glass. The floor covering is linoleum or rubber. Everything can be kept in the highest state of cleanliness with the least amount of work. There is no decoration. Beauty, an essential part of good living, has not been banished because of this, however. It has been achieved at no extra cost by means of good proportions, quiet colour schemes and materials selected to relate to each other. The walls are 25 cm. thick, and their special insulating properties provide ... as much protection against cold and heat as a brick wall 75 cm. thick. This and an efficient central heating system result in an annual saving of 82 cwts. of coke by comparison with conventional heating by stove....

The kitchen was conceived exclusively as a space for cooking, not for sitting and eating. It has therefore been kept as small as possible. It is especially easy to keep clean because of the light colour of the walls, the white gloss paint, the white sink, the mirrored shelf and the wall cladding which is partly of white glass, because all metal parts are nickel plated and the window is a single pane of glass. The table stands in the centre of the long wall. It is at the point of greatest light directly in front of the window which, fixed on a horizontal central axis, does not interfere with the table even when open. The table, which has drawers but not legs, is a board fixed to the wall. At the same height and without spaces between them are the cooker and glass working top, the cupboards and the sink. When standing at the table, the housewife has everything close at hand. At arm's length she can reach the cupboards at her left, the cupboard containing crockery fixed to the wall above it, and the containers for provisions standing on top. At her right is the cooker, and two steps away are the sink and the water heater above it. A closet for brooms and buckets is built-in on the opposite side next to the larder. The sink and cupboard are supported on a low stone base so as to make cleaning easy. The chairs can be put away under the table. The kitchen saves space, time and energy because hygiene and ergonomics determined its form.

The dining room demonstrates how a built-in cupboard (instead of 'buffet' and 'sideboard') and a smooth door without any kind of ornament make a room seem quiet and its cleaning more simple....

After earlier generations, who lacked any style of their own, turned the collecting of antiques into an elevated kind of sport, it is time to discover *our own* style in order to *walk* on our own two feet and to *speak* in *our own* language. Just as it is wrong to write in runes and to speak old German (both were beautiful), so it is impossible for us to wear exaggeratedly pointed shoes or crinolines. Today's developments in science and technology have brought many surprises. Their practical application must have a similar effect. We know that the railways and the bicycle, that Rembrandt and Hölderlin were not accepted at first. We are therefore not surprised if today, in what is historically a particularly difficult period, the law of inertia and habit make it very difficult to assimilate designs appropriate to the age. Nevertheless, particularly a Europe improverished by the war will be forced for financial reasons to accept economical designs....

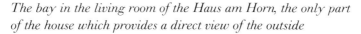

The bay in the living room of the Haus am Horn, the only part of the house which provides a direct view of the outside

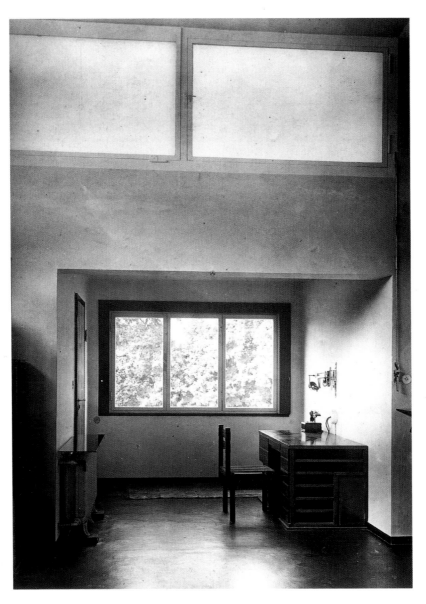

Adolf Behne [art and architecture critic, founder member of the *Arbeitstrat für Kunst*] on the Haus am Horn in 'Das Bauhaus in Weimar' in *Die Weltbühne* 20 September 1923

... The dwelling house is bound up with the question of domestic servants and education and with economic and social problems. Should it leap ahead of its time by seeking 'the' solution – or should it take account of its time and the lack of building materials and personnel? The Haus am Horn stands in the midst of all these difficulties somewhat uninterestedly and unwittingly; ... half an ideal proposal, half the product of its time, ... half model and half idyll – but at no point pure and convincing, it is once again a matter of aesthetics and paper solutions. ...

The Haus am Horn as it is today. The entrance porch is a later addition

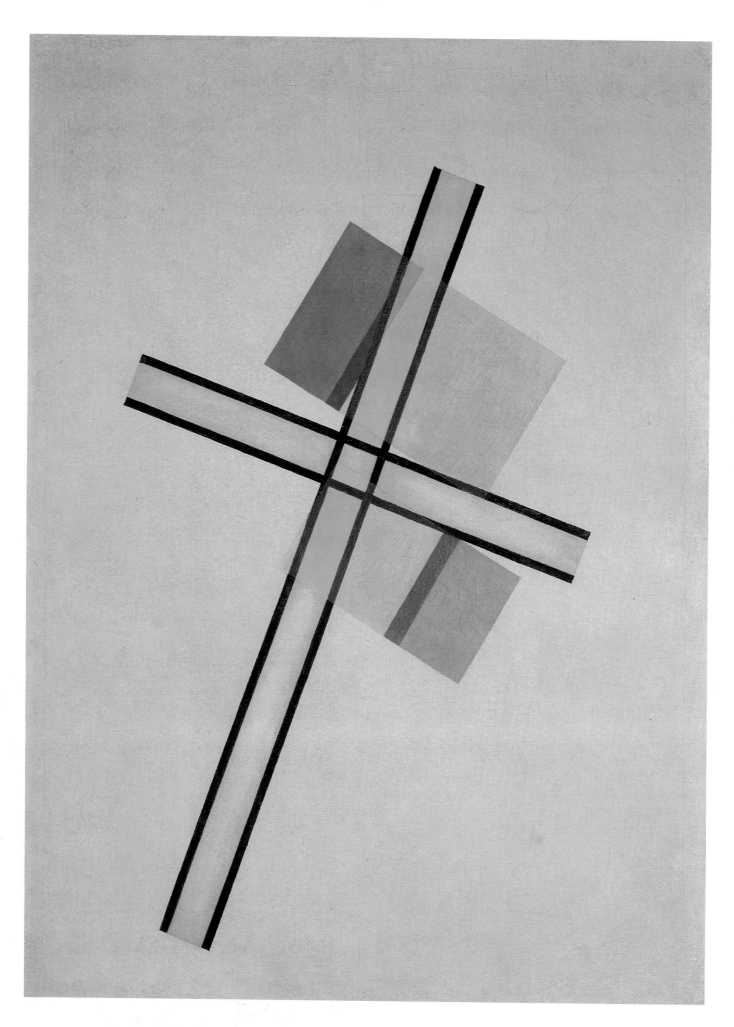

Moholy-Nagy

László Moholy-Nagy diary entry 15 May 1919

During the war I became conscious of my responsibility to society and I am now even more conscious of it. My conscience never stops asking: Is it right to become a painter at times of social upheaval? Can I assume the privilege of art for myself when every person is needed to solve the problems of basic survival? During the last hundred years art and reality had nothing in common. The personal satisfaction of making art has contributed nothing to the happiness of the masses.

Moholy-Nagy, 'Yellow Cross', 1922, oil on canvas

Moholy-Nagy in 1922

László Moholy-Nagy and Ludwig Kassak *Buch Neuer Künstler* 1922

... This is the hour to weigh the past heroes of destruction against the fanatics of construction. There has never been an epoch comparable to ours in which legions of awakened men set out in so many different directions in search of new form – in which so many men burn with a fanatical flame from which bursts the cry of a new birth: an epoch which creates simultaneously the fury of despair and the flaming pillar of positive fight....

László Moholy-Nagy 'Constructivism and the Proletariat' May 1922

... And this reality of our century is technology: the invention, construction and maintenance of machines. To be a user of machines is to be of the spirit of this century. It has replaced the transcendental spiritualism of past eras.

Everyone is equal before the machine. I can use it, so can you. It can crush me; the same can happen to you. There is no tradition in technology, no class consciousness. Everybody can be the machine's master, or its slave....

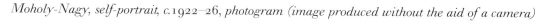

Moholy-Nagy, self-portrait, c.1922–26, photogram (image produced without the aid of a camera)

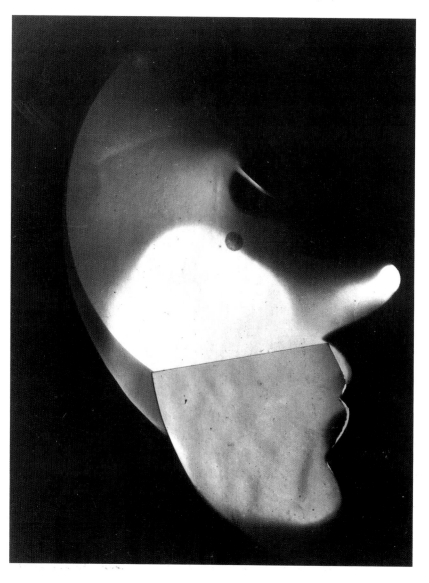

Lucia Moholy [first wife of László Moholy-Nagy] on the 'telephone paintings', 1972

. . . Having embraced Constructivism as his artistic creed, he was anxious to find out in what way the effects of colour were dependent on the size of a painting. He thought the best way to solve the problem was by studying, side by side, several paintings of different sizes, but of identical colours and composition. Taking the view that industrial methods might be employed to serve artistic needs, he made enquiries in the appropriate quarters and soon found an enamel factory willing to produce the panels he wanted.

When the panels, carried out in an enamel technique on a metal base, among them three different sizes of identical colours and composition, were finally delivered, Moholy-Nagy was satisfied, more than satisfied: he was enthusiastic. His wishes had been complied with, his ideas had taken on tangible form, his self-assurance had received a new uplift. His buoyancy exceeded all bounds. I had not seen him in a comparably exalted state for a long time. It did not surprise me, therefore, when, overcome by emotion, he exlaimed – I distinctly remember the timbre of his voice on this occasion – 'I might even have done it over the telephone!' . . .

Moholy-Nagy, double portrait (László & Lucia), c.1923,
photogram of the artist and his wife

László Moholy-Nagy to Alexander Rodchenko

<div align="right">

Weimar, 18 December 1923

</div>

Dear and esteemed comrade Rodchenko, we are planning to publish a series of brochures which will deal with current issues of today.

The relatively ephemeral format of the brochure permits us to have a lively and eventful programme that would cover every creative field; besides this it will give us a chance to have various specialists to tackle each individual problem, in a manner that would make it possible to generate smaller discussions.

I thought the first publication would be a discussion of 'Constructivism'. Although the term here, in Germany, has become very well known in recent times, very few people have a clear idea of its meaning. Therefore we would be very happy if you could explain your own or perhaps the Russian interpretation in general pertaining to this question, in a short article.

We sorely miss the co-operation of our Russian comrades (those who are living in Russia), and we are not quite sure that statements made and positions taken up by Lissitzky and Gabo, who are known here, are representative of the opinion of all the Russian artists.

For this very reason we would like it if your opinion would not be limited to just the problem of Constructivism, but if you could select some particular problems for discussion and definition from the tentative programme here attached.

It would bring us extremely close to our goal – which is to give a summary of all that is contemporary – if you could ask other estimable comrades to co-operate with us and could stimulate them to write articles.

Thus we could hope to have some comprehensive and cohesive picture from Russia, instead of occasional news and individual incursions. We would like to have the articles in German and look forward to receiving your quick answer.

With cordial greetings, Your
László Moholy-Nagy

A tentative programme for a series of brochures

1. Discussion: Constructivism.
2. The new life-construction.
3. On new creation (specific issues).
4. On new creation (in general).
5. Photography;
Film, new film-scripts.
6. New advertising (typography and film too).
7. New issues of education.
8. Constructive biology.
Prospects of the development towards a new medical science (natural and institutional healing).

9. Review of currently published periodicals;

Suggestions for a new correct periodical.

10. A survey of our age (1908–1923).

11. Specific political issues.

12. Specific economic issues.

13. Specific scientific issues.

14. Specific technical issues.

15. Specific issues of art.

16. Organization (as one of the most important issues).

17. Art and propaganda.

18. Architecture and painting.

19. America and Europe.

Americanism and Europeanism; American problems.

20. The relationship between continents;

Constructive geography.

21. The Far and Near East (treasure-house of the world).

22. Music. Mechanical speech and game-machines;

Electric shows;

Synthesis of sound, light, form, movement and scents;

Theatre, circus.

23. Architecture (city, private, ship etc., construction).

24. Problems of glass and other materials as pertaining to new physics and chemistry.

25. The workshop work of the arts: painting

 : construction with various materials.

26. The literature of individual languages: Russian.

 peoples: German.

 Hungarian.

 French.

 American, etc.

World language;

Constructive philogy (Jespersen, Scheffels).

27. Religion, philosophy, metaphysics.

28. The origins of modern creative movements:

in Italy.

in France.

in Russia.

in the Netherlands, etc.

29. New inventions (of practical functions).

30. Utopia.

Naturally we are expecting suggestions and writings from all those who are standing on the principles of *today*.

Moholy-Nagy, 'Light-Space Modulator', 1922–30, reconstruction. Consisting of moving metal and perspex parts and driven by electricity, this kinetic sculpture (which owes much in form and conception to Russian Constructivism) was designed to reflect constantly changing patterns of light on surrounding walls

(right) Preliminary Course students with Moholy-Nagy (wearing spectacles, back row, fourth from right), 1924–25. The students cannot be identified

Paul Citroën on the arrival of Moholy-Nagy 1946

... None of us who had suggested Moholy, liked his Constructivism. This 'Russian' trend, created outside the Bauhaus, with its exact, simulatively technical forms was disgusting to us who were devoted to the extremes of German Expressionism. But since Constructivism was the newest of the new, it was – so we figured – the cleverest move to overcome our aversion and, by supporting Gropius's choice of one of its creators, incorporate this 'newest' into the Bauhaus system.

We were conscious of the danger of drawing into the inner circle the representative of an art form we basically negated. But it was only an experiment, something easily to be undone since Moholy was very young and most probably inexperienced. So Moholy came to Weimar as the 'champion of youth' as we labelled him in contrast to the 'old' faculty members Kandinsky, Feininger and Klee who were between forty and fifty-five....

Paul Citroën on Moholy-Nagy 1946

... Like a strong eager dog, Moholy burst into the Bauhaus circle, ferreting out with unfailing scent the still unsolved, still tradition-bound problems in order to attack them. The most conspicuous difference between him and the older teachers was a lack of the typically German dignity and remoteness prevalent among the older 'Masters' as all Bauhaus teachers were called. He never asked what was the impression he made, or whether what he had to suggest would affect anyone's ego. He knew neither toga nor cothurnus in his relationship to students, and when first he was often mistaken for a student, he was delighted.

We who had been already several years at the Bauhaus were often sceptical of so much innovation, aware of intrigues, jealousies, personal advantages; and we certainly never did any work if there was the slightest danger than anyone else might get credit for it. Moholy was totally uninfluenced by these modifications of our enthusiasm. There never lived anyone more devoted to an objective cause. His high opinion of the importance of the Bauhaus remained unimpaired, and he devoted himself to it with such fervor that we started to discuss his possible collapse. But as a newcomer he got no credit. Many of us used him for our own advantage and burdened him with tasks we ourselves should have solved.
But, with the smiling enthusiasm of a child, Moholy accepted all demands, and his vitality seemed unlimited....

Lyonel Feininger to Julia Feininger

9 March 1925

... Our aims are becoming more and more clear and have been expressed very precisely in an article by Moholy. They go against my grain in every respect, distress me terribly. What has been 'art' for ages is to be discarded – to be replaced by new ideals. There is talk only about optics, mechanics and moving pictures. Coloured diapositives, mechanically produced, stored like gramophone records and placed into viewers, are the art mankind is to have from now on, within reach at every moment, usable according to mood. Co-operation is no longer requested from the onlooker, no call upon the mind to take in what an artist has tried to express – this Moholy calls 'static', not fitting into our fast-moving time. It certainly is a very interesting project, a gadget for the masses, but why call a device like this by the name of art? It is frightening.... Would this create an atmosphere for Klee or myself or some others to grow in? Klee was very depressed yesterday when we talked about Moholy. He called it the 'prefabricated spirit of the time'....

Moholy-Nagy to Lothar Schreyer in Lothar Schreyer, Memories of *Der Sturm* and the Bauhaus, 1966

... Do you really still believe in the old story about man's soul? What people call the soul is nothing more than a bodily function....

The Preliminary Course under Moholy-Nagy

László Moholy-Nagy 'From the Material to Architecture' 1928

... From his biological being every man derives energies which he can develop into creative work. *Everyone is talented.* Every human being is open to sense impressions, to tone, colour, touch, space, experience, etc. The structure of life is predetermined by these sensibilities. One has to live 'right' to retain the alertness of these native abilities.

But only art – creation through the senses – can develop these dormant, native faculties toward creative action. Art is the whetstone of the senses, the co-ordinating psycho-biological factor. The teacher who has come to a full realization of the organic senses and the harmonious sense of the rhythm of life should have a tongue of fire to expound his happiness. ...

Timetable of the Preliminary Course under Moholy-Nagy and Albers, summer 1924. Most of the mornings were devoted to theoretical studies given by Moholy and practical exercises given by Albers. Klee taught the theory of form for an hour on Tuesday, Kandinsky the theory of colour on Friday.

The afternoons began with technical drawing taught by Gropius and others and continued on different days with lectures on mathematics and physics, drawing taught by Klee and Kandinsky and, in the evening, life drawing. Albers's and Moholy's classes were open to all students

STUNDENPLAN FÜR VORLEHRE

VORMITTAG

	MONTAG	DIENSTAG	MITTWOCH	DONNERSTAG	FREITAG	SAMSTAG
8-9						
9-10	GESTALTUNGS STUDIEN MOHOLY REITHAUS		WERKARBEIT ALBERS REITHAUS			GESTALTUNGS STUDIEN MOHOLY REITHAUS
10-11						
11-12						
12-1		GESTALTUNGSLEHRE FORM. KLEE. AKTSAAL			GESTALTUNGSLEHRE FARBE. KANDINSKY	

	MONTAG	DIENSTAG	MITTWOCH	DONNERSTAG	FREITAG	SAMSTAG
2-3			WERKZEICHNEN GROPIUS. LANGE. MEYER RAUM 39			
3-4						
4-5	WISSENSCHAFTL. FÄCHER. MATH. PHYS. AKTSAAL	ZEICHNEN KLEE RAUM 39	Werkzeichnen Raum 39	Baukonstruktionslehre Raum 39	ANALYTHISCH ZEICHNEN – KANDINSKY. R39	
5-6						VERSCHIEDENE VORTRÄGE.
6-7						
7-8		ABENDAKT. KLEE OBLIGATORISCH FÜR VORKURS			ABENDAKT	
8-9						

AN DEN GELB UMRANDETEN UNTERRICHTSSTUNDEN KÖNNEN ALLE GESELLEN UND LEHRLINGE TEILNEHMEN.

László Moholy-Nagy *Vom Material zur Architektur* 1928

... The concepts of mechanics, dynamics, statics and kinetics, the problems of stability, of balance, were examined in terms of three-dimensional forms and the relationship between materials was investigated as were methods of construction and montage.... Today's sculptor knows scarcely anything about the new fields in which the engineer works. Composition, the Golden Section and similar things are certainly taught at the [art] academies, but nothing is said about statics, a knowledge of which could result in an economical working method more than aesthetic rules could.... Yesterday's artist was little concerned with the precise calculation of the weight of his work, for example.... At the Bauhaus students learned to pay attention to these components, too, and the saving of every gram in weight – while the effect remained the same – often represented a small victory for invention....

Fritz Kuhr [student] on his early days at the school: interview in *Bauhaus* 1928

... I arrived in Weimar and was courteously received by Herr Kandinsky. He told me something implausible about abstract painting, lent me his book *Concerning the Spiritual in Art* and then let me go. I wandered along to Moholy and, in the enthusiasm of discussion, said I thought what I saw hanging on his studio wall (a picture by Moholy, but I did not know it was by him then) was stupid rubbish. With great precision Moholy then demonstrated to me (the words 'tensions' and 'repressions' occurred very often in his argument) that I had no right to accuse something I did not understand of being stupid rubbish. That made sense to me. I still had no idea what the point of it was, but I was impressed by the conviction with which Moholy defended abstract painting. At his instigation I then registered for the Preliminary Course.

The Preliminary Course consisted of theory, elementary design and practical work. The theory came from Herr Kandinsky and Herr Klee, the elementary design from Herr Moholy, and the practical work was supervised and influenced by Herr Albers, who did his best to examine and pick to pieces the practical value of my laboriously constructed 'utensils'. And he talked about unrealized possibilities (of which I took no notice).

Together with a girl student I then designed, purely theoretically, an aluminium umbrella (entirely in metal). We wanted to prevent the eventual destruction by rust of the silk. We chose aluminium because of its weight. We abandoned this project because the Preliminary Course Workshop was not equipped for things of that kind. It might have been possible to have an industrial firm take it on had we not come to the conclusion that industry had no interest in solid, durable umbrellas.

Progress in elementary design was very poor. We made sculptures from wood, sawed the wood ourselves, sanded it, stuck it together and then added a piece of glass or metal, but always with the knowledge that we were playing around pointlessly. ...

But then the great, important experience came. I combined the making of my second sculpture with an exercise in balance although I placed the greatest emphasis on aesthetic appeal. With my third sculpture I became aware of the earth's gravity, that is to say, I already knew about the force of gravity but I now experienced it for the first time: with my heart, with my mind, with my every nerve I experienced the earth's gravity.... So I made my fourth sculpture in wood, iron, tin, copper, glass and paper, but the pointless playing around with materials was no longer pointless.

I worked hard on my sculpture; I compared, weighed, polished, bored, painted, dabbed and drew with a seriousness and fervour which only a child can bring to its work. I had never been so free, so relaxed ... in my entire life.... Now it was certain that I would be studying at the Bauhaus for the time being. I had grasped the point of the Bauhaus. Since I am today still a student at the Bauhaus you may take it as proof that for me

the world only has a point if it is a 'Bauhaus'.

'The whole world a Bauhaus!'

Johannes Zabel, study in balance, 1923 (reconstruction), exercise from Moholy-Nagy's Preliminary Course

The Metal Workshop under Moholy-Nagy

László Moholy-Nagy 'From Wine Jugs to Lighting Fixtures' 1938

... When Gropius appointed me to take over the Metal Workshop he asked me to reorganize it as a workshop for industrial design. Until my arrival the Metal Workshop had been a gold and silver Workshop where wine jugs, samovars, elaborate jewelry, coffee services, etc., were made. Changing the policy of this Workshop involved a revolution, for in their pride the gold- and silversmiths avoided the use of ferrous metals, nickel and chromium plating and abhorred the idea of making models for electrical household appliances or lighting fixtures. It took quite a while to get under way the kind of work which later made the Bauhaus a leader in designing for the lighting fixture industry.

I remember the first lighting fixture by K. Jucker, done before 1923, with devices for pushing and pulling, heavy strips and rods of iron and brass, looking more like a dinosaur than a functional object. But even this was a great victory, for it meant a new beginning....

Wilhelm Wagenfeld [student in the Metal Workshop] in *Täglich in der Hand*

. . . Later [Moholy] told me that he had immediately agreed to take on the artistic supervision of the Metal Workshop during his first visit there with Gropius. I want to try to describe why he made this decision in his own words: 'Don't you know, Wagenfeld, wall black with solder, blank glowing metal, bright like sun, gas comes from red tube for fire. So fascinating. I said "yes!"'

In our Metal Workshop there was only an obsolescent machine for grinding and polishing and no other machine tools, only the most essential hand tools for our teachers. Under such conditions we nevertheless made a series of 'Bauhaus lamps' for the Leipzig Trade Fair. I myself was sent to the 'Bauhaus Stand' in the Lighting Hall. Autumn 1924. But we had no success. Dealers and manufacturers made fun of our products. Although they looked cheap, as though machine made, they were actually expensively made by hand. These criticisms were valid, something that I understood only later, actually much later. Looking back, I nevertheless believe that our primitive working methods helped me at least to learn craft skills. . . . If I had been hindered at the start by too many scruples about conceiving my ideas for industrial production, then the Bauhaus lamp of 1924 would certainly have only been a weak, bloodless construction in metal and glass.

In addition, looking back at that time, we should not imagine things in terms of today's industrial potential. Around 1920 factories still made their products largely by hand. Manufacturing methods where the machine had taken over from production by hand were very limited. The manufacture of so-called mass products was still work by hand organized into stages and mechanized. . . .

Otto Rittweger [student in the Metal Workshop] in *Vivos Voco* 1926

. . . We are going into battle against the lighting fitments and hanging lamps which, hung with silken fringes, glass beads and garlands of roses, attempt to transport us in . . . our imaginations to the lands of the Chinese, Japanese or other nations of the world and try to infect us with ideas about 'comfort and mood'! The pompous chandelier, for example, this monstrous dust trap, has to disappear. We must start out not from the light of the tallow candle, not from the light of the oil lamp, but from electric light, the best that we have. The new light thus determines a new form to transmit it. . . .

Wilhelm Wagenfeld in *Junge Menschen* 1924

. . . The table lamp, a prototype for industrial manufacture, achieves the greatest simplicity of form and the most economical use of time and material. A round base plate, a cylindrical tube and a spherical shade are its most important components. . . .

(far left) Marianne Brandt and Hin Bredendieck, 'Kandem' bedside reading lamp, 1928, mass-produced by the Leipzig firm of Körting and Matthiessen.
(left) K.J. Jucker and Wilhelm Wagenfeld, lamp with milk-glass shade, 1923–24

Marianne Brandt from 'Letter to the Young Generation'

... In 1924, when on the advice of Moholy-Nagy, I transferred from the Preliminary Course to the Metal Workshop, they had just begun to produce objects which, though still fully hand-crafted, were capable of being mass-produced. The task was to shape these things in such a way that even if they were to be produced in quantity, making the work easier, they would satisfy all aesthetic and practical criteria and still be far less expensive than any singly produced item....

Gradually, through visits to the industry and inspections and interviews on the spot, we came to our main concern – industrial design. Moholy-Nagy fostered this with stubborn energy. Two lighting firms seemed particularly interested in our aims. Körting and Matthiessen (Kandem) of Leipzig-Leutsch helped us enormously with the practical introduction into the laws of lighting technique and the production methods, which not only

Moholy-Nagy with students in the Metal Workshop, c.1924.
From right to left: Wilhelm Wagenfeld, Marianne Brandt,
Moholy-Nagy and the Workshop Master, Christian Dell.
The others cannot be identified

helped us in designing, but also helped the firms. We also tried to create a functional but aesthetic assembly line, small facilities for the disposal of rubbish and so forth, considerations which in retrospect seem to me no longer requisites for a first class lamp. We went to the trade fair at Leipzig with some student grub as our only food, and returned dead tired but full of new impressions and a thousand plans, our bags stuffed with pamphlets. If we had even dreamed at that time of plexiglass and other plastics, I don't know to what Utopian heights we would have aspired. . . .

Far more difficult than electric lamps was the problem of industrially producing our silverware and other tableware. Not many such things were being produced. So to a certain extent we were branded as a lighting department. We furnished whole buildings with our industrially-produced lamps and only rarely designed and produced special pieces in our Workshop for particular rooms or showrooms. . . .

Marianne Brandt, teapot in brass and ebony with silver-plated interior, 1924.

F. K. Fuchs [journalist] on Marianne Brandt's coffee and tea service in *Deutsche Goldschmiede-Zeitung* 1926

... The convex teapot, as you can instantly see, is a half-sphere standing on four triangular metal elements soldered on to it. It looks unusual, opines the well-mannered aesthete, and it also looks machine made, but why such artiness? He can be answered easily. The machine presses out the half-sphere in a single process. ... So that the whole thing can stand up, supports are soldered on to it. Anything more simple cannot be imagined. Yes, now light dawns. You scratch your head: why didn't I come up with the same idea ages ago? ...

Gradually you understand how fine an instrument a pot like this can be. Even the spout is constructed in such a way that the horrible drip collector becomes superfluous. By way of such technical observations the beauty of this functional object is suddenly revealed. How elegant, how sophisticated, how appealing, yes, how playful 'sober' objectivity can actually be! ...

Marianne Brandt, teapot with internal strainer, 1924, brass,
white tombac and ebony with silver-plated interior

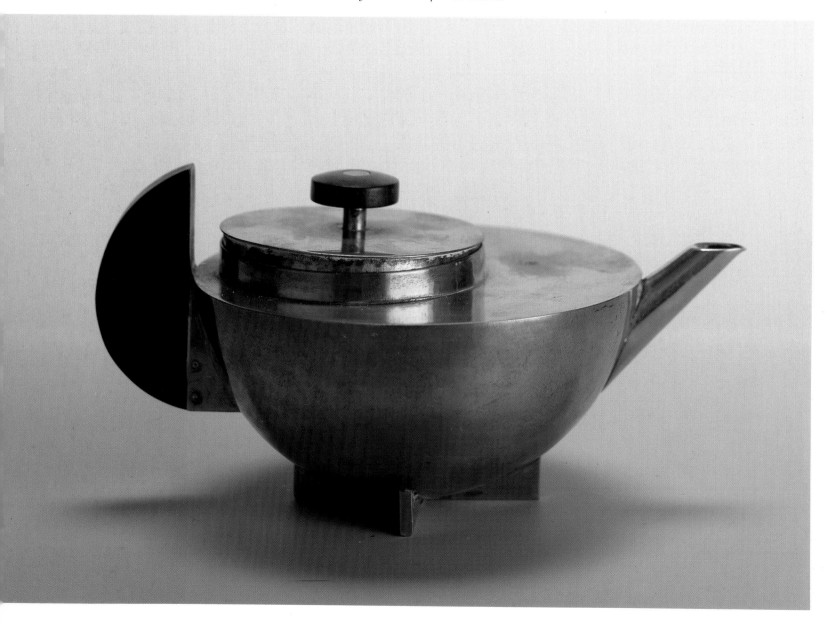

László Moholy-Nagy from 'Vision in Motion' 1928

...The designer... must know that design is indivisible, that the internal and external characteristics of a dish, a chair, a table, a machine, painting, sculpture are not to be separated. The idea of design and the profession of designer have to be transformed from the notion of a specialist function into a generally valid attitude of resourcefulness and inventiveness which allows projects to be seen not in isolation but in relationship with the need of the individual and the community....

Marianne Brandt, ashtray, 1924, bronze and white tombac

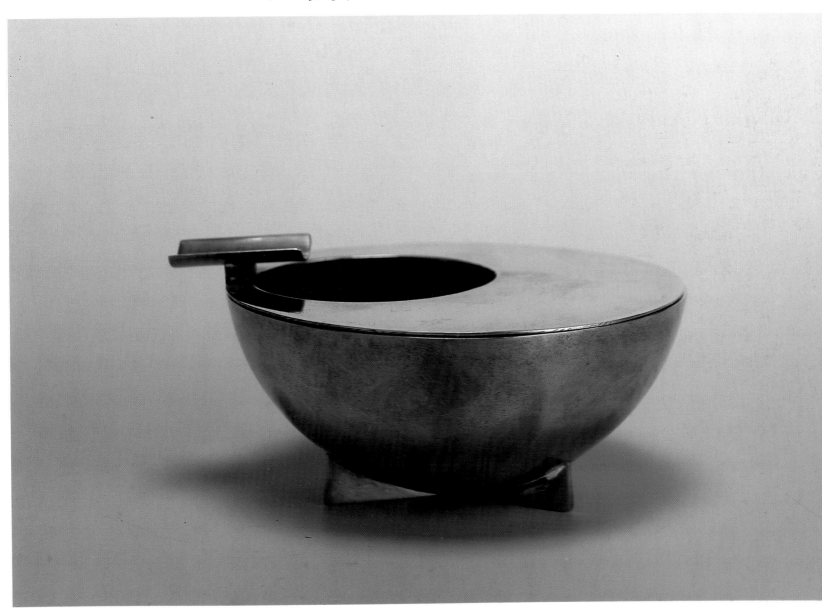

Wilhelm Wagenfeld 'On the Work of the Metal Workshop' in *Junge Menschen* 1924

... Form and function must always attain a clear, unambiguous design in which function has produced the form. The reduction of forms to their most simple elements – the sphere, cylinder, cube and cone – provided a necessary comparison.

The relationship between the various parts of a *service* should not be announced by means of formal similarities. The formal resolution of each object should rather reflect *its* function and thus emphasise its dependence on the other objects. Since the service was made by hand, as much labour as possible was avoided, and this explains the cylindrical form. Because the objects have to contain hot liquids, their bases cannot come into complete contact with a tray or table surface, and for that reason a ring is attached to the bottom of the cylinders. At the same time this achieves a formal separation between the containers and the base. The eccentric positioning of the lids and knobs was functionally necessary since it makes it impossible for the liquid to be spilled. The lid can be opened most easily and simply because the knob, the lifting device, is positioned directly opposite to the hinge. In this way the formally dynamic appearance of the pots arose....

Wilhelm Wagenfeld, coffee and tea service, 1924, white tombac and ebony

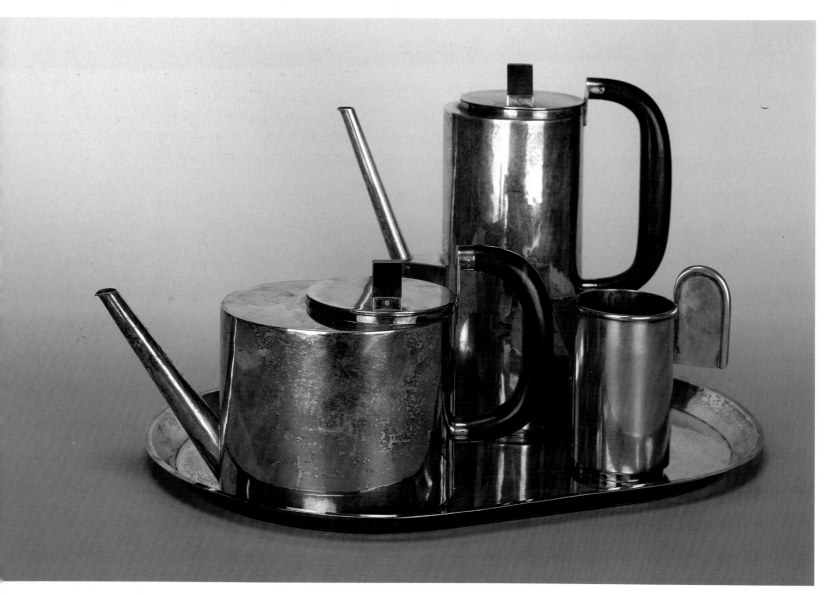

The Other Workshops after the Change in Direction

Walter Gropius 'The Work of the Bauhaus Stage' 1922 [pamphlet]

The collective work of the Bauhaus derives from our efforts to assist in the creation of the new image of the world which in our times has begun to assume form in the realm of space and its organization. We want to introduce a new unifying CONSTRUCTIVE-SPIRIT into all creative work and to help each individual concentrate his activities on this aim. Our field of endeavour embraces every kind of visual art under the guidance of architecture.

We are also working on the DEVELOPMENT OF THE STAGE. A purification and renewal of today's stage which, it seems, has lost its most intimate ties with the world of human feelings, can only be achieved by those who, free from personal prejudice and the restrictions of the commercial theatre, and starting from a common point, are devotedly working fundamentally to clarify the all-embracing problems of the stage in all their practical and theoretical ramifications.

The origin of theatre in a metaphysical longing. It therefore serves to make a metaphysical idea accessible to the senses. The power of its effect on the soul of those who watch and listen to it therefore depends on the success of the translation of the idea into a space that can be perceived by the eye and the ear.

The phenomenon of space is determined by means of finite limitation within infinitely free space, of the movement of mechanical or organic bodies within this limited space, and of the oscillations of light and sounds within it. The creation of the moving, living and artistic space can be achieved only by someone whose knowledge and ability are guided by all the natural laws of statics, mechanics, optics and acoustics, and who finds in the mastery of them all the certain means of giving living form to the spiritual idea he carries within himself....

Oskar Schlemmer to Otto Meyer-Amden

Weimar, early June 1923

... How the Bauhaus stage will develop further is unclear.... Almost as a matter of principle the literary is avoided; for that reason formal qualities. Movement and folding sets. Mechanical things, light effects. Above all, dance. Naturally the craftsmanly Bauhaus people find it more congenial than acting. I regret this somewhat. Poetry about our times is sleeping. The poets let us down....

Kurt Schmidt [student in the Theatre Workshop] **to Dirk Scheper**

1 October 1973

... 'The Man at the Control Panel' (was intended) above all to provide an opportunity of presenting three-dimensional forms in movement and thus to give expression to the technical age.... A man's mechanistically intelligent powers are increased to the point where he becomes a demonic robot. At the centre of the senses, at the control panel, the demon sets free symbolic forms which glide past dancing in characteristic movements as though in a dream ... Finally the demon, disentangling himself from the laws of statics ... collapses....

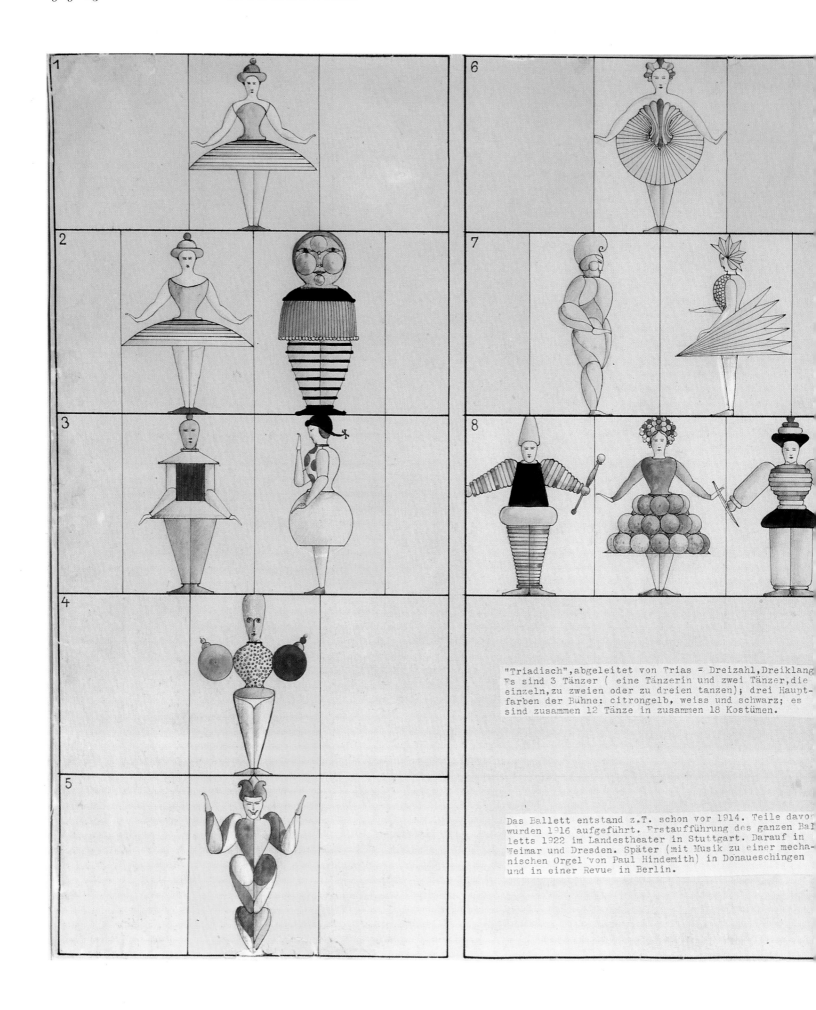

"Triadisch",abgeleitet von Trias = Dreizahl,Dreiklang
Es sind 3 Tänzer (eine Tänzerin und zwei Tänzer,die
einzeln,zu zweien oder zu dreien tanzen); drei Haupt-
farben der Bühne: citrongelb, weiss und schwarz; es
sind zusammen 12 Tänze in zusammen 18 Kostümen.

Das Ballett entstand z.T. schon vor 1914. Teile davon
wurden 1916 aufgeführt. Erstaufführung des ganzen Bal-
letts 1922 im Landestheater in Stuttgart. Darauf in
Weimar und Dresden. Später (mit Musik zu einer mecha-
nischen Orgel von Paul Hindemith) in Donaueschingen
und in einer Revue in Berlin.

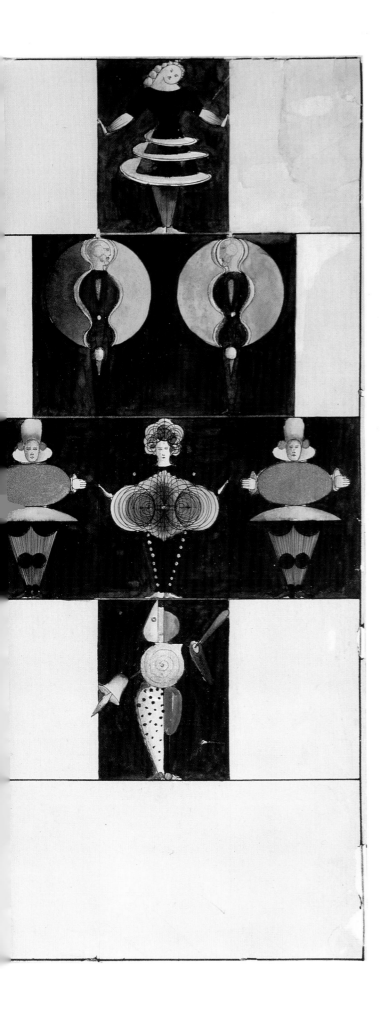

Oskar Schlemmer. (left) Figure-plan for the first Triadic Ballet, *1924–26, pencil, ink, watercolour, and gouache. Schlemmer's typewritten text reads as follows: "Triadic', derived from trias = trio, triad. There are three dancers (one female, two male, who dance singly, in pairs or threes); the stage has three main colours: lemon yellow, white, and black; altogether there are 12 dances in 18 costumes. The ballet partly originated before 1914. Parts were performed in 1916. The entire ballet was first performed at the Stuttgart Landestheater in 1922 and then in Weimar and Dresden. Later (with music for a mechanical organ by Paul Hindemith) in Donaueschingen and in a Berlin revue'.*

(below) Dancers wearing costumes for the Triadic Ballet *made by Carl Schlemmer, 1922–23. Oskar Schlemmer's brother, Carl, was a Workshop Master in the Wall-painting Workshop between 1921 and 1923. He was dismissed after involving himself in political intrigues against Gropius*

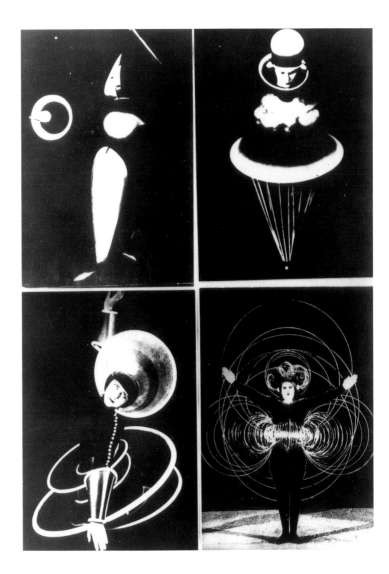

179

Products of the Cabinet-making Workshop. (right) Marcel Breuer, chair, 1922. Breuer's earliest furniture was primitivistic. He then, as this example shows, came under the influence of De Stijl and especially Rietveld

(below) Peter Keler, cradle, 1922. Perhaps the best example of the way in which Kandinsky's theories of primary colours and primary forms came to be practically applied in the Workshops. The cradle is more stable than it looks

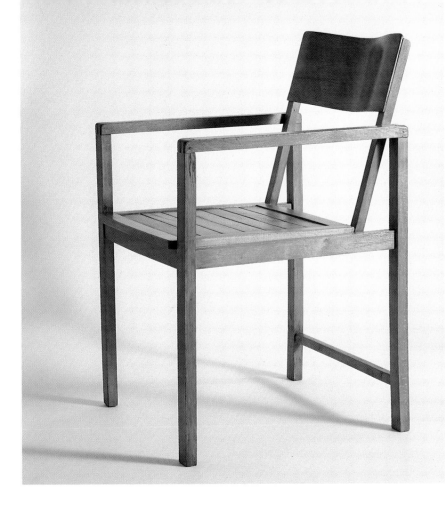

(left) Erich Dieckmann, chair, 1926
(below) Breuer, child's table with two chairs, 1923

Walter Gropius on the commercial prospects for the Bauhaus in October 1924

... Already today there is great interest everywhere in the products of the Weaving Workshop... [It] can be described as the best-equipped hand-weaving workshop in Germany....

Gunta Stölzl 'The Development of the Bauhaus Weaving Workshop'

... Gradually a change took place. We began to sense how pretentious these independent, unique pieces were – tablecloths, curtains, wall coverings. The richness of colour and form became too licentious for us; it did not adapt itself, it did not subordinate itself to living. We tried to become more simple, to discipline our means, to use these in a more straightforward and functional way. Thus we came to yard goods which could directly serve the room, the living problem. The watchword of the new epoch was 'models for industry'....

Walter Gropius to Gerhard Marcks

Weimar, 5 April 1923

... Yesterday I looked at the many new pots you have all been making. Almost all of them are unique objects, and it would be quite wrong if you were not to look for ways in which the good work in them could be made available to more people.... We have to find ways of reproducing some pieces with the aid of the machine....

Max Osborn [art critic] 'Impressions of the Weimar Exhibition' in *Vossische Zeitung* 20 September 1923

... very able work is being done in ceramics, even though the solutions in this field are not so surprising. Marcks sits with his students in the isolation of Dornburg, up the Ilm River, and models pots, jugs, and vessels of all sorts with a lively feeling for form. New types have been created, not all such as to arouse enthusiasm, but many of them convincing and capable of further development. Connections have already been established with industry and these are to be further extended....

Walter Gropius to W. May

Weimar, 23 November 1923

... An enormous number of places in Germany have done their best to get hold of some of our products.... But it's a vicious circle. Production is too low because we don't have enough current funds to pay sufficient workers....

Gerhard Marcks memorandum to the Council of Masters

Dornburg, 2 January 1924

...We must always remember that the Bauhaus is intended to be a place of education; that means that people with a certain amount of talent and personality are trained for tasks which suit them – in our field to achieve something fit to serve as a model. We believe that productive work is the right way to attain this end. But production must never be *the only end*. Otherwise the Bauhaus will become the 101st factory among the 100 that already exist, in other words, a matter of total indifference....

Wassily Kandinsky On the Wall Painting Workshop *April 1924*

The Wall Painting Workshop is different from all other workshops because projects cannot be produced with colour alone.

...The exploitation of the power of colour to shape an existing space... is one of the most important aspects of Bauhaus activities.

This especially complicated and difficult task can only be carried out in some degree if a systematic programme is introduced into the Wall Painting Workshop.

This involves two individual tasks which embrace the nature of colour in a sense necessary for wall painting:
1. The chemical and physical properties of colour – its material substance.
2. The psychological properties of colour – its creative strengths. Two kinds of work are connected with these two points:
1. Technical work – the application of various properties, various pigments and media, the application of colour.
2. Speculative experiments – of an analytical and compositional kind – designs for and the painting of two-dimensional planes and three-dimensional spaces.

...As far as the practical work of the Workshop is concerned, this briefly described programme should be made compulsory with all the consequences resulting from it.

Practical work outside the Bauhaus (commissions) should be made subsidiary to this programme. Since all attempts to give them equal weight have resulted in failures, the productive work of the Workshop should therefore take second place.

This question applies not only to wall painting, but also to sculpture, stained glass, stage and, in part, the Print Workshop.

Report by the Bauhaus Business Manager [Dr. Necker]
on the lack of capital, 23 December 1924

...Unfortunately we have so far been unable even to meet all the orders from the Leipzig Trade Fair. There were also orders from our representative in Berlin which we were either not able to meet at all or only in part. A few pots, for example, were supplied but without the cups intended to go with them. Various clients ... then announced that they would have to return the pots if the cups that went with them were not delivered by Christmas. ...

Oskar Schlemmer in *Die Bühne am Bauhaus* 1925

...Man is both an organism made of flesh and blood and an organism of measurement and number. He is a being of feeling and understanding and many other dualisms. He carries them all within himself and is much better able continually to reconcile this polar duality within himself than in abstract art structures.... Space, like all architecture a structure of measurement and number,... also determines the behaviour of the dancers in itself.... The body itself can demonstrate its mathematics by realizing its physical mechanics which then point into the realism of gymnastics and acrobatics....

Cover of the first Bauhaus book (in its second, improved edition) on international architecture. Edited by Gropius and Moholy-Nagy, fourteen Bauhaus books appeared between 1925 and 1931

INTERNATIONALE ARCHITEKTUR

BAUHAUSBÜCHER

1

Zweite veränderte Auflage

ALBERT LANGEN VERLAG MÜNCHEN

The Cry for Architecture

Oskar Schlemmer diary entry 18 March 1924

...Since the number of those (students) who want seriously to concern themselves intensively and exclusively with building has multiplied, since, therefore, a young group of architects has already emerged, it is not surprising that they are agitating for the basic conditions which they require for their work. They want, it seems to me, to create that kind of Workshop which, with assumptions, rights and duties similar to those of the other Bauhaus Workshops, will enable them to pursue their theoretical and practical ambitions. ...

I do not know whether the loud demand for this Workshop was caused by the dangerous development at the Bauhaus – namely its success. Two Workshops, those for Pottery and Weaving, are already set fair to become representative of the Bauhaus, if they have not already become so. We shan't need to wonder if we are then stuck with the reputation of being a good school of arts and crafts....

Walter Gropius draft of a guide for members of the Bauhaus 1924

Art and technology a new unity! Technology does not need art, but art certainly needs technology very much – example: the building! Both are essentially different, it is therefore impossible to add one to the other, but – those who wish to establish the new architectural idea must rediscover and examine their common creative basis. The means: a thorough preliminary training for these people in craft and technology. Craft is thus the indispensable means to an end. Specialization only *after* completion of the preliminary training. In order to design a thing so that it functions properly, we must (at first) investigate its nature. The elements of that investigation are not only the laws of mechanics, statics, optics, acoustics, but also the laws of proportion. These are spiritual factors. In order to arrive at exactitude here, too, we must consciously seek to objectify the personal factors everywhere, but – every work of art bears the handwriting of its creator. From among a multiplicity of equally economical solutions – there is never just one in each case – the creative individual selects the one which suits his personal taste and feelings.

Hans Volger and Erich Brendel [students] to the Bauhaus Direction

Weimar, 5 September 1924

...Our continuing to study at the Bauhaus depends on the introduction ... of a course in architecture. We are *for* the retention of compulsory work in the Workshops in the mornings, but at the same time we want everything to be done to train us in architecture. This would do justice to the ultimate and final significance of the 'Bau' (building) haus philosophy....

New Interests – Photography, Typography

László Moholy-Nagy catalogue of his first photographic exhibition 1923

...The concretization of light phenomena is peculiar to the photographic process and to no other technical invention. Cameraless photography (the making of photograms) rests on this. The photogram is a realization of spatial tension in black-white-grey. Through the elimination of pigment and texture it has a dematerialized effect. It is a writing with light, self-expressive through the contrasting relationship of deepest black and lightest white with a transitional modulation of the finest greys. Although it is without representational content, the photogram is capable of evoking an immediate optical experience, based on our psychobiological visual organization....

Cover of the Bauhaus book by Moholy-Nagy,
'Painting, Photography and Film', 1925

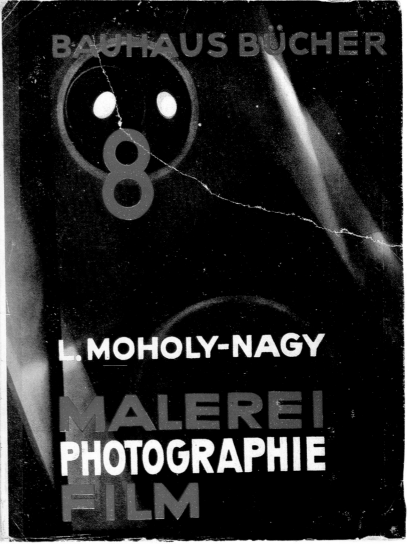

186

László Moholy-Nagy ''Isms or Art' in *Vivos Voco* 1926

. . . The representation of either the object or the human being has been perfected to such a degree in photography that the interpretation through manual means – painting – seems indeed primitive. The battle between brush and camera becomes ridiculous if one realizes, through constant photographic practice, that all representation is interpretation – that the choice of object, segment, light, shadow, even the choice of soft or hard photographic paper, are highly creative 'artistic' decisions. The danger of the photographic medium – including the motion picture – is not aesthetic but social. It is the enormous power of mass-produced visual information that can enhance or debase human values. Brutal emotionalism, cheap sentimentality and sensational distortion can, if they spread unchecked, trample to death man's newly-won ability to see gradation and differentiation in the light-pattern of his world. . . .

Oskar Schlemmer to Otto Meyer-Amden

Dessau, mid-December 1925

. . . During a pause for breath – between, yes, between! – Berlin, Dessau and Weimar, the Bauhaus books are being sent to you. The photography book by Moholy will enchant you, the book by Klee as well, probably. The theatre book perhaps, and I haven't read the Mondrian. But will you agree with the author of the photography book when he wipes the slate clean of everything to do with painting? This is the burning issue at the Bauhaus and in part of the wider art world outside . . . Moholy is so aggressive about this that, like a conqueror, he knows only one enemy – painting – and only one victory – that of photography. Since, in addition, he is Gropius's prime minister at the moment, his influence at the Bauhaus and in the art world is large to the point of being enormous. . . .

Rolf Sachsse [art critic] on Lucia Moholy's photographs

. . . For her photographs (she) employed an arrangement that was both simple and conventional and which in addition could be comfortably set up in the corner of the workshop. At a slight distance from a screen of grey cardboard or cloth . . . she positioned a glass plate horizontally across two stools on which the objects to be photographed were placed . . . if the rear edge of the glass sometimes remained visible in the final picture, it was retouched out so that the objects appeared to hover in front of the screen. . . . Aesthetic considerations had nothing to do with this pictorial arrangement and especially its . . . background. Like the pictures themselves, their genesis was purely instrumental in character. . . .

Herbert Bayer [student] on Bauhaus photography

... We weren't really photographers with the conscious aim of making art. We were simply interested in the possibilities of the camera. And we saw that there were more possibilities than those which already existed. For example: the discovery of new viewpoints, let's say the bird's-eye or worm's-eye view, as we called them, or the discovery of X-ray photography, the photography of the universe, of the stars, etc. All that interested us greatly. We simply took a camera and began to shoot....

T. Lux Feininger [student] on Bauhaus photography

... I perceived how the ambience of the Bauhaus atmosphere (rather than details of daily life) had helped to fashion a partially unconscious point of view. I had not previously observed how much of a satirical intention was perceptible in choice of subject matter and in handling it. The sheer prevalence in number, of clowning and grimacing pictures, is an indication of what I am speaking of. It became clearer to me that there was a two-way traffic here: not only were my 'models' everlastingly ready to 'cut up', but I, too, must have been very ready to photograph their antics....

László Moholy-Nagy 'The New Typography' in *Staatliches Bauhaus Weimar 1919–1923*

... Typography is an instrument of communication. It must communicate clearly in the most urgent form. Clarity must be emphasized because, in comparison with prehistoric pictograms, it is the essence of script. Our intellectual attitude to the world is individually precise (this individual precision is today changing into collective precision), as opposed to the old individually, and later collectively amorphous forms.

Therefore above all, unambiguous clarity in all typography. Legibility – communication must never be allowed to suffer from an aesthetic code adopted in advance....

László Moholy-Nagy in *Painting, Photography, Film* 1925

... A new stage of development began with the first poster ... one began to count on the fact that form, size, colour and arrangement of the typographical material (letters and signs) contain a strong visual impact. The organization of these possible visual effects gives a visual validity to the content of the message as well; this means that by means of printing the content is also being defined pictorially.... This ... is the essential task of visual-typographical design....

1000000

EINE MILLION MARK

WEIMAR, DEN 9. AUGUST 1923
DIE LANDESREGIERUNG

1000000 Mark zahlt die Kasse der Thüringischen Staatsbank dem Einlieferer dieses Notgeldschelnes. – Vom 1. September 1923 ab kann dieses Notgeld aufgerufen und gegen Umtausch in Reichsbanknoten eingezogen werden.

Banknoten nachmacht oder verfälscht oder nachgemachte oder verfälschte sich verschafft und in den Verkehr bringt, wird mit Zuchthaus nicht unter zwei Jahren bestraft.

2000000

ZWEI MILLION MARK

WEIMAR, DEN 9. AUGUST 1923
DIE LANDESREGIERUNG

2000000 Mark zahlt die Kasse der Thüringischen Staatsbank dem Einlieferer dieses Notgeldschelnes. – Vom 1. September 1923 ab kann dieses Notgeld aufgerufen und gegen Umtausch in Reichsbanknoten eingezogen werden.

Wer Banknoten nachmacht oder verfälscht oder nachgemachte oder verfälschte sich verschafft und in den Verkehr bringt, wird mit Zuchthaus nicht unter zwei Jahren bestraft.

5 000 000

FÜNF MILLIONEN MARK

WEIMAR, DEN 9. AUGUST 1923
DIE LANDESREGIERUNG

5 000 000 Mark zahlt die Kasse der Thüringischen Staatsbank dem Einlieferer dieses Notgeldschelnes. – Vom 1. September 1923 ab kann dieses Notgeld aufgerufen und gegen Umtausch in Reichsbanknoten eingezogen werden.

Wer Banknoten nachmacht oder verfälscht oder nachgemachte oder verfälschte sich verschafft und in den Verkehr bringt, wird mit Zuchthaus nicht unter zwei Jahren bestraft.

*Three inflation period emergency banknotes designed in 1923 by
Herbert Bayer for the Government of Thuringia*

László Moholy-Nagy 'The New Typography' in *Staatliches Bauhaus Weimar* 1919–1923

... The objective rendering of facts gives the viewer independence from extraneous interpretations and leads him rather to form an opinion of his own. A similarly significant change is achieved when photography is added to the poster. The poster must be able immediately to communicate the essential elements of an idea. By means of the correct use of the camera and the various photographic techniques – retouching, obscuring, printing one image above another, distortion, enlargement and so on – the greatest possible field for working is opened out....

László Moholy-Nagy 'Typophoto' in *Typographische Mitteilungen* 1925

... Photography, used as typographic material, is extremely effective. It can appear as an illustration alongside the text, or as a 'phototext' in place of words, as an unambiguous means of presentation which in its objectivity does not admit any personal-coincidental interpretation....

László Moholy-Nagy 'Fotoplastische Reklame' in OFFSET, Buch und Werbekunst 1926

... Using photograms, I have experimentally produced title pages for books and magazines and posters for optical companies.... Today it is easy to foresee that our eyes, receptive to ever more refined optical effects, will, by means of similar work, be provided with further rich sensations....

Former head of the largest publishing house in Berlin on Moholy's visit to him in 1926

... His German was abominable, and he had to make up for missing adjectives with expressive gestures. I disliked modern art and I had agreed to give the poor fellow a few minutes only to please one of my art editors. But I became fascinated by Moholy's performance. Under his arms he carried a folder of clippings culled from my own publications. Using a red pencil, he showed me how layout, colour scheme, and illustrations could have been a million times more effective. He criticized my desk lamp – smilingly but cunningly – and he promised me a hundred years of healthy existence if only I'd sit in a functional chair and read by functional light....

From the Outset: Attacks from the Right

Walter Gropius to Max Osborn

Weimar, 16 December 1919

...The stupid philistines of Weimar have thrown down the gauntlet and are trying to whip up a great deal of hostile opinion. We have taken up the fight, and during a meeting that can only be described as grotesque, I succeeded in getting all the laughter on my side. But we're still being undermined in the press.... Actually I welcome this clearing of the atmosphere. There is just a great danger that our budget will be picked to pieces in the regional parliament if it's passionately and systematically opposed by the old German reactionary clique which is very big around here....

Open letter to the artists of Weimar from the national-chauvinist students of the Bauhaus

Weimar, 16 December 1919

...During the meeting of the 'Free association for civic interests' which was held on Friday the 12th of this month, our fellow student Hans Gross energetically supported the idea of an authentically German basis for the Bauhaus. Because of this he was most bitterly attacked and rudely insulted by a section of the student body....

The thinly-represented *German*-thinking students succeeded in ensuring that G[ross] officially remain, while his opponents ... told him to end his studies. As *true Germans*, we are as offended by the measures taken against G[ross] as he is....

Minutes of a meeting of the Council of Masters 18 December 1919

...On Sunday Gropius summoned Gross to come to see him again and told him that he thought the way in which ... he was criticizing the Bauhaus was ugly and sly.... He would no doubt notice the very bitter feelings against him among the other students during the meeting the students had called to discuss him.

Gross had by this time, on 17 December, left the school and claimed that Gropius had withdrawn his grant....

Gropius described this as false....

Because of this false information 13 students had left the school....

Gropius was obliged to conclude that Gross was being used as a battering ram by a clique which has been conspiring against him and the Bauhaus for a long time. They were looking for a political means of discrediting him and the Bauhaus....

Determann did not think Gross's speech was so dangerous. He thinks that after the speech the public went away with the feeling that all parties, even on the right wing, existed in the Bauhaus, and not only ... the Bolshevist-Spartacist [party].

Walter Gropius on politics in the Bauhaus

...If the Bauhaus becomes a playground for political games, it will collapse like a pack of cards. I have always stressed this, and watch like Cerberus to keep politics of any kind out of the school....

Walter Gropius to the journalist **Freiin von Freytag Loringhoven**

Weimar, 31 December 1919

...There are only German-speaking students of German origin (at the Bauhaus). 208 from within the boundaries of the Reich, 2 Bohemian Germans and 2 Hungarians with German names ... only 17 students are of Jewish *origin* of whom *none* has a grant and the majority are baptized Christians. All the others are of Aryan origin....

Freiin von Freytag Loringhoven 'What we intend to do' in *Weimarische Landeszeitung Deutschland* 1 January 1920

...Whoever tries to set himself up as a dictator of taste in Weimar causes deepest bitterness, nothing more ... the demand of the newest, so-called art is 'wait and see'. That's well and good, but we have been waiting years to see what will emerge from the experiments in the new German art, and things get worse, not better. It has become disastrous for the new, young artistic life of Weimar, since an art dictatorship resembling the old army regimen has been enforced on our art school.... We demand that our good indigenous art be respected, that it be fostered and valued, as was previously the case, along with the new....

Article in *Tägliche Rundschau* Weimar, 3 January 1920

As far as we know, the state of affairs in Weimar is as follows. The old, entrenched art circles and the educated lay public are more than bitter about the direction taken by Gropius and his people. Because the Socialist government and especially the Socialist Minister of Culture, the former typesetter Rudolph, are supporting Gropius and sanction his efforts, and because the opposition led by Professor Fleischer want to have him removed, the representatives of each of these views are concentrated in one or other of the two political camps, i.e. either the Socialist or the German-Nationalist. As things stand today, who will triumph is a matter for conjecture.

Departure From Weimar

Walter Gropius to Lieutenant-General Otto Hasse [military commander of the Weimar district]

Weimar, 24 November 1923

... Yesterday morning at half-past ten I was summoned from my office by a [Reichswehr] soldier because there was a search warrant. The house was searched by a deputy officer and six men in a sensational manner. The order can only have been issued on the strength of a malicious, irresponsible denunciation which was not checked.... I am ashamed of my country, your Excellency, ashamed of being apparently without protection in my own country, in spite of my achievements....

Oskar Schlemmer to Otto Meyer-Amden

Weimar, 13 February 1924

... There have just been elections in Thuringia. The government, until now entirely Socialist and a supporter of the Bauhaus, will be replaced by a bourgeois government. All sorts of things will begin to happen soon. Gropius is anticipating them and has a clear plan of campaign in his pocket. Severing of all ties between the State and the Workshops, creation of a limited company. The State will pay only for a small staff of teachers. I only know of these plans at second hand – I am more distant from the throne than ever. Kandinsky, now, as ever, very close to it, is discontented and already displaced by Moholy, the new man. Let's drop the subject now....

Walter Gropius to Ise Gropius [his second wife]

Weimar, late March 1924

... Today was a wild day. There were press notices from Jena and Berlin which openly say that the government will not extend my contract and wants to liquidate the Bauhaus. So I have to change to the offensive now and I will make the ministers sweat. First of all, I have to be sure of the support of the Masters, who will probably stick with me *en bloc* and make their remaining dependent on my staying. There will be a decisive meeting on this tomorrow in my absence.... A committee will then go to the minister and confront him. If he gives no clear answer, we shall give the whole story to the national press....

Ise Gropius to Manon Gropius [Walter Gropius's] daughter with Alma Mahler

Weimar, late May 1924

... He was showered with presents from students and a portfolio from the Masters, fêted gloriously, spontaneously – radiantly ... the whole atmosphere was so open – as I've never seen before. The band was in a fantastic mood – Gropius was carried on the students' shoulders with deafening cheers. At this moment, the Minister of State, Friedrich Schultz, happened to visit; he was surprised and pleasantly disappointed to see the ill-reputed Bauhaus in such spirit. ... The celebration lasted through the following Saturday and Sunday, 24 and 25 May. Walter was heartened....

(below) Wassily Kandinsky, 'Variation IV', card for Gropius's
forty-first birthday, 18 May 1924, ink and gouache.
(opposite) Paul Klee, 'Solution 'ee' of the Birthday Exercise,' 1924, gouache.
These are two from a series of coloured drawings or paintings
presented to Gropius by some of the Bauhaus Masters.
Each was based, however loosely, on a photograph, clipped from
a newspaper, of a gramophone with horn in front of an open
upstairs window and above a closely packed crowd of people

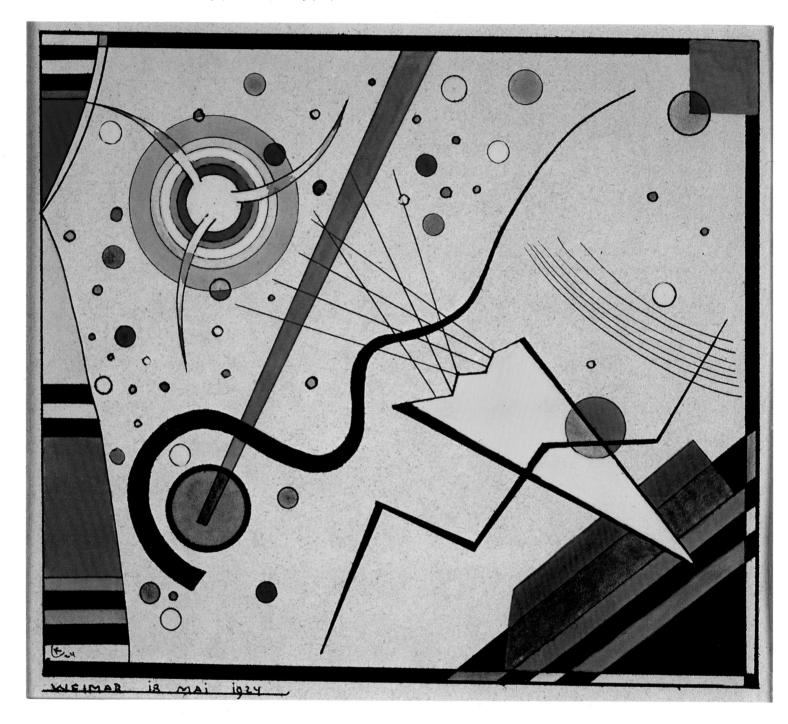

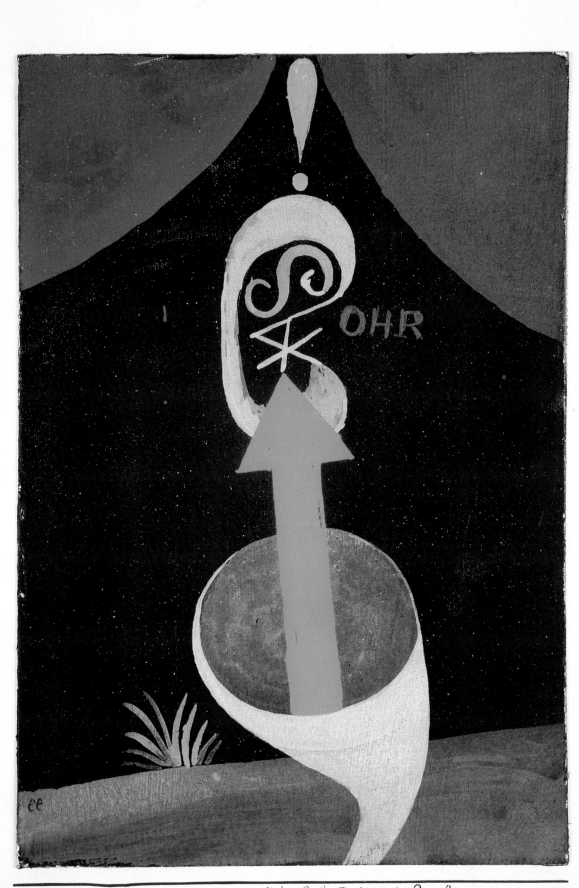

Lösung, ee." der Geburtstags Aufgabe

Theo van Doesburg to László Moholy-Nagy with a request to read it to a meeting of the Bauhaus Masters May 1924, after an earlier article (see p. 130) published by him in *De Stijl* had been used as propaganda by the school's opponents

...When I first came to know the Bauhaus and its artistic programme I was uncommonly interested. In so far as its aims ran parallel to similar efforts that had already been made in Holland with actual buildings, I wanted, without harbouring *the slightest personal ambition*, to support the cause ... both through my own artistic activities and propaganda.

I recall what Herr Walter Gropius said about the work of our *De Stijl* Group when I showed him photographs for the first time in 1920: 'The artists of the *De Stijl* are much more advanced than we. But we don't want to cultivate dogma at the Bauhaus. Everyone should develop his own individual creativity, etc.'

When I moved to Weimar (and not just on my own initiative) to work independently of the Bauhaus, I formed an entirely different impression of the Bauhaus. My flat am Horn – and later my studio on the Schanzengraben – became the focal point of those people who criticized and condemned the internal make-up of the Bauhaus.... The people who urged me to make my own criticisms were not only the enemies of the Bauhaus. They were also friends, Masters, students and close colleagues of the director.

When I was living in Weimar, I was very surprised that those people who were interested in my ideas wanted to learn about them only in secret and that no one discussed the possibility of developing thoughts about a new kind of artistic creation at the Bauhaus in public.

This certainly did not correspond with the Bauhaus manifestos which had been distributed throughout the entire world. Instead of a 'friendly reception for foreign colleagues', I found only growing enmity and mean-spiritedness.

And this entirely inexplicable attitude of the Bauhaus direction towards me,... all the contradictions and confusion obliged me to criticize....

I have never been opposed to the Bauhaus as such or to individual personalities. I based my entire criticism on the following cardinal points:
1. The contradiction between the aims set out in the programme and the methods employed to bring them about.
2. The impossibility of achieving a total structure in the collective building given the absence of discipline and an intellectual community of Masters of Form, Workshop Masters and students.
3. The absence of a general principle.
4. The introduction of purely personal factors into creative matters.
5. The development of metaphysical problems, political, religious or other kinds of speculation instead of jointly dealing with the real problems of formal construction, etc.

At that time I explained my position to various people in Weimar in the following way:

'If the Bauhaus were simply a free school of art, an institute where everyone could experiment according to his mood and inclination, I would be of another opinion.... But the Bauhaus had a programme, claims to have a mission, and now I permit myself the question: how will the Bauhaus achieve its aim, carry out its programme in practice, if it loses itself in Mazdaznan, Ittenism, and the production of individualistic art?'...

Oskar Schlemmer to Otto Meyer-Amden

Weimar, 20 May 1924

... Peace is as distant as ever. During the coming days – weeks? – the decision will be made whether the Bauhaus will continue to exist, with or without Gropius, with or without its Masters. The right-wing Thuringian government, the bourgeoisie, the craftsmen, the local artists with their backs to the wall are making their assault with a variety of slogans. The forest of pamphlets is rustling loudly with opinions for and against, Gropius is publishing a collection of press opinions, a hostile booklet, a pamphlet, has appeared, there is a newspaper campaign and students have made posters in support of the Bauhaus. . . .

The Bauhaus Masters to the Government of Thuringia

Weimar, 26 December 1924

The Director and Masters of the State Bauhaus at Weimar, compelled by the attitude of the Government of Thuringia, herewith announce their decision to close the institution created by them on their own initiative and according to their convictions, on the expiration date of their contracts, that is, 1 April 1925.

We accuse the Government of Thuringia of having permitted and approved the frustration of culturally important and always non-political efforts through the intrigues of hostile political parties. . . .

(signed by all the Masters)

Oskar Schlemmer to Otto Meyer-Amden

Weimar, 17 February 1925

... The dance of the German cities around the golden Bauhaus will soon come to an end.

The lukewarm have separated off from the warm, the hot from the burning hot.
Thus Dessau (in confidence) remains, a smallish town between Leipzig and Magdeburg – ambitious, with aspirations, not without funds –, and it is willing to take on the Bauhaus. . . .

How do you view the march of reaction in Germany? I see very little that is positive in Germany. . . . I don't know whether there will be a civil war or a war between nations. . . .

The Second Phase: Dessau, 1925–32

In one respect Dessau was similar to Weimar. Until 1919, it, too, had been the residence of the rulers of a princely state and was proud of a long cultural and artistic tradition which, like Weimar's, had been stagnating for some time. But in other, more crucial ways Dessau was a quite different city. It had a larger population and was situated not in a rural landscape of forests and hills but close to an important brown coal, open-cast mining area. This resource had persuaded several modern industrial concerns to build factories in Dessau or nearby. No less than twenty-five per cent of the German chemical industry was concentrated in the region, and the huge heavy engineering and aircraft company of Junkers was based in the city itself. Anxious to work more closely with industry, the Bauhaus hoped that it would benefit from the closeness of Junkers above all.

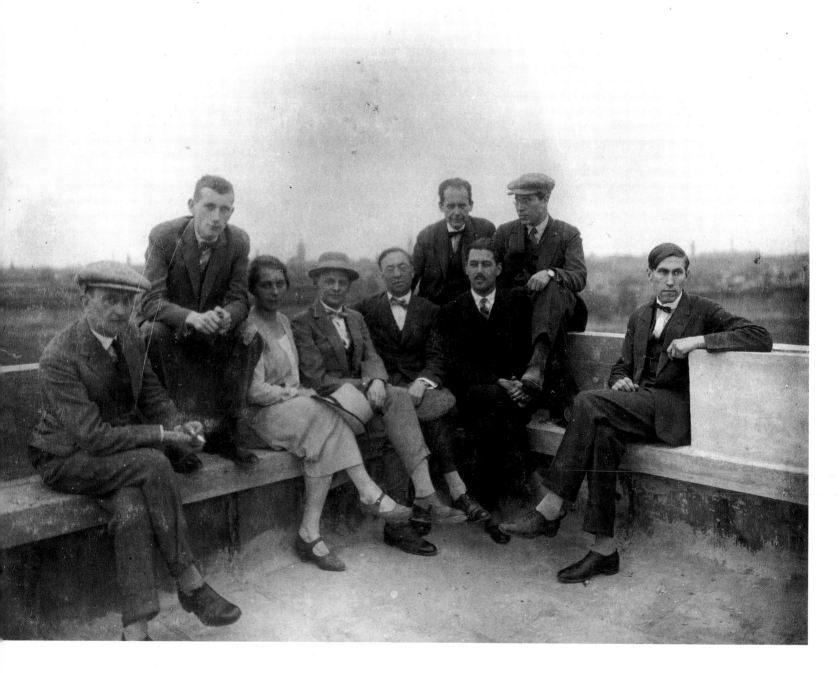

Teachers on the roof of the Dessau Bauhaus, c.1927, photo by Lucia Moholy. From left: Albers, Breuer, Stölzl, Schlemmer, Kandinsky, Gropius, Bayer, Moholy-Nagy, Scheper

In its politics, too, Dessau was agreeably different from Weimar. It had been ruled by the Social Democrats for years, and their majority seemed unassailable even during a period in which support for the nationalists was growing with extraordinary rapidity elsewhere. The Governing Mayor of Dessau, Fritz Hesse, was a Liberal who enjoyed the support of the Social Democrats. It was Hesse's enthusiasm for the Bauhaus which persuaded the municipal government to apportion generous funds and issue an invitation to Gropius and the Council of Masters to move to Dessau. The funds were large enough to pay for new, large buildings for the school and accommodation for some of its students and staff, even though those funds came not from the state of Anhalt, of which Dessau was the capital, but exclusively from the city coffers. (Previously the Bauhaus had been funded not by the city of Weimar but the state of Thuringia.)

Given such financial evidence of Dessau's intentions, Gropius and the majority of the Masters accepted the invitation. But some did not. Christian Dell from the Metal Workshop preferred to take up an appointment in Frankfurt where the School of Arts and Crafts was being reorganized along Bauhaus lines. So, too, did Adolf Meyer who, as a partner in Gropius's private architectural practice, had been closely involved in such projects as the Sommerfeld Villa and the Haus am Horn. Gerhard Marcks decided to leave the Bauhaus Pottery for a post at the School of Arts and Crafts at Burg Giebichenstein near Halle. Some simply stayed in Weimar where, under a new director, the school continued to operate, for a few months still with the name State Bauhaus.

Indeed, Gropius and his Masters had no legal right to the Bauhaus title, its trademark or patents. They belonged to the state of Thuringia which, however, was presumably so glad to be rid of Gropius and his colleagues that it did not bother to bring legal proceedings against him or the city of Dessau.

Until the new Bauhaus building was ready, conditions in Dessau were inevitably difficult. The school did its best to make do with temporary accommodation in premises previously occupied by a mail order company, and most of the teachers continued to live in Weimar from where they commuted to Dessau for several days at a time. Kandinsky was one of the first to move. Klee, who managed to arrange a convenient timetable, spent two weeks of every four in Dessau where he rented a room in Kandinsky's apartment. Many of the students took advantage of the confusion caused by the transition to ignore the timetable and carry on with their own work if they bothered to work at all.

But the temporary arrangements did not last for long. The Bauhaus building, designed by Gropius's private practice (which moved to Dessau with him) was begun and finished with astonishing speed. The foundations were laid in the summer of 1925; the building was ready for use in October 1926; and it was officially opened two months later in the presence of almost a thousand guests.

One of the most celebrated buildings of the twentieth century, the Dessau Bauhaus consisted of a teaching and Workshop wing, a theatre, a canteen, a gymnasium and twenty-eight studio apartments for students, above which was a roof garden. The outstanding visual features were the spectacular glass curtain wailing on the Workshop wing and an enclosed two-storey bridge spanning a road, in which the school administration and Gropius's private architectural practice were accommodated. The interiors were designed and fitted by the Bauhaus Workshops.

In spite of the imposing visual impression made by the building and the many clever functional features it incorporated, it cannot be said to have been an unqualified success. Its flat roof soon began to let in water, cracks appeared in its prefabricated reinforced concrete walls, and the enormous expanse of glass in the Workshop wing ensured that the rooms within were too hot in summer and too cold in winter.

About ten minutes' walk away on a tree-lined street three semi-detached houses for six members of staff and one detached house for the director were built to Gropius's designs at the same time as the main building. They were flat-roofed, painted white and furnished by the Bauhaus Workshops. In spite of their generous, functional design and modern equipment they did not please all of the six teachers (or their wives and families) who lived in them. They nevertheless excited many architectural writers who heaped lavish praise on their conception and execution in the press.

Not only the Bauhaus building in Dessau was different from its Weimar predecessor. The school's statutes, organization and curriculum changed, too. In 1926 it took an additional name which unambiguously stated its purpose: it became a *Hochschule für Gestaltung*, an 'Institute of Design'. Teachers were no longer known as Masters but Professors, and the tandem teaching system, by which each Workshop was run by a Master of Form and a Workshop Master, was abandoned. Skilled craftsmen still taught in the Workshops, but they were now subordinate to the Professors in theory as well as practice.

From the beginning, Gropius had regarded the tandem teaching system as a regrettable but necessary compromise. Teachers who were sufficiently gifted both as creative artists and skilled craftsmen simply did not exist when the Bauhaus was founded, but Gropius hoped and intended that such teachers would eventually emerge from among the school's own students.

One, indeed, had already done so: Josef Albers. Now five others – Marcel Breuer, Herbert Bayer, Hinnerk Scheper, Gunta Stölzl and Joost Schmidt were also appointed to the staff – not as full Professors but 'Young Masters', a title which reflected smaller salaries rather than less responsibility. Each of them was in fact given charge of a Workshop, most of them immediately, Stölzl a little later. She took over the Weaving Workshop in 1927 after Muche had resigned, despairing at what he took to be the inexor-

Hannes Meyer

able march to functionalism and rationalism.

The apprenticeship system did continue to operate for some time, however. Only later did the Bauhaus cease to submit its students to the local guilds for examination. It then introduced examinations and a diploma of its own.

In Dessau some Workshops were closed, others amalgamated, and yet others established for the first time. The Workshops for stained glass and pottery ceased to exist while those for cabinet-making and metal were combined. In Weimar the Printing Workshop was exclusively concerned with graphic art, with producing artists' prints in limited editions. In Dessau it concentrated on layout, typography and advertising. Later, an entirely new Photography Workshop was introduced.

At the same time the Bauhaus began more actively to cultivate links with industry and to market its products in a more determined way. A limited-liability company was founded in order to trade in patents and designs and thus to provide the school with a regular and, it was hoped, growing income. Gropius continued to believe that the school could ultimately be self-supporting financially.

Public relations activities were increased, too. An organization called the 'Friends of the Bauhaus' had been founded in 1923 to attract donations from private individuals. The first issue of a new school journal, designed to appeal to external readers, was published in time for the official opening of the building. The first in a series of 'Bauhaus books' about contemporary art and design also appeared. All of these books were designed by Moholy-Nagy whose restrained but unconventional typography became influential almost immediately.

The most momentous of the changes at Dessau was the introduction of a department of architecture, something many students and members of staff had been requesting for some time. It began its work in 1927 under the direction not of Gropius but Hannes Meyer, a Swiss architect previously best known for his unrealized designs for the League of Nations building in Geneva. Meyer accepted Gropius's invitation a shade reluctantly, seemingly because of what he took to be the continuing romantic and metaphysical bias at the school, an unfortunate result, he believed, of the influence of the powerful and highly individual personalities of such painters as Klee and Kandinsky. Meyer's appointment as Professor of Architecture and, in 1928, as director of the Bauhaus had, as we shall see, fateful consequences.

The atmosphere at the Dessau Bauhaus was quite different from that at Weimar. Housed in its functional, spectacularly modern buildings, the school flourished, not as a place where the crafts lived on in rejuvenated form and where there was more talk than action, but where a new breed of industrial designer, technically knowledgeable, artistically sensitive and skilled in a variety of ways was being trained.

Many of the faces familiar at the Weimar Bauhaus remained

in Dessau, however, and their teaching continued largely
unchanged. Klee and Kandinsky consolidated their courses in
basic design; Albers and Moholy-Nagy ran the Preliminary
Course much as they had done in Weimar; Muche remained in
charge of the Weaving Workshop (although only until 1927);
Schlemmer continued to develop the activities of the Theatre
Workshop. Feininger, whose duties were never onerous, gave up
teaching but stayed on as a kind of artist in residence to whom
students could go for advice. He received no salary but lived
rent-free in one of the Master's houses.

Under Hannes Meyer the architecture department assisted
Gropius with a number of commissions, the most important of
which was a housing estate built in three stages in the Törten
suburb of Dessau. But Meyer was quite different from Gropius,
both as a man and an architect. He was a total rationalist who
believed that aesthetics should play no role in the design of build-
ings, and a Marxist convinced that the architect should be pre-
eminently a social engineer.

Meyer quickly came to be disliked by several of his colleagues.
It was inevitable that his views would antagonize Klee and Kan-
dinsky, but Meyer even annoyed Moholy-Nagy who, in spite of
scientific sympathies similar to Meyer's, insisted on the impor-
tance of individual creativity.

Such antipathies were serious enough while Meyer was Pro-
fessor of architecture, but when Gropius decided to resign in
January 1928 and recommended Meyer as his successor as direc-
tor they became potentially disastrous. The student representa-
tives begged Gropius to remain, and once it was clear that his
decision was irreversible Moholy-Nagy resigned, followed soon
after by Breuer and Bayer.

The reason for Gropius's decision was clear enough: he was
tired out by nine years of administration and by the ceaseless
struggle for the school's survival. He probably sensed that the
nationalist forces which had driven the school out of Weimar
were now gathering strength in Dessau, too, and in any case
wished finally to devote all his energies to his private archi-
tectural practice, especially since the general economic situation
throughout Germany had improved so much that new buildings
were now being commissioned everywhere.

Meyer was not Gropius's first choice as successor. He initially
approached another architect, Ludwig Mies van der Rohe, who
had a far greater reputation than Meyer, but for some reason
Mies refused. But even after Gropius had recommended Meyer's
appointment to the city council and the appointment was ratified,
the founder and first director of the Bauhaus continued to take an
interest in Bauhaus affairs and even to influence them.

Meyer has been treated less fairly than Gropius by most Bau-
haus commentators, who see the period of his directorship as
marking a departure from the school's original aims. Yet Meyer's
achievements were considerable and it can be argued that the

*Cartoon by H.M. Lindhoff (in 'Kladderadatsch', Berlin, 4 March
1928) showing Gropius holding a contract and sitting on the
ruins of the Dessau Bauhaus. The text reads: 'Collapse of the
Dessau Bauhaus. The 'Bauhaus' which was taken over at great
expense by the town of Dessau and directed by Gropius, has
collapsed. On top of the ruins of the house one hears Mr Gropius
moan'*

Bauhaus only began to realize many of Gropius's original aims under Meyer's leadership. It certainly operated more economically and effectively than at any time before 1928. Inspired by the idea of a school with a social mission, Meyer introduced many changes. He increased the number of scientific subjects taught, restricted the influence of the fine-artists on the staff (while making painting classes official), encouraged co-operation between the individual Workshops, developed practical teaching by means of actual commissions, and urged students and staff to concentrate on the design of types and standards for objects of daily use by ordinary people. He also succeeded in attracting more people from humble backgrounds to study at the school.

The results were impressive and tangible. For the first time real co-operation with industry was achieved and Bauhaus designs and patents began to contribute substantially to the school budget. For example, Bauhaus wallpapers met with great success in the building trade (they continue to be marketed today); the Advertising Workshop designed advertisements, exhibition stands and publicity material for Junkers, Suchard and other well-known companies; and the Metal Workshop designed lighting fitments and furniture for mass-production.

As an architect, Meyer was understandably most involved with the architecture department for which he attempted, sometimes successfully, to secure real commissions and projects. Critical of many of Gropius's ideas and attitudes and especially of the existence of Gropius's private architectural practice at the Bauhaus, Meyer was determined that all commissions would be carried out by the Bauhaus from start to finish. He wanted to train students to be architects from the moment the first commissioning letter arrived to the completion of the final account and, influenced by Soviet practice, he organized students into 'vertical brigades'. Students drawn from every year would work together on actual projects. Meyer's main commission during this period, the Trades Union School in Bernau, was, however, mostly carried out by his private practice in Berlin.

It was Meyer's enthusiasm for Soviet examples which was his downfall. Gropius had realized in 1919 that the school needed to present an apolitical face to the public in order to rely on continued public funds, and for that reason he discouraged students and staff from taking part in political demonstrations and making statements which could be politically construed. Meyer was too much of an idealist for such caution, and since Marxism informed everything he did, he saw no reason why politics should not also have their place at the Bauhaus. As a result the students quickly formed political groups – nationalist as well as Communist – within the school.

At any time such a policy would have been ill advised. In Germany in 1930 it was foolhardy. Nationally and regionally the Nazis were gradually assuming influence and power, and everything which seemed remotely left wing was their first target. In opening itself up to attack from political extremists, the school mirrored the German republic itself which was increasingly weakened by attacks from both left and right and which, thanks to the consequences of the Wall Street Crash in 1929, was again on the verge of chaos and financial collapse.

In Dessau, the Social Democratic government and Liberal Mayor saw the writing on the wall and knew that if the Bauhaus were to be saved, Meyer would have to leave it. They knew that by then the majority of Bauhaus staff was of the same opinion and that Gropius, with whom they remained in close contact, had also become disillusioned by Meyer, whom he accused of treachery. In July 1930, they organized a classic coup when Meyer was away from Dessau on holiday. Meyer's loud, articulate and public protests were to no avail. He left the school immediately and, as though to emphasize where his sympathies lay, moved to the Soviet Union 'in order to work', as he put it, 'where a truly proletarian culture is being forged, where socialism is coming into being, where that society already exists for which we here in capitalism have been fighting'. He remained in the Soviet Union, teaching and designing public buildings, until 1936, when he returned to his native Switzerland.

If most of the staff were relieved, many of the students (and not least the large group of Communists among them) were outraged by Meyer's forced resignation. Some of them decided to leave Dessau and work with Meyer in the USSR; others preferred to stay behind and make life difficult for his successor.

Meyer's successor, in the summer of 1930, was the man who had already been offered the directorship in 1928: Ludwig Mies van der Rohe, an architect with an international reputation for designing exceedingly elegant, deceptively simple steel-and-glass buildings. Why he accepted in 1930 what he had refused in 1928 remains a mystery, especially since the politicization of the school in the mean time meant that the directorship would now, initially at least, be a bed of nails. He had urgently to restore the reputation of the school in the eyes of its non-Communist opponents, and in order to do this, he was forced to introduce a degree of discipline that was previously unknown at the Bauhaus. After several incidents which bordered on full-scale riots Mies closed the school for six weeks and expelled the leaders of the protests, all seemingly Communist sympathizers. Soon after the Bauhaus reopened students were sadly comparing it to a traditional high school run on very strict lines, ruled by the timetable and authoritarian teaching methods.

Mies obviously believed that the state of the Bauhaus was so precarious that only a highly disciplinarian director would restore its balance. It is therefore surprising that he did not move permanently to Dessau. He maintained his private architectural practice in Berlin and travelled to Dessau for no more than three days every week, staying overnight in one of the Master's houses.

Like Meyer, Mies regarded architectural training as central to

the Bauhaus curriculum. But he placed even more emphasis on it than Meyer had done, so that the Bauhaus grew even more to resemble a conventional school of architecture. Theory grew increasingly in importance while practice, especially Workshop activity, declined. One of Mies's first acts was to combine the Furniture, Metal and Wall-painting Workshops into a single department for 'interior design' while everything else was reorganized as 'exterior building'. He later reduced the length of the course by a year – from nine to seven semesters.

Mies changed the Bauhaus fundamentally, and partly as a consequence most of the staff still remaining from the school's earlier years resigned. Kandinsky and Klee hung on, but Klee soon also moved, to a professorship at the art academy in Düsseldorf. It is easy to criticize Mies and to regret his transformation of the Bauhaus, but it is at the same time difficult to imagine the enormous pressures, most of them political, to which he must have been subjected.

Developments in Weimar since the Bauhaus had left the city seemed to many in Dessau to be a dreadful warning. There the Nazis had already taken control and had begun to act against every kind of art which they considered 'degenerate' or 'Bolshevik'. They had removed all the modern paintings, many of them by Bauhaus teachers, from the city museum, and a portrait of Hitler hung in one of the offices in the building the Bauhaus had once occupied.

It was not long before events in Dessau took a similar turn: indeed the Nazis achieved control of the city parliament in 1931. Attacks on the school, almost identical to those previously made in Weimar, now multiplied. At the first opportunity the city parliament voted to terminate all staff contracts and cancel its financial grant. The school was closed at the end of September 1932, and soon after storm-troopers moved in, smashing windows and throwing everything they could find out onto the street beneath. They wanted to demolish the building completely, but an international campaign dissuaded them from doing so. Instead, they added a brick façade with conventional fenestration and used the building as a school to train party functionaries. In the autumn of 1932 it seemed that the Bauhaus was finished.

Cover of the cyclostyled magazine of the Communist students at the Bauhaus, April 1932. It bitterly attacked the events of the winter term 1931–32 and demanded 'another Council of Masters, another society, another system'

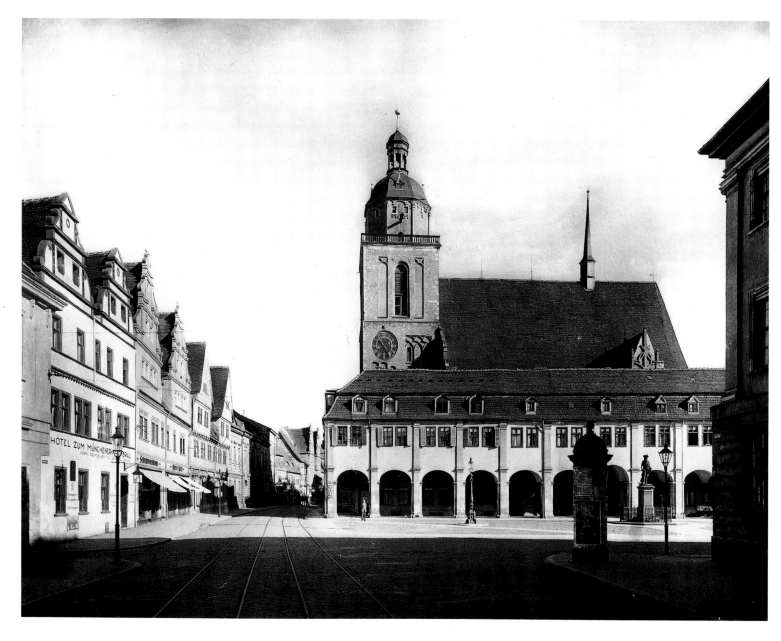

Dessau Market Square with the town hall

The New Buildings, Dessau

Description of Dessau in *Staatliches Bauhaus Weimar, 1919–1928*

Dessau. Mentioned for the first time in 1213. Since 1603 the seat of a line of the House of Anhalt. Important industrial town and transportation centre: Junkers Works (all-metal airplanes), chemical industry, manufacture of machinery, railroad cars, wooden articles, chocolate, sugar. Renaissance palace, residence of the Dukes of Anhalt; small palaces and town houses in baroque and neo-classic styles. Near the town, at Wörlitz, are large eighteenth-century parks in the English 'Romantic' style. . . .

Lyonel Feininger to Julia Feininger

Weimar, 20 February 1925

... In Dessau Frau Kandinsky and Frau Muche were delegated to look around the town – the initial impression not very nice – but then, beyond the working class district, it improved to the point of total enthusiasm. In addition, for the Masters, houses are to be built according to our own wishes and plans in a splendid park, accommodation that will be ready in October! With studios at the top of the house! Water everywhere: the Mulde flows into the Elbe, watersports and sailing, fishing – motor boats....

Kurt Schwitters [Dadaist painter and poet] **to Theo and Nelly van Doesburg**

Hanover, 22 March 1925

... Moholi [*sic*] writes that the Bauhaus is now truly active again – in Dessau.... It's a madly isolated place, not on any main railway line. Dessau is the only German state ruled by the Socialists. It's therefore a party matter that the Bauhaus has been accepted there....

The Dessau Bauhaus. A Junkers promotional photograph
showing a Junkers aeroplane flying overhead

Lyonel Feininger to Julia Feininger

13 October 1925

...The Bauhaus building, a block of three buildings rather, is under construction; the work on them goes on feverishly. They wish to move in by Easter. There will be a special studio wing for 24 master students. The buildings for the Workshops is a huge construction of glass, and the third part, connecting these two, includes the stage, a mess hall and kitchen on the ground floor, on the bridge above the offices. Baths, etc., are in the basement....

'G' 'The Dessau Bauhaus' in *Kunst und Künstler* 1926

The opening ceremony of the Bauhaus was held in Dessau on 4 December. The large number of guests from outside the city exceeded all expectations and testified to the extraordinary interest with which Gropius's work is followed throughout Germany as well as abroad. The new buildings for the Academy and Workshops can indeed be recognized as a model of today's architectural achievements. The consistent exploitation of the potential of new materials and methods has enabled the problems posed by a major project to be solved in exemplary fashion. The plan of the building, which consists of three independent but intimately connected parts has been most carefully thought out, and functional requirements are met within a whole which, in the disposition of space alone, creates an impressive effect.

This is as true of the appearance of the outside of the building with its clearly-distributed cubic masses and the interplay of unified glass walls and horizontally-positioned strips, as it is of the effect of the interior with its well-proportioned, light-flooded rooms. It was a particularly happy idea to incorporate the load-bearing elements into the interior and thus permit the external wall of the large Workshop building to be conceived as an unbroken expanse of glass. We must wait, however, to see what the temperature will be like on the inside. It was also an excellent idea to join the two main buildings by a two-storey bridge supported on four slender columns.... Here there is no longer any question whether the flat roof is preferable to the gable, or whether traditional decoration can be applied to today's buildings. Here the elevation of the new functional form to artistic design has been taken seriously.

The same cannot be said of what the Bauhaus has produced in its attempts to design new domestic objects and appliances. The major effort has been devoted to the design of chairs. The result is a chair in which lightness and comfort have been combined but which, we feel, with its frame made of bare nickel tubes, appears somewhat like something from a laboratory. In this field the Bauhaus is still experimenting, and, what is more, entirely on its own, whereas in the architectural field it is part of a general, Europe-wide movement.

In the future Gropius will have to be aware of the great responsibility which success has placed upon him. The markedly individualistic behaviour of single, problematic personalities which decisively influenced the Bauhaus during its first phase is today less appropriate than ever since the collectivist character of the new architectural ideas now stands in the foreground.

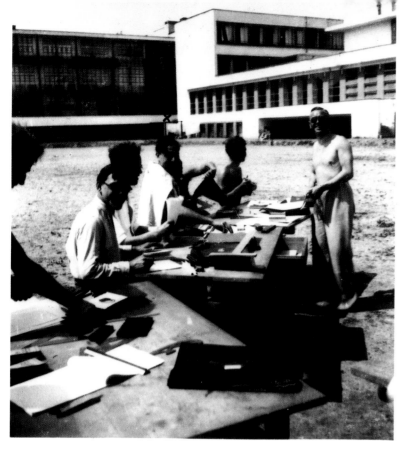

(left) Students working in the open air

(below) The Dessau Bauhaus shortly after its opening. On the left is the bridge (containing the administration and Gropius's private architectural practice) and in the foreground is the glass-fronted Workshop Wing

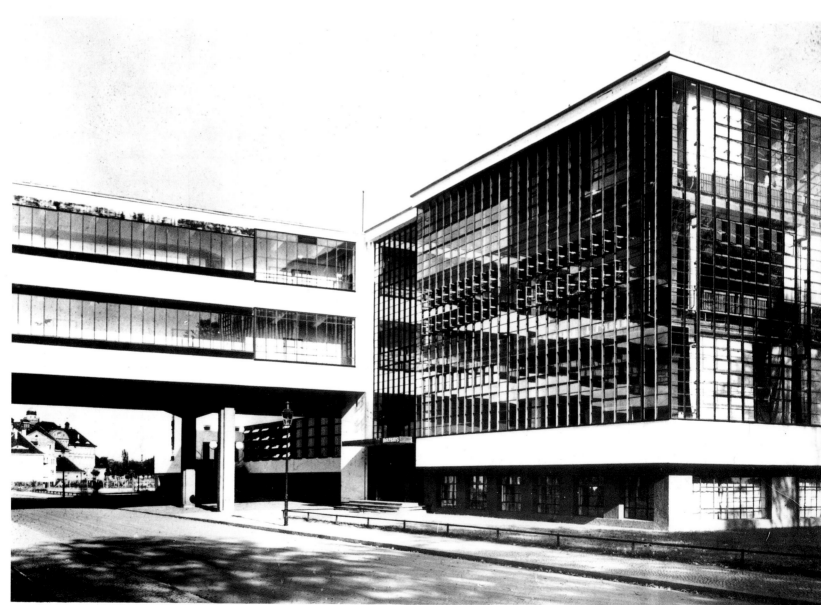

Felix Klee 'Memories of Dessau' in *The Diaries of Paul Klee* 1964

. . . We were never able to accustom ourselves to the city; our only consolation besides the Bauhaus, now grown a bit more mannerly, was the aspiring picture gallery and the tradition-conscious and lively Friedrich Theater, as well as the splendid surroundings of the city with its two mighty rivers and many park areas. Only a half hour away, we discovered a real marvel of landscape gardening: Wörlitz. The old Dessauer (Leopold I of Anhalt-Dessau) had planned the park and not a month passed without Klee's going for a stroll between the Temple of Flora, the climbing rock, and the artificial Vesuvius. . . .

The Dessau Bauhaus from the air, showing its relative isolation from the town. The tall section at the back contained flats for students. Between that section and the Workshop Wing was a single storey in which the canteen and theatre were situated. Below them in the basement was a gymnasium

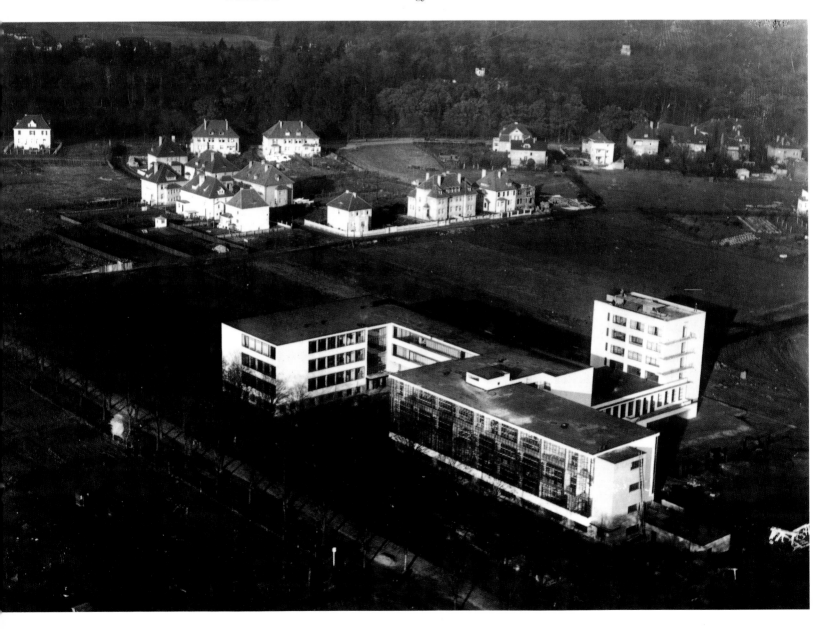

Rudolf Arnheim [art and film critic] 'The Bauhaus in Dessau' in *Die Weltbühne* 1927

... Separated by the railway tracks from the dense concentration of little, pointed, dusty small-town houses, and thus isolated even by their position on a green field on the outskirts [of Dessau], stand two brilliant white, gigantic rectangular shapes, one vertical, the other butted horizontally against it. A few red balcony doors and huge glass windows articulate the planes, but otherwise everything is bare and smooth and cannot be categorized by any conventional definition of house. It is rather as though a lucidly-arranged architectural model is being used to demonstrate what 32,000 cubic m. of constructed space represent. A space for a certain number of people and their working materials. Like the smallest functional object manufactured in the Bauhaus Workshops, this, the largest, has been constructed from a few simple spatial forms. It is for this reason that here, in everything from a brass ashtray to a dwelling house, we acquire a sense of the ... unity of all things made by human hand in contrast to all natural things, a unity independent of size or scale.

The demand for cleanness, clearness and generosity has triumphed here.... Every object betrays the method of its construction; no screw is hidden; no decorative carving conceals which material has been used. One is tempted to assess this honesty even in moral terms.

A purely functional house. Here work is carried out 'constructively' and not, as it once was, with the aim of achieving the most individually rich optical impression possible. Nevertheless this constructive quality does satisfy the eye. Above all what is demonstrated here more clearly than ever is how the practical is at the same time truly beautiful. In terms of aesthetic composition it is also good to see how stair rails, chair legs, door handles and teapots have been made from the same tubular metal. The old 'unity in diversity', until now applied only to buildings, statues and paintings, has taken on a new meaning here: a house in which a thousand different objects stand can be comprehended as a structured whole....

Even colour has been given a function. It serves to separate and orientate: different colours help us to distinguish one storey and the next, which way the doors open and the drawers in a writing desk....

Lyonel Feininger to Julia Feininger

Dessau, 2 August 1926

... I'm sitting on our terrace which is simply blissful. The overhang and the short south wall that, on the plans of the house, we were so unhappy about, give just that comfortable light – without these projections everything would be bathed in the sun and mid-day heat. It's true of all the rooms – they are nicer to live in and almost always larger than we imagined from the plans and without furniture in them.... I stowed away all of our many crates in the basement on Saturday already; all the packing materials have been cleared away. Outside there are many gardeners and diggers clearing all the rubble away. They've put down paths – the surface is being pounded flat. The trees are a blessing, even in the brightest sunlight one's eyes gaze unblinded at the greenery, and the tree-tops stand out so beautifully against the sky. There is real *space* here and one has the impression of being out in the open. I would not have believed that I could get over the loss of our balcony in Weimar so easily – on the contrary, it's a thousand times more beautiful here.... Our dining room is not at all cramped and Andreas's furniture adds so much colour and warmth that it already seems comfortable and beautiful even without pictures....

*Three Masters and their families at one of the teachers' houses,
designed by Gropius. Schlemmer and his wife Tut are on top,
Muche and his wife El in the middle, while Albers, his wife Anni
and their three children are at the bottom. The photograph was
taken in 1926*

Felix Klee on the Masters' Houses

...In July 1926 we moved into the Master's house in Dessau. Burgkühnauerallee number 7.... The colony consisted of five houses: a single house for the director and four double houses for the Masters. In these houses lived Gropius, Moholy-Nagy, Feininger, Muche, Schlemmer, Kandinsky and Klee. Hence we were separated from the Kandinskys only by a wall.... Our little settlement was situated in one of those pine groves characteristic of central Germany, and had no fences to the rear. On the ground floor of our house was the combined music and dining room, the pantry, the kitchen and the maid's room; on the first floor two bedrooms, a room for my mother and the large studio for my father; on the top floor were my workroom and a guest room. The beautiful surroundings as well as the high quality of our neighbours enabled us to forget the somewhat unpleasant emanations of this provincial town. One wall of my father's almost square studio was black. He painted many of his big paintings here. The size of the room was probably an indirect cause of the new tack that Klee's art took at this period....

Paul Klee in his studio at home.
The photograph was taken by Lucia Moholy in 1926

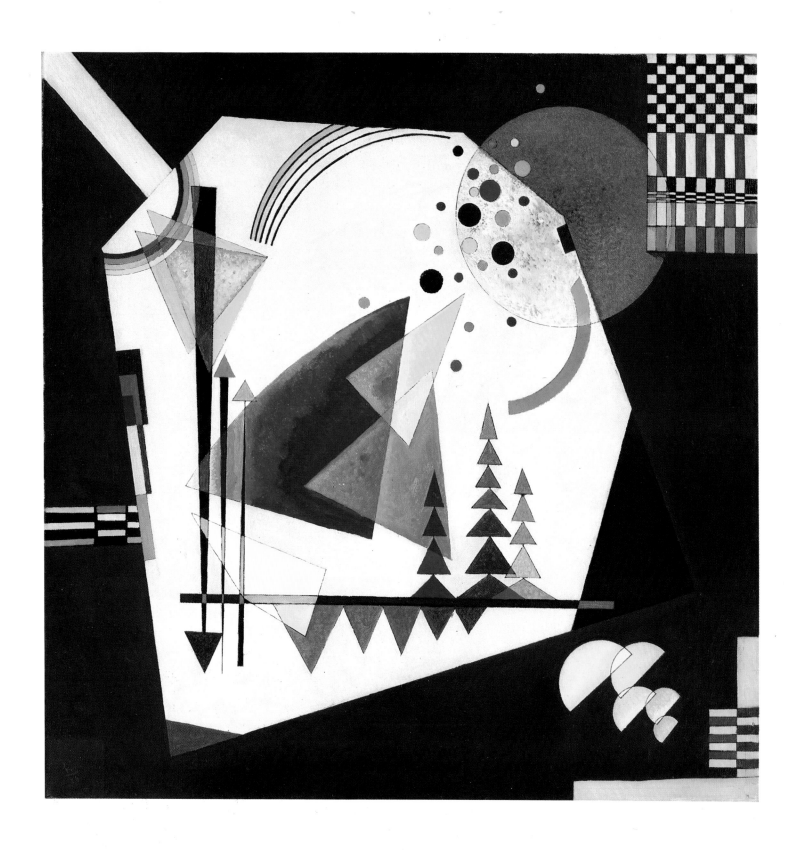

Kandinsky, 'Three Sounds', 1926, oil on canvas

Nina Kandinsky on the Masters' Houses in Nina Kandinsky *Kandinsky und Ich* 1976

... Kandinsky and I were not particularly happy in Gropius's building. There were flaws which did not make living particularly comfortable. Gropius had, for example, made one large wall of the entrance hall of transparent glass so that anyone could look into the house from the street. That bothered Kandinsky who would have preferred his private sphere to be private. Right away he painted the glass wall white on the inside.

Gropius did not want his buildings to have coloured decoration. Kandinsky on the other hand liked to live with colours in a coloured environment. For that reason he had our rooms painted, the dining- room, for example, in black and white. The people at the Bauhaus thought it must be sad to live there, but the exact opposite was the case: the contrasts of black and white created a light-hearted atmosphere.

The living room was painted pale pink with a recess covered in gold leaf. The bedroom was almond green, Kandinsky's workroom pale yellow, the studio and guest room were light grey. The walls of my little private room glowed with a pale pink....

Working to Kandinsky's precise instructions, Marcel Breuer designed the furniture for the dining- and bedrooms in our new house. Kandinsky, at that time right in the middle of his circle period, asked him to make furniture for the dining room, for example, consisting of as many circular elements as possible....

The dining room in Kandinsky's house, showing the painting
opposite on one wall and the furniture with circular elements,
designed by Marcel Breuer

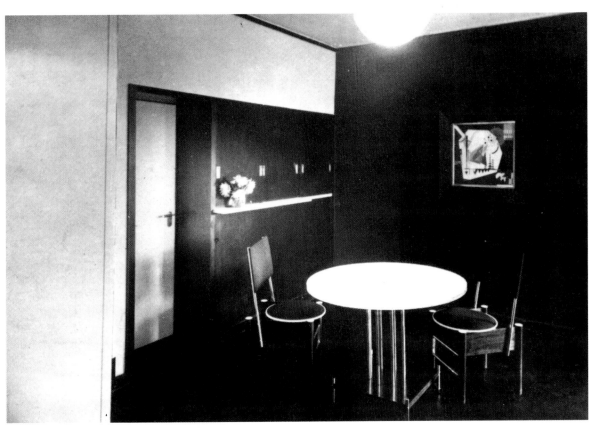

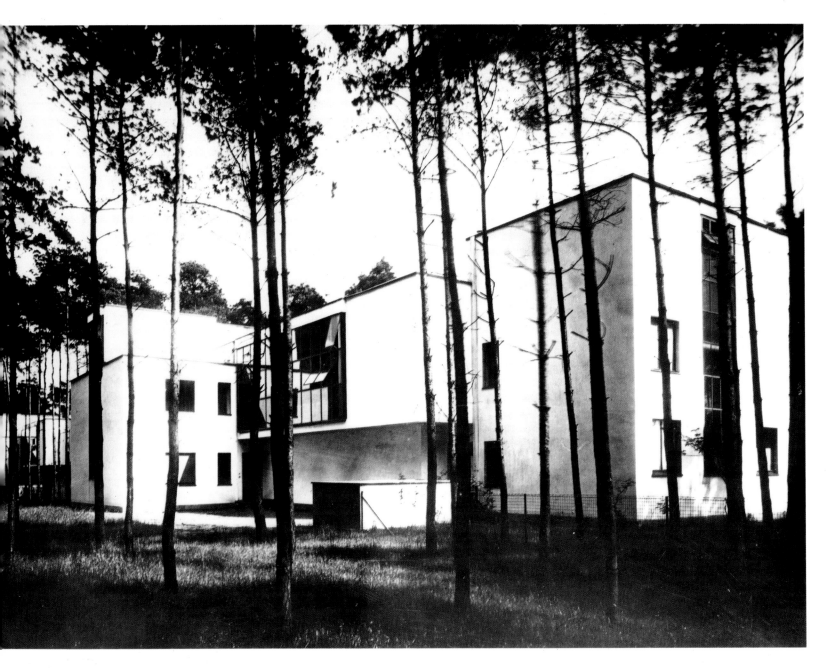

The teachers' houses, designed by Gropius,
seen from the Burgkühnauerallee, Dessau

Lyonel Feininger to Julia Feininger

Dessau, 2 October 1927

... What is going on here is beyond belief and almost beyond endurance. Crowds of idlers
slowly amble along Burgkühnauerallee, from morning to night, goggling at our houses,
not to speak of trepassing in our gardens to stare in the windows. From every vehicle,
horsedrawn or automobile, heads pop out, people crook their necks to get a good eyeful.
Sightseeing tours through the Bauhaus take place every day, architects, craftsmen, trade
unions, women's clubs, and God knows what other associations. Today Moholy was leading
a gang in turned-down collars. They stood in front of our house until all were assembled....
this sort of publicity is hateful....

Fannina W. Halle [journalist] on the Masters' Houses in *Das Kunstblatt* 1929

...A glance into one or other of the houses immediately makes us aware of the enormous differences between the worlds hidden behind all these white-on-white concrete walls, differences which are probably more obvious in number 6–7 than in any of the other double houses. Here, under the same roof, live two powerful artistic personalities, Kandinsky and Klee, both Masters of Form at the Bauhaus. Wassily Kandinsky: the left-hand entrance. One passes a coolly discreet room in pale pink, one partitioned wall of which is gilded. One passes another room, in pure black, but this is made brighter – as though by two suns – by a painting whose colours give off a powerful glow, and by a large round table shining white. One ascends a narrow staircase, and simply by looking at it on the way to the artist's studio one knows that he loves pure cold colours, and that here every form and every colour has a meaning in itself and in combination....

A thin wall separates Kandinsky's workroom from that of his colleague Paul Klee, but one can easily believe that there is a long distance between them since the air which meets us already at the entrance to [Klee's] house seems so different, much more intimate, closer to the earth, more humid even. So different, too, – soft but impressive – is the language spoken here....

Side view of one of the double teachers' houses from the east.
The patios and balconies were so arranged that the outside
could be reached from almost every room

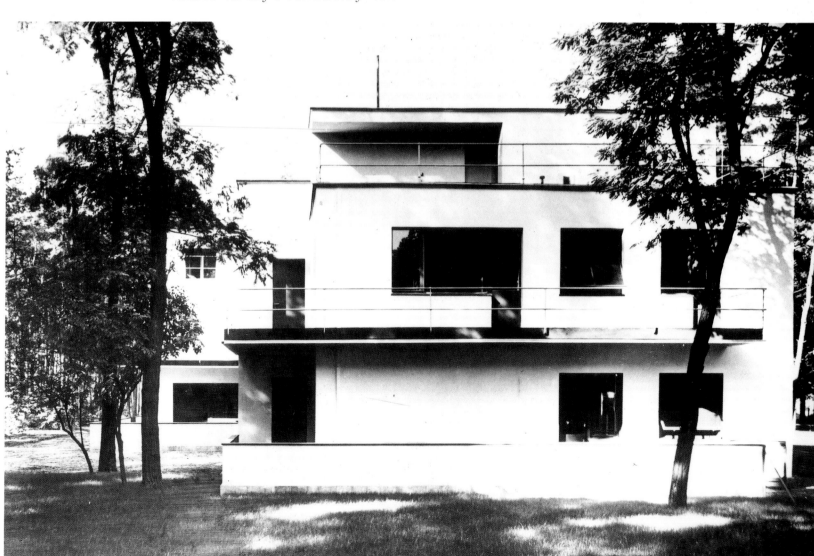

Gropius: Principles of Bauhaus Production

Walter Gropius *Principles of Bauhaus Production* [pamphlet published by Bauhaus Dessau, 1926]

The Bauhaus seeks to contribute to the development of the domestic environment – from the simple household utensil to the completed dwelling – in conformity with the spirit of the times.

Convinced that the house and its contents must inter-relate meaningfully, the Bauhaus attempts to derive the form of each object from its natural functions and limitations and with the aid of systematic experimentation in the theory and practice of form, technology and economics.

Modern man wears modern dress, not historical costume. He also requires modern housing together with all the objects of everyday use which conform to his daily needs and those of the times in which he lives.

An object is determined by its nature. If it is therefore to be designed so that it functions properly – a receptacle, a chair, a house – its essence must first be investigated. This is because it must serve its purpose perfectly, and that means that it must fulfill its function practically, be durable, economical and 'beautiful'. The investigation of the nature of an object in the light of all modern production methods, construction and materials, results in forms which deviate from convention and will often seem unusual and surprising (compare, for example, the change in the design of heating and lighting).

The Bauhaus book about Gropius's buildings in Dessau.
The illustration shows one of the housing types designed for
the estate in the Törten suburb

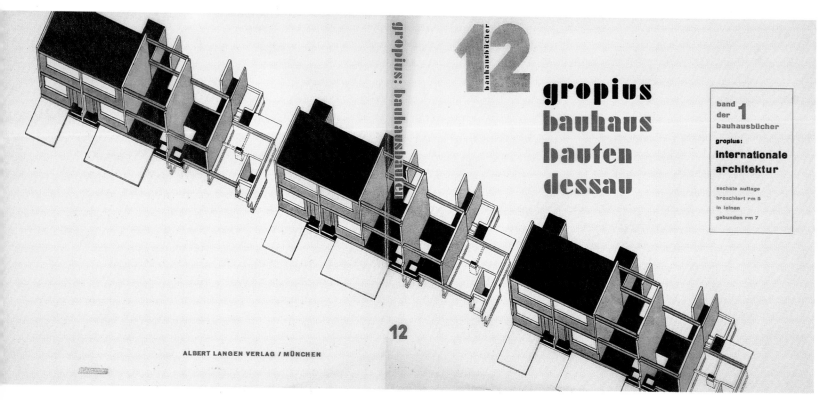

Only through continuous contact with newly evolving techniques, with the invention of new materials and new construction methods will the individual designer acquire the ability to design objects which relate in a living way to tradition and from that relationship develop a new attitude to design:

The determined affirmation of the living environment of machines and vehicles.

The organic design of objects based on their own contemporary laws free of all Romantic beautification and idiosyncrasies.

The limitation to characteristic primary forms and colours comprehensible by everyone.

Simplicity in variety, the economical use of space, material, time and money.

The creation of standard types for all practical commodities of everyday use is a social necessity.

A New Spirit…

Georg Muche 'The Rusty Nail' in *Blickpunkt* 1965

…It was the time when we at the Bauhaus began to think rationally. Until then intuition and ignorance had been our strengths. We made life difficult for ourselves by, for example, attempting to decide during meetings which lasted for hours whether we should mark the doors of the Workshops with letters or numbers or letters and numbers or numbers and letters, and whether these should be white or black or black and white or white and coloured or coloured and black. We considered whether it was correct to write the initial letters of the names of the Workshops on the doors or whether they should follow alphabetical order. When we discovered that the names of two Workshops began with the same letter, we resorted to Ti and Tö. These were the first letters of carpentry (*Tischlerei*) and pottery (*Töpferei*). Fortunately this system was also viable for the other Workshops.

Since we were unconventional, one problem followed another. We tried to introduce something new so that all the objects and materials used at the Bauhaus would be logically ordered and easily found. There would be a room with a card index file and there details of the things could be found. Kandinsky, Feininger, Gropius, Itten, Klee, Schreyer, Schlemmer, Marcks, Moholy – these men gifted with the wisdom of the heart also occupied themselves with such matters. At this particular meeting Oskar Schlemmer said: 'Until now, whenever I had need of a rusty nail, I looked for one somewhere or another and eventually turned one up. But if this new arrangement is ever introduced I shall no longer look. I will go into the office and say 'I require a rusty nail', whereupon a first index card will be extracted from the file and this, under the general heading of Metal, will direct me to Iron. Then, after further shuffling, a further reference will be found on a second card on which small metal objects will be listed. We shall discover that nails are listed on the third card and when that is inspected I wish there to be a list of those places where rusty objects can be found, together with a reference to the location of my nail, rusted and logically positioned.'

These nails, or rather their intellectual background had a great influence on my life.

I took the matter seriously. I constructed, rationalized and built a house of steel. But then the normed pattern of thinking restricted the agility of my thinking. I left the Bauhaus.

Nina Kandinsky on Gropius in Dessau in *Kandinsky und Ich* 1976

... In Dessau Gropius was strangely transformed. It was not only that his interest in the Bauhaus noticeably faded, but also that his views had worryingly changed. It suddenly became fashionable to think that architecture was superior to painting. Architects and painters began to fight each other. The architect Taut published a book in which he tediously attacked pictures hanging on walls. Gropius obviously thought this correct.... His incomprehensible attitude left a painful impression on the painters....

After the barrier between the technologists and painters had become higher and higher, Kandinsky asked him, 'Why did you invite so many painters here if you are basically hostile to painting?'

Gropius had no answer to this. They were talking different languages....

Herbert Bayer, poster for the exhibition at the Kunstverein in Dessau which celebrated Kandinsky's sixtieth birthday

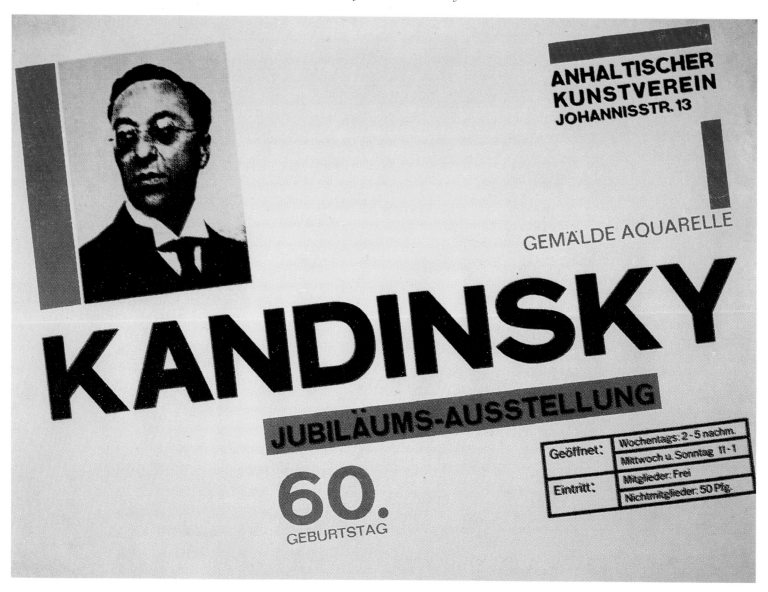

...And Old Metaphysics

Max Bill on Kandinsky in *Kandinsky, Essays über Kunst und Künstler* 1955

...When I arrived at the Bauhaus in 1927 Kandinsky had just celebrated his 60th birthday. I had already enquired in advance what it was that all these painters at the Bauhaus were actually doing,... since officially there was no painting at the Bauhaus. I soon noticed that all these important artists gave classes which had only loose connections with their painting. Thus Kandinsky first taught a kind of 'History of the New Art' and then, following on from it, a class in composition which drew on a knowledge of the way art had developed. A drawing class under his direction consisted of constructing a kind of still-life from a large number of different objects which the students then drew. But they did not copy what they saw, but looked for the structure underlying the entire arrangement. In this way studies were produced in which only the horizontal, vertical or diagonal elements, variously emphasized according to their importance, appeared. Or in which the round and angular forms were contrasted.

The point of the entire class was not 'composition' but 'analysis' of what was there. Not art teaching, but fundamental training in looking. Somewhat later I discovered that in spite of all 'official rejection', painting did go on. There were a few fellow students who did nothing but paint pictures. We disapproved of this very much. We demanded practical results, socially useful products. But deep down there was a '*maladie de la peinture*', a kind of creeping mania for forbidden fruit. I even went so far as to ask one day what these 'free painting classes' given by the Masters were, and whether I could take part in them. So it was that I joined Kandinsky's (and Klee's) free painting class. That meant that one took one's latest 'discoveries' to Kandinsky or Klee once a week. Klee had many students, Kandinsky fewer. His art seemed less accessible than Klee's.... It was only then that I got to know Kandinsky.... Very important was the fact that often painting was not discussed at all: other important questions were raised, even about personal matters.... It was precisely here that Kandinsky's talent for teaching lay: he was a man who gave young people helpful guidance, who did not remove their doubts but awoke in them a sure sense of judgement and an ability continuously to criticize others and themselves....

Wassily Kandinsky 'Point and Line to Plane' 1926

Geometrical point

. . . In geometry, the point is an invisible entity. It must, therefore, be defined as a non-material being. Thought of in material terms, the point resembles a nought.

In this nought, however, are concealed various 'human' qualities. In our minds, this nought – the geometrical point – is associated with the utmost consciousness, i.e. the greatest, although eloquent reserve.

Thus, the geometrical point is, in our imagination, the ultimate and most singular combination of silence and speech.

For this reason, the geometrical point has assumed material form primarily in writing – it belongs to speech and indicates silence. . . .

(left) Karl Hermann Haupt 'Composition', c.1925, watercolour

(above) Lothar Lang, 'Free green form and yellow triangle', exercise for Kandinsky's course, c.1926–27

Paul Klee 'Precise Experiments in the Realm of Art' in *Bauhaus, Zeitschrift für Bau und Gestaltung* 1928

We construct and construct, yet intuition remains a good thing nevertheless. Without it one can achieve much, yet by no means everything. One may work for a long time, do different things, many things, important things, but not everything.

Where intuition is joined to precise research, it speeds the progress of precise research. Precision inspired by intuition is at times superior; but because precise research is precise research, it can, if speed is of no account, make do without intuition, can exist without it, can remain logical, can simply be itself, can boldly bridge the gulf from one place to another, can maintain order in the midst of confusion.

There is enough room for precise research in art, too, and for some time the doors to it have been open. What had already been done for music by the end of the eighteenth century is only just in its infancy in the visual field. Mathematics and physics provide the lever in the form of rules for observation and diversification.

Here there is a salutary compulsion to concern ourselves initially with function and not at first with the completed form. Algebraic, geometric, mechanical exercises are educative steps on the path towards the essential and the functional as opposed to whatever creates an impression. One learns to look behind the façade, to comprehend a thing at its roots. One learns to recognize the undercurrents, learns the prehistory of the visible, learns to dig at great depth, learns to uncover, learns to find causes, learns to analyse.

One learns to pay scant attention to the formalistic and to avoid adopting the ready-made. One learns to make the special kind of progress towards critical penetration, towards the early upon which the later grows. One learns to get up early in order to become familiar with the course of history. One learns what is essential on the path from the source to the real. Learns to digest. Learns to organize movement by means of logical connections. Learns logic. Learns organism.

The result is a loosening of tense relationships. Nothing too tense, inward tension, tension behind, beneath: this means only deep inside, inwardness.

All this is well and good, but it nevertheless lacks one thing: there is no substitute for intuition. One provides evidence, explains, justifies, one constructs, one organizes. Good things, but one does not arrive at the totality....

Ludwig Grote [art historian and museum director] on the importance of the fine arts at the Dessau Bauhaus *Junge Bauhausmaler* 1928

...Probably to redress the balance with the rigorous rationalization that is applied to the point of industrial-technical norming in the Architecture and other Bauhaus Workshops, all the young Bauhaus painters betray an unmistakable tendency towards lyrical, fantastic or grotesque visions, towards the ... extension of the limits of form, towards a kind of Romanticism therefore, which remains full of mystery even if it appears at the same time to have been put between sceptical and ironical quotation marks....

The Preliminary Course under Albers

T. Lux Feininger 'Albers's Preliminary Course', 1960

... One of my first impressions of the *Vorkurs* is Albers introducing a stapler, not so common then as now, and demonstrating its various possibilities with great inward satisfaction, including a statement of the American origin of the machine. I also remember his leading us through a cardboard box factory, a depressing place to me (I confess), and pointing out manufacturing particulars, both good and bad (i.e. capable of improvement), with the kind of religious concentration one would expect from a lecturer in the Louvre....

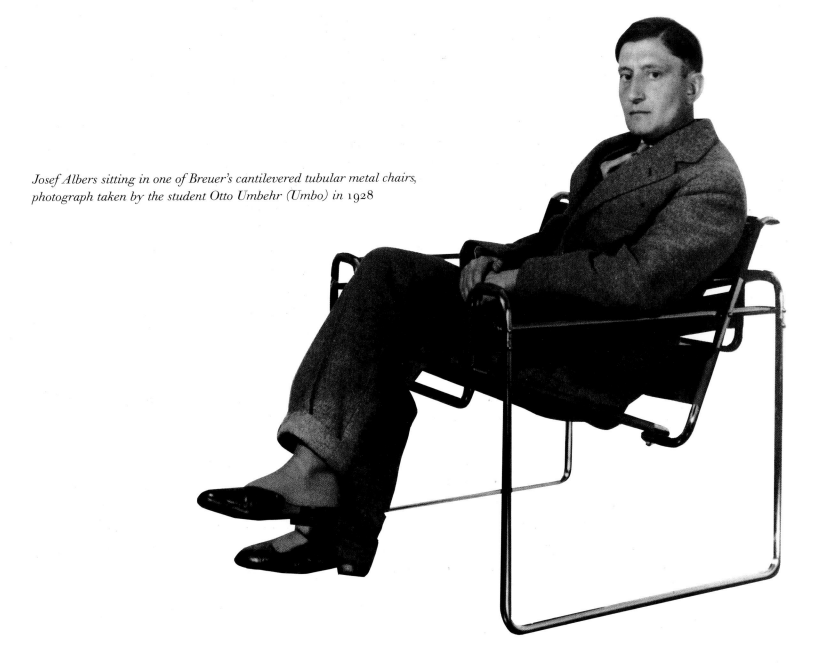

Josef Albers sitting in one of Breuer's cantilevered tubular metal chairs,
photograph taken by the student Otto Umbehr (Umbo) in 1928

Hannes Beckmann [student] 'Formative Years', 1970

... I remember vividly the first day of the *Vorkurs*. Josef Albers entered the room, carrying with him a bunch of newspapers, which were distributed among the students. He then addressed us, saying something like this: 'Ladies and Gentlemen, we are poor, not rich. We can't afford to waste materials or time. We have to make the most out of the least. All art starts with a material, and therefore we have first to investigate what our material can do. So, at the beginning we will experiment without aiming to make a product. At the moment we prefer cleverness to beauty. Economy of form depends on the material we are working with. Notice that often you will have more by doing less. Our studies should lead to constructive thinking. All right? I want you now to take the newspapers you got and try to make something out of them that is more than you have now. I want you to respect the material and use it in a way that makes sense – preserve its inherent characteristics. If you can do without tools like knives and scissors and without glue, all the better. Good luck.' And with these words he left the room, leaving us quite flabbergasted. He returned hours later and asked us to put the result of our efforts on the floor.

There were masks, boats, castles, airplanes, animals and all kinds of cute little figurines. He referred to all this as kindergarten products, which would often have been made better in other materials. He pointed then at a study of extreme simplicity made by a young Hungarian architect. He simply had taken the newspaper and folded it lengthwise so that it was standing up like a folding screen. Josef Albers explained to us how well the material was understood and utilized – how the folding process was natural to paper, because it resulted in making a pliable material stiff, so stiff that it could stand up on its smallest parts: the border of the paper. He further pointed out to us that a newspaper lying on the table would have only one page visually active. The paper had lost its tired look – its lazy appearance. After a while we caught on to his way of seeing and thinking. Fascinating studies in all kinds of materials, like paper, corrugated cardboard, kitchen matches, wire, metal were produced.

We were provided with brass plates approximately nine by twelve inches ... in size, and metal-scissors. The assignment was to use the material in such a way that its inherent quality was preserved. I simply cut along the diagonals of the rectangular brass plate, stopping just before the center of the plate. Then I twisted the two triangular forms at the top and bottom through ninety degrees. The four resulting wings were connected by the half-inch center point where the four diagonal cuts met. Such point connection is, of course, only possible in metal. Any further twisting would have broken off the wings. Josef Albers in his criticism pointed out that the process used to make this study was of the greatest simplicity: four equilength cuts and two twists. He suggested one further improvement. Up until now the metal study would now rest on only three points, taking on a more dynamic appearance resembling a bird in flight. 'Why stand on four legs when three will do?' Albers remarked....

(left) Photomontaged, multiple portrait of Josef Albers by an anonymous student, 1928
(below) Hans Kessler, exercise from Albers's Preliminary Course, 1931. *The transformation of a page from an illustrated magazine*

(left) Arieh Sharon, three-dimensional exercise from Albers's Preliminary Course, 1926 (reconstruction), original cut from a single sheet of cardboard.

(right) Bella Ullmann, 'Movement', exercise from Albers's Preliminary Course, 1929–30. Collage made from cut, patterned wallpaper

Hinrich [Hin] Bredendieck [student] 'Preliminary Course and Sketch', 1979

In the spring of 1927 I arrived at the Bauhaus in Dessau. For me the training began with Albers's Preliminary Course. As I remember, Albers gave a brief talk, just about creative work in general. Then he gave us an exercise: 'Hole in Paper'. We were all, apparently without exception, very surprised: was that truly an exercise? Someone was bold enough to remark that 'We could simply bite a hole in the paper with our teeth'. Again quite unexpectedly, Albers replied, 'Then you'd already have a hole', and with that left the room. Although we were still surprised, we nevertheless began to make a variety of holes. Later we became aware that Albers did not necessarily expect a solution from each of us. His aim was rather to change our conventional way of thinking and to stimulate us creatively. As far as I remember, this 'Hole Exercise' – if you can call it an exercise – was the only one he gave to the whole class. For subsequent work each of us used his own material, chosen by himself or recommended by Albers. Various materials were now employed: wood, paper, glass, wire, plastics, etc. – it was left up to us what and how much we made. Consequently the results were very different. They ranged from an arrangement of pearls on a plate of glass to the optical transformation of a newspaper and simple but also complicated structures made of a variety of materials.

Albers regularly spoke to everyone … and would say such things as 'Achieve more with less', 'visual and structural order', or 'economy of materials'. At the end of term everyone exhibited his work which was then examined by the entire staff. The staff judged whether the student in question had sufficient ability to continue his studies at the Bauhaus. Grades were not given. . . .

New Teachers, New Workshops

Oskar Schlemmer diary entry 25 October 1922

...Marcel Breuer has voluntarily given up painting, for which he would have the talent, and is a cabinetmaker....

Marcel Breuer notes for a Bauhaus evening discussion [lower case as in the original]

...even if i try, i see no chaos in our time, that some painters can't make up their minds whether to paint naturalistically, abstractly or not at all does not mean chaos.
 our needs are clear enough; the possibilities are limited only by ourselves. the main thing is to lend a hand where something needed is lacking, and to move with whatever forces we can command toward a single-minded economical solution....

Marcel Breuer on new materials for furniture 1925

...The thin sheet of veneered plywood is unpopular among professionals because it is an unreliable material, but it nevertheless has great potential for development and in my opinion is the material of the future for the furniture industry – with the aid of clever construction it can be tamed today....

Marcel Breuer 'Metal Furniture' 1928

…Two years ago, when I saw the finished version of my first steel club armchair, I thought that this out of all my work would bring me the most criticism. It is my most extreme work both in its outward appearance and in the use of materials; it is the least artistic, the most logical, the least 'cosy' and the most mechanical.

What happened was precisely the opposite of what I had expected. The interest shown in both modernist and non-modernist circles showed me clearly that contemporary attitudes were undergoing a change, abandoning the whimsical in favour of the rational….

I first experimented with duralumin but because of its high price I went over to using precision steel tubing.

Steel is lighter than wood. This paradox is simply explained if one considers the static properties of the two materials. Even soft steel, though weighing nine times as much as beechwood, is 13 to 100 times stronger according to the type of load imposed upon it. In addition, steel is a relatively homogeneous material which can be much more easily formed into stress-resistant shapes (e.g. a tubular cross-section) than wood, whose mechanical properties are limited by its tendency to splinter and its non-homogeneous nature….

(right) Marcel Breuer

(left) Lilly Reich, storage unit, walnut, c.1930

Marcel Breuer 'Metal Furniture and Modern Spatiality' in *Das Neue Frankfurt* 1928

... Pieces of metal furniture are part of a modern space. They have no style, since the form intended expresses nothing other than their purpose and the construction necessary to meet it. The new space should not be a self-portrait of the architect, nor, at the beginning, should it reflect an individual idea of the souls of the people who use it.

Since we are affected by the most intense and various impressions made by the outside world, we change the way we live faster than in earlier times. It is quite natural that our immediate environment, too, should be subject to corresponding changes. We therefore arrive at furnishings, at rooms, at buildings which can be altered in all their various parts, can be moved and combined in as wide a variety of ways as possible. The furniture, even the walls of a room are no longer massive, monumental, seemingly rooted to the spot or actually built-in. Instead they are airy, penetrable, drawn, so to speak, in space. They hinder neither movement nor the view through space. The room is no longer a composition, no longer a rounded whole – since its dimensions and elements are capable of being changed in fundamental ways. One comes to the conclusion that some proper, usable object will 'suit' any room where it is required, similar to a living, natural organism, a human being or a flower. The reproductions show pieces of metal furniture which have the same formal character determined by the method of their construction in the most varied spaces: in a theatre, auditorium, studio, dining room and living room.

For these items of furniture I particularly chose metal so as to achieve those qualities of modern spatial elements just described. The heavy, pretentious upholstery of a comfortable armchair has been replaced by a tightly-stretched piece of cloth and a few light pieces of bent tubing to provide suspension. The steel employed, and especially the aluminium, meet the greatest statical requirements (the stretching of the material) with strikingly little weight. The sledge form makes [the furniture] easy to move. Each type is constructed from the same normed parts which have been kept simple and can be taken apart and changed at will. These pieces of metal furniture are intended to be nothing more than the apparatus necessary for the life of today....

Marcel Breuer, tubular steel and linen chair, 1928,
mass-produced by Standard Möbel, Berlin

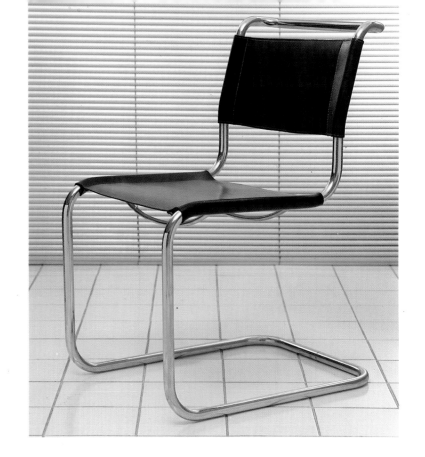

(right) Marcel Breuer, tubular steel and canvas chair B5, 1926–27

(below) Herbert Bayer, cover of catalogue of Breuer's metal furniture, 1927. Illustrated is the cantilevered tubular steel armchair of 1925–26 indicating the elastic fabric elements. What Breuer wrote in the catalogue about the chair appears on p.229

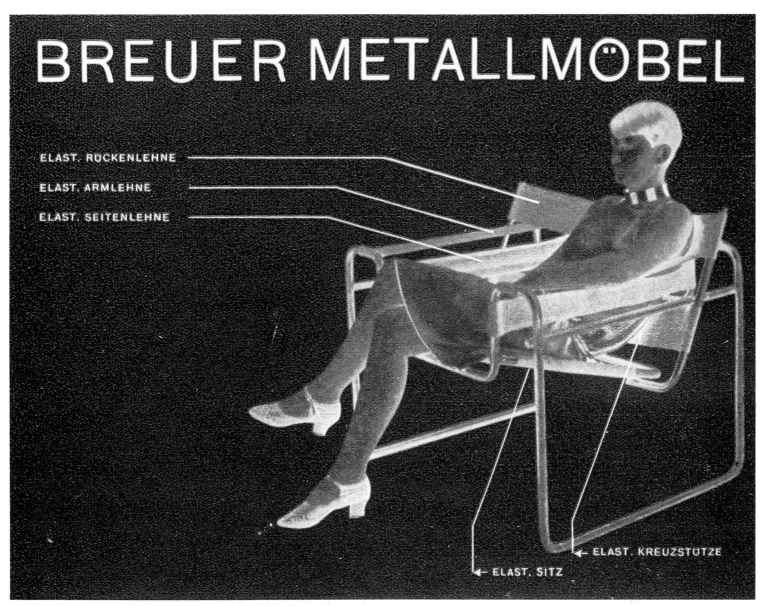

BREUER METALLMÖBEL

ELAST. RÜCKENLEHNE

ELAST. ARMLEHNE

ELAST. SEITENLEHNE

ELAST. KREUZSTÜTZE

ELAST. SITZ

Joost Schmidt *How I Experienced the Bauhaus* [undated typescript]

. . . The more the Workshops were developed and the teaching took effect . . . the more pleasure was taken in discussing and theorizing. The Workshop activity became a healthy counterbalance.

Production became more important. Technical skills had to be learned and applied. Now a joy in experimentation, heedless of every extreme, developed. That was fortunate. Only in the extreme and the point at which it meets real life can limits be recognized and the correct path found.

Marcel Breuer's first chair, for example, was a curious Expressionist sculpture. His further attempts led him to a chair made out of steel tubing which then caused a furore.

Or Jupp (Josef) Albers who preferred glass. He went to the rubbish tips, collected glass splinters, the bottoms of bottles and scrap metal and made surprising glass pictures with them. From these strange beginnings he developed the Stained Glass Workshop. . . .

Josef Albers, four glasses from a tea service, 1926

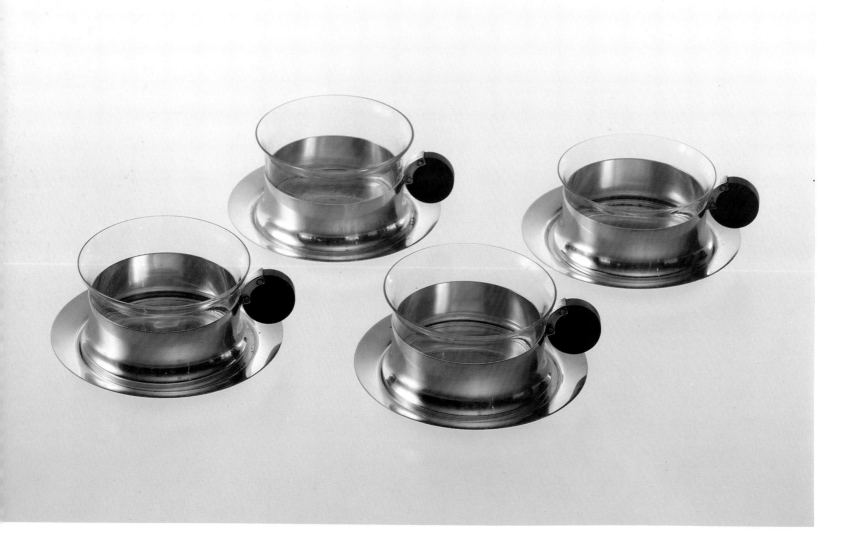

Wilhelm Lodz [student] on the Design Work of the Metal Workshop at Dessau

... Work on objects generally began with a Workshop discussion that was always led by Moholy. He was given technical support by Christian Dell or his successors. These Workshop discussions ... were always like collective consultations. Collectively we exchanged knowledge about the function of the object that was to be developed. If it was to be a tea or coffee service, for example, we would learn everything about the methods commonly used to make coffee or tea all over the world. ...

I believe that Moholy-Nagy had a quite different conception of what a craftsman is – not the craftsman who makes everything by hand, but a person who has mastered the processes of hand as well as industrial manufacture, who supervises them and who, because of his mastery and supervising skills, can influence the design [of an object]. Whether he happens to need to produce an industrial prototype by hand or is able to use a machine is of no account. In each case he designs logically and consistently in terms of mechanized production. ...

Wilhelm Wagenfeld, parts of a heat-resistant tea service, 1922.
It was mass-produced by the Schott glass company in Jena,
who kept it in production for many years

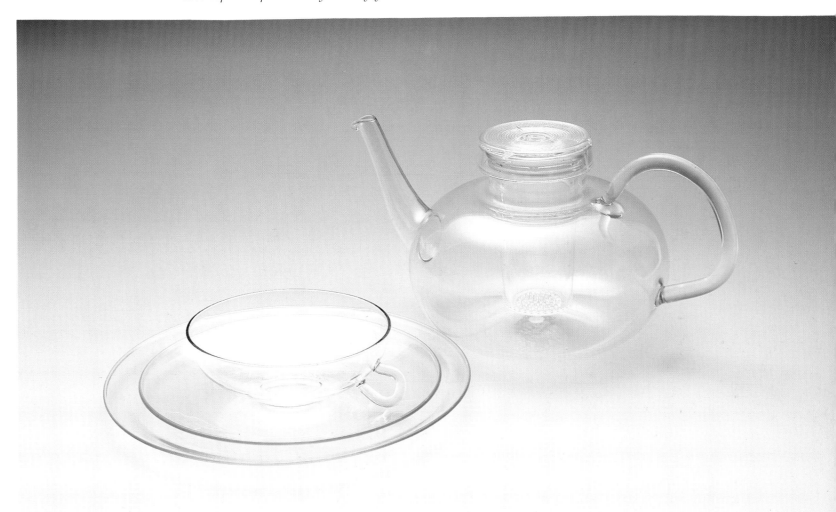

The Weaving Workshop

Gunta Stölzl on weaving in *Offset, Buch- und Werbekunst* 1926

...Since the development of the mechanized loom has so far not reached the point where it can offer all the possibilities of the handloom, and since it is precisely these possibilities which the person needs in the course of creative development, we are concerned primarily with *hand weaving*. This is because work with the handloom alone provides so much scope and permits a concept to develop from one experimental stage to the next until the emergence of such concentration and clarification enables a protype to be supplied to industry and mechanically reproduced.

Since the use of fabric and, with that, the purposes it can meet are so various, a few types of weaving are set out here:

A covering or curtain – these are easily moved and changed objects which meet each individual's taste and needs in their forms and colours.

A floor carpet can form part of the overall composition of a room and as such can function as a spatially determining element. But it can just as well be conceived as a self-sufficient 'thing in itself' which, in its formal and colouristic language can treat some two-dimensional visual theme.

Upholstery material – demands a charming, structural surface effect by means of its fixed spatial position and functional purpose.

The gobelin and wall decoration are not functional objects. Other standards apply to them; they exist in the area of free artistic expression which is nevertheless determined by the weaving process....

Anni Albers 'The Weaving Workshop' 1938

...It was a curious revolution when the students of weaving became concerned with a practical purpose. Previously they had been so deeply interested in the problems of the material itself and in discovering various ways of handling it that they had taken no time for utilitarian considerations. Now, however, a shift took place from free play with forms to logical composition. As a result, more systematic training in the mechanics of weaving was introduced, as well as a course in the dyeing of yarns. The whole range of possibilities had been freely explored: concentration on a definite purpose now had a disciplinary effect.

The physical qualities of materials became a subject of interest. Light-reflecting and sound-absorbing materials were developed. The desire to reach a larger group of consumers brought about a transition from handwork to machine-work: work by hand was for the laboratory only; work by machine was for mass production.

The interest of industry was aroused....

Otti Berger, hand-woven rug, c.1930

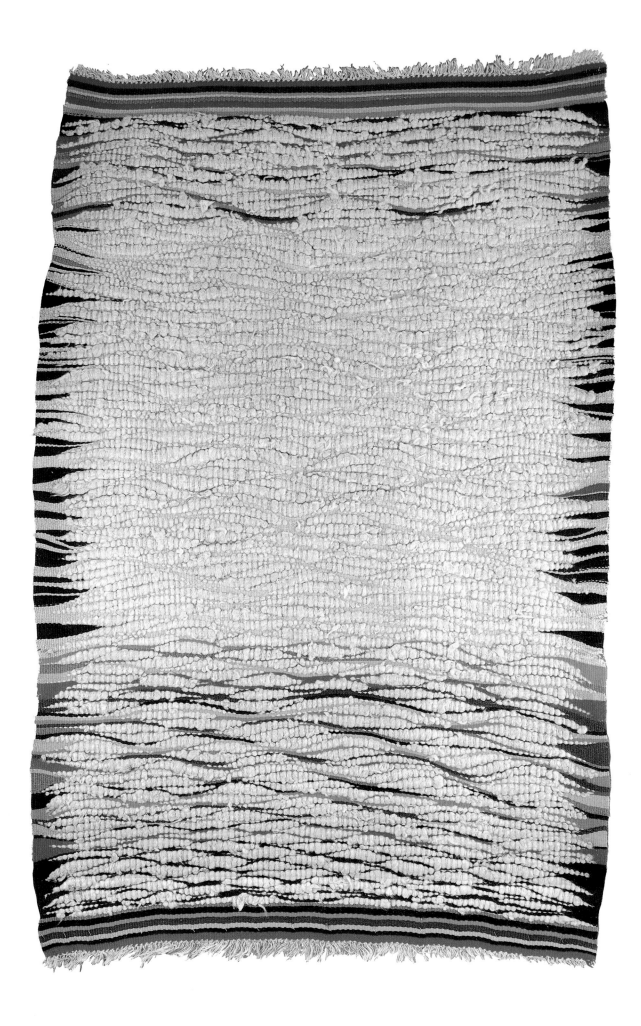

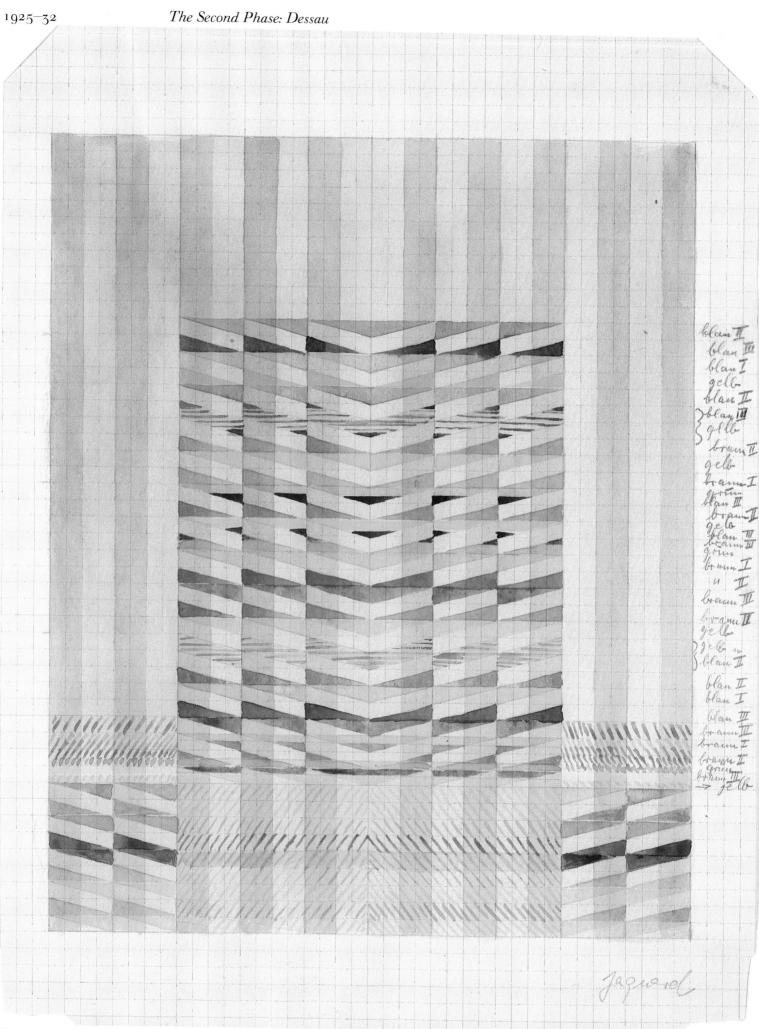

Gunta Stölzl, design for Jacquard woven hanging, 1928–9, watercolour and pencil

Helene Nonne-Schmidt in *Vivos voco* 1926

Why do we continue to concern ourselves with weaving rather than look for entirely new materials which have the same qualities as woven fabric: which can be dyed, are elastic, can be made to any size, are easily divisible, soft, and above all economic, but which do not depend on the painstaking and, in spite of the extreme technical complications, formally restricted process of weaving?...

One day such a new artificial material will certainly exist. But that is a task for the chemical industry and the university laboratories. Once this material has been invented and can be economically produced, weaving for us will have finished.

(below left) Immeke Mitscherlitsch-Schwollmann, design
for a wall-hanging, 'America', 1928, collage, watercolour,
on watercolour board.
(below right) Lena Bergner, sample of clothing fabric, 1930

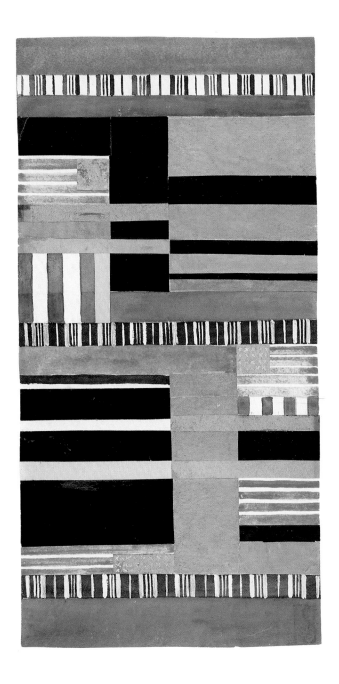

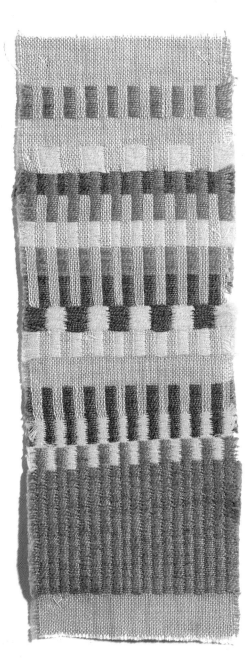

Gunta Stölzl, design for a gobelin, 1927, watercolour

(right) Gunta Stölzl, design for a wall-hanging, 1927, watercolour

The Graphics Workshop

Herbert Bayer 'Simplified Script' 1925

...attempt at a simplified way of writing:

1. this method of writing is recommended by all innovators of writing as our writing of the future.

2. by writing everything in lower case, our writing loses nothing but becomes more easily legible, learnable, considerably more economical.

3. why have two symbols for one sound such as A and a? why two alphabets for one word, why twice the number of symbols, if half the number accomplishes the same thing?...

(left) Herbert Bayer, self-portrait postcard, 1928, photomontage.
(right) Marianne Brandt's student identity card

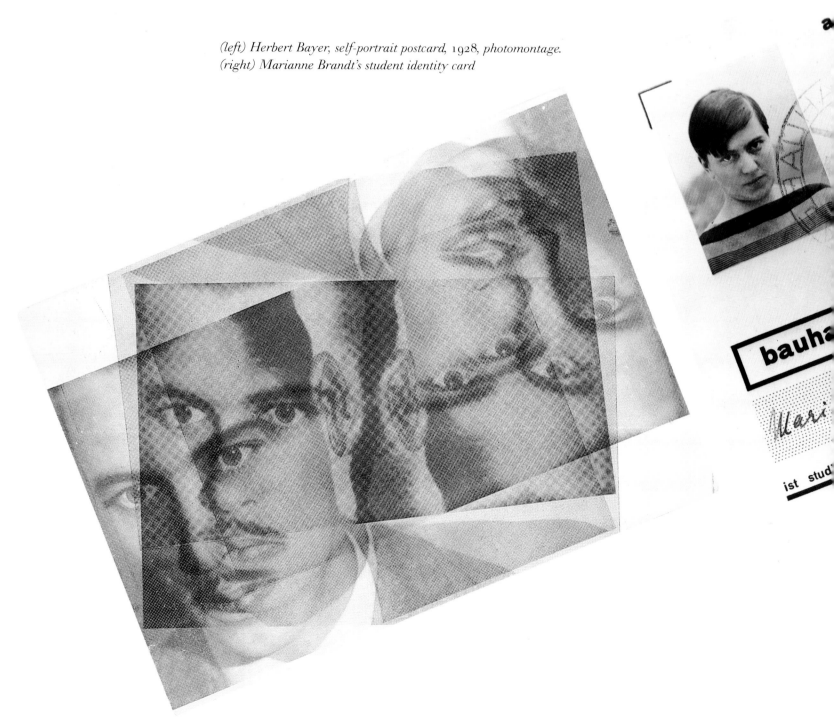

Herbert Bayer extract from acceptance speech for the *Deutsche Gesellschaft für Fotografie* prize, Cologne 1969

... I first came to the Bauhaus in 1921, bringing with me an interest in what are today dubbed 'the visual arts,' owing to my previous experience as a commercial illustrator.

There was a printer's workshop for lithography and related fine arts at the Bauhaus in Weimar. Since there was no workshop for 'graphic design,' I entered the Workshop for Wall Painting which was already quite typical of my later orientation towards all forms encompassed by the plastic medium.

At this time, the Bauhaus had undergone a huge shift from the prevailing trend of craftsmanship to the idea summed up by Gropius with the slogan 'art and technology – a new unity'.

I was impressed by El Lissitzky's work as well as by Moholy-Nagy's technological and scientific ideas. As a Master at the Bauhaus in Dessau I set up a Workshop for 'Typography and Advertising' in which we could experiment with new techniques....

A unique aspect of the Bauhaus was its ability to instantly realize ideas, irrespective of what was at one time thought to be correct. Moreover, with design function as the standard, the main consideration wherever design is concerned is to expedite achievement of the desired goal. Whoever has something to say about his environment manages to attract an audience without having to advertise. It seemed a logical jump from typography to photography. Just as typography is human speech translated into the visually legible, so photography became for us reality translated into readable images. At the Bauhaus we were not concerned with *l'art pour l'art* but were preoccupied rather with the business of concrete communication....

I was young and not especially aware of the different currents and fashions in the art world during those years. How was this possible at the Bauhaus, you ask? The answer is that my work at that time was motivated more by instinct than consciousness. Also I could only take a limited amount of art instruction for I had to work in the Workshop in order to support myself. The average member of the Bauhaus was as poor as a church mouse.

I remember having seen Dadaist collages as well as Kurt Schwitters himself, who would drop over for an occasional visit. The influence of Dadaism is quite noticeable in one-of-a-kind dance posters, invitations, and birthday cards (both personal as well as those for public display)....

When it came to solving complicated assignments effectively, such as the cover design of a magazine, I had to switch back and forth between creative resourcefulness and pragmatic thinking.

For the cover of the Bauhaus magazine of November 1927, it was my intention to express something of the content of the magazine without the use of words. The basic patterns, the symbolic elements essential to the tenets of the Bauhaus, are united with the draftsman's tools along with the magazine itself. This montage, that is the 'assemblage' of various elements, takes place wholly before photographing....

1 Großer Markt

Seit der Gründung Dessaus am Ende des XII. Jahrhunderts bildet der Große Markt den Kern der Stadt. An den Langseiten stehen im Norden die „Buden", im Süden die Hofkammer — um 1700 von holländischen Baumeistern errichtet in den Formen des Barockklassizismus. Rechts ragt der Turm und das Dach der Schloß- und Marienkirche herüber. Rückwärts schließen die Bürgerhäuser der Zerbster Straße mit Renaissancegiebeln den Markt ab. Das Bronzedenkmal des „Alten Dessauers" ist eine Wiederholung des Schadowschen Originals in Berlin.

(left) Joost Schmidt, cover and two pages from a prospectus issued by the Dessau tourist office, 1931.

(opposite below) Joost Schmidt, cover and contents page of the design magazine Die Form, *(published by the Werkbund) November 1926*

(below) Herbert Bayer, cover for a brochure issued by the Dessau tourist office, 1926

Herbert Bayer on typography and advertising design 1928

...Today advertising has become necessary as a result of business competition. In addition it is ... a cultural expression and an economic factor and is thus a characteristic mark of its times....

The design of functional advertising should above all be based on the laws of psychology and physiology. Today advertising design is a matter that is almost exclusively dealt with in a subjective way. For that reason precision in neither the calculation of its effectiveness nor its aims is possible.... These considerations gave rise to a course in advertising with a broad basis. Typography is regarded as a part of it....

Joost Schmidt on sculpture 1928

I. In his mind, everyone adds the word 'art' to the word 'sculpture'. Since everyone has his own idea of 'art' we reject the word 'art' together with all the notions which accompany it. We can survive without it. II. We do not intend to bring architecture, sculpture and painting together into a new unity, what has already been split into three should not be linked again!...

The Bauhaus Stage

Hans Fischli

...Whenever the Schlemmer Group (his students in the Stage Workshop) walked around or sat at a table in the canteen one had to look at them twice – first they would be theatrical and only afterwards would they be drinking milk out of ordinary glasses. But I never succeeded in seeing Schlemmer himself first in that way and then normally.... Always, whether he was seated and talking, eating or drinking, standing, walking or demonstrating something ... he appeared as though on holiday from one of his paintings. It seemed to me that of all the Masters Schlemmer could be seen most often with the students....

Oskar Schlemmer diary entry 13 July 1925

...To paint this renunciation! As my last picture. I am too modern to paint pictures. The crisis in art has taken hold of me ... Stage! Music? My passion! But also: the breadth of the field.... A completely free hand for the imagination. Here I can be new, abstract, everything. Here I can be old with success. Here I am free from the dilemma I find myself in on painting – to slide back into an artistic genre in which inwardly I no longer believe....

Oskar Schlemmer 'Balletic Mathematics' in *Vivos Voco* August–September 1926

… Let's not complain about mechanization but take joy in mathematics! Not in the kind of mathematics sweated over in the classroom, but in that artistic, metaphysical kind of mathematics which necessarily comes into play at the point when, as in art, feelings begin to assume a concrete form, where the unconscious and subconscious achieve the clarity of consciousness. 'Mathematics are religion' (Novalis) – because they possess the ultimate, most refined and delicate properties. The only danger is that they kill the feelings and suffocate the unconscious at the moment of germination. Mathematics therefore require not the conceit of the schoolmaster but the wisdom of the artist. If today's artists love the machine and technology and organization, if they desire precision rather than vagueness, then this is only because they wish to rescue themselves from chaos and long for form. And if they prefer to turn to older, earlier forms of art rather than to those of today and yesterday, it is only because they respect form and rules. When Stravinsky reaches back to Bach and Pergolesi or Busoni turns to Mozart, or when in painting the return of figuration occurs across a broad front, then this is only a mark of respect for a safer foundation – tradition. If 'excess leads to the palace of wisdom', then this is also true of the frequently audacious excursions of the innovators into the frontier lands of art and beyond them, from hovering between heaven and earth to the terra firma of facts. Flake's definition of the state of today's art, which says that we are now dealing with the 'constraints of the metaphysical', hits the nail right on the head. But constraints of this kind are called form, shape, law, mathematics.

The same is happening in the special field of the dance. With the old kind of ballet a piece of classical, and therefore formally-determined art is doubtless becoming extinct. The exact course of training, the kind of choreography which developed over centuries, the 'freedom within constraint', can, at their most refined, still fascinate today. The full-blooded Russian genius for dance has been most happily allied to French tradition and has taken it to its ultimate triumph. Then chaos arrived: the methodology of the schoolmaster by the side of Expressionist ecstasy, the sugar-sweet, the merely flirtatious by the side of heroic rubbish. But the worthwhile should not be dismissed with phrases. What came from Dalcroze, was organized by Laban and intensified by Mary Wigman, is worthwhile. But are not the Negro jazzman, the perfect tapdancer and the rubber-jointed phenomena of the circus and music halls also not worthwhile for the same reason? Is the question: artist or artiste? Ethics or aesthetics? What standards should apply in the midst of this drama of the reversal of values? Is it the minority of intellectuals who are decisive, or is it the masses who have long since opted for entertainment wherever it can be found?

… I myself am for the bodily mechanical, the mathematical dance. And further I am for starting with the one-times-one and the ABC because I see strength in simplicity – in which every significant innovation is rooted. Simplicity, understood as the elemental and typical out of which the various and particular develop organically; simplicity, understood as the *tabula rasa* and complete removal of all the eclectic baggage of all styles and periods, ought to provide a path to the future. It will indeed provide it if the person who embodies this philosophy of dance has feelings, is a human being.

The human being is as much an organism of flesh and blood as a mechanism of dimension and proportion. He is a creature made up of emotion and intellect and of this or that number of further dualisms. He carries all of them within him, and has the ability

continuously to reconcile the polar duality within himself much better than by making abstract artistic creations external to himself. . . .

What I mean are those creations which, in the dance, grow out of spatiality, out of a sense of space. Space, like all architecture, is a form consisting of dimensions and proportion. It is an abstraction in the sense of being in opposition to, if not actually protesting against nature. Space, if it is regarded as determining the laws governing everything which takes place within its borders, also determines the gestures of the dancer within it. By means of the verticals described by the moving, dancing figure a stereometry of space comes into being, almost by itself, out of basic geometry, out of the pursuit of the vertical, horizontal, diagonal, circle and curve. If we imagine space to be filled with a soft, plastic mass which registers the dancer's movements as a sequence of negative forms, we should see from this example the direct relationship of the geometry of the plane to the stereometry of space. The body itself can demonstrate its own mathematics by freeing its physical mechanics which then point in the direction of gymnastics and acrobatics. Such aids as poles (the horizontal balancing pole) or stilts (a vertical element) can, as 'extensions of the tools of movement', bring space to life by expressing it as a frame consisting of lines, while spheres, cones and tubes can do the same for the three-dimensional relationships within space. This points the way towards the spatially three-dimensional 'costume' which, free from all traces of existing styles, has to do with 'objectivity' or 'design' or 'style' in the new, absolute sense.

If we think at the same time of the possibilities opened up by today's extraordinary technical advances – represented by precision instruments, scientific apparatus of glass and metal, artificial limbs used in surgery, fantastic diver's suits and military uniforms – and if we then think of applying and transferring these products which serve the rational aims of a fantastic, materialistic age to the, oh, so irrational and aimless field of artistic creation, then images arise beside which those dreamed up by the fantasist E.T.A. Hoffmann or by people in the Middle Ages look like kids' stuff. Our so soberly practical age has no time for play – or has forgotten the point of it. What little remains of the desire for it is increasingly met by superficial, banal little pleasures. At a time when religion is dying out, a sense of community is disappearing, everything sublime is being extinguished and people are capable of enjoying only the crudely erotic or the artistically exaggerated, all profound artistic tendencies seem to be marked with the stigma of the sectarian and esoteric. It is therefore both reasonable and necessary that the art of the new epoch should quite naturally use technology and newly-invented materials to provide the forms and vessels for the expression of the spiritual, abstract, metaphysical and ultimately religious.

As a beginning which points the way the *Triadic Ballet* came into being. . . . Called 'Triadic' (from triad) because it is performed by three dancers and because its entire symphonic and architectonic structure consists of three parts and creates a unity from dance, costume and music. The special characteristics of the ballet are the coloured, three-dimensional costumes, the human figure which is in an environment of basic mathematical shapes, and the corresponding movements of that figure in space. The *Triadic Ballet*, which avoids being actually mechanical or actually grotesque and avoids heroic pathos by observing a certain harmonic mean, is a part of a larger entity, a 'Metaphysical Revue', to which the theoretical investigations and actual work of the stage department of the Dessau Bauhaus are related. Our immediate intention and wish is to achieve such a unity in terms of a comically grotesque ballet. . . .

Karl Hermann Haupt, 'The Red Man', c.1925, gouache and watercolour

Oskar Schlemmer 'Das figurale Kabinett' 1927–8

[The eighteen figures are] in part larger than life-sized and equipped with devices which enable them to be moved and carried backwards. The figures are very strongly coloured and, arranged side by side, fill a stage twelve metres wide. The heads can be removed and are interchangeable... Note: those carrying the figures must be dressed in black body stockings and head coverings....

...[The figures] perform a ballet like a kind of round. Here very interesting formations are made possible by means of dressing in line in military fashion. The effects of these formations are heightened by changing light which often totally alters the coloured figures....

Georg Schmidt on Schlemmer's Space Dance, 1929 in *Basler National-Zeitung* 30 April 1929

...Three kinds of gait of the human body – three characters of colour – three characters of form, all of them indissolubly joined: yellow, pointed hopping – red, full striding – blue, quiet walking....

T. Lux Feininger, 'Still life with five Bauhaus theatre masks',
c.1928–29

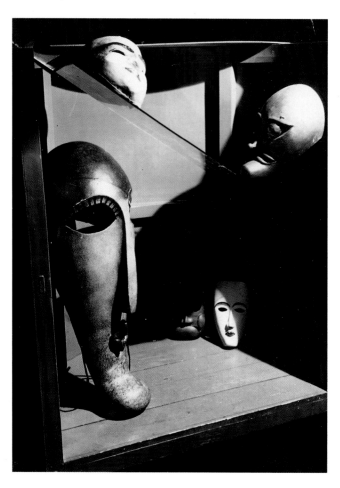

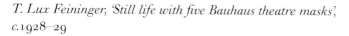

(right) Heinz Loew, model for a mechanical stage
at the Bauhaus, c.1927

Oskar Schlemmer on the 'Catch-phrase party' to celebrate the first anniversary of the Dessau Bauhaus building, to his wife

1 December 1927

... We are preparing a sweet and sour drama, 'The Case of Weimar' with 'climax', 'conflict', etc., everything full of catchword references. For example, the ladder will be the 'ladder of feelings' (Moholy) with every step made of a different substance – sausages, wires, brooms, wool, etc. Moholy is actually making such 'ladders of feeling' in the Preliminary Course – various materials on a wooden board which you have to stroke with your fingers and 'feel' while your eyes are closed.... It can be very funny. We're going to poke fun at a lot of things happening now.... Naturally we shall come down on CO-OPERATIVE, Meyer's battle cry, especially hard – the Architecture Department generally....

T. Lux Feininger on Schlemmer's Stage Workshop, 1960

... For full-scale performances Schlemmer could call on the services of an impressive number of collaborators ... while the work in the stage class, where there were few students, was restricted to the design, construction and conservation of masks, costumes and properties as well as to the planning, direction and co-ordination of future choreographic developments, dramatic sketches and ideas. The last were discussed in a committee under Schlemmer's chairmanship....

I, an enthusiastic and very young admirer, could not understand how a man who had so much to give could give way to a majority which was really not always expert or well-informed, without ever complaining. I wanted him to assert himself more.... He possessed the most individual vocabulary I have ever heard....

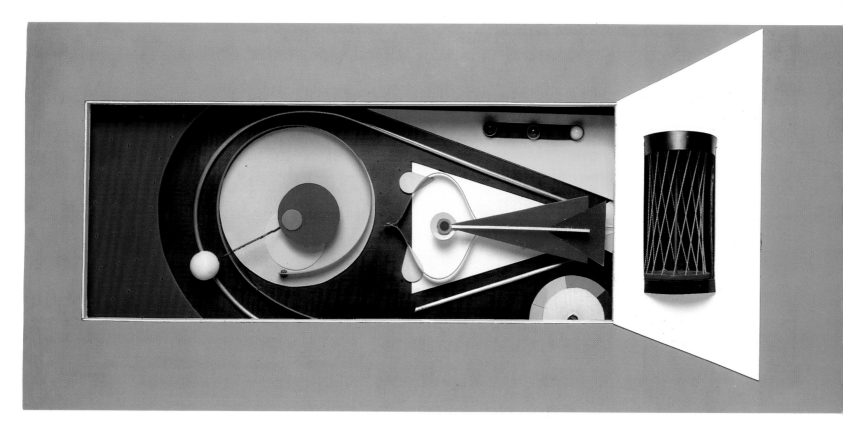

Hannes Meyer and the New Department of Architecture

Hannes Meyer 'The New World' 1926

...Building is a technical not an aesthetic process, artistic composition does not rhyme with the function of a house matched to its purpose. Ideally and in its elementary design our house is a living-machine. Retention of heat, insulation, natural and artificial lighting, hygiene, weather protection, car maintenance, cooking, radio, maximum possible relief for the housewife, sexual and family life, etc. are the determining lines of force. The house is their component. (Snugness and prestige are not leitmotifs of the dwelling house: the first resides in the human heart and not in the Persian carpet, the second in the attitude of the house-owner and not on the wall of the room!)

 ...Individual form, building mass, natural colour of material and surface texture come into being automatically and this functional conception of building in all its aspects leads to pure construction. Pure construction is the characteristic feature of the new world of forms. Constructive form is not peculiar to any country; it is cosmopolitan and the expression of an international philosophy of building. Internationality is a prerogative of our time....

Walter Gropius to Hannes Meyer

Dessau, 18 December 1926

...Mart Stam [Dutch architect] doesn't want to leave Holland and after initial wavering declined my offer. After I got to know you here I immediately wanted to ask if you had the desire and inclination to undertake this task with us.... Actually there are no clearly defined limits so that the way the task is organized can be left to the person who wants to undertake it. In any event I have to get this architectural group here started as quickly as possible and would be very pleased if you would say yes....

Hannes Meyer to Walter Gropius

3 January 1927

...At my present time of life what counts in my decision about taking on a new task is entirely whether it fits in with how I am developing. What is most attractive about your offer is the opportunity to be and work with young people. I am further attracted by the prospect of addressing the problem of the professional training of student architects. As a decided 'collectivist', I am attracted by the idea of co-operation within a working community.

 I cannot, however, form a clear picture of what my task at the Bauhaus would be. I do not know a single student and have not the slightest idea of the students' mentality. What I saw at the dedication ceremony were, after all, superficialities – apart from the valuable and informative discussions with you and the Masters Kandinsky, Moholy, Schlemmer and Breuer. I see the work exhibited in connection with the opening of the building from the narrow abc point of view, and I am for the most part highly critical – with the exception of

250

those things that have great potential for further development, such as the steel house, the steel furniture, parts of Schlemmer's theatre, Kandinsky's basic teaching as well as parts of your basic course. Much reminds me spontaneously of 'Dornach – Rudolf Steiner' and therefore sectarian and aesthetic. As a realist, you will sense this danger to your work even more strongly than I, since I have perhaps misunderstood a great deal out of ignorance of the motives. . . .

Hannes Meyer from the curriculum vitae written to accompany his application to the Bauhaus, 1927

. . . By 'ARCHITECTURE' I understand something which collectively and with the exclusion of everything personal meets all the needs of life, whose realization is subject to the law of least resistance and economy, whose aim must be to achieve an optimum of functionality. . . .

Walter Gropius in *Bauhaus* 1927

. . . The dwelling house is a technically functional organism the unity of which is organically composed of many individual functions. . . . Building means the organization of the processes of life. Most individuals have similar needs in their lives. It is therefore logical and . . . economical to satisfy these mass needs in a unified and similar manner. . . . In itself the standardized type does not restrict cultural development but is precisely one of its preconditions. . . . It is the sign of social order and of the highest level of culture. . . .

Hannes Meyer to Willi Baumeister [abstract painter]

Basel, 13 February 1927

. . . After examining everything again and in spite of all 'ifs and buts' I have now accepted. In any case I have the feeling that I have come to a turning point in my life and find myself sliding from right to left. In other words the new world, for example, has once again become too tame and too little anarchistic, too much like Scheidemann, therefore . . . ! . . . Chance has it that I shall very probably exchange houses with Oskar Schlemmer . . . provisionally for one year. . . .

Oskar Schlemmer to Otto Meyer-Amden

17 April 1927

. . . Once again and instigated not least by Hannes Meyer, there has been a general outbreak of iconoclasm throughout the house. . . . In the house now taken over by the Meyer family everything has been taken down from the walls and all the furniture put away that could be dispensed with. . . .

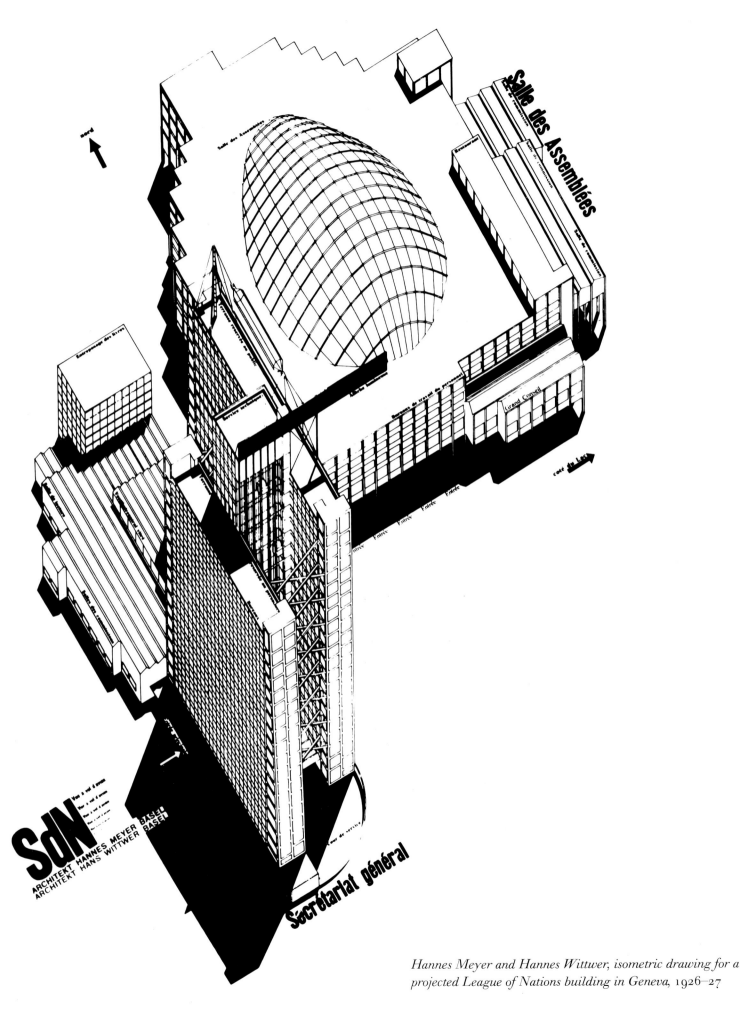

*Hannes Meyer and Hannes Wittwer, isometric drawing for a
projected League of Nations building in Geneva, 1926–27*

Oskar Schlemmer to Otto Meyer-Amden

Dessau, 17 April 1927

... One of his mottoes for architecture is 'The organization of needs'. But this in the broadest sense and certainly not ignoring the spiritual. He said that the strongest impressions here were made by pictures (mine and Moholy's), although not the rooms in which he saw them. He was particularly taken by abstract things by me.... Klee doesn't interest him, he thinks he must still be in a state of trance, and Feininger doesn't interest him either. Kandinsky does because of his theories. Perhaps he is naturally closest to Moholy, although he is very critical of some things.... Muche's new steel house doesn't interest him since very little of it is made from steel. Gropius can be pleased to have got this honest chap as a new flower in his buttonhole....

Hannes Meyer to Willi Baumeister

Dessau, 24 November 1927

... For four weeks (the only) picture by you has been hanging on our dining room wall.... What one misses here entirely is contact with other people. With very few exceptions everyone leads his own independent life while pretending for the benefit of the outside world to share a unified aim.... It's strange that I have the greatest inward affinity with the oldest Masters, with Kandinsky and Klee, and naturally with Oskar Schlemmer who is always 'present' although I seldom see him. Gropius has nothing at all to do with me. We don't understand each other at all. It's a pity but probably not to be changed....

Hannes Meyer to Adolf Behne

Dessau, 24 December 1927

... I received your enquiry about the Federal School of the General Federation of German Trades Unions – I scarcely need to tell you that I and our Building Department are burning to secure a commission.... For three or four years [sic] we have been working only in theory ... have been able only to stand by and look on while Gropius's private practice is constantly having things to build. We are faced (very much between ourselves) with disagreements which touch on the entire Bauhaus problem. Not only I myself but also other colleagues no longer have any desire to go on as we are in the same old way.

In the present circumstances a commission which came via me to the Building Department would act as a boost to the morale the like of which I cannot long for enough....

I could carry out the *building commission* only as the '*Building Department of the Dessau Bauhaus*', with me working only as 'leader'.... The only important thing for us is that our Building Department Secure the commission and not Gropius's private practice once again....

Oskar Schlemmer to Tut Schlemmer

27 January 1928

...Hannes Meyer has great success with the Mayor. They're already saying there that he's done most for the Bauhaus. It's by no means impossible that Hannes Meyer will one day see Gropius off. Perhaps he will resign. The next meeting is on Monday or Tuesday. Moholy won't be staying. The dispute with Hannes Meyer was too serious for that. Both of them in the same building is no longer conceivable....

László Moholy-Nagy letter of resignation from the Bauhaus

17 January 1928

...As soon as creating an object becomes a specialty, and work becomes trade, the process of education loses all vitality. There must be room for teaching the basic ideas which keep human content alert and vital. For this we fought and for this we exhausted ourselves. I can no longer keep up with the stronger and stronger tendency toward trade specialization in the Workshops.

 We are now in danger of becoming what we as revolutionaries opposed: a vocational training school.... The spirit of construction for which I and others gave all we had – and gave it gladly – has been replaced by a tendency toward application. My realm was the construction of school and man....

The Departure of Gropius

Walter Gropius to Wassily Kandinsky

Dessau, 7 February 1927

...You are uninformed as to the superhuman burden I have to carry here, which is further significantly increased through the malfunctioning or the seclusion of some of the Masters.

 I have to declare today that I can only continue to work if I receive the distinct assurance of the Masters to support me more than up to now. Otherwise I have to withdraw, because it is of no use to wear oneself out for nothing....

Oskar Schlemmer to Tut Schlemmer

Dessau, 4 February 1928

...The latest and most important news – that will appear in the newspapers on Monday – is that Gropius is leaving! You're amazed, right? Yesterday he told me and then everyone in the course of a quickly-organized meeting.... Naturally the successor is Hannes Meyer....

Oskar Schlemmer to Tut Schlemmer

Dessau, 5 February 1928

… Yesterday [the architectural historian Sigfried] Giedion was here and gave a lecture with slides. After that a dance was planned in the canteen. But the news that Gropius would be leaving was already (too early) circulating around the town and among the students. They were beside themselves and the band didn't want to play because they thought it would be tactless. But then Gropius addressed the students in the canteen and urged them to dance now especially. Then things were very happy if also too tense. Gropius was very lively. Around three o'clock Andi (Weininger) sat down at the piano and sang his old Hungarian songs and the atmosphere became melancholy until Kuhr started to speak. He said to Gropius: 'You are not permitted to leave us! We have gone hungry here for an issue and if necessary will continue to starve. The Bauhaus is no mere trifle which can simply be handed to someone else. The Council of Masters is reactionary, the students all stand behind you, we have a mission to complete that is set out in Schlemmer's Manifesto for the 1923 Exhibition. That is our programme, that of the Bauhaus which is yours and ours. Hannes Meyer as director of the Bauhaus is a catastrophe! That is the destruction of the Bauhaus!' Gropius replied that although '*in vino veritas*', Kuhr was mistaken. Today nothing depended on a single individual any more, circumstances had changed totally, one should take a positive, never a negative view, they had to demonstrate that they could achieve something, and so on. …

Grete Dexel [writer on architecture and design] 'Why is Gropius Going?' 1928

… Practice has overturned the original programme. Today the Bauhaus is, or wants to be, not a manufacturing workshop and not a commercial business, but a *laboratory for the making and testing of usable prototypes which industry can mass produce much more economically.* The Bauhaus does not directly produce anything, therefore, only indirectly like the research institutes and experimental laboratories of the universities and big industrial firms. It cannot, as was the hope in Weimar, support itself by the sale of its own products because expensive, individually-crafted objects are outside its field of interest, and the mass production of goods is neither within its capabilities nor is it its aim. The Bauhaus therefore costs money and needs a considerable budget to do its work.

If our great industries were nationalized the matter would be more simple. The State could then spend large amounts of money on many such laboratories or Bauhauses, the work of which would directly benefit it. Instead of that, circumstances are such that industry, which *could* be the true beneficiary of the work of the Bauhaus, is only making modest use of this institute's work, and it is doing nothing, at least for the time being, to provide it with any sums worth mentioning. Although licences for the manufacture of Bauhaus designs have this year been multiplying considerably (more than forty prototypes from the Metal Workshop are being reproduced industrially together with large numbers of steel and other kinds of furniture as well as designs from the Weaving Workshop), there is still no prospect that regular funds for new, large-scale experiments will be acquired in this way. Such experiments can still only be made in connection with existing commissions – and obviously only within modest limits – and there is not even enough money available to show sufficient examples of completed work at the Bauhaus.

One hears of large subsidies. One learns that the National Research Association has put 350,000 Marks at the disposal of the city of Dessau, and one makes connections (mostly while protesting angrily) between such sums and the Bauhaus. But the Bauhaus takes no part of it. This money is for the construction of dwellings for which systematic experiments to test new building methods and materials are being carried out under Gropius's direction. These dwellings and an employment exchange for the city of Dessau will still be built by Gropius in spite of his departure. The members of the Bauhaus will have the opportunity to learn, the opportunity to contribute here or there, but the school's budget will not be increased because of it....

The city of Dessau cannot be criticized. It does whatever is possible. The machinations of the parties of the right, made harmless by the energetic and understanding attitude of Mayor Hesse and the consistent support of the left wing, are responsible for interminable annoyance but will cause no damage as long as the present parliamentary coalition lasts.

Gropius had the idea of the Bauhaus and he realized it. Today it stands firm. It has arrived at the maximum number of 160 students; it has achieved success in the world outside; it has an international reputation. It is working, as far as its finances allow, but it is not working completely in the spirit of its programme, and it is realizing the aims of its former director only conditionally. Gropius, the organizer on the grand scale, has grown tired. He prefers to devote his energies to his own work instead of weakening them in the ceaseless battle against hostile forces and in the fruitless attempt to put the Bauhaus on a firm financial footing. That is why he is going.

The departure of other Masters, of Moholy-Nagy, the director of the Metal Workshop and of Marcel Breuer the director of the Cabinet-making Workshop, is not the result of Gropius's departure but there are similar reasons for it. Large-scale experimentation is necessary for Breuer's work and he is hoping that he will have the chance to make closer contacts with industry if he works on his own. There are private and practical reasons for Moholy's departure, too. Together with Gropius he will continue to edit the Bauhaus books published by Albert Langen and he will remain in the same contact with the Bauhaus as will the other Masters who are leaving.

Now, however, the question arises whether the 'new man' will succeed in any way in intensifying the work of the Bauhaus with the funds at his disposal.... He has not issued a manifesto. Until now he has developed the architectural department at the Bauhaus which up to now has not functioned as such. It appears that he will teach more than Gropius did or than it was possible for Gropius to do....

Oskar Schlemmer to Tut Schlemmer

Dessau, 26 March 1928

...Gropius's farewell party is over. The large number of slides didn't work – because of idiocy, but it was good. It meant a massive amount of work, many amusing things happened, people laughed a lot and sympathized with me, the chronicler in a gown and white wig, over the idiotic bungling....

Following the presentation there was dancing.... Gropius was carried and pulled around more than he could bear. Everyone shouted and screamed. I was very tired and went home alone at 4.30. It lasted until morning, many didn't sleep. Gropius and Pia [Ise Gropius] left today....

Hannes Meyer as Director

Hannes Meyer in the *Anhalter Rundschau* 23 November 1928

...The Bauhaus... does not wish to select the most talented ... but rather to attract the greatest possible number [of students] in order that they may then find an appropriate place in society.... Each student must be an effective element in a symbiosis....

Hannes Meyer 'Bauhaus und Gesellschaft' in *Bauhaus* 1928

...As designers
our activity is determined by society and society sets the limits of our tasks. Does not our society in Germany today demand thousands of elementary schools, gardens, houses and hundreds of thousands of apartments for the people??
 Millions of pieces of furniture for the people??
(To what avail here the chirpings of some connoisseur or another for the Cubistic cubes of Bauhaus sobriety?)...
Art?
All art is order...
Art is not a means of beautification.
Art is not the expression of emotion.
Art is only order...
 Finally, all design is crucially determined by the landscape:
to the sedentary person whose work is personal and localized it is unique.
If this home complex lacks mobile people the work will easily become typical and standard.
A conscious experience of the landscape is building as the determination of destiny.
As designers we fulfil the destiny of the landscape.

Mart Stam: M-Kunst in *Bauhaus* 1928

...The Bauhaus, the building, the director, the teachers, the students — none of them is there to make art self-indulgently but to achieve productive work. What is meant by productive work is not only the work in workshops and factories, however. It is just as productive to study the elements of design and to test their previously unrealized potential for use. I remember paintings by Mondrian and Lissitzky, photographic experiments by Man Ray, and three-dimensional studies by some of the Russians (Tatlin, Gabo, etc.) which have significance for architecture.... They may not be regarded as an aim in themselves. They should not be regarded as art but as a means to clear and basic thought.
 We have no need for art, for composition. No balance, no symmetry and no asymmetry. What we require is that everything works, that every function is borne in mind, every need met....

Hannes Meyer to Mart Stam

Dessau, 9 July 1928

... As agreed, I hereby request you to give a vacation course in architectural theory during the coming week, 16–21 July.... Since I have just privately accepted a commission from the town of Bernau to build a double house to accommodate four families ... in the vicinity of the Federal School of the General Federation of German Trades Unions, this building could be used as a practical exercise with all those present. The further setting up of the project could then be given to course members as vacation work, selected on the basis of the best of all student's work....

'In his uncompromising battle against ornament a Dessau architect has cut off his own ears and those of his entire family' – a cartoon by Thomas Theodor Heine from the satirical magazine Simplicissimus *(Munich), 3 September 1928*

Oskar Schlemmer diary entry June 1928

...That art is now finally finished is already being proclaimed by the sparrows from the flat roof of the modern architectural style. *Neue Sachlichkeit*: the 'weightiest' art is the most precise. Abstraction: has ascended up into the nirvana of architecture. For that reason it's also 'understood' by architects. The spirit which you comprehend. The community meets in communal places....

Anonymous in *Bauhaus* 1928

...There is also a Bauhaus Romanticism. Americanisms, the mania for technology, the contempt for the spirit and all the other superior airs are put on by some people at the Bauhaus just as ostentatiously as one used to wear a velvet jacket and extravagant cravat.... These modern detractors of the soul and the feelings above all!

They blissfully listen to every sentimental triviality on the gramophone as long as it's American.

Oskar Schlemmer to Willi Baumeister

Dessau, 18 April 1929

...Am more fed up with this place than ever. Hannes a disappointment. Not only to me. Gropius was a man of the world, after all, capable of the grand gesture, of taking risks when it seemed worthwhile. The other fellow is petty-minded, a boor – and, most important, not up to the job. Toward the theatre, my special area, he is 'personally' negative; he wants a social and political slant, which rubs me the wrong way....

Hannes Meyer to J. J. P. Oud [Dutch architect]

Dessau, 22 July 1929

...As a result of various changes (the departure of Oskar Schlemmer, etc.) we anticipate that we shall soon be able to appoint a new Master to the Bauhaus. We would value the presence here of a Dutchman or Scandinavian since neither of these cultural regions is as yet represented....

Oskar Schlemmer to Otto Meyer-Amden

Gross Dirschheim, 8 September 1929

...The painters at the Bauhaus are not waging open battle against the opposition, which consists of architecture, advertising, 'relevant' pedagogy. Meyer's *dernier cri*: 'sociology'! The students are supposed to do something on their own, fulfill a commission 'with the maximum feasible minimum of direction'; even if the results are unsatisfactory, the sociological factor is considered an asset, something *new*. (I always think involuntarily of the joke: 'Master, the trousers are finished, should I mend them now?'). The goal of these attempts: a (Master-less) Republic of Students. ('With the salary of one Master I can give happiness to x number of students!' Hannes Meyer.)....

Hannes Meyer to Karel Teige [Czech artist and writer]

Dessau, 31 October 1929

…I believe that such an eminent … artist and writer as yourself might very well be able to find a place among us.… I could imagine that you would be able to work at the Bauhaus above all in propaganda, in writing, in the theatre and typography.…

Felix Klee on Hannes Meyer in *Paul Klee* 1988

…Meyer … had very different ideas, and the Dessau Bauhaus became very stiff and regulated. Everything now was geared toward architecture. A rigid schedule of ten hours a day kept people busy from early in the morning until late at night, and on top of that came emphasis on gymnastics and sport. It was all in complete contrast to the founding ideas of the Weimar Bauhaus.…

Philipp Tolziner [student] 'Mit Hannes Meyer am Bauhaus und in der Sowjetunion (1927–1936)

…Probably all the students in the Building Department were for Hannes Meyer. We were enthusiastic about his efforts to solve our tasks in a way based on science and about his slogans 'serve the people!', 'people's needs instead of luxury requirements!' and 'everything we make must be high in quality and at the same time low in price!'. We were for standard types and standardization generally, and did our best to apply all these solutions in our projects and their practical realization.

But with the worsening of the economic crisis at the end of the 1920s we came to the conclusion that all these efforts were pointless under the existing capitalist conditions, since the unemployed were not in a position to buy our comfortable furniture nor to live in our high-quality houses – in spite of low rents.…

Kurt Kranz [student] 'Memories of the Dessau Bauhaus', 1984

…We lived in tiny attics or modest rooms in the smallest flats which Junkers had built for its workers. Mostly we did not have enough money to eat as much as we wanted to. In the Bauhaus canteen the arguments never stopped. There I came to know about many ideologies from anarchosyndicalism to the wisdom of the Orient as well as the usual slogans about the dictatorship of the proletariat. We stood on agit-prop vehicles, laughed at by the workers who mistrusted us deeply in our functional hairstyles. One quickly learned to judge political propaganda. By contrast to the sterile talk about German Expressionism and Cubism, the brand new Surrealist Manifesto of 1929 excited us.…

The Primacy of Architecture

Hannes Meyer on building, in *Bauhaus* 1928

... building is the deliberate organization of the processes of life.

building as a technical procedure is therefore only a partial process. The function diagram and economic programme are the main guiding principles in a building scheme.

building is no longer an individual task in which architectural ambition is realized.

building is a joint undertaking of craftsmen and inventors, only he who can himself master the living process in working jointly with others ... is a master builder.

building has grown from being an individual affair of individuals (promoted through unemployment and housing shortage) to a collective affair of the nation.

building is only organization:

social, technical, economic, psychological organization....

Hannes Meyer, the Federal Trades Union School at Bernau, near Berlin

Adolf Behne on the Federal Trades Union School at Bernau near Berlin in *Zentralblatt der Bauverwaltung* 1931

...The dictatorship of form has been deposed, life is victorious and seeks its own configurations....

The building is required to cater for one hundred and twenty male and female students in 60 rooms....

Hannes Meyer recognized that they are not 120 individuals of just any kind, but people for whom the idea of community has already gone deep into the blood, and so it was into communities that he structured his building. Its basic unit is not a single entity but a group of ten students each who remain in the same group when studying, pursuing sporting activities, playing games and eating.... Effectively then, only ten people live on each corridor, under conditions which favour work and comradeship....

The charming terrain has been left virtually untouched. The distant, uninterrupted view from the communal rooms and living quarters is indescribably beautiful and this was precisely one of the points the architect thought most important: to create the most intimate relationship between nature and the building, free from all officialdom and starchiness.

Hannes Meyer believed that he could most quickly achieve this aim if he dealt with each form and every material without any affection. He did not start out with any stylistic concept, neither that of the country house nor of the Bauhaus, and he created a house which in all its conciseness and severity is amiable and which, in spite of the fanatical way the project was developed... stands there naturally, as though a matter of course....

Philipp Tolziner 'Mit Hannes Meyer am Bauhaus und in der Sowjetunion' (1927–1936)

...I was accepted into the Bauhaus by Walter Gropius, and studied for my Bauhaus Diploma under the direction of Hannes Meyer.... I was, I believed, one of what was then a new type of Bauhaus student who already possessed a vocational training (I, for example, was a trained maker of cane furniture), I already had some experience of work and life and was disappointed... by the study already begun [elsewhere]. Some of us were even students who had qualified in architecture at a polytechnic or university and had professional experience as draftsmen. At the Bauhaus we wanted to acquire in the shortest time possible the knowledge which would enable us to become champions of the new architecture. ...

In the first and second semesters of the course in architectural theory (led, alongside Hannes Meyer, by the architect Hans Wittwer), I went to lectures and took part in exercises given by Wittwer in design, orientation, the calculation of sunlight and its direction and installation, in analytic building given by Hannes Meyer, and the theory of building materials, architectural construction, statics, the theory of solids, reinforced concrete, iron construction, calculation, management theory and psychotechnology given by three other teachers. There were also courses given by guest teachers: the Dutch architect Mart Stam, for example, taught city planning.

I list all the subjects that formed the course of architectural theory because this syllabus was conceived by Hannes Meyer. Later professional practice showed that it was swamped by technical subjects. It was probably equivalent to the syllabus for the training of an architectural engineer....

Now acquainted with Hannes Meyer's architectural theory and some of his projects and living and working in the buildings by Walter Gropius, we began to understand the difference between the aims and working methods of each. The question for us was: who is right, for the architectural philosophy of whom shall we decide?...

I was responsible for the technical condition of the Bauhaus building and for the organization of the necessary repair work and was thus sufficiently aware of the technical inadequacies of the building, above all of the construction of its flat roof. But it was primarily the functional weaknesses in the Workshop wing which we experienced, especially in the summer semesters. The rooms – we called them 'sweat boxes' – were almost unusable as rooms for teaching, working and especially drafting: above all because of the way the gigantic areas of glass let heat, from which the curtains gave no protection, into the room, and because of the low beams of light reflected up by the floor. We understood the aesthetic effect, created by the glass cube of the Workshop wing set proud above the supporting storey of pillars, which Gropius intended, but we also noticed that he had given the worst lighting conditions imaginable to the rooms for typography and printing above all....

All that determined our position: we were for Hannes Meyer!...

I can well remember the significant changes which occurred at the Bauhaus when Hannes Meyer began his directorship and which were also noticeable on the second floor of the bridge. Until about the end of 1928 Walter Gropius's private architectural practice was situated there. Then its place was taken by the Building Department of the Bauhaus. All of Hannes Meyer's commissions were carried out as Bauhaus commissions and worked on there. A single exception was the competition to design the Trades Union School at Bernau. This project, in which Hannes Meyer was invited to participate before he took over the Bauhaus, was carried out in the private studios in Hannes Meyer's and Hans Wittwer's houses. After it had won the prize and the commission [to design the final building] had been given to Hannes Meyer he led the further work alone. The work ... was carried out by Bauhaus students who were already working in Meyer's design office in Berlin. As a result Hans Wittwer severed connections with Hannes Meyer and left the Bauhaus....

Hannes Meyer to Karel Teige

Dessau, 24 March 1930

... Why do you emphasize that the building in the Törten suburb of Dessau was carried out under my direction? I was so proud that truly collective – that's to say anonymous – work was being done at the Bauhaus for the first time....

Painting Classes – Official!

Hannes Meyer to Willi Baumeister

Dessau, 24 November 1927

... To the horror of all likeminded friends among the pack of those who visit me, there now hangs a 'W.B.' above the dining table in all its poster-like proportions. I am being branded as a backslider. I must admit that it amuses me to see something in front of my nose on the wall for a time once again. At the moment I am thinking hard about the subject of 'colour in architecture' and am also talking in class about this subject at present....

Ernst Kállai 'Zehn Jahre Bauhaus' in *Die Weltbühne* 1930

... Whoever glanced into the studios and rooms of the *Bauhäusler* at night was amazed by the many painters who were standing here and there at their easels, brushing away at their canvases – a few only in secret, like schoolboys secretly writing poetry, perhaps with a bad conscience, because they were not brooding over modern functional buildings, collapsible chairs or lamps....

Ursula Schuh [student] 'In Kandinsky's Classroom' 1964

... Searching, I walk past the closed doors bearing the often-quoted, impressive names, down the silent corridors until I find the door: Painting Class. Kandinsky. Thank God! 'He' has not yet arrived. I find a seat. Benches. Tables, like a school classroom.

'He' arrives. Everything shadowy immediately flees before the vital, quick, light-blue gaze through the finely-polished lenses of his spectacles. A gaze which is interested in everything. Which seems constantly to be uncovering new mysteries in the world outside. Then there are questions and answers, and, without noticing, we are already in the midst of the problems of his colour course. He has brought with him a large number of rectangles, squares, discs and triangles in a variety of colours which he holds up in different combinations in order to test and develop our visual sense. In this combination, for example, the yellow seems to be in front and the blue behind it. If I add this black to it, 'what happens then?' etc., etc....

Only later did I notice Kandinsky's almost femininely sensitive but very controlled mouth. The hair speckled with grey. The worthy, rather preceptor-like nature of his appearance. The correctness of the dark suit. The snow-white shirt, the bow tie ... brown shoes. The studied elegance of a scientist in 1931....

(right) Franz Ehrlich, Relief Construction, 1928, oil on board

(below) Franz Ehrlich, Blue with Yellow and White Point, 1929, oil on board

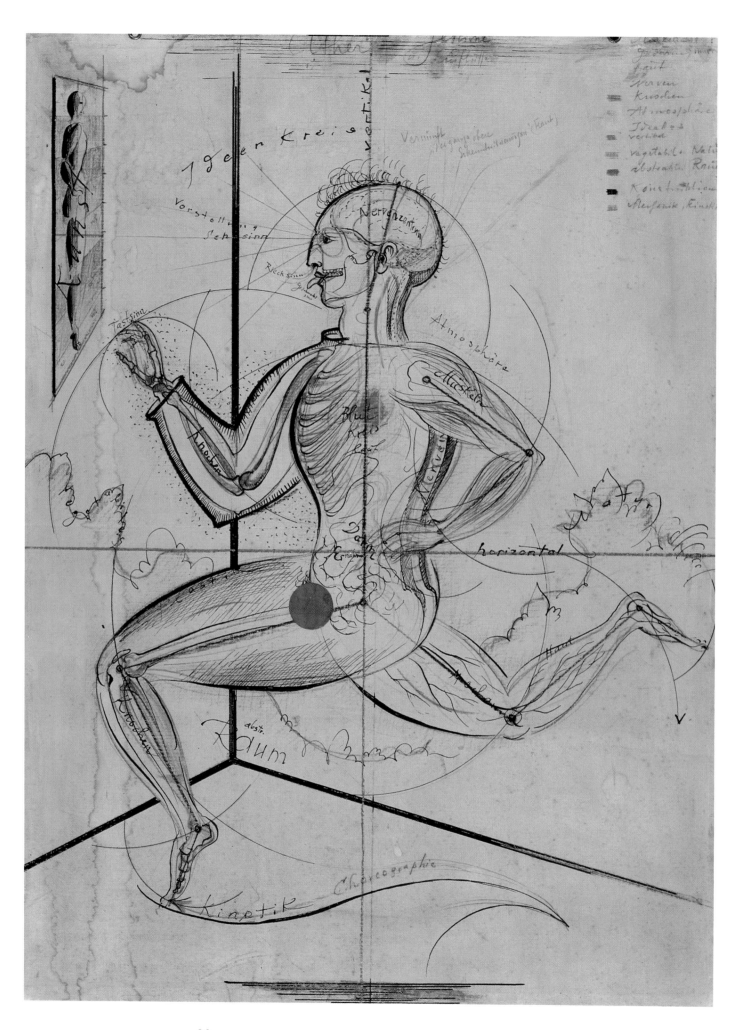

'Art is Order' in the Workshops

Hans Fischli on Schlemmer's new course 'Man'

... He taught his course, his theme – Man – to the entire student body in the hall. It was open to all of us, not compulsory, rather a matter of honour.... It was 1928–1929. The archaic principle of the Golden Section was being rediscovered. In his first book, *Vers une architecture*, Le Corbusier had just then used it as a standard, applied it as a measure to the façades of old and new buildings. He had not as yet described his 'modulor' which he had derived from the principles governing the proportions of the human body.

This great theme was developed for us in his classes by Oskar Schlemmer, the painter who was born in Stuttgart in 1888.

Standing on a small podium and using chalk and an angled blackboard on the wall, he showed us proof after proof – like a dancer, as though using himself as his own visual aid.

With his hand he drew – you saw the confident mark he made before it was really there – the schemata of the human body with its harmonic series of measurements.

An artist taught anatomy.

A man with intelligence talked about the point of our senses.

A painter and dancer showed us – young people – Man at the centre of all things and revealed his image.

He taught us the theory of harmony by using the human body as an example. He showed the course of the lines which describe the shoulders during balanced striding. Or those of the head while going up or down stairs.

He taught us to see early Greek sculpture and to read Greek philosophy

Schlemmer needed great courage for his course which was exclusively concerned with beauty, with harmony.

Sharp, angular, cubic was trumps.

The right angle, the vertical and horizontal became for the outside world Bauhaus style ... Schlemmer, putting the human body, the system of its measurements at the centre approved of the free swing of a line, of the circle and sphere.

And in order to bring his preference closer to us, he drew the systems of the human body for us until each of us saw how his circles came out of it....

After Schlemmer had demonstrated to us that the construction and relative measurements of the human body are the most sensible objects for contemplation, the proof of his theory of harmony, and we believed him, he had us practise drawing from the nude model. Students of both sexes posed. He did not walk up and down amongst us, didn't look over our shoulders to control what we were doing and did not add corrections in the margins of our paper. Somewhere in the hall he sat and drew like one of us....

Schlemmer, 'Man', 1928, schematic representation showing man's
relationship to space and time, to nature and ideas, together with
his mechanical and biological functions. Made in connection with
Schlemmer's course on the nature of man

Hans Fischli on a student competition to design wallpaper

... I was clear about one thing. Art had to be excluded.... What made me angry during the painting process were the areas where the paint was applied unevenly: oil plus circles plus colour.... I also used forks, a comb, a razor without blades, everything that had teeth and gaps.... I became clever, applied bands of different colours and then went over them up and down in wave movements. Most time was taken up with waiting so that nothing was smeared.

There was white in white,

a yellowish shimmer on brownish furrows,

ochre earth beneath,

greenish hay harvest above yellow-green stubble,

at a few points bright grey dust.

A considerable pile of ideas resulted.

I selected from them carefully – everyone was permitted to suggest twelve variations – and gave them titles:

Structure in Yellow

Structure in White

Structure in etcetera, up to twelve.

I submitted them and won two-thirds of the prizes, my remaining designs were purchased.... I was the winner and inventor of Bauhaus wallpaper....

The ... papers with subtle colour variations were collected into the blue and yellow 'Bauhaus Pattern Book', after the Bauhaus people had learned to adapt to the industrial manufacturing process and the firms to their ideas about colour....

Hinnerk Scheper on the purpose of Bauhaus wallpaper

... By using mechanical reproduction to produce an industrial product accessible to everyone we were able to popularize and give general currency to our manner of treating walls and also to our principles of spatial organization....

Otti Berger on the demands made of stretched materials 1930

... The function of cloth wall covering is to protect the wall, to isolate it against heat or cold, perhaps to increase light. It must above all have a tightly stretched appearance and be hygienic, preferably washable....

One of a series of advertisements by Joost Schmidt for Bauhaus wallpapers, 1931. The slogan reads: 'The future belongs to Bauhaus Wallpaper'

Oskar Schlemmer to Hannes Meyer memorandum of 11 March 1929 about a tour to be made by the Bauhaus theatre

. . . Don't expect me to draw [political cartoons] like George Grosz or make [theatrical productions] like Piscator. I think that we can reasonably leave political theatre to the Russians who do it much better, and apart from that I believe that the German problem lies somewhere else. . . .

'The Young Theatre of the Bauhaus' in a Bauhaus revue, c.1928.
Much to Schlemmer's dismay, informal theatrical productions
took on an increasingly political bias during Meyer's directorship
and were increasingly inspired by Soviet agit-prop examples

Gunta Stölzl 'The Development of the Bauhaus Weaving Workshop' 1931

...Every school ... must be directly connected to the process of life ... materials in space ... must serve their 'function'.... Understanding of and empathy with the spiritual problems of building will show the logical path....

Joost Schmidt *Schrift?* in *Bauhaus* 1928

...historical and national vanities and prejudices belong, like their respective letter forms, once and for all on the cultural garbage heap where the archaeologists can amuse themselves with them....

Anonymous press report of a lecture about advertising graphics given by Joost Schmidt 1930

...As an ideal, Joost Schmidt proposed the setting up of a large advertising agency which would be all the more significant since there is so far nothing like it in Germany today....

Interviews with Students

Interviews with students *Bauhaus Zeitschrift für Gestaltung*, vols. 2, 3 and 4, 1928

Questions 1–3:
How old are you, how long have you been here, which Workshop do you work in?
Where did you study or work before you came here?
Why did you come to the Bauhaus?
Otto Berger:
1 Please ask the Registry.
2 At some dead place from the past.
3 In order to conquer myself and find the *self.*
Rosa Berger:
I came to the Bauhaus because the only people I liked in the entire weaving school in Berlin had been at the Bauhaus. Then I took the opportunity to look at the Bauhaus in Weimar and there, too, *what went on in the canteen was more important for me than in, e.g., the exhibition hall....*
Max Bill:
Before I came to the Bauhaus I worked at the School of Arts and Crafts in Zurich but was dissatisfied. At the Bauhaus I wanted first to study architecture because *Corbusier had turned my head....*

Hermann Bunzel:

28 years old, second year, two terms in the architecture department.

Studied and practised in Coburg, Bremen, Stallupönen and Neustadt-bei-Coburg.

I needed to escape from the architectural swamp that was usual then. . . .

Lotte Burckhardt:

23 years old, third semester, Joinery Workshop

. . . Everything I read and heard about the Bauhaus and everything I saw led me to conclude that here at least the teaching was as broad as possible and that work was consistent.

Fritz Kuhr:

The circumstances which brought me to study at the Bauhaus were, so to speak, accidental. At the Folkwang Museum in Essen I saw pictures by Feininger, Kandinsky, etc., and stood in front of them like an ox in front of a red church door. . . . I was enormously attracted by the idea of learning from Kandinsky what his paintings were actually meant to mean. . . .

Fritz Levedag:

I've studied virtually everywhere, in elementary schools, high schools, specialist schools for the bakery trade, and I liked to hang around railway stations and on dark streets because there's a lot to study there.

Why did you come to the Bauhaus? After I had started my so-called 'artistic career' in my father's business – isn't a pastry-cook a kind of artist too? Well, my friend, just you try to make a glazed, caramelized, transparent ornamental topping for a cream-puff pomegranate dessert! I arrived Next episode in the following issue.

Questions 4 and 5:

What were your first impressions? Were you disappointed or did everything live up to expectations?

If you were disappointed, what was the reason?

Max Bill:

. . . My impression of the Bauhaus was not what I had expected; I was somewhat disappointed, but then I gradually found what had attracted me to the place: clarity

Lotte Burckhardt:

4. . . . not everything is as ideal as I imagined it would be. So much is talked about community and co-operation, and because there is so much talking, one forgets that something has to be done

Question 6

What did you later discover to be valuable about the Bauhaus? Where did you find that your personal abilities and ambitions were encouraged? Apart from your special Workshop training, have you been stimulated to take a new attitude to life? If yes, in what did this stimulus consist? What social and personal, spiritual and material demands do you make of a new attitude to life?

Wera Meyer-Waldeck:

What I find valuable is not what is taught but how it is taught. That people are trained to think and act independently before they are given the necessary knowledge.

Teaching of the kind carried on in the Preliminary Course, for example, is scarcely capable of improvement.

Petra Petitpierre, 'Zwei' (Two), 1929, watercolour

Hermann Bunzel:

. . . The necessity for the Preliminary Course – torture for me in the beginning – became clear in time as the irreplaceable preparation for logical thought and action. I understood that one sought to *provide experience and to apply both practical ability and technical knowledge to the creation of a new form of life*. . . .

Lothar Lang:

The most valuable thing I found at the Bauhaus is the communal life of the Bauhaus people, the new rights and responsibilities which, although unwritten, are nevertheless based on a relatively firm sociological attitude and which therefore seem to me well suited to become the basis of a better social order.

Questions 7–9:

Opponents of the Bauhaus claim that 'the Bauhaus training rejects the idea of basing future developments on the great works of the past and despises methods tested by time'. To what extent do you think this criticism correct or false?

In what do you see the difference between 'art' in the traditional sense and 'design' in the new sense?

Do you see the purpose of new creation only in terms of practicality and usefulness? If yes, why? If no, why do you think that a purely spiritual kind of creativity is still possible or necessary today? In what do you see the value of technology? In what do you see the value of art?

Hermann Bunzel:

. . . It is wrong to maintain that we rejected the past. In terms of building it is complete nonsense, since every further development, every renewal is based on yesterday's experience. With the new, growing, living-standard it will be time even for outsiders to collaborate on what the Bauhaus has pioneered.

Traditional: to create something beautiful with a great deal of effort.

Today's motto: to achieve much good with little

Rosa Berger:

. . . *I must admit that I still don't know with any certainty where 'art' in the conventional sense stops and 'design' in the new sense begins*. . . .

I find that people's attitudes at the Bauhaus are extremely materialistic. But that is connected with the whole organization and with the kind of work carried on in the Workshops . . . *Too much emphasis on objectivity! Special case: 'architects'!*

Max Bill:

. . . the highest demand for the individual from the social point of view: *personal freedom* It is for that reason that technology is so essential. Technology is intended to liberate man, but because of the capitalist system it has enslaved him even more. *Perhaps if personal liberty is one day achieved, everyone will be his own artist; there will be good and bad ones (as there are today); for those who only make art, and those who experience art for themselves*. . . .

Lothar Lang:

...The first demand and the new kind of design are to be found in the area of the purely practical (the building of houses, etc.) because that is the basis of all human existence. As soon as this first demand is met, the second, the demand for purely spiritual creation, comes into play. This demand can to so strong that the first is absorbed, or at least strongly influenced by it....

Co-op [Co-op was Hannes Meyer's code name]:

...technology is a logical aid, art is a spiritual aid, both are means by which the human being can grow: the aim is *the conscious being.*

Question 10:

What do you intend to do when you leave the Bauhaus?

Otti Berger:

...Get married (as if I would)!

But I have no doubt that I shall yet do stupid things, i.e. make compromises which are inappropriate for a member of the Bauhaus, but then one would not be a 'proper' member of the Bauhaus any more.

Wera Meyer-Waldeck:

...I can only answer that I am very curious about this myself and that I'd very much like to know.

Helmut Schulze:

...to work together with others, even if in a subordinate role, for the longed-for substance of the new epoch. My work is dedicated to humanity.

Gerhard Moser:

The 'vocation' of the Bauhaus member is *either* to remain at the Bauhaus and carry out problematic experimental work so that he can put the results of this work at the disposal of the coming new social order... *or to fight for this future order on the outside, irrespective of on which front,* whether as painter, artist or worker. The only decisive thing is that he commits his greatest working strength to it.

Max Bill:

There is no point in leaving the Bauhaus as long as things outside are as they are today.

I think of the Bauhaus as larger than it is in reality: Picasso, Jacobi, Chaplin, Eiffel, Freud, Stravinsky, Edison, etc., are in a sense also members of the Bauhaus. Bauhaus is a spiritual, progressive movement, an attitude which might be called religion.

Co-op:

I shall later retire from the Bauhaus to the Bay of Whales or the Happy Hunting Grounds.

The New Photography Department

Howard Dearstyne [student] on Walter Peterhans 1986

...Among Meyer's ... appointees was Peterhans, photographer, philosopher, pedagogue and perfectionist. Meyer brought Peterhans to the Bauhaus to establish a photographic department which, however much photography had been propagated at the school in Weimar and Dessau by Moholy-Nagy and embraced by the students, had never existed before as such.... Some of the finest photos made, at the time, of Bauhaus textiles and other objects were his work. He also taught higher mathematics to those who were interested....

Ellen Auerbach on Peterhans's photography class

...I shall never forget being present at the preparations for a still-life of six small objects, wool, silk, chiffon, etc., which he set up and photographed. With the aid of two 500-watt bulbs and admirable stamina and sensitivity, he worked at it for hours....

When the wool at last looked at its most woolly and the silk at its most silky, he was ready to expose the negative. After he had developed the plate he seemed dissatisfied and left the still-life in place. Next morning he discovered the reason for his dissatisfaction. After darkness had fallen, a tiny amount of brightness from the minimal daylight was absent. He took the picture again....

Walter Peterhans on the present state of photography 1930

...[Research] which would allow, for example, snow to appear not only as a bright spot beside the dark spots of shadows and the ground, but in the material tangibility of a heap of crystals. We are concerned here with concrete problems of photographic technique and not with the illusory, Moholy problem of photography with distorting lenses or without perspective....

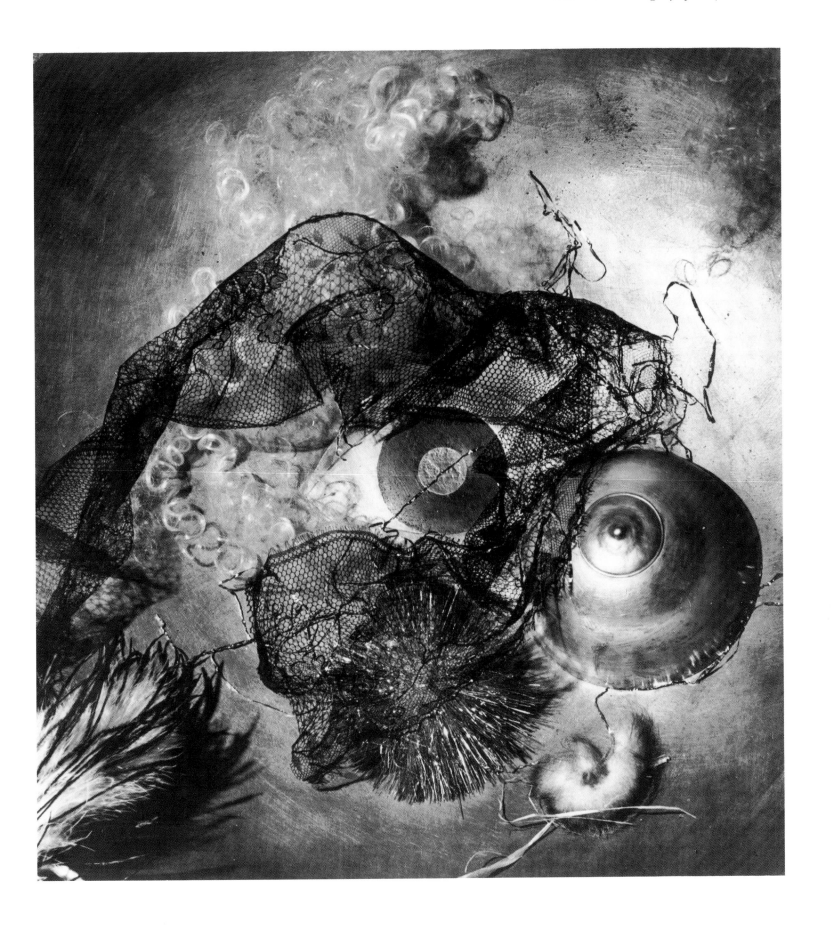

Walter Peterhans, 'Portrait of the Beloved – Still-life with veil', 1929

The 'Metal' Party

Report of the Bauhaus 'Metal' Party *Anhalter Anzeiger* 12 February 1929

...Even the entrance to the party was a novelty. It led down a slide built into the bridge between the two Bauhaus buildings, and even the most dignified personalities could be seen sliding down it into the rooms where the party was being held.... Everywhere there was music, bells, clanging and ringing – in the rooms, on the stairs, wherever one went.... Every part of the populace was represented. Most people wore 'metallic' costumes.... An amusing confusion of film scenes alternated with a variety of performances by representatives of the Bauhaus....

Oskar Schlemmer diary entry February 1929

...A children's slide covered in white sheet metal led one past innumerable gleaming silver balls, lined up and sparkling under spotlights, right into the heart of the party, but first one had to pass a tinsmith's shop. Here the need for every sort of metal could be filled; there were wrenches, tin cutters, can openers! A stairway, of which every step gave out a different tone, a true 'backstairs joke' (in the course of the evening there emerged virtuosi of stair-climbing), led to the tombola; here one could not, to be sure, win folding metal houses and 'living-machines', but things almost as good: steel chairs, nickel bowls, aluminium lamps, lovely cakes with a bit of glitter, and natural and unnatural art. But then on to the realm of true metallic pleasure. Bent sheets of foil glittered and reflected the dancers in distortion, walls of silvered masks and their grotesque shadows, ceilings studded with gleaming brass fruit bowls, everywhere coloured metallic paper and the ever-beautiful Christmas-tree balls, some of enormous size.

The Bauhaus band had dressed festively in coquettish silver top hats, and it launched into the music with great *élan*, rhythm and verve. On the stage, bolts of foolishness dropped from leaden tongues; there was an amusing 'ladies' dance' performed by men, and a sketch in which, to be sure, metal was represented only by the spike of a helmet; these two numbers satisfied everyone's desire to laugh and look....

The Bauhaus looked lovely from the outside, radiating into the winter night. The windows were pasted on the inside with metallic paper; the white and coloured light bulbs were concentrated according to room. The great block of glass permitted long vistas; and thus for one night this house of work was transformed into the 'high academy for creative form'....

(above right) The 'Metal' Party on 9 February 1929, showing the slide across the bridge into the Workshop Wing.
(below right) Invitation to the Metal Party, 1929, printed on metal foil

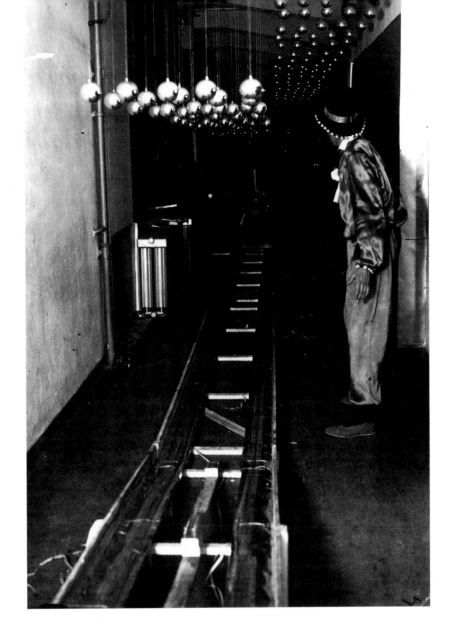

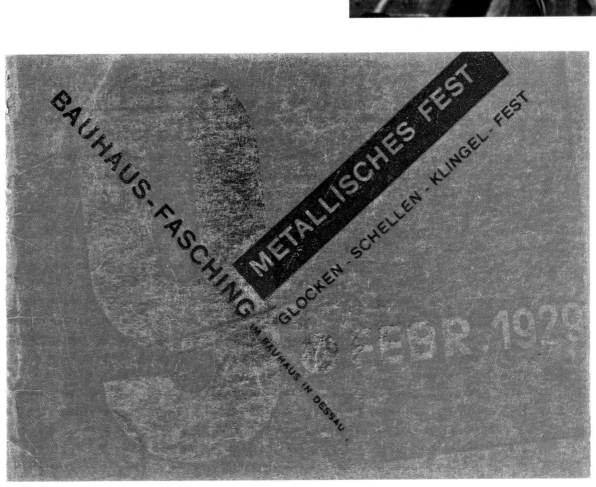

Bauhaus 'Style'?

Ernst Kállai 'Ten Years of the Bauhaus' in *Die Weltbühne* 1930

...Ten years have passed since Walter Gropius reorganized the Weimar School of Arts and Crafts and gave the new school the name 'Bauhaus'. The success of what he founded is well-known. What, when it started life in Weimar, was a highly controversial experiment undertaken by a few outsiders, has become a large and flourishing business....

Today everyone knows the score. Flats with a great deal of glass and polished metal: Bauhaus style. The same with domestic hygiene but without a homely atmosphere: Bauhaus style. Tubular steel armchair frames: Bauhaus style. A lamp with a nickel-plated base and an opaque glass disc as a lamp shade: Bauhaus style. Wallpaper with a cubic pattern: Bauhaus style. Picture on the walls, but what does it mean?: Bauhaus style. Typography with bold rules and sanserif typeface: Bauhaus style. everything written in lower case: bauhaus style. EVERYTHING DECLAIMED LOUDLY: BAUHAUS STYLE....

There is no protection against such embarrassing or humorous misuses by the fashionable fixers of our splendid modern epoch. His Majesty the Snob desires something new. Very nice. There are enough architects who can fashion a new decorative attraction out of the Bauhaus style....

But let us take comfort. The Bauhaus style also has its social application – for the little people who live on housing estates, for the labourers, clerks and wage-earners. They are crammed into the smallest flats. Everything very functional and economical. Furniture and appliances within easy reach and ... a tube from the gas main in their mouths. There are simply two sides to the logic of the Bauhaus style. One for the many and another for the few who can afford it....

Walter Gropius in *The New Architecture and the Bauhaus* 1935

...A 'Bauhaus Style' would have been a confession of failure and a return to that devitalizing inertia, that stagnating academicism which I called into being to combat. Our endeavours were to find a new approach which would promote a creative state of mind in those taking part and which would finally lead to a new attitude toward life....

Meyer's Dismissal

Ernest Kállai on Hannes Meyer 1930

... The new director had great promise. But in spite of all his accurate insight and good intentions, he obviously lacked sufficient security, strength and consistency of purpose to achieve thorough-going changes. Today his improvements still remain only partial and they complicate the situation only because they come up against the insuperable barrier of the legacy of the previous director, which in theory and practice still dominates the teaching staff....

Albert Mentzel [Communist student representative] on the Bauhaus in 1930

... The rejection of formal authority, work on the basis of mutual co-operation.... Everyone works according to his power, according to his abilities as an equal part of the larger whole. Now: working trends of this kind should be seen to have failed temporarily.... This time formal authority triumphed. A way to agreement was not found....

Caricature of Hannes Meyer by Adolf Hofmeister, 1930.
The labels read: 'From the Bauhaus, to Moscow, take care!
architecture'

Sport at the Bauhaus, photograph by T. Lux Feininger, c.1928.
Under Hannes Meyer, sport and gymnastics became parts of the official curriculum for the first time

Hannes Meyer 'My Ejection from the Bauhaus' an open letter to Mayor Hesse, Dessau'
in *Das Tagebuch* 1930

... I received your letter of 1 August 1930 informing me of my immediate dismissal from the
directorship of the Dessau Bauhaus at the same time as I learned from the Berlin press of the
maid who was sacked without notice by her employer because she had dared to do her work
without stockings and therefore, so to speak, bare-legged. Although I have not stolen any
silver spoons I nevertheless willingly join her. When all is said and done I also owe my
sacking without notice to my habit of offering for inspection not so much my legs naked and
uncovered as my ideas. As my now former superior you will perhaps allow me to indulge this
strange habit of mine in this open letter.

What has come to pass?

On 1 April 1927 I was appointed Bauhaus Master of Architecture at this High School for
Design by Professor Walter Gropius, the founder of the Dessau Bauhaus. On 1 April 1928
I took his place as director after Mies van der Rohe had refused the offer of the same post.
I thus became a stop-gap, the insignificant follower of a great predecessor....

What did I discover at the time of my appointment? A Bauhaus whose reputation
exceeded its achievements many times over and which exploited that reputation in an
unparalleled public relations campaign. A 'High School for Design' in which a
problematically-constructivized product was fashioned out of every tea glass. A 'Cathedral
of Socialism' in which a medieval cult was fostered by pre-war revolutionaries with the
assistance of their juniors who, while squinting towards the left, concurrently hoped to be
canonized saints in the same temple somewhen in the future.

Incestuous theories barred every approach to design that was appropriate for life: the cube
was trumps and its sides were yellow, red, blue, white, grey, black. This Bauhaus cube was
given to the child to play with and to the Bauhaus snob as a knick-knack. The square was
red. The circle was blue. The triangle was yellow. One sat and slept on the coloured
geometry of the furniture. One lived in the coloured sculptures of the houses. As carpets
on the floors lay the psychological complexes of young girls. Everywhere art strangled life.
Thus my tragicomic situation came about: as head of the Bauhaus I was opposed to the
Bauhaus style.

I fought constructively with the aid of my teaching: All life is a striving for
oxygen + carbohydrates + sugar + starch + protein. All forms of construction must therefore be
anchored in this world. Building is a biological, not an aesthetic process. Building is not the
creation of effect by an individual but a collective act. Building is the social, psychic,
technical and economic organization of the processes of life. Building is the demonstration of
a philosophy and a strong conviction is inseparable from powerful work. I taught the
students the connection between building and society, the path from intuited form to
scientific architectural research and I taught them to demand not luxury but to meet the
needs of ordinary people. I taught the students to despise the great variety of idealistic
realities and aspired with them to understand the only reality that can be controlled, that of
the measurable, visible and ponderable.

My aim was design founded on science and the pedagogical development of the
Institute underwent significant changes: the economist joined the architectural engineer....
I combated the proverbial collective neuroses of the Bauhaus – the fruit of one-sidedly
spiritual activities – by introducing instruction in sport: a 'High School without Physical

Exercise' seemed to me to be nonsense. The weekly teaching plan took into account the periodic changes in the receptivity of the students and the main emphasis of the week fell on three eight-hour days of Workshop activity. For the winter of 1930–31 a basic course in *Gestalt* psychology ... had been planned, another in sociology was prepared and I was working towards the course in socio-economics that was lacking. . . .

Mr Mayor, you are aware of the success of these two years' work at the Bauhaus: the annual income from production of around 128,000 Marks (1928) was almost doubled. The number of students rose from about 160 to 197 and we were able to keep the numbers down only by imposing entrance requirements. The membership of the 'Friends of the Bauhaus' increased from 318 to more than 500. During the last accounting year 32,000 Marks were given to students in the form of loans and members of the working class were therefore able to study at the Bauhaus. . . . Industry came to our door, employed trained students, contracted to manufacture Bauhaus textiles, lamps, standardized furniture and wallpapers under licence. The aeroplane, chocolate and preserving industries commissioned us to design important trade exhibitions. . . .

Mr Mayor, after returning from the opening of the Bauhaus touring exhibition in Zurich I visited you on 29 July 1930. In Dessau, much excitement: the 90 flats on the estate in Dessau-Törten, the first collective undertaking of our architecture deparment, were ready. Thousands inspected them. The entire press welcomed the flats unreservedly. A two-and-a-half room flat with kitchen, bath, fixtures and fittings for 37 Marks 50 Pfennigs rent a month! At last a project in keeping with the concept of a new Bauhaus. Although achieved under my intellectual leadership it was carried out by a group of young students. Relieved, I enter your office. . . . You demand my immediate resignation. The reason: my alleged politicization of the Institute. The director of the Bauhaus may never by a Marxist. The cause: my voluntary and private donation to the International Workers' Aid Organization for the benefit of the needy families of striking miners in the Mansfeld coalfields. In vain my renewed assurance that I had never belonged to any political party. . . . In vain my assurance that my activities had always been in cultural and never party politics. You squeezed my throat and took my nervous smile for a sign of agreement.

Thus I was bumped off from behind. And during the Bauhaus vacation, too, while I was far away from those colleagues who are close to me. The Bauhaus mafia is celebrating. The local Dessau press finds itself in a moralistic fever. The Bauhaus Condor Gropius sweeps down from the Eiffel Tower and picks at my directorial corpse while W. Kandinsky is comforted and stretches himself out on the sand of the Adriatic: It is Finished. . . .

Mr Mayor, zoos, museums and racetracks are expressions of the municipal need for self-importance. To 'Wörlitz' and 'Junkers' Dessau was added a 'Bauhaus'. There, instead of exotic animals, those weird human beings honoured by the world as great artists are kept. My firmest conviction is that art cannot be taught. The young Bauhaus artists, that clover field cultivated by the oddest painter-individualists, will lie fallow in our epoch that is living through the greatest social upheavals and collective needs. It is altogether criminal to offer the young designer who will put himself at the disposal of tomorrow's society the stale nourishment of yesterday's artistic theories to sustain him on his way. It is here that the root of the conflict lies: you flirt with your culturally Bolshevik Institute while simultaneously forbidding its members to be Marxists. For the mafia hiding behind you the Bauhaus is a place of mad political passions, professorial vanities and an aesthetic clip-joint. For us Bauhaus people it is a place in which life is constructed anew. . . .

Oskar Schlemmer to Gunta Stölzl

... Gropius annoyed me, Hannes annoyed me, I'm a good friend of both of them, party of the centre, for me, make the centre strong! Oh well, we know all about that – we are living on rumours, what happened and what may be. I read about a court of arbitration but never about what was decided. Baumeister will be appointed to depose the isolated Kandinsky (yes??), peace and quiet will come in everywhere since it's for this purpose that Mies van der Rohe is going to Dessau.

You're all in a bed of roses, there are no appointments to be kept any longer and no little political mouse can be heard squeaking any more unless it's breathing its last. – This is roughly how I imagine a change of government: before it was left and now it's right. Are you protesting? It's said that all the students are standing firm behind Hannes? ...

Apropos: Hannes's swansong in the *Tagebuch* was very good. Who doesn't find it funny? The wolf has finally thrown off its sheep's clothing, but why only now? ...

Communist students on the dismissal of Hannes Meyer in *Bauhaus* 1930

Herr Kandinsky, is it true

that you or your wife Nina spread the news about Hannes Meyer's contribution to 'Red Relief' so that it appeared in the press?

Herr Kandinsky, is it also true that you knew what was about to happen even before your departure for your summer vacation? Did you, together with Governing Mayor Hesse, decide on a successor already before your departure – or how else is it that Hesse specifically refers to you in his telegram to the Masters?

Herr Gropius, is it true

that following the sacking of Hannes Meyer you suggested to Governing Mayor Hesse that the canteen be closed other than at mealtimes and that the Preller House be closed completely? (An attempt was made to close the canteen).

Herr Gropius, is it also true that after the 'Circle of Architects' had protested against the action of the municipal authorities you objected to the protest five minutes later?

Alexander Schawinsky 'Heads or Tails? On the case of the Bauhaus' in *Berliner Tageblatt*, 10 January 1931

... What do the people at the Bauhaus say? They felt deceived by the way Hannes Meyer dealt with things. They would demand a plan of action but vague meetings were held instead. They would draw up plans and receive the agreement of the director today only to be told the opposite tomorrow. They would ask serious questions of their leader and be given frivolous answers in return. At decisive moments Hannes Meyer would be away on his travels, having taken the power to make decisions with him in his hand luggage. He listened to the untalented who were clutching at slogans. He looked after the painters and later poked fun at them. He ridiculed individualism but hung up pictures by Klee, Kandinsky and Feininger in front of his touring circus. He wanted to appear as a martyr for Communism

but never lifted a finger for Communism. He proclaimed collectivism without qualification but claimed every achievement for himself alone. . . . He laughed with the uncreative about formalism, that poor, well-flogged, dead horse, but the formalistic attitudes of his own degenerated into a biological aesthetic. In short, he never let his right hand know what his left was doing.

Yes, Hannes Meyer, you were killed from behind! The deed cries out to the heavens. Where are your friends, your colleagues?

Kállai, Mart Stam, Wittwer, Brenner, Schlemmer, Albers, Kandinsky, Klee, Peterhans. . . . Where are you all?

The rest is silence.

Xanti Schawinsky to Walter and Ise Gropius

13 January 1931

. . . This article was our most beautiful piece of collective work. My personal contribution consisted merely of the sleepless nights in each of which I produced *one* sentence. . . .

Howard Dearstyne on Hannes Meyer's departure 1986

. . . I doubt that Meyer was a knowing conniver, concealing his dark intentions until the opportunity of carrying them out presented itself. I am inclined to agree with Mies that he was an immature individual who endeavoured to compensate for his feelings of insecurity by obstreperousness in his speech and rashness in his actions. Only this can explain the fact that, having been relieved of his position as director of the Bauhaus, he sought out Mies in his atelier in Berlin and wept as he pleaded his cause. . . . He was outgoing and approachable and he associated on friendly terms with the students, something which one could hardly say of Mies. This is a reason, no doubt, why such a furore was raised when he was fired in 1930.

Meyer brought a kind of order into the Bauhaus curriculum which had not existed under Gropius. He placed the emphasis in the teaching on architecture and introduced into the curriculum the courses which would give the students a well-rounded architectural education – those technical courses which Gropius, in his *Idee and Aufbau*, had recommended, so lamely, that a student take at another institution. It now became possible for the Bauhaus to offer a bona fide architectural diploma. The students sought this certification of their achievement because it proved to be a genuine aid in landing a job. . . .

Walter Gropius to Tomás Maldonado [director of the Hochschule für Gestaltung, Ulm

Cambridge (Mass.), 27 November 1963

. . . That Meyer endangered the existence of the institute says less about his political idealism than his political lack of instinct and reveals his inability to strike a balance between practical work and political theory. . . .

His strategy and tactics were too petty; he was a radical petit bourgeois. His philosophy culminates in the assertion 'life is oxygen plus sugar plus starch plus protein', to which Mies promptly retorted, 'Try stirring all that together – it stinks'. . . .

Mies van der Rohe as Director

Howard Dearstyne on the arrival of Mies, 1986

...When Mies arrived at the school, his reception was scarcely wholehearted. A large number of students, egged on by a handful of militant Communists, gathered in the canteen and demanded that he exhibit his work, to enable them to decide whether or not he was qualified to direct the Bauhaus. Mies was incensed and called in the Dessau police to restore order. I was not among the students who gathered in the canteen to voice their protest against Meyer's firing and the hiring of Mies. Actually, I was not heart-broken when Meyer left. I had become weary of his exaggerated functionalism....

The internal disorder at the Bauhaus caused the closing of the school for some six weeks. By the time the Bauhaus reopened in the summer of 1930, Mies had expelled the main troublemakers and tranquillity reigned. Taking no chances, he interviewed each remaining student individually in his office on the bridge (the two-storey building element which spanned the street between the Bauhaus and the Trades School, which was a separate institution). When my turn came, I entered the new director's office with some trepidation.... I asked him another question, one inspired by my long subjection to Meyer's materialistic doctrines. I said to Mies, 'Is it no longer right to seek beauty in architecture?' He quickly assured me that one might still strive for beauty in architecture....

(right) Mies van der Rohe.
(left) Chair by Mies in tubular metal and woven fabric, c.1930

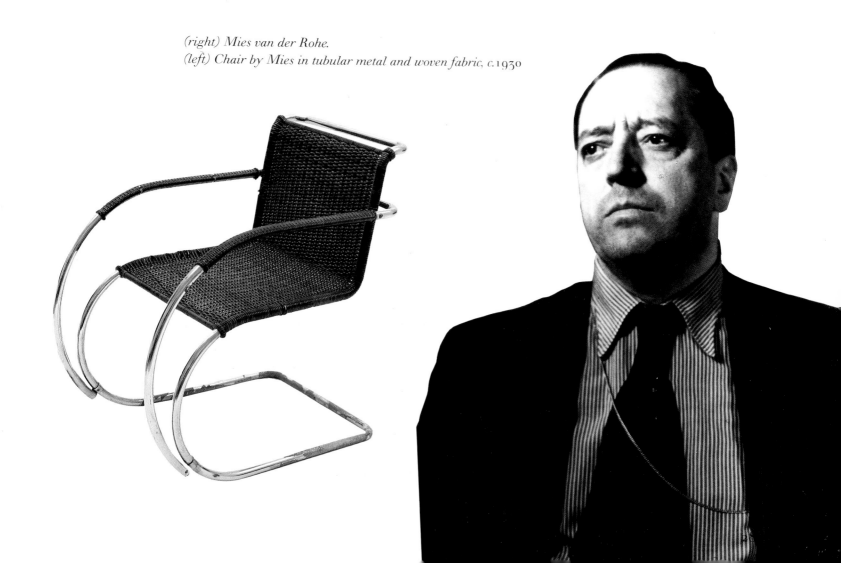

Ludwig Mies van der Rohe 'The New Epoch' in *Die Form* 1930

... The new epoch is a fact: its existence does not depend on whether we say 'yes' or 'no' to it.

But it is neither better nor worse than any other period. It is simply a fact and as such indifferent to all value judgements. For that reason I shall not spend much time attempting to interpret the new epoch, to reveal its relationships or uncover the structure which supports it.

Nor do we want to place too much importance on the questions of mechanization, standardization and norming.

And we wish to accept as fact the changed economic and social conditions.

Blind to all value judgements, all these things take their pre-ordained course.

What will alone be decisive is how, given these facts, we assert and express ourselves.

It is only then that the intellectual problems begin. Everything depends not on the 'what' but only and entirely on the 'how'. To say that we are producing goods and with what materials we are producing them reveals nothing on an intellectual level.

Whether we build tall or flat, with steel and glass, reveals nothing about the value of these buildings.

Whether we strive for centralization or decentralization in city planning has to do with practical, not value judgements.

But precisely the question of value is decisive. We have to set new values, point to ultimate goals in order to achieve standards.

The point and justification of any epoch, therefore of the new age, too, lies entirely and exclusively in the fact that it offers the mind the preconditions for and means of existence. ...

Communist Bauhaus students on Mies van der Rohe's statement in *Bauhaus* 1930

... 'The new epoch exists independent of whether we say 'yes' or 'no' to it, but it is neither better nor worse than any other period.'

Only an individualist who has lost all contact with the rest of the world can see the world in this way. But with what authority does Mies write 'we'? If 'we' means unworldly artists, then he is right to say that the new epoch exists independently of whether they say yes or no to it. But the matter is different if *we* do not view the new epoch from the metaphysical angle. The epoch exists, but it depends precisely on whether the 'we' means capitalism or the proletariat. And on that further depends whether the new epoch is better or worse.

To dwell on these elementary matters would be a pointless waste of time. Every member of the Bauhaus is clear enough in his mind not to believe in such metaphysical rubbish any longer. There would be no point in wasting a single word on this issue if it were not for the fact that this is being said by the *director of the Bauhaus*. But for that reason it acquires special interest for us. At this moment it becomes policy and we have to take a stand. ...

Paul Klee to Lily Klee

Dessau, 13 September 1930

...At the Bauhaus things developed as I thought, and for me not entirely unpleasantly. The row caused by the students grew louder and louder so that the knot had to be cut. The term was therefore finished early. The gentlemen used the time gained in this way to reorganize. That also required new regulations, and those students who accept them will re-register before 21 October. The mayor was present at the meeting which decided this and naturally justified the decision with his usual skill so that the Council of Masters agreed to it retrospectively.

Mies himself is brave, and betrayed no desire to waste his energies by wobbling hither and thither. May he always keep his nerve – otherwise he, too, will get burned....

At least I don't have to give any more lectures. The occasional unjustifiably punished student will want to show me work to make up for the missing teaching. Even as a private individual I couldn't prevent this, and at the moment I'm ... still a Bauhaus Master....

Wilhelm Jakob Hess, design for colour co-ordinated interior for a studio apartment in the Junkers housing development, 1932, an exercise made during the interior design course run by Hinnerk Scheper

Wassily Kandinsky to Werner Drews [former student]

15 March 1931

...The National Socialist Ministry in Weimar has removed all the new pictures from the museum. A portrait of Hitler now hangs in the administrative offices of the former Bauhaus. In Berlin, Schultze-Naumberg officially insults all the painters who work in new styles. Our new title is 'the Eastern *Untermenschen.*' And so on, and so on in this vein....

You already know that the Bauhaus is being judged superficially and falsely here, too. In spite of the country's extraordinarily bad financial predicament we must be glad that the Bauhaus goes on and that the future – as far as we can see from today's position – is secure. Since the summer we have a new director – Mies van der Rohe, who is so good that one couldn't imagine a better one. Since this winter term the painting class has its own beautiful room in the former 'Prellerhaus' which we unfortunately had to close. The majority of students living there were acting impossibly, and there was nothing else for it but to take these... studios away from the students and turn them into classrooms. The painters have benefited, however. More and more people come to have their work criticized and discussed – proper students from the painting class and visitors from other classes who take a 'platonic' interest in the teaching. It's always very lively. Elsewhere in the building, too, hard work is going on, and the atmosphere is healthy again after the forced departure of the former director Hannes Meyer. H.M. wanted to turn the BH into a Marxist school, and a few students engaged so outrageously in politics that the others (by far the majority) couldn't get any work done any more....

'M' [an anonymous student of architecture] **to a Swiss architect**

Dessau, 26 June 1932

...When I arrived at the Bauhaus there was a tremendous crisis. Fifteen people, among them the student representatives, most of them Communists, had been thrown out. The student representatives had fought hard for students' rights which, since Hannes Meyer left, have scarcely existed.

At one time lamps, furniture, woven products, designs for wallpaper, every imaginable kind of utensil were made here. When the Bauhaus changed from being an institute for experimentation and became a school, all the designs – most of which had been made by students – were sold under licensing arrangements to factories. The school gives only 10% of the licence fees to the student fund.

At one time it was possible for almost any gifted person to come to the Bauhaus. After a few terms they were paid a great deal of money for their work in order to live. Now, unfortunately, only the better off are offered places.

After we had been here a few days an election for new student representatives was to take place. It was then that we realized that there are two factions at the Bauhaus who are fighting each other like cats and dogs. On one side there are the Communists and left wing sympathizers, on the other the right, among whom everyone from members of the 'Youth Group' to Nazis are represented....

Today the Bauhaus is a school run by a clique to an extent known scarcely anywhere else. Nothing more can be seen of a 'free' working community of creative people. At eight o'clock you go to school and at five in the afternoon, having completed that day's courses, you go home again. Naturally you can learn a great deal in some courses and some things are good. Many maintain that the Bauhaus is much better than it used to be now that it's more like a technical school. Mies is a fabulous architect, but as a man, and especially as director, he is very reactionary... We, the members of the Preliminary Course, have been here three months already and he has never put in an appearance, let alone said anything to us.... Students in their fifth and sixth semesters work exclusively with him....

There are still a few wonderful teachers at the Bauhaus. Joost Schmidt, Scheper and Arndt. Schmidt is a great advertising person, Scheper has a genius for colour... Arndt teaches representational geometry and perspective. They were all students at the Bauhaus themselves, and they are all suffering under today's regime of school methods and timetables....

Architecture and Town Planning

Howard Dearstyne to his mother

20 December 1931

... Mies van der Rohe continues to hold us to the small problems. But that he is right in doing this is indicated by the fact that it takes weeks or months to do a small house of this nature in a decent way. The very simplicity of these houses is their chief difficulty. It's much easier to do a complicated affair than something clear and simple.

We're learning a tremendous lot from Mies van der Rohe. If he doesn't make good architects of us he'll at least teach us to judge what good architecture is. One of the uncomfortable (perhaps) sides of associating with an architect of the first rank is that he ruins your taste for about all but one-half of one per cent of all the architecture that's being done the world over....

Howard Dearstyne to his mother

[Dessau], 12 June 1932

... We (our semester, 4 people), have gotten well acquainted with him [Mies van der Rohe] and he seems to enjoy talking with us more than with the lower semesters. We discuss everything, architecture, art, philosophy, politics, etc. These discussions don't, therefore, always have a direct bearing upon our work but are tremendously interesting and valuable because Mies van der Rohe is a man of profundity and richness of experience. It would be worth my while being here just for these discussions if I did no designing whatever. My hope is that the Bauhaus doesn't break up and that I can return....

Pius Pahl [architecture student] on Ludwig Hilberseimer, 1970

... During the fourth semester I also try to study town planning with Hilberseimer.
I enter the room in which the classes are given and sit down a little apart from the others.
They come in one by one and find places on tables, benches, stools, and window ledges.
They debate. I am waiting for Hilbs, but in vain. After some time one of the older students,
perched on a radiator, is addressed as Hilbs. What a surprise for a former student of the
Höheres Staatliches Technikum!...

Ludwig Hilberseimer 'The apartment in our time' 1931

... It is significantly cheaper to build low-rise houses than high-rise apartment blocks.
In future, it will be most practical to combine both types in mixed estates where the low-
rise house with its own garden will prove most suitable for families with children, while the
apartment in the high-rise together with the distant views it affords will be most suitable
for couples without children and single people. The basic problem of housing type is social,
however. Each type will change in response to social trends: whether to preserve the family,
break it up, or leave the choice of lifestyle to each individual....

*Model by Ludwig Hilberseimer in a variety of woods to aid the
study of the relationship between building forms and population
density,* 1930

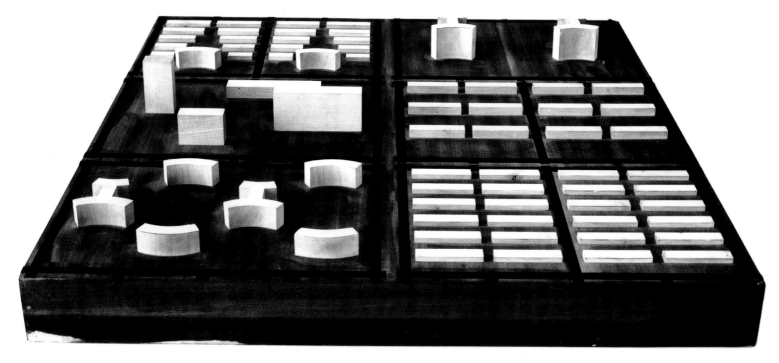

Selman Selmanagić [Jugoslav student] in 1976 on the planning of a housing estate for employees of the Junkers company in 1932

...The plans for the estate were based on scientific analyses. We started by discovering the social structure of the area (where the estate was to be built).... From the circumstances of the lives of the blue- and white-collar workers we made prognoses about future requirements for dwellings, free-time activities, further education, etc. Communal amenities played a large role in the plans.... Four groups of housing, each for 5,000 inhabitants, were provided with social centres. Traffic was consistently kept away from pedestrian zones. Ring roads and access routes relieved the inner zones of the housing estate....

Rudolf Ortner, design for the basic element of 'the house that grows' – in other words, can be expanded at will, 1931–32

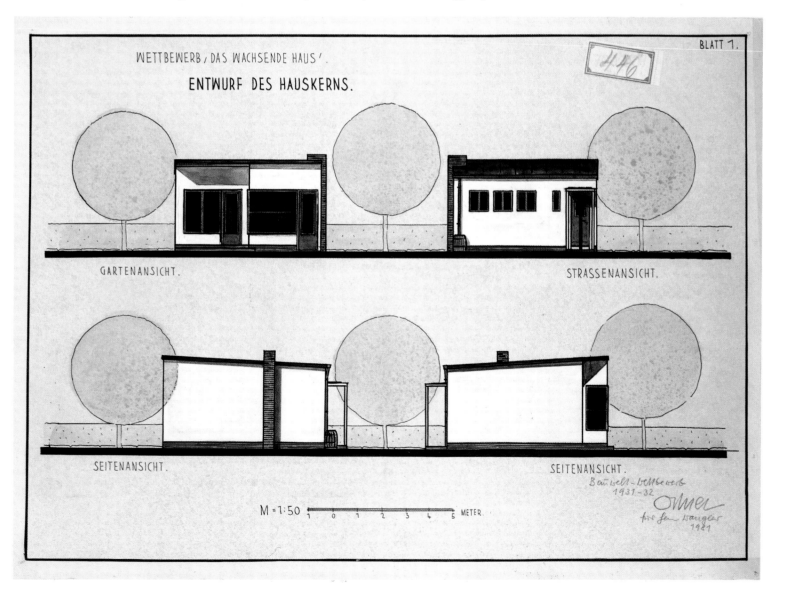

Growing Hostility from Outside

Paul Kmiec [Communist, Member of the Dessau City Council] May Proclamation to the Members of the Bauhaus end of April 1931

... 50 million unemployed, starving masses of humanity, workers' families robbed of food, an insoluble economic crisis in all imperialist countries: these are the results of the capitalist profit-making system; this is the state of the world on the First of May 1931.

Fascism, the new tool of the capitalists instead of the 'democratic' state now deemed unsatisfactory; imperialist armaments for a new war between the peoples of the world ...: these are the last attempts by a system in collapse to postpone its demise.

The consolidation of the socialist state in the USSR ...; in all countries a bitter class struggle: this is the reality of our time.

They want to remove you from this reality. They want to educate you in a false, 'objective' atmosphere, in order to turn you into the tame servants of a declining social order bereft of ideas.

Members of the Bauhaus!

The problems of the age are not the 'formal' and the 'functional', not the 'modern' and the 'new'. The root problem of the age embraces all areas of human activity and creativity and is *social revolution*! ...

Members of the Bauhaus! Do not be misled by the illusion that the Bauhaus is more advanced than other places of higher education. The wave of Fascism which is inundating all such institutions is also flooding the Bauhaus. As in the other schools, it is an instrument in the hands of Fascist authorities, National Socialist parliamentarians and so-called liberal teachers.

They forbid you to speak freely! They forbid you to act freely! They forbid you to associate with those people who want true progress!

Workers are forbidden to enter the Bauhaus, as they are all other schools. Productive work in the Workshops has been stopped, the grants reduced to lower than the minimum, the school fees raised (fees for foreign students), self-help relies on philanthropy.

The Bauhaus is without direction because it wants to be apolitical. The Bauhaus has no ideas because it is administered by bureaucrats. The Bauhaus is Fascistic because it distances the students from the problems of the time....

'M' [an anonymous student of architecture] **to a Swiss architect**

26 June 1932

... We are constantly warned not to annoy the philistines in the town with our style of dress and behaviour. The Masters, worried about their salaries, try to be nice to the Nazis in every way....

Karl Willy Straub [journalist] in *Die Architektur im Dritten Reich* 1932

...The New Objectivity with its eternal repetition of horizontals and the monotonous juxtaposition of identically-shaped windows – declared to be a 'rhythmical principle' – has aroused suspicion.... The empty uniformity of this kind of building, the endless repetition of elements that are always the same, produce not 'structured intensity' but structured boredom. In their fanaticism, its advocates even go so far as to claim that '...in today's modern architecture the horizontal and vertical are potentially interchangeable'.

Is this not a public admission of the bankruptcy of a trend which will end in chaos? All the eternal, previously valid laws of architecture are being turned upside down....

If only the modern tendency had called a halt at the efficiency and honesty of the pitched roof!... [The pitched roof] is a symbol of the mind...; it has become as much the banner of the national movement as the flat roof is the shop-sign of the internationalist tendency....

The Bauhaus transformed into a school for Nazi party officials

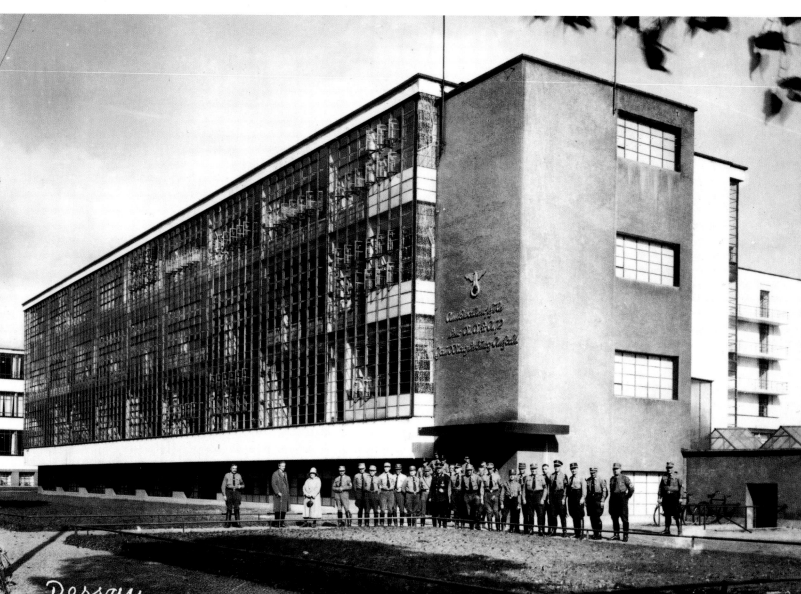

Rudolf Paulsen [journalist] 'Culturally Bolshevik Attacks' in *Völkischer Beobachter*
30 March 1932

… Whether Gropius is a Jew or not is entirely irrelevant here. The people find the new style
of building so foreign that they speak of the Palestinian style. And that is entirely justified.
For these smooth and insipid garages for people to live in, these bench-assembled dwellings
are, in our German landscape, simply a mockery of all natural connection with the soil.…

*Two pages from a Leipzig illustrated magazine, 4 September
1932, with an 'obituary' for the Dessau Bauhaus. The tone of the
captions is highly positive and expresses the hope that the school
will move to Leipzig*

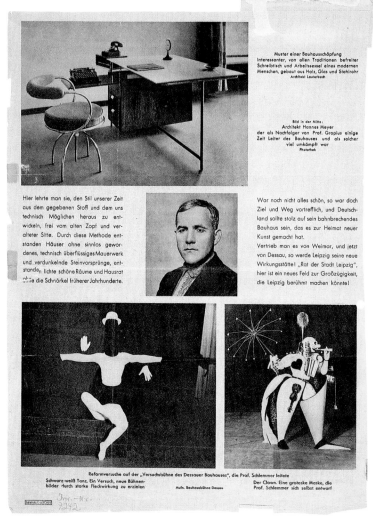

Alfred Kurella [journalist] 'What Has the Bauhaus to do with Us!' in *Magazin für alle*, 1931

... Since its foundation in Weimar, the Bauhaus has survived many vicissitudes. In 1924 it was forced to leave Weimar because the new reactionary government of Thuringia was unwilling to put up with this 'seed-bed of Bolshevism'. But it found new patrons in Dessau, the city dominated by the Junkers Works. Big industry saw more clearly than the narrow-minded Thuringian government that 'Bolshevism' had nothing to do with it, and that here a modern, liberal-bourgeois attitude to art had for the first time emerged from the spirit of industrial production rooted in science and technology.... But after Junkers had come close to bankruptcy, the municipal coffers of Dessau had been almost emptied and the orders had ceased, the Bauhaus lost its economic base. After much to-and-fro, the city of Dessau, under Nazi leadership, withdrew support from the Bauhaus and it was closed.

Now it is to be reborn in the Steglitz suburb of Berlin.

While all these developments were occurring outside the Bauhaus, a battle was going on inside it between two contradictory attitudes to art – the 'functional' and the 'formalist'. Gropius, who wanted to reconcile the two approaches, resigned from the institution he had founded in 1928. Under the leadership of the new director, Hannes Meyer, the 'functional' tendency came to dominate for a time. Simultaneously, however, a new force appeared: out of the ranks of the students, and above all from members of the working-class, there emerged a Marxist criticism of the 'new approach to art'. They recognized that the correct notion of adapting art to the forms of production and life in modern society is viable only if that 'modern' society is understood *not to be that of declining capitalism* within which industry is already in decline and which is excluding increasingly large sections of the population from modern forms of life. It is viable only if the starting point for a revolution in the artistic structuring of the material environment is taken to be the *socialist* salvation and development of modern production methods with the workers as the decisive section of modern society....

The advance of this new philosophy within the Bauhaus resulted in a deep crisis. Here, the bourgeois ideologists of the 'old Bauhaus' recognized a common enemy. The director, Hannes Meyer, who for them did not attack these Bolsheviks – this time the description was correct – with sufficient energy, was removed together with forty students....

With the exclusion of the core of the Marxist opposition, the battle within and about the Bauhaus has not come to an end. This opposition will repeatedly emerge afresh ... with that same inevitability with which the Bauhaus itself once emerged as an opposing force within bourgeois art. Its removal to Berlin will only accelerate this process. Here it will be decided whether the Bauhaus as a force for bourgeois renewal will collapse together with the capitalist economy, or whether it will live on and bear fruit as the hotbed of a new socialist art allied to the revolutionary workers' movement and will thus be able to recapture those positive values which it created with its attempt to adapt art to the 'modern forms of production and life'. In the interests of the art of the future the revolutionary proletariat should be concerned with this single possible salvation for the Bauhaus....

The Final Phase: Berlin, 1932–33

Deprived of its building and financial grant, the Bauhaus was delivered a mortal blow. But Mies van der Rohe was determined to keep the Bauhaus alive, if only as a shadow of its former self. Six days before the school was officially closed in Dessau he was able to announce that it would continue as a private institution in Berlin. Although he told students that the new semester would begin in October, at that stage he had not found any accommodation. He worked with great speed and managed to find a large disused telephone factory on Birkbuschstrasse in Steglitz, a suburb to the south-west of the centre of Berlin. It afforded a great deal of space, good natural light and could be adapted to the needs of teaching without much cost or effort. Steglitz, moreover, was relatively quiet, close to the forest and lakes on the edge of the city and connected by bus and railway to the centre.

Curious though it may seem, the Berlin location was also likely to provide more freedom from the unwelcome attentions of hostile politicians than a provincial city like Dessau: the larger the

The disused telephone factory in the Steglitz suburb of Berlin in October 1932, shortly after the Bauhaus acquired it (photograph by Howard Dearstyne)

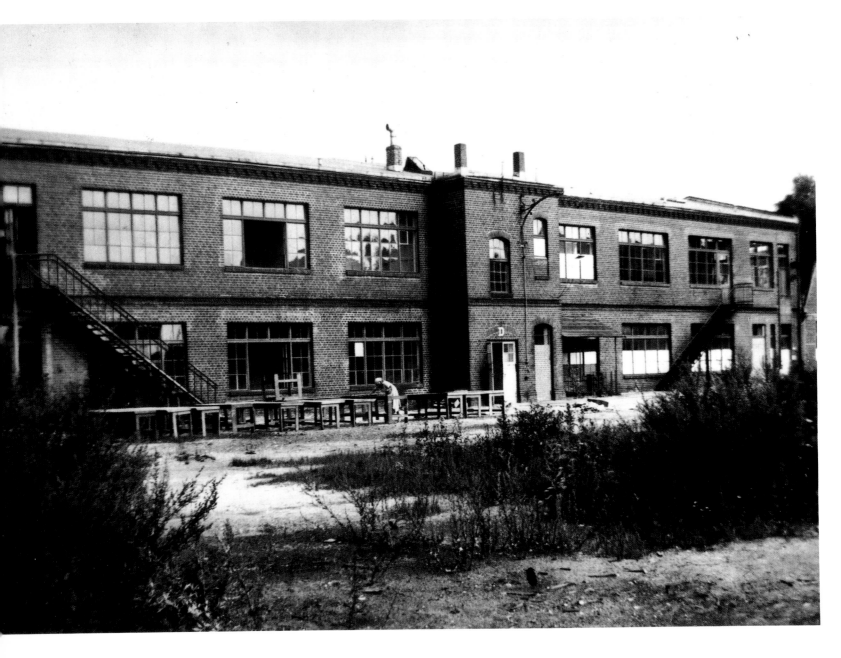

place, the less visible an institution like the Bauhaus would be. As it turned out, however, the size of the capital was unable to offer the school protection.

The rent was relatively cheap and Mies knew that students could be relied upon to repair and refit the building; but finding sufficient funds to support the new, independent school was bound to be the major problem. Student fees therefore had to be increased and private individuals asked for donations. Mies was also shrewd enough to make sure that the director retained the rights to all Bauhaus products and patents which might legally have been claimed by the city of Dessau and which continued to bring in a not inconsiderable income. In February 1933, grand public Carnival parties were organized – largely for fundraising purposes – in the new building; leading German artists donated works for the tombola. The parties proved very successful and were a great demonstration of public support for the Bauhaus.

Work began again and it briefly seemed possible that life at the Bauhaus might become as normal as circumstances allowed. But political developments intervened. In January 1933 Hitler became German Chancellor and the Nazis began to implement their repressive policies on a national scale. National Socialists in Weimar and Dessau had left the Bauhaus in no doubt about the party's attitude to it. The school was 'one of the most obvious refuges of the Jewish-Marxist conception of "art"... so far beyond all art that it can only be judged pathologically': it was a danger to the nation and would not be allowed to exist in the new Germany. On 11 April 1933, a few days after the start of the summer term, the Bauhaus was closed down by the police, acting on the instructions of the Gestapo.

Matters were not as straightforward as they must have seemed, however. In 1933 Nazi cultural policy was still not entirely clear, and such leading figures as Goebbels were prepared to argue that some of the contemporary art widely condemned as 'degenerate' did in fact embody 'German' values and might be encouraged by the State. There were those in the party anxious to defend Mies van der Rohe, too, and Mies himself, in common with many artists and intellectuals at the time did not immediately reject National Socialism out of hand. This explains why Mies attempted to negotiate with the authorities for the Bauhaus to be re-opened.

However, the conditions set down by the authorities proved unacceptable. Mies wrote to all students on 10 August, telling them that the faculty had decided to dissolve the Bauhaus. It was a miserable end to a great institution. The Bauhaus was dead, but its teachers and students lived on to disseminate its influence throughout the world and especially in the United States.

The student Ernst Louis Beck leaving the Bauhaus

Berlin

The Move to Berlin and the End of the Bauhaus

Mies van der Rohe circular to the students 24 September 1932

...The Bauhaus will continue as an independent institute in Berlin.

I shall be able to announce the location of the building in a few days after the completion of negotiations.

Teaching will begin on 18 October.

We are forced to set the fees at 200 Reichmarks for the winter and 100 Reichmarks for the summer term.

Foreigners must pay double fees.

In order to enable gifted but poor students to study at the Bauhaus, 20 per cent of the students can receive free places....

Hinnerk Scheper to Lou Scheper

October 1932

...In recent days Mies has expressly emphasized that the Bauhaus is not his personal affair and that we should all work to support it as we have up to now....

Annemarie Wilke [student] **to Julia Feininger**

Berlin, 21 February 1933

...Our festival (for carnival) was glorious, a great success... and obviously something special even by Berlin standards.... The rooms in the basement made an incredibly distinguished impression, furnished and decorated as though for a great social occasion. One's not used to that kind of thing at other parties in Berlin.... The care we had taken and the relatively expensive materials we had used were consequently the first things people noticed. Upstairs things were rather different. The room designed by Peterhans, which I thought was the most beautiful of all, just about matched those designed by Mies ... although by contrast those by Albers and Engelmann can only be described as 'popular'. Juppi's [Albers's] arena for the people... was always full right down to the last chair... Engelmann's pub looked like a marquee at the Munich beer festival... But there, too, it was always full, and when they're in expansive mood people aren't formal any more. The harmonious kitsch which surrounded you there suited the goings-on very well.... The tombola was a very important matter.... A member of the Bauhaus, ... with us since the autumn, won the glorious [sculptured] head by Sintenis..., the sculpture by Kolbe was won by an old schoolmistress from Stettin who certainly won't know how to do it justice, and Anni Albers's brother got the Mataré [sculpture]. Mies himself got the Baumeister [painting] – which was very beautiful by the way – while a ticket he gave away [won] the Klee.... The room in which the prizes were set out looked wonderful. Above all, it added weight to the distinguished impression made by our festival – no-one did anything silly there as we had feared. It was Mies's own room. The large raw-silk curtain from Dessau hung at the windows, the walls and ceiling were covered with stretched muslin, the sculptures stood on the table, the pictures on the walls.... On Saturday the second large public Bauhaus party will be held....

Wassily Kandinsky to Werner Drewes [former student]

Berlin, 10 April 1933

... So far the BH continues to exist. In the next few days the new summer term begins. In spite of the troubled times 17 new students have joined. But only a few foreigners. There is a new Japanese girl, however, who naturally speaks almost no word of German. In spite of that she asked me where she could buy my book *Point & Line*. The people at the Bauhaus work on and are happy.

But in the art world, too, a great deal of demolition is going on: many museum and academy directors have been given leave of absence. ... In the Dresden gallery all the paintings in the 'modern style' have been taken down. ... Quantities of weapons and munitions belonging to Communists have been discovered. I'm convinced that the Comm. are preparing a big revolt throughout the Reich and that the Reichstag fire was intended to be the signal for the start of it. ...

Naturally it hurts us 'modern artists' a lot that the new government misunderstands the new art. It's completely different in Italy! The new architecture and the new art there (Italian Futurism) are recognized as Fascist art. ...

Now we shall see how things develop and what becomes of our art. In any event artists should remain apolitical, think only of their work and devote all their energies to it. ...

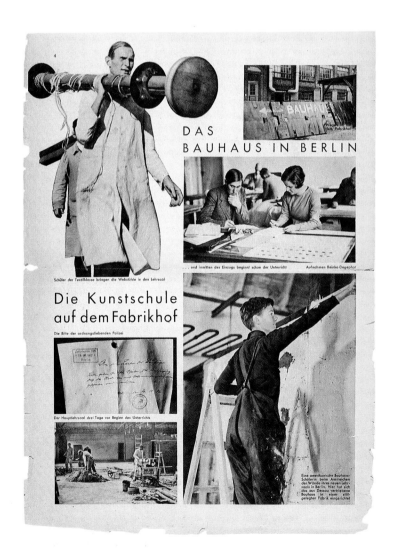

Page from an illustrated Berlin magazine, October 1932, showing the Berlin Bauhaus, 'The art school in a factory'. At the top left, students are shown carrying parts of looms. Centre right, Albers teaches a student. Bottom right, an American female student painting a classroom wall

Hans Kessler [student] **to his mother**

...Two detachments of police armed with rifles surrounded the Bauhaus and thoroughly searched the building. Those without identity cards were taken to police headquarters.... After the search the Bauhaus was sealed and put under guard. If the whole thing weren't so serious for us, this silly action by stupid people would be laughable.... The reports in the newspapers were crazy. The *Berliner Lokalanzeiger* wrote that Mies had fled to Paris and that Gropius, the former director of the Bauhaus, was in Russia (but neither has any intention of leaving Berlin). There was also mention of 'Communist material' that had been found. This 'Communist material' consisted of a few old issues of the *Weltbühne* and the *Tagebuch*....

Frank Trudel [student] 'The end of the Bauhaus', c.1980

...One Saturday morning the Berlin Bauhaus building was suddenly occupied by the police and the Gestapo. Officially no work was done that day. In spite of that more than a dozen students and Mies van der Rohe were caught in the occupiers' net. We were herded together in the entrance hall. Mies also stood there at the door of his office. The powerfully-built man filled the door frame completely and appeared unwilling to move. Not far from him stood a member of the Gestapo with his finger on the trigger of his carbine. How easy it would have been for such a thing to go off in the hands of a Nazi henchman (...shot while escaping), and the world would have been the poorer by one significant personality. But there were obviously too many witnesses present. We were taken by lorry to the main police station (on Alexanderplatz) and shoved into the corner of the reception room for prisoners. For at least one long hour nothing happened. Then a major in American uniform appeared at the entrance and greeted the policeman present with amazing casualness. He didn't show his papers, but all those in uniform in the room stood to attention. He then explained that he had been sent by the American Military Attaché to take all the foreigners among us away with him. In scarcely comprehensible German he read out a list of names on which mine was surprisingly included. Once outside he led us to a place somewhat hidden from view. 'You're not yet in safety. Leave Germany today.' Having said that – and what's more in genuine Berlin dialect – he got into a waiting car and disappeared. I have never discovered whether he was in fact an American or a German actor. Certainly we had been helped by the respect for any uniform that was then still enormous in Germany....

Ludwig Mies van der Rohe 'The End of the Bauhaus' North Carolina School of Design
Student Publication 1953

…One morning, I had to come from Berlin in the streetcar and walk a little, and I had to
pass over the bridge from which you would see our building, I nearly died. It was so wrong.
Our wonderful building was surrounded by Gestapo – black uniforms with bayonets. It was
really surrounded. I ran to be there. And a sentry said, 'Stop here.' I said, 'What? This is my
factory. I rented it. I have a right to see it.'

'You are the owner? Come in.' He knew I never would come out if they didn't want me to.
Then I went and talked to the officer. I said, 'I am the director of this school', and he said,
'Oh, come in', and we talked some more and he said, 'You know there was an affair against
the Mayor of Dessau and we are just investigating the documents of the founding of the
Bauhaus.' I said, 'Come in.' I called all the people and said, 'Open everything for inspection,
open everything.' I was certain there was nothing there that could be misinterpreted.

The investigation took hours. In the end the Gestapo became so tired and hungry that
they called their headquarters and said, 'What should we do? Should we work here forever?
We are hungry', and so on. And they were told, 'Lock it and forget it.'

Then I called up Alfred Rosenberg. He was the party philosopher of the Nazi's culture,
and he was the head of the government [*sic*]. It was called *Bund Deutsche Kultur*. I called
him up and said, 'I want to talk with you.' He said, 'I am very busy.'

'I understand that, but even so, at any time you tell me I will be there.'

'Could you be here at eleven o'clock tonight?'

'Certainly.'

My friends Hilbersheimer and Lily Reich and some other people said, 'You will not be so
stupid as to go there at eleven o'clock?' They were afraid, you know, that they would just kill
me or do something. 'I am not afraid. I have nothing. I'd like to talk to this man.'…

I told Rosenberg the Gestapo had closed the Bauhaus and I wanted to have it open again.
I said, you know, the Bauhaus has a certain idea and I think that it is important. It has
nothing to do with politics or anything. It has something to do with technology.' And then
for the first time he told me about himself. He said, 'I am a trained architect from the Baltic
States, from Riga.'… I said, 'Then we certainly will understand each other.' And he said,
'Never! What do you expect me to do? You know the Bauhaus is supported by forces fighting
our forces. It is one army against another, only in the spiritual field.' And I said, 'No, I really
don't think it is like that.' And he said, 'Why didn't you change the name, for heaven's sake,
when you moved the Bauhaus from Dessau to Berlin?' I said, 'Don't you think the Bauhaus is
a wonderful name? You cannot find a better one.' He said, 'I don't like what the Bauhaus is
doing. I know you can suspend, you can cantilever something, but my feeling demands a
support.' I said, 'Even if it is cantilevered?' And he said, 'Yes.' He wanted to know, 'What is it
you want to do at the Bauhaus?' I said, 'Listen, you are sitting here in an important position.
And look at your writing table, this shabby writing table. Do you like it? I would throw it
out of the window. That is what we want to do. We want to have good objects that we have
not to throw out of the window.' And he said, 'I will see what I can do for you.' I said, 'Don't
wait too long.'…

The Final Phase: Berlin

Office of the Secret Police, Berlin to Mies van der Rohe

21 July 1933

HIGHLY CONFIDENTIAL.

...The re-opening of the Bauhaus, Berlin-Steglitz, is, with the agreement of the Prussian Minister for Science, Art and People's Education, conditional upon the removal of a number of obstacles:

1) Messrs Ludwig Hilbersheimer and Wassily Kandinsky may no longer be employed. Their posts are to be filled by people of whom it can be guaranteed that they share the National Socialist philosophy.

2) The previous syllabus does not meet the requirements of the new State for its internal construction. A suitably revised syllabus will therefore be submitted to the Prussian Cultural Minister.

3) The gentlemen on the staff will complete a questionnaire which satisfies the terms of the new law governing civil servants. The continuation and re-opening of the Bauhaus are subject to the immediate removal of these obstacles and the meeting of these conditions....

Wassily Kandinsky to Werner Drewes

Berlin, 23 July 1933

...So our BH no longer exists and I regret it very much. We had no offers from other towns as we did before since the questions about which way art will be allowed to go are still open and are the object of heated discussion. At the moment a battle is being fought about the recognition of '*Die Brücke*' [group of Expressionist artists], approval of which is still only partial. Apparently there is a long way to go to abstract art!...

Iwao Yamawaki, 'The Coup Against the Bauhaus', 1932, photomontage

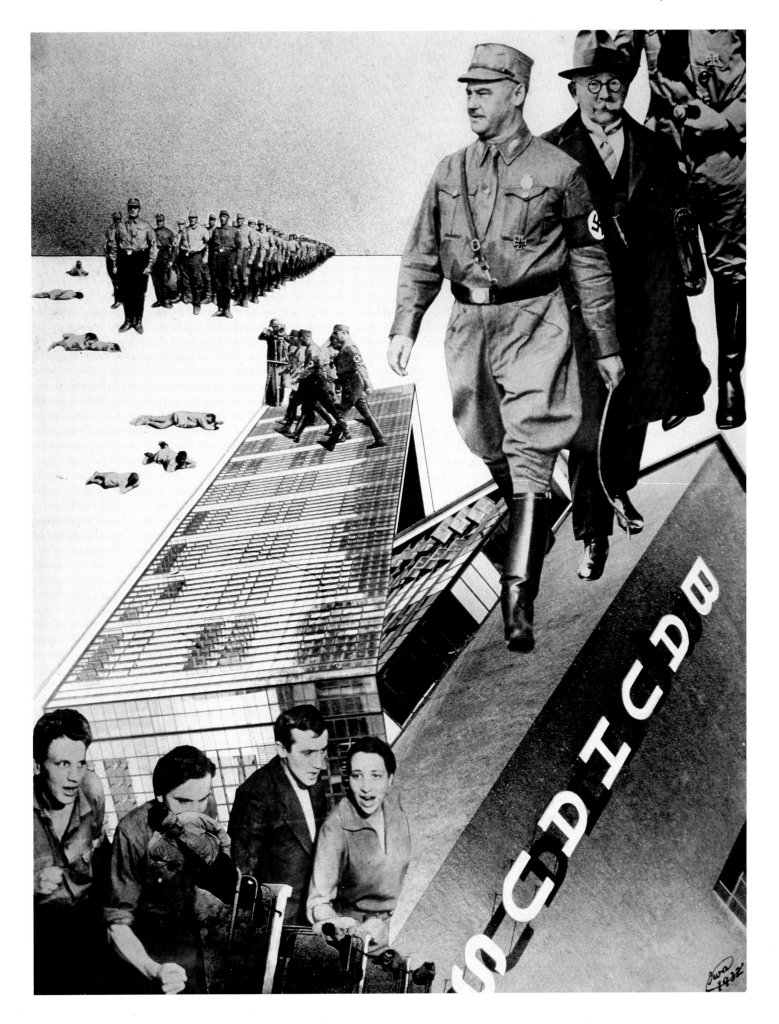

Postscript

It is one of the ironies of history that Nazi persecution ensured many artists and intellectuals a wider international reputation than they would otherwise have enjoyed. It is doubtful that the Bauhaus would ever have been so widely celebrated and influential had it not attracted the attention of the National Socialists. By 1933 it was well known and admired in specialist circles throughout Europe and in the United States, but its closure and the emigration of many of its former students and teachers ensured not only a much wider international reputation but also a growing influence on the architecture, design and art education of many countries throughout the world.

After 1933 several attempts were made to revive or continue the educational methods of the Bauhaus, and most of them were in America where most of the leading personalities of the school emigrated. In 1937 Moholy-Nagy founded a 'New Bauhaus' in Chicago while Gropius later disseminated Bauhaus ideas in the architectural department of Harvard University. Josef Albers taught courses similar to the Bauhaus Preliminary Course at both Black Mountain College and Yale University. After the Second World War, in 1950 in the German city of Ulm, a *Hochschule für Gestaltung* was founded, with Max Bill, a former Bauhaus student, as its first director.

These were merely the most visible and famous results of the continuing influence of the Bauhaus. Wherever former students and staff emigrated, and even where they did not, versions of Bauhaus teaching methods and Bauhaus-influenced architecture and design appeared and continue to affect theory and practice in art schools and design studios. The entire man-made environment, from whole buildings to the furniture and equipment in them, daily reflects the impact made by the Bauhaus on modern life.

Not that the influence of the school has been accepted uncritically by everyone. In the field of architecture especially, the Bauhaus is now widely seen to have created as many problems as it solved; and the brief life of the *Hochschule für Gestaltung* in Ulm demonstrated that Bauhaus teaching methods were only ever as good as the charismatic, inspired individuals who devised and applied them.

The history of the Bauhaus itself has also proved contentious.

Not much love was ever lost between Hannes Meyer and Walter Gropius. In 1931, Meyer organized an exhibition called 'Bauhaus 1928–1930' in Moscow. With the rise of Stalinism, and monumentalism in Russian architecture, the show was not well timed and met with a cool reception. Critics and public alike felt that the exhibits did not match their preconceived ideas of the Bauhaus.

In 1938, Walter Gropius, his second wife Ise, and Herbert Bayer organized a Bauhaus exhibition at the Museum of Modern Art in New York. Many other former Bauhaus teachers contributed to the show. It was well timed, presenting a face of German

Three stamps issued by the German Democratic Republic in 1980. They illustrate, from the top, Georg Muche's and Richard Paulick's Steel House on the Törten estate in Dessau, Hannes Meyer's Trades Union School at Bernau, and Gropius's shop with apartments above, also on the Törten estate

art prohibited by the ever more threatening Nazis. But, by skating over the first, 'romantic' period of the Bauhaus, concentrating on the years between 1922 and 1928, and ignoring the achievements of Meyer's directorship, it provided a very incomplete view of the Bauhaus and its development and established what can only be described as 'The Bauhaus Myth'.

After the Second World War that myth proved more tenacious in the West than the East. While the immigrants Tom Wolfe described as the 'White Gods', above all Gropius and Mies van der Rohe, were worshipped in the USA as the pioneers of modern architecture (their enormous debt to such Americans as Frank Lloyd Wright curiously forgotten), Bauhaus ideas were criticized as 'formalist' in the USSR and its satellites, including the Eastern part of Germany.

Not until the 1960s, when Communist party attitudes to the visual arts in general shifted and became more liberal, was the Bauhaus regarded as anything more than an institution which, as a popular guidebook to Weimar complained, had led to 'the total destruction of all architectural values'. Then, however, those of the school's many ideas which were undeniably socialist were rediscovered, and the years of Hannes Meyer's directorship especially reassessed. Gropius's Dessau Bauhaus buildings, too, bricked up and left to deteriorate since the Nazi party vacated them, were painstakingly restored on government instructions. Initially used for a variety of purposes, in 1991 the buildings finally came to house a school of art and architecture once again.

Despite all the revealing differences in interpretation of the Bauhaus legacy in the East and West, there was some consensus all along: the recognition that the true Bauhaus spirit is embodied not by any particular style but by a philosophy – of life as well as art. That spirit is not confined by any moribund tradition but takes its strength from the conviction that buildings and objects must draw on a living tradition which is constantly renewing itself. Contemporary problems must repeatedly be addressed in a contemporary way, while acknowledging the need for high artistic standards and meeting what are commonly perceived as general needs.

For better or worse, the Bauhaus has left an indelible mark on the environments we all inhabit. Most of the chairs we sit in, many of the desks we sit at, the design of most of the implements we use, even the magazines and books we read, have an appearance and are the result of attitudes unimaginable without the example of the Bauhaus. It is a mark of the school's achievement, as well perhaps as of the impoverishment of our own post-modernist age, that the designs produced by an institution that closed more than half a century ago should continue to seem so thoroughly, so dramatically modern.

Three stamps issued by the Federal Republic of Germany in 1983 to mark the fiftieth anniversary of the closure of the Bauhaus. They show, from the top, Moholy's 'Modulator', an abstract design by Josef Albers, and Gropius's Bauhaus Archive in West Berlin.

'The White Gods' in Tom Wolfe *From Bauhaus to Our House* 1983

... All at once, in 1937, the Silver Prince himself was here, in America. Walter Gropius; in person; in the flesh; and here to stay. In the wake of the Nazis' rise to power, Gropius had fled Germany, going first to England and coming now to the United States. Other stars of the fabled Bauhaus arrived at about the same time: Breuer, Albers, Moholy-Nagy, Bayer, and Mies van der Rohe.... Here they came, uprooted, exhausted, penniless, men without a country, battered by fate.

Gropius had the healthy self-esteem of any ambitious man, but he was a gentleman above all else, a gentleman of the old school, a man who was always concerned about a sense of proportion, in life as well as in design. As a refugee from a blighted land, he would have been content with a friendly welcome, a place to lay his head, two or three meals a day until he could get on his own feet, a smile every once in a while, and a chance to work, if anybody needed him. And instead —

The reception of Gropius and his confrères was like a certain stock scene from the jungle movies of that period. Bruce Cabot and Myrna Loy make a crash landing in the jungle and crawl out of the wreckage in their Abercrombie and Fitch white safari blouses and tan gabardine jodhpurs and stagger into a clearing. They are surrounded by savages with bones through their noses — who immediately bow down and prostrate themselves and commence a strange moaning chant.

The White Gods!

Come from the skies at last!

Gropius was made head of the school of architecture at Harvard, and Breuer joined him there. Moholy-Nagy opened the New Bauhaus, which evolved into the Chicago Institute of Design. Albers opened a rural Bauhaus in the hills of North Carolina, at Black Mountain College. Mies was installed as Dean of Architecture at the Armour Institute in Chicago. And not just Dean; Master Builder also. He was given a campus to create.... Twenty-one large buildings, in the middle of the Depression, at a time when building had almost come to a halt in the United States — for an architect who had completed only seventeen buildings in his career —

O white gods....

L. Patsitnov [Soviet art historian] 'The Creative Heritage of the Bauhaus' 1962

... The Bauhaus had to pay dearly for its indifference to social matters. The working principles it developed were unable to resist the pressures of reaction. Taking the needs of industrial technology and the real needs necessary for the development of modern art as its starting point, it nevertheless cleared a path for the new educational and creative methods which destroyed the principles on which the bourgeois aesthetic consciousness was based.

The theoreticians of decorative and applied art who examine the complicated picture of the situation of that time and arrive at the source of those contradictions ... will find in the theory and practice of the Bauhaus not only the classically precise expression of those contradictions, but also invaluable material with which to construct a harmonic system of aesthetic education in the coming society....

Philipp Tolziner on Hannes Meyer in the Soviet Union

... But then the ... news came that Hannes Meyer had been invited to work in the Soviet Union and that he was doing his best to secure invitations for a group of his former students. ...

During the period of industrialization in the Soviet Union, the training of a cadre of qualified people – from skilled craftsmen to engineers – was vitally important. So a special organization was set up to plan and design all the buildings necessary for their training – industrial and technical schools and polytechnics. The organization was called GIPROVTUS, the 'State Insitute for the Design of Technical Teaching Institutes'. Its tasks were enormous ... Hannes Meyer and the other seven of us joined this collective as an activist brigade with the responsible name 'Red Front'.

Hannes Meyer was overburdened with professional work, since, while working for GIPROVTUS in 1931, he was also simultaneously Professor at the Moscow Architectural Institute, Consultant to the Institute for City Planning in the Russian Federation, and a member of a commission for the building of the Palace of Soviets. Some of the members of our brigade also taught at the Moscow Architectural Institute at that time. ...

In the autumn of 1931 an exhibition selected by Hannes Mayer and organized by the Society for Foreign Cultural Relations (VOKS) opened in Moscow and was later shown in Kharkov. It was intended to show the Soviet public something of 'The Dessau Bauhaus under the directorship of Hannes Meyer, 1928–1930'. ... Hannes Meyer did not intend to present a complete picture of the Bauhaus, but rather to stage an exhibition of 'his Bauhaus'. As I was able personally to judge, the exhibition was coolly received by architects and artists in Moscow and Kharkov because it corresponded too little to the Bauhaus they knew about and admired. ...

At the end of 1931 Meyer left GIPROVTUS and then worked primarily in the field of city planning. In 1934 and 1935 he was Director of the Housing Department at the then recently-founded Architectural Academy. ...

The personal ties between the members of our brigade and Hannes Meyer were above all the result of our co-operative work. After the gradual break-up of the brigade after 1932, we continued to live together in our communal apartment in Moscow. ... After the war, I remained as the only former member of the 'Red Front' brigade which lived on in the Soviet Union and continued to work in accordance with Meyer's ideas. ...

Tomás Maldonado 'Is the Bauhaus relevant today' in *Zeitschrift für die Hochschule für Gestaltung* 1963

... We answer the question 'is the Bauhaus relevant today?' in the affirmative, although with reservation. What we understand by the Bauhaus is not what is usually associated with the name, in other words, a teaching institution or a movement in the art and architecture of the 1920s. If we say that the Bauhaus is today relevant again, we are thinking of another Bauhaus, a Bauhaus that was often proclaimed but never realized, a Bauhaus which was unable to develop, which undertook, although unsuccessfully, to open up a humanistic view of a technological civilization, i.e. to see the human environment as a new 'concrete field for design activity'. We are thinking of a Bauhaus which attempted to direct Germany towards an open and progressive culture. ...

John Eisenhammer [British journalist] 'Old Bauhaus new Big Idea' *The Independent* London, 28 August 1991

...Professor Rolf Kuhn has that 'East German dissident pastor' look about him; his ample locks falling into the luscious undergrowth of his beard. Such were the hirsute trappings of many church leaders who strode out of the twilight world of opposition to the Communists to lead the great demonstrations of 1989.

Professor Kuhn is no priest, but he, too, was called upon to lead the tens of thousands who gathered in the city of Dessau during that mad, momentous autumn. The call came less because of the inspiring locks than the fact that as head of the recently reborn Bauhaus, he had rapidly made a name for himself in town as a man willing to stand up to the Communist authorities....

In 1987, Professor Kuhn was appointed the first director of the re-opened building, in a tentative experiment by the authorities. Two years later those waves of demonstrations across East Germany that finally toppled the Communist regime were the salvation of Professor Kuhn and the Bauhaus. For his innovative directorship of the Bauhaus had already made him a targeted man, the subject of an investigation by the Building Ministry in East Berlin.

He had encouraged experimental theatre on the restored stage of the Gropius building that sharply criticized the country's rulers; he espoused the use of sociology, a heresy in the East, in town planning; he had dared to invite an Israeli guest to one of the new international Gropius seminars. The investigation was well under way when it was swept aside, along with everything else, in November 1989.

Just as the Bauhaus had first emerged in 1919 as the product of momentous historical upheaval, so in 1989 history offered it another chance.

...the new Bauhaus 'Big Idea' [is] the industrial garden region, or the bringing together of industry and nature. 'In the Twenties, the challenge was to relate art and technology to one another. Today, it is to bring art, technology and nature together. There needs to be a new unity', says Professor Kuhn. 'That means the new team is looking for ways to resolve today's problems, not produce similar chairs, houses and lines as in the Twenties. That would be style-worship, and the very opposite of the Bauhaus idea.'

...The centre closely adheres to a favourite theme of the Bauhaus: to think globally and act locally; aiming to put its ideas to the test on its doorstep. Local circumstances could hardly be more appropriate, or more challenging.

Professor Kuhn traces on a map a triangle between Dessau, Wörlitz to the east and Bitterfeld to the south. 'Those are the ingredients of the industrial garden region', he says. Dessau: a city bombed to bits during the war because it was home to the Junkers aircraft factories, then devastated by modular prefab buildings and the ravages of neglect and pollution; Wörlitz: the site of one of the most beautiful landscaped parks in continental Europe, completed during the latter part of the eighteenth century; Bitterfeld: centre of the East German chemical industry, an area so poisoned by pollution that it has become a world-famous monument to man's ability to destroy his environment.

'To find a way out of this desert, that is our task. If we can establish a new harmony, if we can find a happy relationship between nature, industry and the towns, then we will have succeeded in something far more important than whether the Bauhaus today can design a spectacular new building. That we can leave to people in Berlin, London or New York.'

The revived Bauhaus cannot compete with the big, established architectural schools, and should not try to. 'We have to work away at our own belief in the importance of the social idea. There must be nothing nostalgic about the place.'

But already the Bauhaus, with the floors of its workshops strewn with plans, drawings and photographs; with the corridors of the accommodation block echoing at 5am to the roars of drunken Dutch students there on a two-week seminar course; with its basement bar, built illegally by the first students before the Communist overthrow and now an 'in' place in drab Dessau, is a long way from the dumb tourist attraction that the guardians of orthodoxy in East Berlin had in mind when they ordered the restoration of the building in the late Seventies. . . .

By the early Eighties, it was still not expected to have any idea of its own, any soul.

That now is Rolf Kuhn's mission, backed by generous finance from the Bonn government, the state of Saxony – Anhalt, and the European Commission. It is time to free the spirit. . . .

Herbert Bayer extract from prose poem 'Homage to Gropius' 1961

. . . for the future
 the bauhaus gave us assurance
 in facing the perplexities of work;
 it gave us the know-how to work.
 a foundation in the crafts,
 an invaluable heritage of timeless
 principles
 as applied to the creative process.
 it expressed again that we are not to
 impose aesthetics
 on the things we use, to the structures
 we live in,
 but that purpose and form must be seen
 as one.
 that direction emerges when one considers
 concrete demands, special conditions,
 inherent character
 of a given problem.
 but never losing perspective
 that one is, after all, an artist. . . .

Guide to Principal Personalities

Albers, Josef (1888–1976): From 1920 a student, and between 1923 and 1933 a teacher at the Bauhaus, Albers was at first responsible for part of the Preliminary Course and then directed it after Moholy-Nagy's departure in 1928. Older and more experienced than most of his fellow students, Albers was extraordinarily versatile. A maker of stained glass, a designer and photographer, Albers eventually concentrated on painting during his later years in the USA, to which he emigrated in 1933. At the Bauhaus (where he met and married the student weaver Anni Fleischmann), he developed a highly original and imaginative approach to the manipulation of such common materials as paper and metal. In the USA he developed Bauhaus ideas at Black Mountain College, North Carolina, where he was an influential teacher.

Arndt, Alfred (1898–1976): Trained as an engineering draftsman, Arndt joined the Bauhaus as a student in 1921 and took his Journeyman's examination in wall painting four years later. In 1929 he was appointed by Hannes Meyer to the staff of the Dessau Bauhaus, where he taught technical drawing and perspective until the school was closed. After that, he worked as an architect, at first in East Germany and then in West Germany.

Bayer, Herbert (1900–1985): Born in Austria, Bayer studied at the Bauhaus from 1921 until 1923 and again from 1924 until 1925, when he was appointed to the staff. He remained at the school until 1928, when Gropius resigned as director. One of the most versatile Bauhaus graduates, Bayer was a painter, photographer, designer and architect, but his most original and influential work was in the field of typography and graphic design. He emigrated to the USA in 1938 and in the same year organized, together with Gropius, a large and influential Bauhaus exhibition at the Museum of Modern Art, New York.

Behrens, Peter (1868–1940): an architect and designer who began his career as a painter and graphic artist, Behrens was a member of the Darmstadt artists' colony around the turn of the century and, between 1903 and 1907, director of the School of Arts and Crafts in Düsseldorf, where he introduced a kind of practical instruction that proved influential for the development of education in craft and design in Germany. In 1907 he became chief architect and designer of the AEG (General Electricity Company) in Berlin, and was responsible for the design of its buildings, products and advertisements. As one of the first of a new breed of industrial architects and designers (and as a member of the *Deutscher Werkbund*), Behrens helped create the climate that made the Bauhaus possible. Two future directors of the school, Gropius and Mies van der Rohe, worked as assistants in Behrens's practice in Berlin before the First World War.

Brandt, Marianne (née Liebe) (1893–1983): Having studied painting and sculpture at the School of Fine Art in Weimar from 1911 until 1917, she returned to Weimar in 1923 and was a student at the Bauhaus until 1926. Then, from 1927 until 1929, she was employed as an assistant. She is best known for her elegant industrial designs in metal and glass, although she also produced a large number of imaginative photomontages. After 1945 she remained in what became the GDR.

Breuer, Marcel (1902–1981): Born in Hungary, Breuer studied at the Bauhaus from 1920 until 1924, where he concentrated on furniture design, moving quickly from primitivist beginnings to a method of assembly influenced by the *De Stijl* designer Rietveld. From 1925 until 1928 Breuer also taught at the Bauhaus, developing his revolutionary designs for chairs and other furniture constructed, according to engineering principles, from lightweight metal tubing. In 1935 he emigrated to London, where he worked as a designer and architect, and in 1937 moved to the USA, where he taught architecture at Harvard University.

Citroen, Paul (1896–1983): German-born of Dutch parents, Citroen studied at the Bauhaus from 1922 to 1925, where he was one of many students who, initially attracted to Itten's Mazdaznan beliefs, was then converted to Moholy-Nagy's more rational views. He was a painter, photographer and photomonteur.

Dearstyne, Howard (1903–1978): A student of architecture at the Bauhaus from 1928 until 1932, Dearstyne was the only American to be awarded the Bauhaus Diploma. After the closure of the school in 1933, Dearstyne became a private student of Mies van der Rohe before returning to the USA to practise as an architect. In 1941 he became a colleague of Albers at Black Mountain College, North Carolina, and in 1957 was appointed by Mies to teach architecture at the Illinois Institute of Technology in Chicago. Dearstyne's book *Inside the Bauhaus* contains a lively account of his experiences at the school.

Doesburg, Theo van (1883–1931): The most familiar of the several pseudonyms (another was I.K. Bonset) adopted by the Dutch theorist, painter, designer and art impresario Christian Küpper, who founded the *De Stijl* group and edited (and funded) the *De Stijl* magazine. Although best known for the uncompromising attitude to abstraction which he shared with Piet Mondrian, van Doesburg also produced Dadaist work. One of the most energetic and charismatic figures of the age, van Doesburg first visited the Weimar Bauhaus in December 1920, when Gropius may have implied that a teaching post was in the offing. This did not materialize, however. Nevertheless, van Doesburg moved to Weimar in the spring of 1921 and remained there, on and off, until early 1923, publishing *De Stijl* and running his own course in opposition to the Bauhaus, which he regarded as too Romantic in its attitudes. Several students left the Bauhaus and allied themselves with van Doesburg, whose activities in Weimar were a constant irritant to Gropius and his staff. The change in direction that occurred at the school between 1921 and 1923, was in no small measure the result of van Doesburg's influence.

Feininger, Lyonel (1871–1956): Born in New York of German parents, Feininger moved to Germany in 1887, intending to study music. He turned to painting instead, however, studying at first in Hamburg and then in Berlin. He began to paint seriously in 1907, after working as a political and strip cartoonist for German and French magazines and American newspapers. Feininger was a member of the Bauhaus staff from 1919 until 1932, at first as Master of Form in charge of the Printmaking Workshop and then, after 1925, as a Master without teaching responsibilities. He returned permanently to the USA in 1937. Most of Feininger's paintings are of architectural subjects, treated in a way that owes much to Cubism.

Feininger, T. Lux (1910–): Son of Lyonel Feininger and a Bauhaus student from 1926. At first involved in the Theatre Workshop, he became a member of the Bauhaus Jazz Band in 1928 and from 1927 to 1931 was a successful photojournalist. In 1929 he began to paint. In 1936 he emigrated to the USA, where he taught painting.

Graeff, Werner (1901–1978): One of the most gifted students at the Bauhaus from 1921 until 1922, Graeff came under van Doesburg's influence and left the school to join the *De Stijl* group. A painter, photographer and designer, he emigrated in 1934 to Spain and in 1936 to Switzerland. Graeff returned to Germany in 1951.

Gropius, Walter (1883–1969): Gropius was an architect and designer and one of the pioneers of industrial architecture in Germany. He was also the founder of the Bauhaus and its director between 1919 and 1928. Between 1908 and 1910 Gropius was an assistant in Peter Behrens's architectural practice in Berlin. He was also a leading member of the *Deutscher Werkbund*, and the designer (with Adolf Meyer) of the Fagus Shoe-Last Factory, Alfeld-an-der-Leine (1911), and Werkbund Exhibition Buildings in Cologne (1914). The designer of the Bauhaus building in Dessau (1926), Gropius devoted himself to private practice after resigning from the Bauhaus in 1928. Between 1934 and 1937 he was in London, where he worked together with Maxwell Fry on such projects as Impington Village College near Cambridge. He then emigrated to the USA, where he became Chairman of the Architectural Department at Harvard University. In 1946 he founded 'The Architects' Co-operative' with whom he designed, among other large-scale projects, the Pan-Am Building in New York City.

Grunow, Gertrud (1870–1944): Trained as a music teacher, Grunow taught 'harmonization theory' at the Bauhaus from 1919 until 1923.

Hilbersheimer, Ludwig (1885–1967): An architect and town planner, Hilbersheimer was appointed to the Dessau Bauhaus in 1929, where he directed the architecture department until the arrival of Mies van der Rohe. A friend of Mies, he remained at the Bauhaus until it closed in 1933, and in 1938 emigrated to the USA, where he became professor of town planning at the Illinois Institute of Technology in Chicago.

Hirschfeld-Mack, Ludwig (1893–1965): One of the first students to enrol at the Bauhaus in 1919, he was the first to take the Journeyman's examination three years later. As the elected student representative for much of that time, Hirschfeld-Mack did much to establish good relations between the students and staff and to organize a lively social programme. Primarily a painter and printmaker, he also developed a series of 'Reflecting Light Compositions', projections of moving abstract patterns which anticipated abstract film. After leaving the Bauhaus, Hirschfeld-Mack taught in various schools until emigrating to England. Interned during the Second World War, he was then transported as an enemy alien to Australia. There he was discovered in an internment camp by the headmaster of Geelong Grammar School, who appointed him to teach art at the school. He remained in Geelong until his death.

Itten, Johannes (1888–1967): Itten was appointed to the Bauhaus staff in 1919, probably on the recommendation of Gropius's then wife, Alma Mahler, who knew Itten and his private art school in Vienna. At the Bauhaus Itten devised and taught the Preliminary Course and was also Master of Form in several Workshops. Until 1921 he was the most influential member of staff, responsible for the pronounced Expressionist and metaphysical bias of the school's teaching and largely responsible for the appointment of Klee, Schlemmer and Kandinsky to the staff. Then, as the school developed a more rational and Constructivist approach, Itten's influence began to wane, and in 1923 he was persuaded to resign. A painter of limited talent, Itten was a remarkably gifted teacher and theoretician – in spite of his adherence to the pseudo-religious cult of Mazdaznan. After leaving the Bauhaus, Itten founded a private art school in Berlin and then, after brief periods in Krefeld and Amsterdam, moved to Zurich.

Kandinsky, Wassily (1866–1944): Born in Moscow, where he studied natural science and the law, in 1896 at the age of thirty, Kandinsky moved to Munich to study painting at the Academy. He remained in Munich until 1914, when he was obliged to leave Germany and return (via Sweden) to Russia. By then he had already established a reputation as one of the first abstract painters and as a brilliant theoretical writer – his *Concerning the Spiritual in Art* was published in 1912, as was the *Blue Rider Almanac*, which he coedited with Franz Marc. Until 1921 Kandinsky worked enthusiastically with the revolutionary Soviet government as both teacher and administrator, but then disillusionment set in and he returned to Germany to paint in Berlin. The following year he was appointed to the Bauhaus, where he remained until its closure in 1933, for some of the time as the deputy director. As a teacher, he was reponsible for the Wall-Painting Workshop in Weimar, a course in colour and form, and another in analytical drawing. In 1933 he emigrated to France, where he died.

Klee, Paul (1879–1940): When Klee joined the Bauhaus staff in 1920, he had only recently begun to establish his reputation as a highly individual, unusually imaginative painter. His most important contribution to Bauhaus teaching was a course designed to reveal the affinities between art and nature and to isolate the essential properties of colour and form. Less aloof than his friend Kandinsky, Klee was one of the most popular and respected teachers at the school. He resigned from the Bauhaus in 1931 and moved to the Düsseldorf Art Academy as Professor of Painting. In 1933 he left Germany and returned to his native Switzerland.

Marcks, Gerhard (1889–1981): A sculptor by training and inclination, Marcks joined the Bauhaus staff in 1919 to become Master of Form in the Pottery Workshop, which was situated not in Weimar, but in the picturesque village of Dornburg, some twenty-five miles away. He remained there until 1925, when the school moved to Dessau. He had collaborated with Gropius before the First World War, making terracotta reliefs for one of Gropius's interiors at the Werkbund Exhibition in Cologne. From 1925 until 1930 Marcks taught sculpture at the School of Arts and Crafts at Burg Giebichenstein near Halle, where he was also director from 1930 until 1933, when the Nazis dismissed him.

Meyer, Adolf (1881–1929): Between 1911 and 1925 Meyer was a partner in Gropius's architectural practice and collaborated with him on all of the latter's major projects. Although never a full member of the Bauhaus staff in Weimar, Meyer did give some lectures and classes on building to interested students.

Meyer, Hannes (1889–1954): A Swiss architect of decidedly left wing views who was based in Basle between 1919 and 1927, Meyer joined the Bauhaus in 1927, at first to teach architecture, and then to direct the new architecture department. When Gropius resigned in 1928, Meyer was appointed director of the Bauhaus in his place. He introduced many changes to the school, most of them politically inspired. Politics proved his downfall. Increasing attacks on the school from the right meant that a left wing director was a liability, and Meyer was dismissed by the Dessau city authorities in 1930. He immediately left Germany for Moscow, where he worked as a teacher and town planner until 1936. From 1936 until 1939 Meyer was in Switzerland, and from 1939 until 1949 in Mexico. He returned to Switzerland in 1949.

Mies van der Rohe, Ludwig (1886–1969): Like Gropius, Mies joined the architectural practice of Peter Behrens in Berlin after qualifying. A classicist who worked with modern materials, Mies was in charge of the planning and construction of the Weissenhof housing development in Stuttgart (1926–7) and designed the German pavilion at the International Exhibition in Barcelona in 1929. Urged by Gropius to succeed him as Bauhaus director in 1928, Mies refused, but after the dismissal of Hannes Meyer in 1930, he accepted the offer of the same post. He was also in charge of the architectural department. When the Dessau Bauhaus was closed, Mies reopened the school as a private institution in Berlin and remained there as director until that, too, ceased to function in 1933. Initially not unsympathetic to some of the Nazis' social and political aims, Mies emigrated to the USA in 1938, where he taught in Chicago at the Illinois Institute of Technology. An influential designer of furniture as well as an architect, Mies was responsible for such buildings in the USA as the Seagram Building (New York City) and the Houston Museum (Texas).

Moholy, Lucia (née Schulz) (1894–1989): She married László Moholy-Nagy in Berlin in 1921 and moved with him to the Bauhaus in Weimar in 1923, where she practised as a photographer. The Moholy-Nagys left the Bauhaus in 1928 after the appointment of Hannes Meyer. Never formally employed by the school, Lucia was nevertheless closely associated with it, taking photographs for, and co-editing Bauhaus publications with her husband. She separated from Moholy-Nagy in 1929 and in 1933 emigrated to London, where she lived and taught until 1958. In 1959 she moved to Switzerland, where she died.

Moholy-Nagy, László (1895–1946): Born in Hungary, he at first studied law. In 1918 he began to concentrate on painting and to associate with the avant-garde group of artists MA ('Today'). In 1919 he moved to Vienna, and in 1920 from there to Berlin. In 1921 he met El Lissitzky, the Russian Constructivist painter, who had a crucial influence on his work and ideas. Moholy taught at the Bauhaus from 1923 until 1928 where, directing the Preliminary Course as Itten's successor, his intellectual approach to the creative process did much to change the school's direction. A painter, photographer, typographer and industrial designer, Moholy was also Master of Form in the Metal Workshop and co-edited the influential Bauhaus books. In 1934 he emigrated to Amsterdam, and to London a year later, where he quickly established a reputation as a maker of documentary films. In 1937 he left England for Chicago where he founded the 'New Bauhaus'. This soon closed because of financial difficulties. He then set up the 'Institute of Design' in Chicago, whose teaching was also based on Bauhaus principles. He directed the Institute until his death.

Muche, Georg (1895–1987): Muche taught at the Bauhaus between 1920 and 1927, initially as an assistant to Itten on the Preliminary Course and as Master in several Workshops. Primarily a painter, Muche also designed two houses, the Haus am Horn in Weimar and the Steel House in Dessau.

Peterhans, Walter (1897–1960): Between 1929 and 1933 Peterhans was director of the photography department he himself established at the Dessau Bauhaus. He had studied mathematics, philosophy and art history before taking up photography, and his wide knowledge and varied interests informed both his teaching of and his own approach to, photography. In 1938 Peterhans emigrated to the USA. In 1953, having returned to Germany, he was a guest lecturer at the *Hochschule für Gestaltung,* Ulm, the West German attempt to revive Bauhaus educational methods after the Second World War.

Röhl, Karl-Peter (1890–1975): A student at the School of Fine Art in Weimar before the First World War, Röhl returned to it after army service and witnessed the foundation of the Bauhaus. He was one of the most enthusiastic and productive students during the school's early years, painting and sculpting in an Expressionist style and designing the first official Bauhaus seal. When van Doesburg arrived in Weimar in 1921 Röhl was one of several students to be converted to his ideas. He left the Bauhaus, joined the *De Stijl* group and began to paint in a rigorously geometric manner.

Scheper, Hinnerk (1897–1957): Scheper was one of the many students to enroll at the Bauhaus during its early years, having already qualified at other art schools. Scheper, who arrived in Weimar in 1919, had studied wall painting in Düsseldorf and Bremen. In Weimar, too, he specialized in wall painting and qualified as a Journeyman in 1922. After working as a freelance consultant, he rejoined the Bauhaus, now in Dessau, in 1925 and became director of the Wall-painting Workshop, where he developed a new approach to the application of integrated colour schemes to the exteriors and interiors of buildings. Scheper remained at the Bauhaus until its closure in 1933 – apart from almost three years working as an adviser in Moscow. After 1945 most of his work was in architectural conservation.

Schlemmer, Oskar (1888–1943): A painter, sculptor, theatre designer and director, Schlemmer taught at the Bauhaus from 1920 to 1929, at first as Master of Form in the Stonecarving Workshop and then in the Theatre Workshop, where he developed his *Triadic Ballet*. Schlemmer also conceived and taught a course on 'Man'. In 1929 he left Dessau for the Breslau Academy and then, in 1932, moved to Berlin, where he was relieved of his teaching post by the Nazis. In all his many artistic activities Schlemmer was concerned with clarity and balance, based on the exploitation of a repertoire of basic, essentially geometrical forms. An inspired theoretician, his letters and diaries provide unique insights into the daily life, teaching methods and principles of the school.

Schmidt, Joost (1893–1948): One of the most popular members of the Bauhaus, Schmidt studied fine art in Weimar before the First World War. In 1919 he returned from army service to enroll as a student at the Bauhaus, where he qualified in 1925. At first he specialized in wood carving and was responsible for the decorative carvings in the Sommerfeld Villa, Berlin. Later, for the 1923 Bauhaus exhibition, he made sculptural reliefs for the vestibule of the main Bauhaus building. In 1925 he joined the Bauhaus staff and remained at the school until 1932. Schmidt was by no means only a sculptor. He was also a gifted typographer and graphic designer. In Dessau and Berlin he taught typography, life drawing and three-dimensional design.

Schreyer, Lothar (1886–1966): After studying law, Schreyer became a painter, theatre designer and director. Before joining the Bauhaus staff in 1921, he was associated with Herwarth Walden's Sturm gallery and theatre, the centre of the Expressionist movement in Berlin. He founded the Stage Workshop at the Bauhaus but resigned in 1923 after the school's change of direction. His memoirs, *Erinnerungen an Sturm und Bauhaus*, although written many years after the events he describes, are among the most lively accounts of life at the school in Weimar.

Stölzl, Gunta (1897–1983): One of the most innovative weavers of the twentieth century, Stölzl was a student at the Bauhaus between 1919 and 1925, when she became first an assistant in the Weaving Workshop and then, in 1927, its director. She left the Bauhaus in 1931 and moved to Switzerland, where she spent the rest of her life.

Teige, Karel (1900–1951): A Czechoslovak art critic and theorist, Teige gave a series of guest lectures at the Dessau Bauhaus in 1929 at the invitation of Hannes Meyer.

Thedy, Max (1858–1924): As a teacher of painting at the School of Fine Art in Weimar, Thedy was one of several members of staff (others were Richard Engelmann and Walther Klemm) whom Gropius was obliged to employ when the School was amalgamated with the School of Arts and Crafts to form the Bauhaus. Somewhat reactionary in his attitudes, Thedy had little sympathy with Gropius's ideas and plans and did his best to establish a new School of Fine Art, independent of the Bauhaus. He succeeded in 1920, when the Bauhaus was obliged to share its premises with the new school.

van de Velde, Henry (1863–1957): A Belgian painter, architect, designer and theorist, van de Velde was associated with the avant-garde in Brussels, painting in the Neo-Impressionist manner before designing objects and buildings in the Art Nouveau style of which he was one of the earliest and most influential practitioners. In 1900 and 1901 he worked as an interior designer in Berlin, and in 1902 moved to Weimar as an adviser on crafts and industrial design. In Weimar he founded the School of Arts and Crafts, which in 1919 was amalgamated with the School of Fine Art (the buildings of both of which van de Velde designed), to become the Bauhaus. By then van de Velde had left Germany, having proposed three people as possible successors to the directorship of the School of Arts and Crafts. One of them was Gropius, who before the First World War had collaborated with van de Velde in the *Deutscher Werkbund*.

Wittwer, Hannes (1894–1952): An architect, Wittwer joined the Bauhaus with his partner Hannes Meyer in 1927, first as an assistant and then, in 1928, as a full member of staff in the architecture department. In 1929 his partnership with Meyer was dissolved and Wittwer left the Bauhaus for an appointment at the school of arts and crafts at Burg Giebichenstein near Halle. In 1934 Wittwer returned to his native Switzerland.

Bibliography

This is intended only as a basic guide to further reading in English. An exhaustive bibliography (up to 1975) appears in Hans-Maria Wingler, *The Bauhaus*, 3rd. ed., 1975. Full details of the texts used for the documentary section can be found in the source notes overleaf.

Bayer, Herbert, Gropius, Walter & Ise (eds.), *Bauhaus 1919–1928*, Museum of Modern Art, New York, 1938, (reprinted, London, 1975).

Busch-Reisinger Museum, collection catalogue, *Concepts of the Bauhaus*, Cambridge, Mass., 1971.

Dearstyne, Howard & Spaeth David (ed.), *Inside the Bauhaus*, London, 1986.

Droste, Magdalena, *Bauhaus 1919–1933*, Cologne, 1990.

Fiedler, Jeannine (ed.), *Photography at the Bauhaus*, London, 1990.

Franciscono, Marcel, *Walter Gropius & the Creation of the Bauhaus in Weimar. The Ideals & Artistic Theories of its Founding Years*, Urbana, Ill., 1971.

Gropius, Walter, *The New Architecture & the Bauhaus*, London, 1935.

Hirschfeld-Mack, Ludwig, *The Bauhaus: An Introductory Survey*, London, 1947.

Kostelanetz, Richard (ed.), *Moholy-Nagy*, New York & Washington, 1970.

Naylor, Gillian, *The Bauhaus*, London, 1968.

Naylor, Gillian, *The Bauhaus Reassessed. Sources & Design Theory*, London, 1985.

Ness, June L. (ed.), *Lyonel Feininger*, New York, 1974.

Neumann, Eckhard (ed.), *Bauhaus & Bauhaus People*, New York, 1970.

Passuth, Krisztina, *Moholy-Nagy*, London 1985.

Roters, Eberhard, *Painters at the Bauhaus*, London, 1969.

Royal Academy, London, exhibition catalogue, *Fifty Years of the Bauhaus*, 1968.

Rowland, Anna, *Bauhaus Source Book*, Oxford, 1990.

Scheidig, Walter, *Crafts of the Weimar Bauhaus*, London, 1967.

Schlemmer, Tut (ed.), *The Letters & Diaries of Oskar Schlemmer*, Middletown, Conn., 1972.

Westphal, Uwe, *The Bauhaus*, London, 1991.

Whitford, Frank, *Bauhaus*, London, 1984.

Wingler, Hans M., *The Bauhaus*, Cambridge, Mass., & London, 1969 & subsequent editions.

Sources of Documents

Permission to reproduce letters, memoirs and writings has been generously granted by many people, institutions and publishers. The publishers and the Editor of this volume have made every effort to contact all copyright holders, but those we have been unable to reach are invited to contact us so that acknowledgements can be made in subsequent editions.

The following abbreviations have been used:

BHA: Bauhaus Archiv, Berlin.

Getty: J. Paul Getty Center for the Humanities and the History of Art, Los Angeles.

STAW: Thüringisches Staatsarchiv, Weimar.

Neumann: Eckhard Neumann (ed.) *Bauhaus und Bauhäusler*, DuMont, Cologne, 1985.

Schlemmer letters: Tut Schlemmer (ed.), *Oskar Schlemmer, Briefe und Tagebücher*, Gerd Hatje, Stuttgart, 1977.

Wingler 1975: Hans M. Wingler, *Das Bauhaus*, Gebrüder Rasch, Bramsche & DuMont, Cologne, 3rd ed 1975.

Prehistory

17 William Morris, 'Arts and Crafts Circular Letter', Longmans, London 1898, quoted after Hans M. Wingler, *The Bauhaus*, (trans. Wolfgang Jabs and Basil Gilbert), The MIT Press, Cambridge, Mass. & London, 1978, p.19.

Henry van de Velde, 'Ein Kapitel über Entwurf und Bau moderner Möbel', in *Pan* (Berlin), vol.III, 1897, pp.260–64, quoted after Tim & Charlotte Benton (eds) *Form and Function*, The Open University & Crosby, Lockwood, Staples, London, 1975, pp.18–19.

18 Henry van de Velde, in *Die Renaissance im modernen Kunstgewerbe*, Berlin, 1901, quoted after Benton & Benton (eds), p.32

Adolf Loos, *Ornament und Verbrechen*, 1908, in A.L., 'Sämtliche Schriften I', Vienna, 1962, p.201.

19 Gottfried Semper in *Wissenschaft, Industrie und Kunst*, Friedrich Vieweg, Brunswick, 1852, quoted after Wingler, 1975, p.24.

Hermann Obrist, quoted after H.M. Wingler, *Kunstschulreform, 1900–1933*, Bauhaus Archiv, Berlin, 1977, pp.83–85.

20 Peter Behrens, 'Kunstschulen', in '*Kunst und Künstler*', Berlin, vol.V, No.5, February 1907.

William Morris, 'Arts and Crafts Circular Letter', quoted after Wingler, 1975, p.19.

21 Anonymous, 'Description of Weimar' in 'Weimar', *Encyclopaedia Britannica*, 11th ed., London, 1911.

22 Joost Schmidt, 'How I experienced the Bauhaus', undated [1947] typescript, Getty.

Henry van de Velde, 'The Seminar for Arts and Crafts', in *Geschichte meines Lebens*, Piper, Munich, 1962, p.209.

Henry van de Velde, letter to E. von Bodenhausen, quoted after Leon Ploegaerts and Pierre Puttemans *L'Oeuvre Architecturale de Henry van de Velde* Brussels/Quebec, 1987, p.76.

Henry van de Velde, letter to Walter Gropius, quoted after Wingler, 1975, p.28.

23 Joost Schmidt, Getty.

24 Henry van de Velde, 1962, pp.291–93.

25 Walter Gropius, letter to Karl Ernst Osthaus, quoted after H. Hesse-Frielinghaus (ed.), *K.E. Osthaus, Leben und Werk*, Recklinghausen, 1971, pp.470–72.

Walter Gropius, letter to Karl Ernst Osthaus, ibid.

Walter Gropius, letter to his mother, quoted after Reginald R. Isaacs, *Walter Gropius, der Mensch und sein Werk*, Vol.I, Gebr. Mann, Berlin, 1983, p.196.

Manifesto of the *Arbeitsrat für Kunst*, pamphlet, Berlin, May 1919.

Walter Gropius, 'Baukunst im freien Volkstaat', in *Deutscher Revolutionsalmanach für das Jahr 1919*, Berlin, 1919, pp.134–36, quoted after Hartmut Probst & Christian Schädlich, *Walter Gropius*, vol.3, Gesammelte Schriften, Verlag für Bauwesen, Berlin, 1987, p.65.

28 Henry van de Velde, letter to Walter Gropius, original in BHA, quoted after Wingler, 1975, p.27.

29 Walter Gropius, letter to Fritz Mackensen, original in BHA, quoted after Wingler, 1975, p.29.

Gropius to Ernst Hardt, original in STAW.

Walter Gropius to his mother, quoted after Isaacs, p.207.

Walter Gropius to Ernst Hardt, original in STAW.

Weimar

38 Walter Gropius, *Manifesto and Programme of the Bauhaus Weimar*, pamphlet, Staatliches Bauhaus, Weimar 1919

42 Johannes Driesch, letter to Lydia Driesch-Foucar, quoted after exh. cat. *Keramik & Bauhaus*, Bauhaus Archiv, Berlin, 1989, p.78.

Johannes Driesch, letter to Lydia Driesch-Foucar, exh. cat., *Keramik & Bauhaus*, p.78.

Schlemmer, letters, p.42.

43 Kämmer, original in STAW.

Gropius, memorandum to the Student Council, original in STAW.

46 Alma Mahler, in *Mein Leben*, Fischer, Frankfurt-am-Main, 1963, pp.122–23.

Gropius, memorandum to the Thuringian Cultural Minister, original in STAW.

Kämmer, orginal in STAW.

Gropius, quoted after Marcel Franciscono, *Walter Gropius and the Creation of the Bauhaus in Weimar*, University of Illinois Press, Urbana, Ill., 1971, pp.258–59.

47 Feininger, letter to his wife, quoted after Wingler, 1975, pp.42–43.

Feininger, letter to his wife, quoted after Wingler, 1975, p.43.

48 Gropius, speech to students, original in STAW, quoted after Karl-Heinz Hüter, *Das Bauhaus in Weimar*, Akademie Verlag, Berlin, 1976, pp.210–11.

52 Thedy, original in STAW.

von Bode, quoted after Wingler, 1975, p.42.

Schlemmer, letters p.47.

Schlemmer, letters p.103.

53 von Erffa, quoted after Walther Scheidig, *Crafts of the Weimar Bauhaus*, Studio Vista, London, 1967, p.18.

Arndt, in Neumann, p.103.

Itten, *Mein Vorkurs am Bauhaus. Gestaltungs- und Formenlehre*, Otto Meier, Ravensburg, 1963, p.10.

54 Stölzl, original in BHA.

Klee, in Felix Klee (ed.), *Paul Klee, Briefe an die Familie*, vol.II, 1907–1940, DuMont, Cologne, 1979, pp.970–71.

57 Arndt, in Neumann, pp.103–104.

Itten, *Mein Vorkurs am Bauhaus*, p.81.

59 Itten, *Kunst der Farbe*, Otto Maier, Ravensburg, 1961, p.114, quoted after exh. cat. 50 Years of the *Bauhaus*, Royal Academy of Arts, London, 1968, p.40.

Itten, 'Analysen alter Meister', in Bruno Adler (ed.) *Utopia. Dokumente der Wirklichkeit*, Bruno Adler, Weimar, 1921, quoted after Wingler, 1975, p.56.

60 Schlemmer, letters, p.49.

62 Citroen, in Neumann, pp.88–94.

64 Schlemmer, letters, pp.54–56.

68 Schreyer, *Erinnerungen an Sturm und Bauhaus*, List, Munich, 1960, pp.106–107.

69 Klee, *Beiträge zur bildnerischen Formlehre*, quoted after Günther Regel (ed.), *Paul Klee, Kunst-Lehre*, Reclam, Leipzig, 1987, pp.91–105.

72 Fischli, quoted after exh. cat. *Bauhaus Utopien, Arbeiten auf Papier*, Kölnischer Kunstverein, Cologne, undated, p.115.

74 Klee, *Wege des Naturstudiums*, quoted after Regel (ed.), pp.67–70.

76 Fischli, quoted after exh. cat. *Bauhaus Utopien*, p.121

80 Schlemmer, letters, p.86.

81 Kandinsky, in *Staatliches Bauhaus Weimar, 1919–1923*, Bauhausverlag, Weimar and Munich, 1923, p.26, quoted after Wingler, 1975, p.88.

82 Schreyer, in Schreyer, pp.128–29.
Kandinsky, in *Staatliches Bauhaus Weimar, 1919–1923*, quoted after Wingler, 1975, pp.88–89.

84 Schlemmer, letters, p.43.
Schmidt, Getty.
Schlemmer, letters, p.47.
Schlemmer, original in STAW.

86 Anni Albers, 'The Weaving Workshop', in Herbert Bayer, Walter Gropius & Ise Gropius (eds.), *Bauhaus 1919–1928*, Museum of Modern Art, New York, 1938, p.141.
Gunta Stölzl, 'Die Gebrauchstoffe der Bauhausweberei' in *Bauhaus. Zeitschrift für Gestaltung*, Dessau, July 1931, quoted after Wingler, 1975, p.180.

87 Dr Otto, original in STAW.
Gropius, original in STAW.

90 Schlemmer, letters, p.50

91 Hirschfeld-Mack, in *Berliner Börsenkurier*, 24 August 1924.

92 Hans Haffenrichter, in Neumann, p.118.

94 Lou Scheper, in Neumann, p.177–78.

95 Herbert Bayer, 'Bilder in Raum', in *Form + Zweck, Fachzeitschrift für industrielle Formgestaltung*, Berlin, vol.11, no.3, 1979, pp.58–59.

99 Statutes, in *Satzungen Staatliches Bauhaus Weimar*, pamphlet, Weimar, 1923.
Feininger, quoted after June L. Ness (ed.), *Lyonel Feininger*, Praeger, New York, 1974, p.112.

101 Prospectus for *Bauhaus-Drucke – neue europäische Graphik*, quoted after Wingler, 1975, p.57.
Kandinsky, intro. to *Kleine Welten*, twelve original prints printed by the Bauhaus, Propyläen Verlag, Berlin, 1922.

103 Gropius, original in STAW.
Gropius, original in STAW.
memorandum of a discussion between the Workshop Masters, original in STAW.

104 Schreyer, in Schreyer, p.104.
Driesch-Foucar, quoted after exh. cat. *Bauhaus Keramik & Bauhaus*, p.73.

106 Gropius, in STAW.

107 Helene-Nonne Schmidt, interview with Basil Gilbert, in Neumann (ed.), pp.188–89.

110 Gropius, original in STAW.
Adolf Sommerfeld, original in STAW.

111 Alfred Arndt, 'Life at the Bauhaus and its Festivals', quoted after exh. cat. *Bauhaus 50 years*, p.311.

112 Bayer, in Herbert Bayer, *Herbert Bayer, painter, designer, architect*, Reinhold, New York, 1967, p.10.

113 Driesch-Foucar, quoted after exh. cat. *Bauhaus Keramik & Bauhaus*, p.71.
Arndt, quoted after exh. cat. *Bauhaus 50 years*, p.311.

115 Dr Emil Herfurth, *Weimar und das Staatliche Bauhaus*, Hermann Böhlau, Weimar, 1920, pp.13–14.
Driesch-Foucar, quoted after exh. cat. *Bauhaus Keramik & Bauhaus*, p.73.
Staatsrat Rudolph, original in STAW.

117 Schmidt, original in Getty.
Gropius, quoted after Isaacs, pp.251–52.

118 Schlemmer, letters, p.48.
Marie-Luise von Banceis, 'Bauhaus Drachenfest in Weimar', *Berliner Tageblatt*, Berlin, 18 Oct 1922, quoted after Wingler, 1975, p.70.

119 Arndt, quoted after exh. cat. *Bauhaus 50 years*, p.311.
Nonne-Schmidt, in Neumann, p.190.
Gropius, original in STAW.
Schawinsky, quoted after exh. cat. *Xanti Schawinsky: Malerei, Bühne, Grafikdesign, Fotografie*, Bauhaus Archiv, Berlin, 1986, pp.183–84.

120 Schreyer, in Schreyer, pp.107–108.

121 Molnár, 'Das Leben im Bauhaus' in H. Gassner, (ed.) *Wechselwirkungen, Ungarische Avantgarde in der Weimarer Republik*, Marburg, 1986, pp.273 ff.

122 'Sex at the Bauhaus', Weimarer Zeitung 1924.
Banceis, quoted after Wingler, 1975, p.70.
Anonymous, *Weimarer Zeitung*, 13–14 June, 1924.
Kole Kokk in *8 Uhr Abendblatt*, Berlin, 18 February, 1924.

125 Felix Klee in Neumann, *Bauhaus und Bauhäusler*, DuMont, Cologne, 1985, pp.79–86.

126 Theo van Doesburg, quoted after Joost Baljeu, *Theo van Doesburg*, Studio Vista, London 1974 p.41.

127 Schlemmer, letters, p.57.

130 Werner Graeff, in Neumann, p.131.
Graeff, 'Bemerkungen eines Bauhäuslers' (1963), in exh. cat. Werner Graeff: *Ein Pionier der Zwanziger Jahre*, Marl, 1979/80, p.7.
Vilmos Huszar, 'Bauhaus' in *De Stijl*, Weimar, September, 1922.

131 Feininger, quoted after Wingler, 1975, p.68.

132 Schlemmer, letters, p.52.

133 Schlemmer, STAW, quoted after Franciscono, pp.288–89.
Schlemmer, letters, p.57.
Schlemmer, STAW.

134 Gropius, STAW, quoted after Hüter, pp.230–31.

135 Marcks, quoted after Franciscono, pp.296–97.

138 Schlemmer, letters, pp.63–64.
Ilya Ehrenburg, 'Briefe aus Café Deutschland in 1922', quoted after *Weimar im Urteil der Welt*, Berlin & Weimar, 1971, pp.304–306.

139 Gropius, original in STAW.

140 Graeff, quoted after Dearstyne, p.67.

141 Gropius, original in STAW.
Marcks, original in STAW.
Feininger, quoted after Ness, p.125.

142 Schlemmer, quoted after Hüter, pp.242–43.

143 Feininger, quoted after Ness, p.126.

145 Giedion, in Neumann, pp.133–34.

147 Schlemmer, letters, p.62.

150 Mies van der Rohe, quoted after Howard
 Dearstyne, *Inside the Bauhaus*, London,
 1986, p.79.

151 Walter Passarge, in *Das Kunstblatt*,
 Potsdam, vol.VII, 1923, pp.309ff, quoted
 after Wingler, 1975, pp.81–82.

152 Augusta de Wit, in *Nieuwe Rotterdamsche
 Courant*, Rotterdam, 27 August 1923,
 quoted after Dearstyne, p.77.

153 Masters and students, original in STAW.

 Paul Westheim, in *Das Kunstblatt*, Berlin,
 vol.VII, 1923, p.319, quoted after Wingler,
 1975, p.82.

154 Dr Erwin Redslob, quoted in Bayer, Gropius
 and Gropius (eds.), p.93.

155 Josef Albers in 'Werkstattarbeiten des
 Staatlichen Bauhauses zu Weimar' in
 supplement to *Neue Frauenkleidung und
 Frauenkultur*, Karlsruhe, 1924, quoted after
 *Form + Zweck. Fachzeitschrift für
 industrielle Formgestaltung*, vol.11, no.3,
 1979, pp.7–9.

157 Adolf Behne in *Die Weltbühne*, Berlin,
 vol.19, no.38, 20 September 1923, p.29.

159 Moholy-Nagy, in Sibyl Moholy-Nagy,
 László Moholy-Nagy, ein Totalexperiment,
 Florian Kupferberg, Mainz & Berlin, 1972,
 p.25.

160 Moholy Nagy & Ludwig Kassak, *Buch
 Neuer Künstler*, quoted after Sibyl Moholy-
 Nagy, pp.31–32.

 Moholy-Nagy, in *MA*, May 1922, quoted
 after Richard Kostelanetz (ed.), *Moholy-
 Nagy*, Praeger, New York, 1970, p.185.

161 Lucia Moholy, *Marginalien zu Moholy-
 Nagy, Marginal Notes*, Scherpe, Krefeld,
 1972, pp.75–76.

162 Moholy-Nagy, in Krisztina Passuth,
 Moholy-Nagy, Thames & Hudson, London,
 1985, pp.392–93.

165 Paul Citroen, quoted after Sibyl Moholy-
 Nagy, pp.42–43.

166 Citroen, quoted after Sibyl Moholy-Nagy,
 p.47.

 Feininger, quoted after Ness, p.142.

 Moholy-Nagy, in Schreyer, p.138.

167 Moholy-Nagy, *Von Material zu Architektur*,
 Kupferberg, Mainz & Berlin, 1928, quoted
 after Sibyl Moholy-Nagy, *Moholy-Nagy:
 Experiment in Totality*, MIT Press,
 Cambridge, Mass., 1950, pp.44–45.

168 Moholy-Nagy, *Von material zu Architektur*,
 quoted after exh. cat. *Experiment Bauhaus,
 Das Bauhaus-Archiv, Berlin (West) zu Gast
 im Bauhaus Dessau*, Kupfergraben
 Verlagsgesellschaft, Berlin, 1988, p.34.

169 Fritz Kuhr, in *Bauhaus. Zeitschrift für
 Gestaltung*, Dessau, 2/3, 1928, quoted after
 Wingler, p.265.

 Moholy-Nagy, quoted after exh. cat.
 Experiment Bauhaus, p.34.

170 Moholy-Nagy, in Kostelanetz (ed.),
 pp.80–81.

171 Wilhelm Wagenfeld in exh. cat. *Experiment
 Bauhaus*. pp.27–28.

 Otto Rittweger, in *Vivos Voco*, Leipzig, vol.5,
 nos.8–9, August/September 1926,
 pp.293–94.

 Wilhelm Wagenfeld, in 'Junge Menschen',
 special issue of *Bauhaus. Zeitschrift für
 Gestaltung*, 1924.

172 Marianne Brandt, in Neumann, pp.97–99.

174 F.K. Fuchs, in 'Deutsche Goldschmiede-
 Zeitung', 1926, p.222.

175 Moholy-Nagy, *Vision in Motion*, 1928.

176 Wilhelm Wagenfeld, in 'Junge Menschen',
 1924, quoted after *Form + Zweck*, vol.11
 no.3, 1979, p.11.

177 Gropius, in *Die Bauhausbühne. Leitung
 Lothar Schreyer. Erste Mitteilung*,
 pamphlet, December 1922.

 Schlemmer letters, p.66.

 Kurt Schmidt, in exh. cat. *Experiment
 Bauhaus*, p.266.

182 Gropius, quoted after exh. cat. *Bauhaus
 Utopien*, p.8.

 Stölzl, quoted after Dearstyne, p.130.

 Gropius, in STAW.

 Max Osborn, in *Vossische Zeitung*, 20
 September 1923, quoted after Dearstyne,
 p.119.

 Gropius, quoted after exh. cat. *Keramik &
 Bauhaus*, p.20.

183 Gerhard Marcks, in STAW.

 Wassily Kandinsky, copy in BHA.

 Dr Necker, quoted after exh. cat. *Keramik &
 Bauhaus*, p.24.

184 Schlemmer (ed.), *Die Bühne im Bauhaus*,
 1925 (Bauhausbuch).

185 Schlemmer letters, p.72.

 Gropius, BHA, quoted after Wingler, 1975,
 p.90.

 Hans Volger & Erich Brendel, in STAW.

186 Moholy-Nagy, quoted after Sybil Moholy-
 Nagy, pp.27–8.

187 Moholy-Nagy, in *Vivos Voco*, Leipzig, vol.5,
 nos.8–9.

 Schlemmer letters, p.84.

 Rolf Sachsse, in R.S., *Lucia Moholy*, 1985,
 pp.16ff.

188 Herbert Bayer, interview in *Kunstreport*,
 No.4, 1986, p.23.

 T. Lux Feininger, In exh. cat. *T. Lux
 Feininger, Photographs of the Twenties and
 Thirties*, New York, 1980, no page nos.,
 quoted from exh. cat. *Experiment Bauhaus*,
 p.230.

 Moholy-Nagy, 'Die Neue Typographie', in
 Staatliches Bauhaus Weimar, 1919–1923,
 Weimar, 1923.

 Moholy-Nagy, *Painting, Photography, Film*,
 Bauhaus Book No.8, 1925.

190 Moholy-Nagy, 'Die neue Typographie' in
 Staatliches Bauhaus Weimar, 1919–23,
 Weimar & Munich, 1923.

 Moholy-Nagy, 'Typophoto', in
 Typographische Mitteilungen, 1925.

 Moholy-Nagy, 'Fotoplastische Reklame', in
 Offset. Buch- und Werbekunst, Leipzig, No.7,
 1926, p.391.

 Berlin publisher, in Sibyl Moholy-Nagy:
 Moholy-Nagy. Experiment in Totality, MIT
 Press, Cambridge, Mass. & London, 2nd. ed.
 1969, pp.41–42.

191 Gropius to Max Osborn, original in STAW.

 Bauhaus students, original in STAW.

 Minutes, original in STAW.

192 Gropius, quoted after Gillian Naylor: *The
 Bauhaus Reassessed. Sources and Design
 Theory*, Herbert Press, London, 1985, p.60.

 Gropius, original in STAW.

 Freiin von Freytag Loringhoven, in
 Weimarische Landeszeitung Deutschland, 1
 January 1920.

 Anonymous, in *Tägliche Rundschau*,
 Weimar, 3 January 1920.

193 Gropius, BHA, quoted after Wingler, 1975,
 p.89.

 Schlemmer letters, p.72.

 Gropius, quoted after Isaacs, vol.I, p.322.

 Ise Gropius, quoted after Isaacs, vol.I, p.328.

196 van Doesburg, STAW, quoted after Hüter,
 p.89.

197 Schlemmer letters, p.73.

 Bauhaus Masters, quoted after Wingler,
 1975, p.106.

 Schlemmer letters, p.76.

Dessau

204 Anonymous, in *Bauhaus Dessau*, prospectus, 1927, quoted after Wingler, 1975, p.117.

205 Feininger, in Wingler, 1975, p.108.

Kurt Schwitters, in Ernst Nündel (ed.), *Kurt Schwitters. Wir spielen, bis uns der Tod abholt. Briefe aus fünf Jahrzehnten*, Ullstein, Frankfurt-am-Main, Berlin, Vienna, 1975, p.93.

206 Feininger, quoted after Ness, p.147.

'G', quoted after Günter Feist (ed.), *Kunst und Künstler aus 32 Jahrgängen einer deutschen Kunstzeitschrift*, Henschelverlag, Kunst und Gesellschaft, Berlin, 1971, p.276.

208 Felix Klee, in Felix Klee (ed.) *The Diaries of Paul Klee* (trans. anon.), University of California Press, Berkeley & London, 1964, pp.416–17.

209 Rudolf Arnheim, 'Das Bauhaus in Dessau', in *Die Weltbühne*, Berlin, no.23, 1927, quoted after Ursula Madrasch-Groschopp (ed.), *Rudolf Arnheim, Zwischenrufe. Kleine Aufsätze aus den Jahren 1926–1940*, Gustav Kiepenheuer, Leipzig & Weimar, 1985, p.22.

Feininger, quoted after Wingler, p.130.

211 Felix Klee, in Felix Klee, *Paul Klee* (trans. Richard & Clara Winston), New York, 1962, p.55.

213 Nina Kandinsky, *Kandinsky und Ich*, Munich, 1976, pp.118–19.

214 Feininger, quoted after Ness, p.158.

215 Fanina W. Halle, in *Das Kunstblatt*, Potsdam, vol.XIII, no.7, July 1929, pp.203ff., quoted after Wingler, 1975, p.158.

216 Gropius, *Grundsätze der Bauhausproduktion*, pamphlet, Bauhaus Dessau, 1926, quoted after exh. cat. *Tendenzen der Zwanziger Jahre*, Neue Nationalgalerie *et al.*, Berlin, 1977, 1/182.

217 George Muche, *Blickpunkt*, Tübingen, 1965, pp.153–54.

218 Nina Kandinsky, p.137.

219 Max Bill (ed.), *Kandinsky, Essays über Kunst und Künstler*, Bern (1955), revised edition 1963, pp.10ff.

221 K. Lindsay & P. Vergo (eds.), *Kandinsky Complete Writings*, pp.529 ff.

222 Paul Klee in *Bauhaus. Zeitschrift für Bau und Gestaltung*, Dessau, vol.II, 1928.

Ludwig Grote, in exh. cat. '*35 Junge Bauhausmaler*', Halle, 1928.

223 T. Lux Feininger, in Neumann, p.181.

224 Hannes Beckmann, in Neumann (ed.), pp.275–77.

226 Hin Bredendieck, in *Form + Zweck*, 3, 1979, pp.63–65.

228 Schlemmer, in Tut Schlemmer (ed.), p.62.

Marcel Breuer, quoted after Bayer, Gropius and Gropius (eds.), p.172.

Marcel Breuer, quoted after exh. cat. *Experiment Bauhaus*, p.120.

229 Marcel Breuer, 'Metallmöbel' in Werner Graeff (ed.) *Innenräume*, Stuttgart 1928, p.227 quoted after Benton and Benton, p.226.

230 Marcel Breuer, in *Das Neue Frankfurt*, Frankfurt-am-Main, No.1, 1928, quoted after exh. cat. *Tendenzen der Zwanziger Jahre*, pp.1–186.

232 Joost Schmidt, Getty.

233 Wilhelm Lodz, quoted after Wingler, p.143.

234 Stölzl, 'Weberei am Bauhaus', in *Offset, Buch- und Werbekunst*', Leipzig, 1926, no.7, quoted after Wingler, 1975, pp.125–26.

237 Anni Albers, in Bayer, Gropius & Gropius (eds.), pp.141–42.

Helene Nonne-Schmidt in *Vivos voco* 1926.

240 Bayer, quoted after Arthur A. Cohen *Herbert Bayer, the Complete Works*, Cambridge (Mass.) 1989, pp.358–9.

241 Bayer, exh. cat. Heinz Loew, 'Plastische Werkstatt Dessau 1927–1932', p.44.

244 Bayer, quoted after Wingler, pp.143–44.

Schmidt, quoted after exh. cat. *Experiment Bauhaus*, p.394.

Hans Fischli, quoted after exh. cat. *Hans Fischli – Malerei, Plastik, Architektur*, Zürich 1968, p.60.

Schlemmer, in Tut Schlemmer (ed.), p.79.

245 Schlemmer, *Tänzerische Mathematik*, in *Vivos Voco*, Leipzig, vol.5, nos.8/9, August–September 1926, quoted after Wingler, 1975, pp.128–29.

248 Schlemmer, quoted after exh. cat. *Experiment Bauhaus*, p.219.

Georg Schmidt, in *Basler National-Zeitung*, 30 April 1929, quoted after exh. cat. *Experiment Bauhaus*, p.274.

249 Schlemmer, *Das figurale Kabinett*, 1923, quoted after Wingler, 1975, p.74.

T. Lux Feininger, quoted after exh., cat. *Experiment Bauhaus*, p.68.

250 Meyer, 'Die Neue Welt', in *Das Werk*, Zurich, 1926, vol.13, no.7, pp.205–224, quoted after Lena Meyer-Bergner (ed.), *Hannes Meyer. Bauen und Gesellschaft. Schriften, Briefe, Projekte*, Verlag der Kunst, Dresden, 1980, pp.29–30.

Gropius, Getty, quoted after exh. cat. *Hannes Meyer, Architekt, Urbanist, Lehrer, 1889–1954*, Bauhaus Archiv Berlin, p.166.

Meyer, quoted after Lena Meyer-Bergner (ed.), pp.41–42.

251 Meyer, quoted after exh. cat. '*Experiment Bauhaus*'.

Gropius, quoted after exh. cat. *Bauhaus Utopien*, p.280.

Meyer, quoted after exh. cat. *Hannes Meyer*, pp.166–67.

Schlemmer, in Tut Schlemmer (ed.), p.91

253 Schlemmer, letters, p.91.

Meyer, quoted after exh. cat. *Hannes Meyer*, p.167.

Meyer, quoted after exh. cat. *Hannes Meyer*, p.216.

254 Schlemmer, letters, p.101.

Moholy-Nagy, quoted after Sibyl Moholy-Nagy, pp.46–47.

Gropius, quoted after Isaacs, vol.I, p.411.

Schlemmer, letters, p.101.

255 Schlemmer, letters p.102. Grete Dexel, 'Warum geht Gropius?', in *Frankfurter Zeitung*, 17 March 1928, quoted after Walter Vitt (ed.), *Walter Dexel, Der Bauhausstil – Ein Mythos. Texte 1921–1965*, Josef Keller, Starnberg, 1976, pp.26–29.

256 Schlemmer, letters, p.105.

257 Meyer, in *Anhalter Rundschau*, Dessau, 23 November 1928.

Meyer, 'Bauhaus und Gesellschaft', in *Bauhaus. Zeitschrift für Gestaltung*, Dessau, 1929, vol.3, no.1, p.2., quoted after Lena Meyer-Bergner, p.50.

Stam 'M-Kunst', in *Bauhaus. Zeitschrift für Gestaltung*, vol.2, nos.2/3, 1928, p.16.

258 Meyer, quoted after exh. cat. *Hannes Meyer*, p.168.

259 Schlemmer, letters, p.106.

Anonymous, in *Bauhaus 4.*, 1928, p.21.

Schlemmer, letters, p.111.

Meyer, quoted after exh. cat., *Hannes Meyer*, p.168.

Schlemmer, letters, p.113.

260 Meyer, quoted after exh. cat. *Hannes Meyer*, p.171.

Felix Klee, quoted after *Paul Klee*, 1988.

Tolziner, quoted after exh. cat. *Hannes Meyer*, p.245.

Kranz, in Neumann (ed.), p.341.

261 Meyer, 'Bauen', in *Bauhaus. Zeitschrift für Gestaltung*, Dessau, 1928, vol.2, no.4., pp.12ff.

262 Behne, in *Zentralblatt der Bauverwaltung*, special issue, vol.51, no.14, 1931, pp.213–22.

Tolziner, quoted after exh. cat. *Hannes Meyer*, pp.234–40.

263 Meyer, quoted after exh. cat. *Hannes Meyer*, p.242, note 4.

264 Meyer, quoted after exh. cat. *Hannes Meyer*, p.167

Kállai 'Zehn Jahre Bauhaus', in *Die Weltbühne*, Berlin, 1930, vol.26, 1930, pp.135–39, quoted after Tanja Frank (ed.), *Ernst Kállai, Vision und Formgesetz. Aufsätze über Kunst und Künstler von 1921 bis 1933*, Gustav Kiepenheuer, Leipzig & Weimar, 1986, pp.158.

Schuh, in Neumann (ed.), pp.240–41.

267 Fischli, quoted after exh. cat. *Hans Fischli*, p.59.

269 Fischli, quoted after exh. cat. *Hans Fischli*, pp.74–75.

Scheper, quoted after exh. cat. *Experiment Bauhaus*, p.304.

Berger, quoted after exh. cat. *Experiment Bauhaus*, p.96.

270 Schlemmer, quoted after Dirk Scheper, *Oskar Schlemmer, das Triadische Ballett und die Bauhaus-Bühne*, Berlin 1988, p.208.

271 Stölzl, 'Die Gebrauchsstoffe der Bauhausweberei', in *Bauhaus. Zeitschrift für Gestaltung*, Dessau, July 1931, quoted after Wingler, 1975, p.180.

Schmidt, 'Schrift' in *Bauhaus II*, 1928.

Anonymous, newspaper cutting in BHA.

Interviews with students, Bauhaus Zeitschrift für Gestaltung, vols. 2, 3 and 9, 1928.

276 Dearstyne, p.216.

Auerbach, in exh. cat., *Experiment Bauhaus*, p.242.

Peterhans, in exh. cat. *Bauhaus Utopien*, p.162.

278 Anonymous, in *Anhalter Anzeiger*, Dessau, 12 February 1929.

Schlemmer, letters, p.109.

280 Kállai, quoted after Tanja Frank (ed.), pp.133–34.

Gropius in Walter Gropius, *The New Architecture and the Bauhaus*, London, 1935, p.37.

281 Kállai, quoted after Tanja Frank (ed.), p.140.

Mentzel, quoted after exh. cat. *Hannes Meyer*, p.144.

283 Meyer, 'Mein Hinauswurf aus des Bauhaus', in *Das Tagebuch*, Berlin, 1930, quoted after Lena Meyer-Bergner (ed.), *Hannes Meyer. Bauen und Gesellschaft. Schriften, Briefe, Projekte*, Verlag der Kunst, Dresden, 1980, pp.67–73.

285 Schlemmer, letters, p.120.

Communist students, in *Bauhaus, Sprachrohr der Studierenden*, No.3, 1930.

Schawinsky, 'Kopf oder Adler?' in *Berliner Tageblatt*, 10 January 1931.

286 Schawinsky, quoted after exh. cat. *Xanti Schawinsky: Malerei, Bühne, Grafikdesign, Fotografie*, Bauhaus Archiv, Berlin, 1986, p.199.

Dearstyne, *Inside the Bauhaus*, pp.209–10.

Gropius, in '*Ulm, Hochschule für Gestaltung*', No.10, 1964, p.70.

287 Dearstyne, p.220–22.

288 Mies van der Rohe, 'Die neue Zeit', in *Die Form*, Berlin, 1 August 1930, vol.5, no.15, p.406, quoted after Wingler, 1975, pp.173–74.

Communist students, in *Bauhaus, Sprachrohr der Studierenden*, No.3, 1930.

289 Klee, in Felix Klee (ed.) *Briefe an die Familie*, vol.2, 1907–1940, DuMont, Cologne, 1979, pp.1139–40.

290 Kandinsky, quoted after cat. *Bauhaus Berlin*, p.27.
'M', quoted after exh. cat. *Bauhaus Berlin*, pp.67–68.

291 Dearstyne, p.228.

Dearstyne, p.233.

292 Pahl, in Neumann (ed.), p.333.

Hilbersheimer, 'Die Kleinstwohnung im treppenlosen Hause', in *Bauhaus. Zeitschrift für Gestaltung*, Dessau, January 1931, quoted after Wingler, 1975, p.178.

293 Selmanagić, 'Entwurf einer Arbeitersiedlung', in *Form + Zweck. Fachzeitschrift für industrielle Formgestaltung*, vol.8, 6/1976 ('50 Jahre Bauhaus Dessau') pp.31–32.

294 Kmiec, quoted after exh. cat. *Bauhaus Berlin*, p.38.

'M', quoted after exh. cat. *Bauhaus Berlin*, p.69.

295 Straub, *Die Architektur im dritten Reich*, Berlin, 1932, pp.14–20.

296 Paulsen, in *Völkischer Beobachter*, 30 March 1932, quoted after exh. cat. *Bauhaus Berlin*, p.52.

297 Kurella, in *Magazin für alle*, Berlin, No.12, 1931, pp.39–42.

Berlin

300 Mies van der Rohe, quoted after exh. cat. *Bauhaus Berlin*, p.61.

Scheper, quoted after exh. cat. '*Bauhaus Utopien*', p.107.

Wilke, quoted after exh. cat. *Bauhaus Berlin*, pp.119–21.

301 Kandinsky, in exh. cat. *Bauhaus Berlin*, p.126.

302 Kessler, in exh. cat. *Bauhaus Berlin*, p.176.

Trudel, in Neumann (ed.), pp.326–27.

303 Mies van der Rohe, 'The End of the Bauhaus' in North Carolina University State College of Agriculture and Engineering, School of Design Student Publication, vol.3 no.3, spring 1953, pp.16–18, quoted after exh. cat. *Bauhaus Berlin*, pp.154–55.

307 Office of the Secret Police, quoted after exh. cat. *Bauhaus Berlin*, p.143.

Kandinsky, quoted after exh. cat. *Bauhaus Berlin*, p.144.

Postscript

308 Tom Wolfe, *From Bauhaus to Our House*, Jonathan Cape, London, 1983, pp.45–47.

Patsitnov, *Das schöpferische Erbe des Bauhauses, 1919–1933*, Institut für angewandte Kunst, Berlin, 1963, p.35.

309 Tolziner, in exh. cat. *Hannes Meyer*, pp.260–63.

Maldonado, in '*Ulm, Zeitschrift für die Hochschule für Gestaltung*', nos.8/9, 1963, pp.5ff.

310 Eisenhammer, 'Old Bauhaus new Big Idea', in *The Independent*, London, 28 August 1991.

311 Bayer, 'Homage to Gropius' 1961, quoted after '*Herbert Bayer: Painter, Designer, Architect*, Reinhold Publ., New York, and Studio Vista, London, 1967, p.10.

(frontispiece)
Cover for offprint of essay by Gropius: 'Idea and Development of the State Bauhaus Weimar', 1923
Anon.
Frank Whitford.

12 Page from catalogue of rush-seated chairs by Morris and Co., late 19th century
William Morris Gallery, London

14 Electric fan designed for AEG, 1908
Peter Behrens, A.E.G.

15 Walter Gropius as cavalry officer during the First World War
Bauhaus-Archiv, Berlin

16 Poster for Tropon Food Company, 1897
Henry van de Velde, Lithographed poster

20 Study in ornament, c.1909
Anon. Student
Kunstsammlungen zu Weimar

21 View of Weimar, c.1910
Anon., photograph
Private Collection, Weimar

23 Henry van de Velde at home, Weimar, c.1910
Photograph by Louis Held
Foto-Atelier Louis Held Inhaber
Eberhard Renno, Weimar

26 (top)
Locomotive, 1912
Designed by Walter Gropius

26 (bottom)
Fagus shoe-last factory in Alfeld-an-der-Leine, 1911
Designed by Walter Gropius (with Adolf Meyer), Photograph
Bauhaus-Archiv, Berlin

27 (top)
Commemorative metal plaque with lettering, 1919
Lettering designed by Walter Gropius

27 (bottom)
Machine hall for the Werkbund Exhibition, Cologne, 1914
Walter Gropius (with Adolf Meyer), Photograph
Bauhaus-Archiv, Berlin

28 Portrait of Walter Gropius, 1920
Photograph by Louis Held
Foto-Atelier Louis Held Inhaber
Eberhard Renno, Weimar

30 Invitation to the opening ceremony of the Bauhaus, 21-3-1919
Karl-Peter Röhl, Lithograph
Bauhaus-Archiv, Berlin

32 Illustration for the Manifesto and Programme of the Bauhaus, 1919
Lyonel Feininger, Woodcut
Resource Collections of the Getty Center for the History of Art and the Humanities
© DACS 1992

33 The first page of the Programme of the Bauhaus, 1919
Lyonel Feininger
Resource Collections of the Getty Center for the History of Art and the Humanities
© DACS 1992

34 Cover of the Bauhaus book: 'An Experimental House by the Bauhaus', 1925
László Moholy-Nagy
Bauhaus-Archiv, Berlin

36 Programme of the topping out ceremony of the Sommerfeld Villa, 18-12-1920,
Designed by Martin Jahn
Resource Collections of the Getty Center for the History of Art and the Humanities

39 Design for Bauhaus seal, 1919
Karl-Peter Röhl, Pen and ink
Thüringisches Hauptstaatsarchiv Weimar

43 Portrait of Oskar Schlemmer
Photograph

44 Römisches (Roman), 1925
Oskar Schlemmer
Oil on canvas, 97.5 × 62 cm
Oeffentliche Kunstsammlung Basel, Kunstmuseum

45 Barfusserkirche in Erfurt, 1924
Lyonel Feininger
Oil on canvas, 18 × 24 cm
Staatsgalerie Stuttgart, © DACS 1992

47 Portrait of Lyonel Feininger, c.1922
Photograph by Hugo Erfurth
Bauhaus-Archiv, Berlin

50 Colour study (produced during Itten's Preliminary Course), c.1920
Max Peiffer-Watenphul, Collage with coloured paper
Bauhaus-Archiv, Berlin

51 Abstract Composition, c.1922
Hans Haffenrichter, Gouache on paper
Private Collection, New York
Photo courtesy Barry Friedman Ltd

55 Study in rhythm (produced during Itten's Preliminary Course), c.1920
Max Peiffer-Watenphul
Bauhaus-Archiv

56 (top)
Study in rhythm (produced during Itten's Preliminary Course), c.1920
Werner Graeff
Bauhaus-Archiv, Berlin

56 (below right)
Study in materials (produced during
Itten's Preliminary Course), 1920–21
Vincent Weber
Bauhaus-Archiv, Berlin

56 (below left)
Study in three-dimensional form
(produced during Itten's Preliminary
Course), 1920–21
Rudolf Lutz
Bauhaus-Archiv, Berlin

58 (left)
Study in contrast, c.1920
(reconstruction)
M. Mirkin, Various materials
Bauhaus-Archiv, Berlin

58 (right)
Study in dark and light tones (produced
during Itten's Preliminary Course),
c.1920
Friedl Dicker
Bauhaus-Archiv, Berlin

59 Sketch analysing Meister Franke's
'Adoration', 1920–21
Johannes Itten
Bauhaus-Archiv, Berlin

62 Portrait of Johannes Itten, 1921
Photograph by Paula Stockmar
Bauhaus-Archiv, Berlin

64 Advertisement for Mazdaznan diet and
cookery books
Anon. Students
Thüringisches Hauptstaatsarchiv
Weimar

65 Portrait of Georg Muche, c.1921
Photograph by Lucia Moholy
Bauhaus-Archiv, Berlin

66 Colour Composition, c.1920
Johannes Itten or Friedl Dicker
Painted collage
Bauhaus-Archiv, Berlin

67 Zwei Eimer (Two Buckets), 1923
Georg Muche
Oil on hardboard
Bauhaus-Archiv, Berlin

69 (left)
Drei Formen in einer Form (Three
forms in one form), 1923–4
Gertrud Arndt
Bauhaus-Archiv, Berlin

69 (right)
Vollkonstruktiv Logisch (Fully
constructive, logical), 1923–24
Gertrud Arndt
Bauhaus-Archiv, Berlin

73 (top)
Diagrammatic sketch illustrating
structure of Bauhaus teaching, 1922
Paul Klee
Bauhaus-Archiv, Berlin
© DACS 1992

72–3 (below)
Four pages from Klee's teaching
notebook, for lectures first given in
Winter, 1921–22
© DACS 1992

75 Colour studies (produced during Klee's
class), c.1923
Joost Schmidt
Jürgen Holstein GmbH

80 (left)
Portrait of Wassily Kandinsky, 1930
Photograph mounted on board
17.5 × 12.5 cm
Jurgen Holstein GmbH
© ADAGP, Paris and DACS, London
1992

80 (right)
Questionnaire seeking to demonstrate
affinities between primary colours and
primary forms, 1923
Completed by Alfred Arndt
Bauhaus-Archiv, Berlin

76 Paul Klee in his studio, Bauhaus
Weimar, 1925
Photograph by Felix Klee,
Alexander Klee

77 Orientalische Gartenlandschaft
(Oriental Garden Landscape), 1924
Paul Klee
Watercolour, pen and ink,
21.9 × 16.7 cm
Ulmer Museum – On permanent loan
from Landessammlung
Baden-Wurttemburg
© DACS 1992

78 Kristall-Stufung (Crystal Gradation),
1921
Paul Klee
Watercolour
Oeffentliche Kunstsammlung Basel,
Kupferstichkabinett, © DACS 1992

79 Auf Grau (On Grey), 1923
Wassily Kandinsky
Oil on canvas, 120.2 × 140.5 cm
Solomon R. Guggenheim Museum, New
York
Photo: David Heald © Solomon R.
Guggenheim Foundation, New York and
© DACS FN 49.1214 © ADAGP, Paris
and DACS, London 1992

85 The weaving workshop, Weimar, 1921
Photograph
Hochschule fur Architektur und
Bauwesen Weimar

86 Weaving sample for a wall hanging,
c.1925
Immeke Mitscherlitsch-Schwollman
35 × 25 cm
Jürgen Holstein GmbH

87 Weaving sample for a wall hanging,
c.1925
Immeke Mitscherlitsch-Schwollman,
25 × 21 cm
Jürgen Holstein GmbH

88 Carpet, 1922–23
Otte Koch
Kunstsammlungen zu Weimar

89 Appliqué fabric, 1921
Ida Kerkovius
Bauhaus-Archiv, Berlin

90 Costume and Mask design for central
figure in Schreyer's play 'Man', 1922
Lothar Schreyer
Bauhaus-Archiv, Berlin

91 'Kreuzspiel', Three stages of a reflected
light composition, c.1923
Ludwig Hirschfeld-Mack
Bauhaus-Archiv, Berlin

92–93 'Spielgang für Kreuzigung', Two pages
from diagrammatic 'score' of Schreyer's
play 'Crucifixion', 1920
Lothar Schreyer
Bauhaus-Archiv, Berlin

94 Design for a competition in the USSR,
1925
Fritz Schleifer
Watercolour and black ink on yellowish
japan paper 37.2 × 46.2 cm
Jürgen Holstein GmbH

95 Colour exercises (produced during Klee's
class), c.1920
Joost Schmidt
Watercolour (gouache)
Hauswedell and Nolte

96–97 Study for colour scheme of upper floor
of the Auerbach house, Jena, 1924
Alfred Arndt
Bauhaus-Archiv, Berlin

98 Page from the article 'Analysis of Old
Masters' in 'Utopia, Dokumente der
Wirklichkeit', 1921
Johannes Itten and Friedl Dicker
Bauhaus Archiv, Berlin

99 (left)
Bookbinding, c.1923
probably Anni Wotiz
Parchment
Bauhaus-Archiv, Berlin
Frank Whitford

99 (right)
Cover of Bauhaus regulations showing
official seal, 1922
Seal designed by Oskar Schlemmer

100 Reaching for the Stars, 1922
Ludwig Hirschfeld-Mack
Lithograph, 42.2 × 31.6 cm
Art Gallery of New South Wales,
Purchased 1961

102 (top)
Chess set, 1924
Josef Hartwig
Bauhaus-Archiv, Berlin

Index